FREDERICK LAW OLMSTED

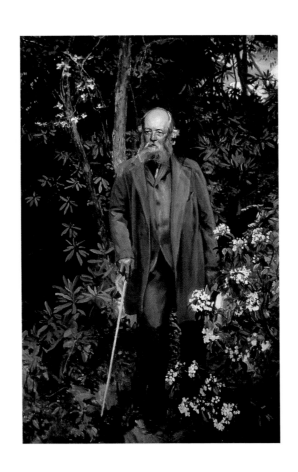

FREDERICK LAW
OLMSTED

DESIGNING THE AMERICAN LANDSCAPE

CHARLES E. BEVERIDGE AND PAUL ROCHELEAU
EDITED AND DESIGNED BY DAVID LARKIN

RIZZOLI
NEW YORK

First published in the United States of America in 1995 by
RIZZOLI INTERNATIONAL PUBLICATIONS, INC.
300 Park Avenue South
New York, New York 10010

Library of Congress Cataloging-in-Publication Data

Beveridge, Charles E.
 Frederick Law Olmsted: designing the American landscape / Charles E. Beveridge
and Paul Rocheleau ; edited and designed by David Larkin.
 p. cm.
 Includes bibliographical references (p.) and index.
 ISBN 0-8478-1842-X
 1. Olmsted, Frederick Law, 1822-1903. 2. Landscape architects—United States—
Biography. 3. Landscape architecture—United States. I. Rocheleau, Paul. II. Larkin,
David. III. Title.
SB470.O5B47 1995
712'.092—dc20
[B] 95-12042
 CIP

Designed by David Larkin / A David Larkin Book

Printed in Italy

Frontispiece: John Singer Sargent, *Portrait of Frederick Law Olmsted,* 1895.

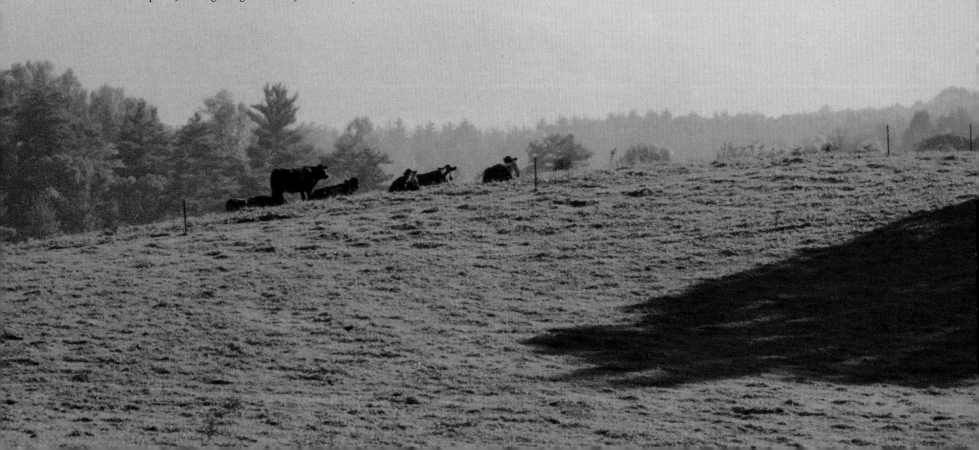

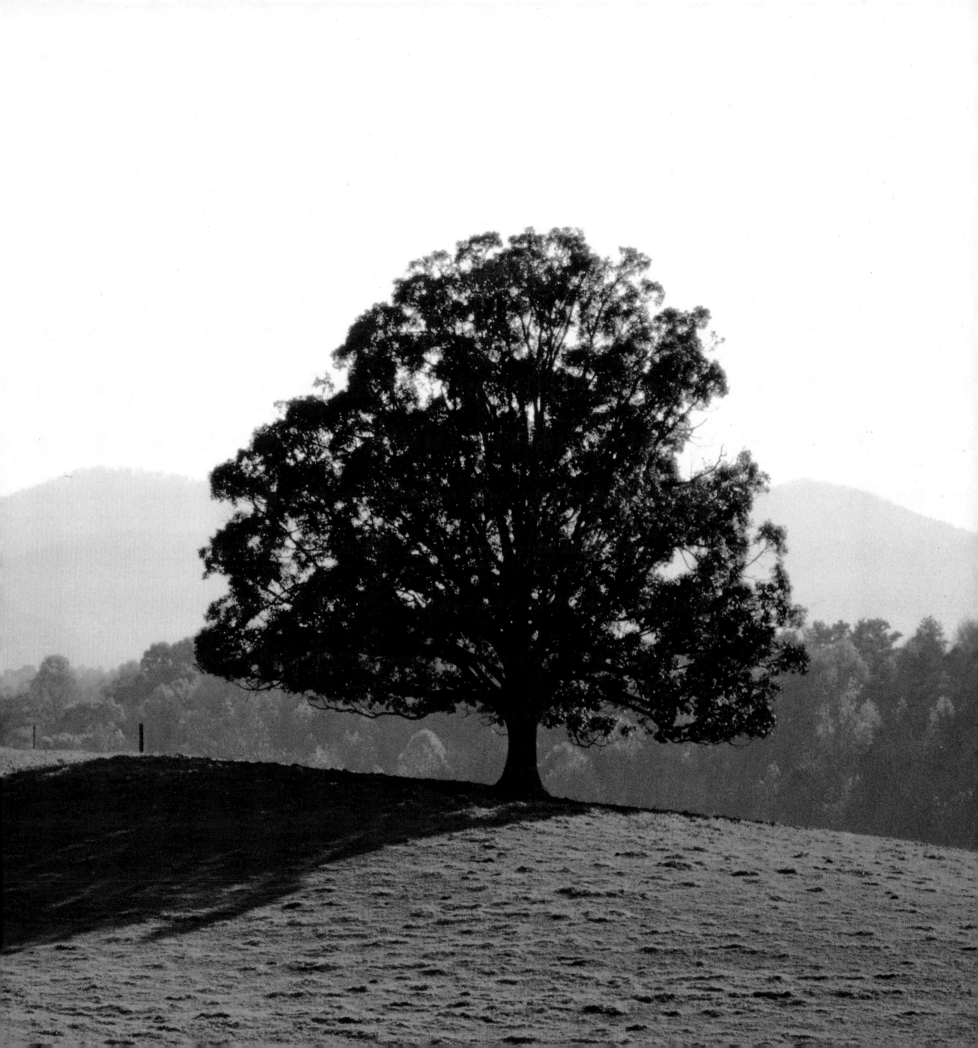

CONTENTS

CONTENTS

Preface

THE STORY OF FREDERICK LAW OLMSTED is a tale of epic proportions. Even his best-known accomplishments as a landscape architect suggest a man of impressive resolve and resourcefulness: co-designer of Central Park, the first great American urban park; head of the first Yosemite commission; leader of the campaign to protect Niagara Falls; designer of the U.S. Capitol Grounds and West Front terrace; site planner for the Great White City of the 1893 World's Columbian Exposition; planner of Boston's "Emerald Necklace" of greenspace and of park systems in many other cities.

Beyond that are other, less tangible, contributions. With his partner Calvert Vaux he chose the term "landscape architect" that members of his profession in the United States would use thereafter, and with Vaux he invented the "parkway"—a landscaped drive for pleasure vehicles separate from commercial carts and wagons—first designed in Brooklyn in 1868. During his career Olmsted defined what the large urban park in America would be and created the first park systems and urban greenways in this country. In Riverside, Illinois, he created the most comprehensively planned suburban residential community of nineteenth-century America, while in the San Francisco Bay area he devised an innovative and water-conserving landscape style for the semiarid American West. At Biltmore Estate in North Carolina he launched the first great experiment in scientific forestry in this country. He developed a style of landscape design that still exerts a strong influence on his profession and founded a firm that dominated that profession for nearly a century.

Some of his work is obscured by the passage of time. In the public mind his career merges with that of the son who shared his profession and name. For one hundred years a Frederick Law Olmsted played a leading role in American landscape architecture. Few are aware that in 1895 Frederick Law Olmsted, Jr., succeeded his father in that role. During their combined careers, the Olmsted firm undertook more than six thousand commissions, of which fully half were carried out on the ground. Also obscured is the contribution of John C. Olmsted, who was Olmsted's partner for a decade and senior partner in the firm of Olmsted Brothers from 1898 to his death in 1920.

Other aspects of Olmsted's legacy can be described only in superlatives. He designed more parks and public recreation grounds than any landscape designer before him, and carried out more commissions than any predecessor in his art. He also had higher

ambitions for his profession than any of his contemporaries. He sought to create spaces that had great psychological power and carefully planned every detail so as to achieve that purpose. At the same time, he defined a role for the landscape architect in planning a series of social institutions—parks, parkways, park systems, scenic reservations, residential communities, academic institutions, and private estates—that he hoped would transform the public and private life of the people of the United States.

Part of the significance of his contribution stems from the social vision that he brought to his profession in its formative years. Before he finally settled on landscape architecture for his life's work, he played a role in several social movements of the day. As a gentleman farmer he sought to ameliorate the isolation of the American farmer. As a traveler in the South and author of three books describing his journeys, he provided the antislavery movement with a reasoned and powerful critique of slavery and slave-labor society. He was an activist as well as a writer, helping to arm freesoil settlers in the Southwest and securing northern support for antislavery German settlers in Texas. From 1855 to 1857 he served as managing editor of *Putnam's Monthly Magazine*, a leading political and literary journal. During the Civil War he was the originator and co-founder of the *Nation*, which is still published today. When the Civil War broke out he became the executive head of the U. S. Sanitary Commission, predecessor to the Red Cross. In two years he forged a national organization for distributing relief supplies to the volunteer soldiers of the Union army, created an efficient inspection system of army camps, and helped to reorganize of the army medical corps.

Drawing from a disparate series of experiences over thirty years, and without benefit of a college education, Olmsted created a new profession during the three decades following the Civil War. In the process, he made a unique contribution to the course of art in the American republic. He combined keen aesthetic sensibility with the administrative skills required to implement his designs. To the task he brought immense dedication and determination. Inspired by a strong sense of duty and a lofty concept of the role of the landscape architect in American life, he drove himself unrelentingly. The result is evident today in scores of public parks and other spaces that provide a special amenity of landscape art for millions of Americans.

The Years of Preparation

FREDERICK LAW OLMSTED was born on April 26, 1822, in Hartford, Connecticut, a member of the eighth generation of his family in that community. His forebear, the immigrant James Olmsted, had been one of the original founders of the settlement in 1636. That heritage was to have great influence on Olmsted's development in the years to come.

His mother died when he was only four, and his father, John Olmsted, soon married a spinster friend of his wife and sired four more children. The existence of a stepmother and growing family of half-siblings resulted in a close bond between Olmsted and his younger brother John Hull Olmsted, the only other child of Olmsted's father and mother. They shared little of the new family circle, however; Frederick was sent away to be schooled by a country parson in another town when he was seven. During the next ten years, he lived with a succession of clergymen in Connecticut and Massachusetts. He never spent a full year at at home in Hartford again.

His father sent him away so young, he said, in order to give the boy the best opportunity for a good education and for religious conversion; he had been denied both and felt the lack severely. But in both respects his hopes for his son were not realized. The ministers who cared for him sometimes sent him to the common schools; Joab Brace of Newington, Connecticut, with whom Olmsted lived from the age of nine to fourteen, left his four pupils to study on their own for most of the day. Occasionally, however, he would take off his shoes and creep up the stairs to the door of the loft where they sat. "If I was telling a story," Olmsted later recounted, "my stories were generally of runaways—the parson would wait until I reached a situation of interest, when he would break in shouting 'Oh! the depravity of human nature!' and seizing a ruler, a stick of firewood or a broom handle, go at us all pellmell over the head and shoulders." Whatever the shortcomings of his education at Brace's, the boy learned to wash in the cold and to take his turn, even at the age of nine, in chopping firewood for the household in winter.

By the age of fifteen Olmsted had received an adequate common school education, despite the episodic nature of his schooling. His religious instruction was not as successful. For the most part his spiritual care was left to Sunday school teachers, whom he described as "vain, ignorant and conceited big boys and girls—parrots or quacks at the business." Although he later claimed that he had had seventy-two religious experiences, Olmsted emerged from his schooling with little more than an aversion to ministerial pretensions and religious beliefs that were accepted but not understood.

Perhaps the most important aspect of his early schooling was the variety of people with whom he came in contact. During his first year away from home, for instance, he spent much of his time wandering around the township of North Guilford and accompanying the parson, Zolvah Whitmore, on his rounds. Here, people allowed him to take part in their activities and took time to answer his questions. His experiences elsewhere were less happy but served to strengthen the traits of independence and pertinacity that were to mark his character.

Ironically, it was at his home in Hartford, and from his father, that Olmsted received the education that in the end was the most important. A shy and retiring man who was uncomfortable in social surroundings and talked little on any occasion, John Olmsted had a well-developed aesthetic taste that expressed itself in the way he furnished his home and in the prints and other artworks that he amassed. His great love, however, was the natural world. Olmsted later said that "his sensitiveness to the beauty of nature was indeed extraordinary, judging from the degree in which his habits were affected by it." He gave more time and thought to that subject than anyone Olmsted knew "who could not and would not talk about it or in any way make a market of it."

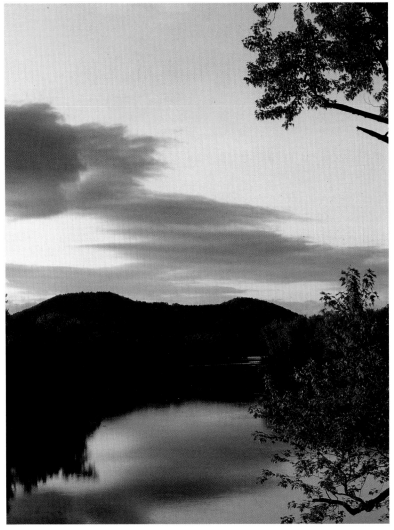

Walpole, New Hampshire.

John Olmsted included his son in his pursuit of the beauty of nature. One of Olmsted's earliest recollections was of riding on horseback across the meadows of the Connecticut River in the early evening, seated in front of his father's saddle. After he left home for his schooling, he always returned to join his family in their annual "tours in search of the picturesque." By the time he was sixteen those expeditions had taken him north to the White Mountains and west to Niagara Falls, as well as up and down the more familiar terrain of the Connecticut valley. The group traveled slowly, stopping often to view especially pleasing scenes. Although there was little conversation, the boy received a thorough and continuous instruction in the appreciation of scenery. At his father's hands he learned the first of those lessons in "taste" that would so influence the course of his life and, eventually, the nature of his art. In all of this his stepmother played a role as well, since she too was an avid lover of the picturesque and an enthusiastic collector of wild plants.

Just when Olmsted was ready to enter college and begin a more demanding and systematic educational regime, a freak accident altered his plans and his life. In 1836 a severe case of sumac poisoning partially blinded him, and for several years thereafter his eyes troubled him. The New York specialists whom his father consulted recommended that he should do little reading, and so for the next four years he continued his desultory combination of studies and outdoor wandering. "At the time my schoolmates were entering college," he later wrote, "I was nominally the pupil of a topographical engineer but really for the most part given over to a decently restrained vagabond life, generally pursued under the guise of an angler, a fowler or a dabbler on the shallowest shores of the deep sea of the natural sciences."

This rural idyll could not last indefinitely, however, and in August 1840 his father sent him to New York to work in a dry-goods-importing firm and learn about the business. Within a year and a half the experiment had failed, and Olmsted was relieved to be back in Hartford and free from the restraints of a clerk's life. The next fall his brother entered Yale College, and Olmsted occasionally visited New Haven and began to form friendships with his brother's friends. But in the meantime he was not preparing himself for the future. His solution to that dilemma was to travel further afield: in April 1843 he sailed for Canton, China, as a ship's boy aboard the bark *Ronaldson*. Doubtless he had in mind the exploits of his seafaring greatuncles, as well as the tales of adventure he had read.

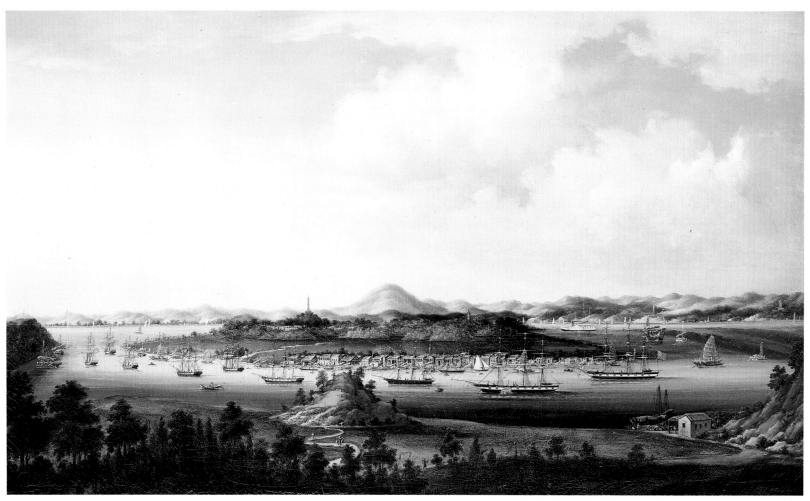

Youqua, *Whampoa.*

Whatever his expectations, however, he was sorely disappointed. Instead of improving his health and filling out his slight frame, he suffered a continuing series of illnesses that nearly shattered his health. On the return voyage he suffered from scurvy. Emaciated to the point that he resembled "a purser's shirt on a handspike," he landed in New York in such a condition that his father did not recognize him.

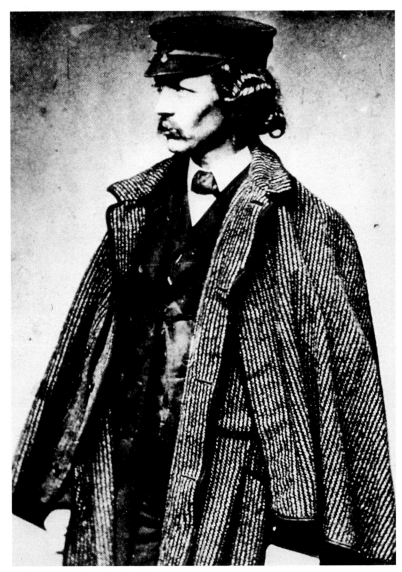

Frederick Law Olmsted, c. 1860.

LIFE AT YALE

Soon after the end of his voyage he briefly took up studies as a special student at Yale, seeking scientific training that would help him in his chosen career as a farmer. Sickness prevented his return after the first semester, but he often visited his brother and friends during the next year. Among them was Charles Loring Brace, a lifelong friend who devoted a forty-year career to founding and directing the Children's Aid Society in New York City. What Olmsted contributed to the group was his

"vivacity"—an intensity and liveliness that sometimes startled newcomers to the group and that must have been excited by the camaraderie he shared with those friends. His friends also noted the indomitable enthusiasm with which Olmsted approached life. As one of them observed to his brother, "He is an Enthusiast by nature. Many of his favorite schemes will go to naught, but he'll throw it aside and try another and spoil that and forget them both while you or I might have been blubbering over the ruins of the first." That enthusiasm would be a precious resource for Olmsted when he faced the many trials and disappointments of his career as a landscape architect.

During Olmsted's brief stay in New Haven he was introduced to a number of young women. He was particularly smitten by petite and pretty Elizabeth Wooster Baldwin, the brightest and most socially prominent of all. The granddaughter of Roger Sherman and daughter of the current governor of the state, she represented both social standing and the graces of culture. He idealized Elizabeth from the start, and her open, friendly manner allowed him to dare to speak his thoughts. After he left New Haven, she declared that it was "neither right nor best" that they continue a correspondence, but she remained strong in his memory. In later years he endowed her with the role of preceptor: it was in her family's drawing room, he remembered, that he first learned to value such "prophets" as Ralph Waldo Emerson, James Russell Lowell, and John Ruskin. Nearly fifty years later, he still retained a clear image of her: "You lifted me a good deal out of my constitutional shyness, and helped more than you can think to rouse a sort of scatter-brained pride and to make me realize that my secluded life, country breeding and mis-education were not such bars to an 'intellectual life' as I was in the habit of supposing." Literature and the fine arts were the domain of women at that time, and much of Olmsted's exposure to those subjects would take place in the company of women.

CARLYLE AND CONVERSION

In 1846, during his year of apprenticeship with the farmer George Geddes in western New York state, perhaps his most significant experience was a kind of secular conversion. He read Thomas Carlyle's autobiographical work *Sartor Resartus* and adopted the philosophical conclusions of the protagonist. The message of the book lay in the

hero's transition from despair to his affirmation of the "Universal Yea." Olmsted eagerly adopted Carlyle's assertion that "Conviction, were it never so excellent, is worthless till it convert itself into Conduct." A Christian life should be expressed in action, and increasingly Olmsted ordered his belief and his life around Carlyle's exhortation to "Do the Duty which lies nearest thee."

The following summer he admitted to Brace that he had no original views on religious questions and deprecated the importance of ideas in themselves. "We have work to do, as well as to think and feel," he wrote his friend. "Let us help each other then to give our thoughts a practical turn. . . . There is great *work* wants doing in this our generation, Charley, let us off jacket and go about it." His final statement of religious belief, in the book of English travels he wrote in 1851, paraphrased St. James: "True religion is this, to visit the widows and fatherless in their affliction, and to keep oneself unspotted in the world." The fact that Olmsted's religious quest ended in a sanctification of work done for the good of others gave strong impetus to the immersion in professional duties that characterized the rest of his life. He considered that his work was his duty and subordinated family responsibilities and recreation with friends to it. As old age approached, he recognized how much this had been the pattern of his life. Writing to an old friend, in 1890, he confessed, "I have been selling being for doing."

Above and opposite: Sachem's Head, Connecticut.

EARLY FARMING EXPERIENCE

Early in 1847, Olmsted's father bought him his first farm, where he could combine his care of the land and his love of the sea. The site was Sachem's Head, a promontory of woods, marshes and bold rocky shores on the Connecticut coast near New Haven. There he set eagerly to the task of reclaiming fields that had been "skinned" by generations of impecunious farmers before him. There he also made his first landscape plan, for a house he proposed to build near the shore. Before he completed many improvements he moved again—this time to a farm on the outer shore of Staten Island where he lived from the spring of 1848 to the spring of 1855.

During his early years on Staten Island, John Hull Olmsted and Charles Loring Brace were completing their professional studies in New York City. They often gathered at Olmsted's farm on weekends. Olmsted demonstrated two traits that would persist throughout his life. One was his suspicion of habitual and traditional belief and the other was the importance of using reason to solve problems. In pressing these views on his friends, he showed his old vivacity. Describing one of those weekends on Staten Island, Brace marveled at the amount of talking that went on. "One steady stream from six o'clock Saturday night till twelve," he recounted, "beginning next day, and going on till about twelve the next night, interrupted only by meals and some insane walks on the beach!" The arguments between Brace and Olmsted were intense, too, he said, "a torrent of fierce argument, mixed with diverse oaths on Fred's part, and abuse on both!" Brace was impressed with his friend's performance during these debates. John Hull Olmsted had been concerned when he visited his brother at Sachem's Head about the low level of conversation in the household. He was sorry that Olmsted had not gone to college: "He has fine capabilities naturally I think," John wrote, "but they want training now most shockingly." Olmsted admitted as much, saying that he found it increasingly difficult to write letters. "It's your trade to think and write and every day adds to your Handiwork," he observed. "Your mind cutting book leaves daily is a self-sharpening tool; mine rooting dirt and floating downstream grows dull, water logged and rusty."

Still, Olmsted learned important skills during his years as a farmer. On Staten Island he launched into the job with enthusiasm and played a leading role in founding an agricultural improvement society on the island. He improved the soil of his own farm and convinced the society to import one of the first English machines for making tiles for "thorough-drainage" of soil. He also improved the sanitation and landscaping of his farm. In managing as many as eight farmhands he gained skills that he would call on a decade later when he directed the work of four thousand in the construction of Central Park.

EUROPEAN TRAVEL

Olmsted did not remain simply a farmer for long. At the end of two years he took off six months to travel to the British Isles and the Continent with John and Charles Loring Brace. He described the first part of the trip, from Liverpool to the Isle of Wight, in his first book, *Walks and Talks of an American Farmer in England*. The English countryside delighted him. He was especially pleased by the way that generations of settlement had merged nature and society. The mild light and hazy atmosphere produced an effect of "quiet peaceful, graceful beauty, which the works of man have generally added to." Having read the works of English landscape writers in his youth, he was anxious to see the parks and estates designed by people like Humphry Repton and Lancelot "Capability" Brown. The sight of Eaton Hall, an estate near Chester where both had been employed, led him to a prophetic admiration of the landscape gardener's art. "What artist so noble," he exclaimed, "as he, who with far-reaching conception of beauty and designing power, sketches the outline, writes the colours and directs the shadows of a

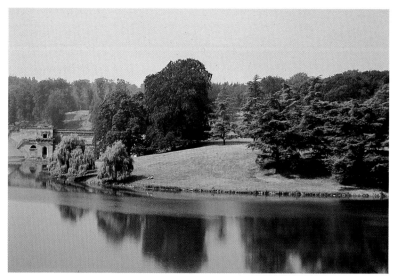

Park at Blenheim Palace, Oxfordshire.

picture so great that Nature shall be employed upon it for generations, before the work he has arranged for her shall realize his intentions." In time he would come to know other estates created by Britain's greatest landscape gardeners, including Capability Brown's arcadian scenery at Blenheim.

Soon after landing at Liverpool, Olmsted encountered his first professionally designed public park, and the closest in Europe to what he would himself come to design. This was Birkenhead Park, designed in 1844 by Sir Joseph Paxton, who had designed the Crystal Palace of the 1851 Exposition in London and planned extensive additions to the grounds of Chatsworth, the great estate of the dukes of Devonshire. After spending five minutes in the park, Olmsted was ready to admit "that in democratic America there was nothing to be thought of as comparable with this People's Garden." He minutely examined the park and its construction with the aid of its staff. The careful engineering, the gently curving walks and drives, the mounding of earth to create separate spaces planted for different effects, all introduced him to design principles that he would apply in Central Park eight years later.

During his tour he also met leading English social reformers and he returned home with a renewed sense of dedication. To Brace, who remained in Europe for the rest of the year, he appealed, "Conform now, and when you come to America *fight* We want ten thousand such apostles of ideas as you to come and work . . . against the material tendency that is swamping us."

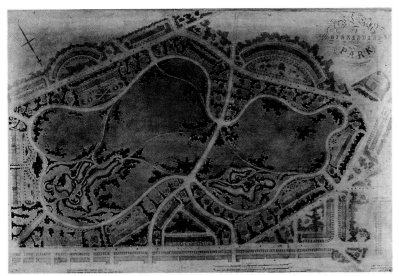

Plan of Birkenhead Park, near Liverpool, c. 1844.

GENTILITY AND TASTE

By this time Olmsted had developed a set of social values and a program for improvement of American society that would guide both his judgments and his actions for the rest of his life. For his concept of the kind of person the good society should produce, however, Olmsted drew from the eighteenth-century tradition of the gentleman. With the enthusiasm and optimism of his own century he looked forward to the time when all people in America, whatever their social position, would have the education and manners of gentlemen. This was true even before he met the like-minded reformers who became his close friends. As early as 1846, when he looked forward to the life of a gentleman farmer and agricultural reformer, he asserted that it was the duty of government to encourage "a democratic condition of society" by providing education that not only gave the poor the ability to read and write but also refinement and taste. Through his various careers Olmsted's goal was to help create an American society where all people had the qualities of gentility. Olmsted wanted the government to assist this process by creating a variety of cultural institutions dedicated to educating the whole populace. Since his concern was with the development of a new level of civilization, he put as much hope in social institutions as he did in governmental ones. For him and many other reformers of the time, the crucial institution in society, the most enduring and with the strongest educational force, was the family. Social attitudes and values were formed at an early age within the family setting by precept and by example; the family and the home must become civilized before society at large could be transformed. It was there, above all, that people would learn to be gentlemen and gentlewomen. For Olmsted the physical aspect of the homestead was important as an indicator, and as a force in its own right, creating the most conducive setting for the development of domesticity and gentility. What he looked for was the presence of "taste"—that mixture of aesthetic values, cleanliness, and sense of propriety that not only marked the gentry but served as an important means of moving society from a state of barbarism to one of civilization.

In formulating his own ideas on these questions, Olmsted drew from the teachings of thinkers who, like himself, were descended from the first generation of settlers in New England. One was Timothy Dwight, president of Yale College from 1785 to 1817 and a leading figure in Connecticut at the time. Another was Andrew Jackson Downing, the first important American landscape gardener.

The basic source for Timothy Dwight's views is his *Travels in New-England and New-York*, in which he examined the society of those regions with much the same eye that Olmsted later brought to bear on the South. Applying the standards of the Land of Steady Habits, he drew many unflattering comparisons between the orderly villages of the Connecticut valley and the barbarous scattered population of the New York frontier. He saw the society of the valley as the most admirable in the United States. The towns themselves were neither too large nor too small, and they were designed for living, rather than simply for trade and manufacture. Their residents lived close enough together to form a real community and yet not, as in European villages, so close as to be "incapable of admitting around each house the beautiful appendages of shrubs, trees, gardens and meadows." Society was homogeneous: most inhabitants were economically independent and modestly prosperous, and there were no overweening rich or degraded poor. In fact, Dwight asserted, a considerable number of both farmers and mechanics of the Connecticut valley merited "the appellation of gentlemen."

Timothy Dwight was concerned not only with preserving old forms of this society but also in improving it. The method he taught was one that Olmsted took to heart. In his *Travels*, Dwight offered a classic analysis of how encouragement of taste could promote a civilized life:

There is a kind of symmetry in the thoughts, feelings, and efforts of the human mind. Its taste, intelligence, affections, and conduct are so intimately related, that no preconception can prevent them from being mutually causes and effects. The first thing powerfully operated on, and in its turn proportionally operative, is the taste. The perception of beauty and deformity, of refinement and grossness, of decency and vulgarity, of propriety and indecorum, is the first thing which influences man to attempt an escape from a grovelling, brutish character; a character in which morality is effectually chilled or absolutely frozen. In most persons this perception is awakened by what may be called the exterior of society, particularly by the mode of building. Uncouth, mean, ragged, dirty houses constituting the body of any town, will regularly be accompanied by coarse, grovelling manners. The dress, the furniture, the equipage, the mode of living, and the manners, will all correspond with the appearance of the buildings, and will universally be in every such case of a vulgar and debased nature.

Town square, Haverhill, New Hampshire.

18

Good taste, then, covered a wide range of values: it included cleanliness and efficiency as well as beauty and refinement. It was the key to a full education and the means by which all classes in America could achieve gentility.

Another New England author who strongly influenced Olmsted's thinking about social reform was Andrew Jackson Downing. Son of a Massachusetts nurseryman who had established a nursery in Newburgh, New York, in the midst of the country seats of the Hudson River gentry, Downing married into that circle and became the designer of their houses and grounds. His books on rural architecture, landscape design, and horticulture gained him a national reputation, and his periodical, *The Horticulturist and Journal of Rural Taste and Rural Art*, which he edited from 1846 until his tragic death in 1852, emphasized the importance of agricultural reform and the development of taste. Olmsted subscribed to the *Horticulturist*, wrote occasional pieces for it, and was deeply influenced by the lessons Downing taught. Downing strengthened beliefs that Olmsted had acquired from other teachers and gave him new views of the role of landscape gardening and horticulture in American life. Downing's great concern was the importance of taste, and his recurrent theme was the improvement of the home.

He urged the advantages of the tasteful arrangement of buildings and plantings on farms, and his conception of the "ferme ornée," which combined beauty and utility, became Olmsted's image of what a farm should be.

Downing reinforced Olmsted's patriotism and showed him how concern for the true wealth of the country should express itself in the improvement of the home. The program he proposed was the same that Olmsted was adopting as an improver of the "ignoble vulgus." "The love of country is inseparably connected with the *love of home*," Downing wrote. "Whatever, therefore, leads man to assemble the comforts and elegancies of life around his habitation, tends to increase local attachments, and render domestic life more delightful." To this development, Americans must look for "a coun- terpoise to the great tendency towards change, and the restless spirit of emigration, which form part of our national character; and which, though to a certain extent highly necessary to our national prosperity are . . . opposed to social and domestic happiness." Such doctrine was a strong restatement of views that Olmsted had absorbed from thinkers like

Timothy Dwight and his family's minister Horace Bushnell and that already formed an important part of his reformist's creed.

For Downing the social purpose of landscape gardening extended beyond the setting of the individual farm or country seat to the physical arrangement of the entire community. He urged that with the constant creation and growth of new settlements throughout the country "the plan and arrangement of new towns ought to be a matter of national importance." In established towns he called for "social planting reform" that would line the streets with trees in the tradition of elm-shaded New England villages. Downing was quick to point out that his interest in good houses and pleasant grounds did not arise simply from his aesthetic sensibilities. Such things, he said—in a phrase reminiscent of Timothy Dwight—were "only the external sign by which we would have the country's health and beauty known. . . ." Pleasant surroundings were the sign of civilization: "the tasteful appearance which we long for in our country towns, we seek as the outward mark of education, moral sentiment, love of home, and refined cultivation, which makes the main difference between Massachusetts and Madagascar."

Concern for another kind of communal need led Downing to agitate for public parks in villages and cities. He repeatedly urged in the *Horticulturist* that New York City should have a large park. City dwellers needed the refreshment of green space and fresh air. By bringing together people of all ranks and minimizing conflict between classes, public parks could play an important social role in a democracy. They could also help to educate the lower classes in the graces of gentility. Downing, like Olmsted, hoped for the day when all Americans would be gentry. That monarchical and aristocratic countries such as England and Germany should have large public parks while nominally democratic America had none worthy of the name was a disgrace and travesty.

Downing was Olmsted's mentor in what taste should be and how "rural" taste" could be used to improve the civilization of America. Both in his own life and in his writings he epitomized the mixture of manners, aesthetic concern, and reforming purpose that Olmsted wished to achieve for himself. Although in his later career Olmsted found much to criticize in Downing's landscape designs, he always affirmed his importance as a teacher of the role of taste in society.

JOURNEYS IN THE SOUTH

Soon after the publication of his travel book in 1852 Olmsted embarked on a more ambitious travel-writing adventure. Through his connections with the newly founded *New York Daily Times,* Charles Loring Brace arranged for him to act as that newspaper's correspondent in the slaveholding South. He made two trips for this purpose, spending a total of twelve months in the South between December 1852 and July 1854. From these travels he wrote seventy-four newspaper letters and a three-volume series of description and analysis: *A Journey in the Seaboard Slave States* (1856), *A Journey Through Texas* (1857), and *A Journey in the Back Country* (1860). His writings constitute the most extensive and detailed study of southern society by any writer of the time. His critique of slavery contributed significantly to the ideology of the Republican party, which was taking form in these years.

During his first journey to the South he paid special attention to the condition of the slaves. But by the time of his second trip in 1853–54, the intensifying debate over the expansion of slavery changed his focus. The new controversy was touched off by the Kansas–Nebraska Act, which opened to slavery portions of the West that had been closed by the Compromise of 1820. Olmsted became more concerned with the negative effects of slavery on the white population of the South and on the cause of freedom throughout the country. He became active in the movement, led by the New England Emigrant Aid Society, to create free-soil settlements from Kansas to Texas to serve as barriers to the expansion of slavery. He even raised funds for Sharps rifles and a mountain howitzer to defend the free-soil settlement of Lawrence, Kansas.

The most significant experience in the South for Olmsted's own career, however, came as he began his second journey in late 1853. While visiting Nashville, Tennessee, he spent much of his time with Samuel Perkins Allison, a Yale classmate of his brother John. Allison was a slaveholder and, Olmsted concluded, a good example of a southern gentleman. The subject of their debate was the relative desirability of free-labor and slave societies. Olmsted was firmly convinced of the superiority of free labor, but Allison argued effectively that northern society produced few gentlemen worthy of the name. When Olmsted countered by claiming that "there were compensations in the *general* elevation of all classes at the North," Allison forced him to admit the "rowdyism, ruffianism, want of

high honorable sentiment & chivalry of the common farming & laboring people of the North."

The encounter showed Olmsted how much must be accomplished before the North could effectively demonstrate the superiority of a free-labor society. Without that demonstration there was no hope of convincing southerners to abolish slavery. The program that Olmsted outlined foreshadowed his later career as a landscape architect. It showed how central to his program of social reform was the raising of the general cultural level of the entire society. In a letter to Charles Loring Brace he wrote, "Our educational principle must be enlarged and made to include more than these miserable common schools." It was necessary to "get up parks, gardens, music, dancing schools, reunions which will be so attractive as to force into contact the good & bad, the gentlemanly and the rowdy." Thus, a series of public cultural institutions would be established that would provide the poor with "an education to refinement and taste and the mental & moral capital of gentlemen."

Later in his second southern journey Olmsted encountered a living example of his highest hope for American society—a community where all members had the "mental & moral capital of gentlemen." He found this remarkable world in the German settlements north of San Antonio. Through Adolf Douai, editor of the antislavery *San Antonio Zeitung,* he met a group of German forty-eighters, people of education and culture who had fled Germany after the suppression of the republican revolutions of 1848 in which they had taken part. He left a rhapsodic description of an evening gathering on a small farm where the excellent piano accompaniment enabled the participants to perform the ensemble parts of Mozart's *Don Giovanni.* Elsewhere he encountered teamsters camped on the prairie who repeated passages from Dante and Schiller "as they lay on the ground looking up into the infinite heaven of the night," and met people who quoted Hegel, Schleiermacher, Saint Paul, and Aristotle with familiarity and yet lived "in holes in the rock, in ledges of the Guadalupe, and earn their daily bread by splitting shingles." Such a society of cultured laborers was, for Olmsted, a glimpse of the millenium.

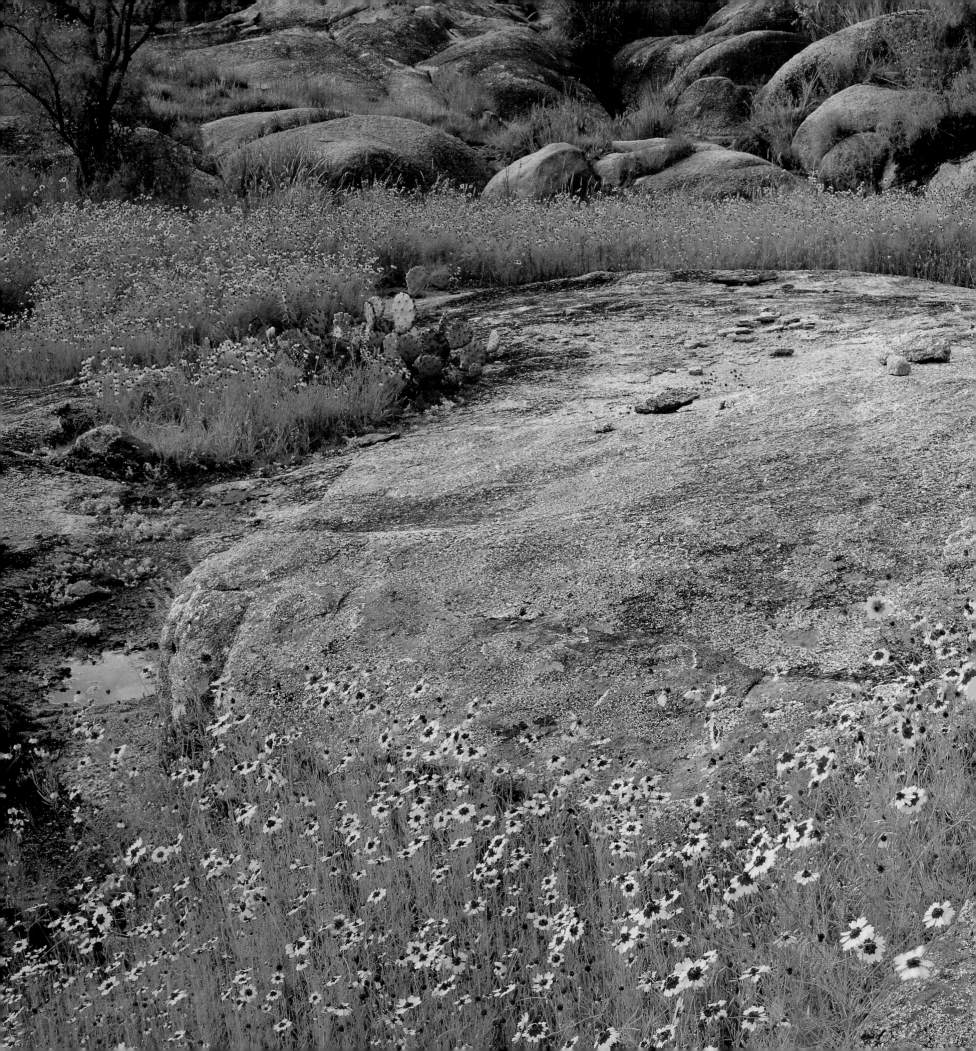

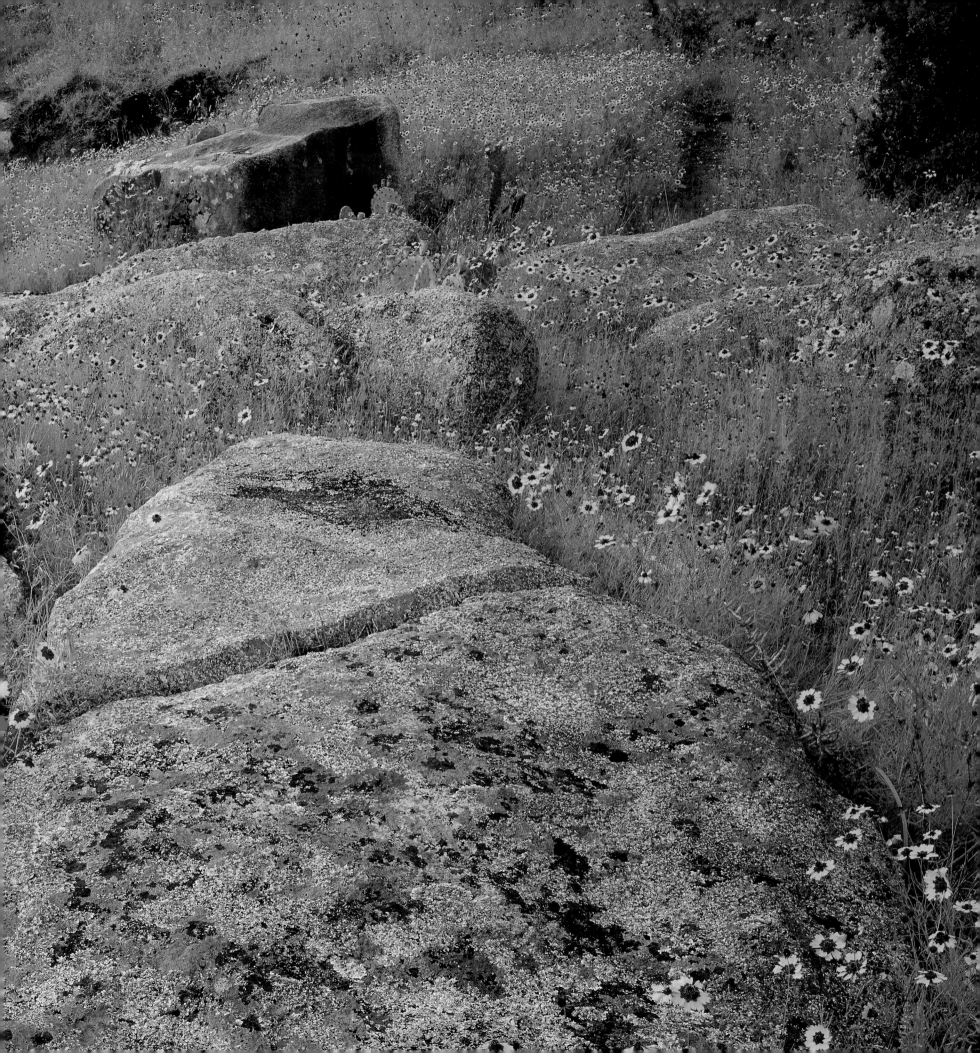

The scenery of the hill country north of San Antonio intrigued Olmsted as well. He remarked on the special beauty of the upper Guadalupe River, saying "I have rarely seen any resort of wood-nymphs more perfect than the bower of cypress branches and vines that overhang the mouth of the Sister creek" at Sisterdale. Elsewhere he encountered narrow valleys and hills "rugged with projecting strata of limestone." These strata, lying horizontally, gave the hills the appearance of artificial structures. In smaller valleys he found "real Sonora scenery," with a scattering of stunted live oaks and, amidst the grass, "large cacti, yuccas, and agaves, scattered over the arid rocky elevations."

Olmsted's admiration for the republican and antislavery German immigrants reinforced his concern about the fate of republican government. During the decade of the 1850s he saw the improvement of northern society as crucially important. It was the mission of the northern states to demonstrate both the viability of free labor and of political systems based on self-government. The various efforts at social reform that he embraced during this period were conceived in the setting of the struggle to strengthen the cause of free labor and democracy throughout the world.

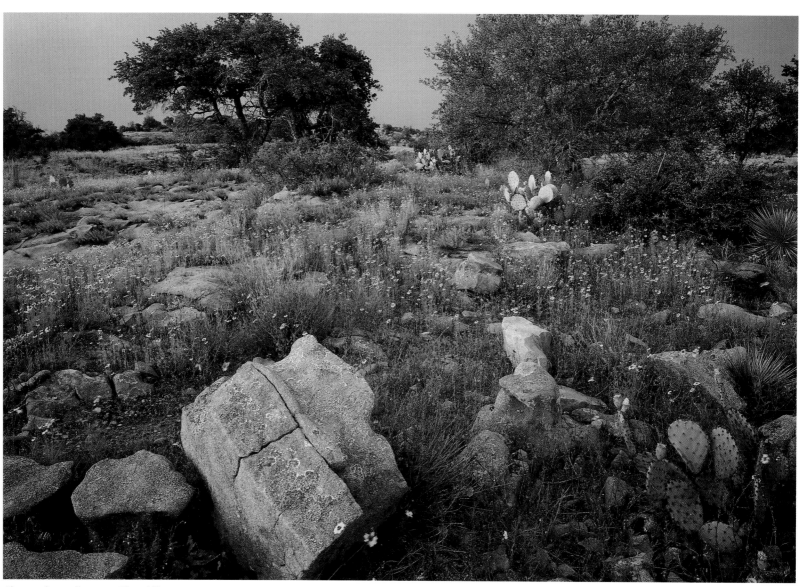

Above and preceding pages: Texas hill country.

THE "LITERARY REPUBLIC" OF NEW YORK

Following his second tour of the South Olmsted turned increasingly to a literary career. His brother assumed responsibility for the Staten Island farm, while Olmsted concentrated on writing his books on the South. At the same time he became the managing editor of *Putnam's Monthly Magazine*, a leading journal of literature and political commentary. In the spring of 1855 he moved to New York City, where he would live and work for most of the next twenty-five years. He set out to make *Putnam's* the "best outlet of thought in the country." His collaborators, Parke Godwin and George W. Curtis, wrote articles on political topics, while Olmsted secured contributions from literary figures. In the process he met and corresponded with many leading authors. Among the manuscripts that he first published were Thoreau's *Cape Cod* and Melville's *Benito Cereno*.

Olmsted's work as editor of *Putnam's* and partner in the publishing firm of Dix, Edwards & Company expanded his horizons in other ways. In 1856 he spent eight months in Europe on a business trip, traveling through Italy, the German states, France, and England. In London he became well acquainted with the many parks of the city and its environs, and in Paris he saw the parks constructed under Napoleon III. At the same time he developed a new hatred of the despotism that was spreading over Europe, as personified by Napoleon III and his overthrow of the French republic in 1852.

DESIGNING CENTRAL PARK

The following year, 1857, was a pivotal and tragic one in Olmsted's life. During the spring and summer he continued to work at *Putnam's* and Dix & Edwards. He also wrote a series of letters on his southern travels for the *New York Daily Tribune* as he completed *A Journey in the Back Country*. All of this came to a sudden end in August when his publishing firm failed. Casting about for new employment, he successfully applied for the position of superintendent of New York's new Central Park, whose board was beginning to prepare the site for construction. But six weeks later a new tragedy struck: John Hull Olmsted died of tuberculosis. In his last letter John wrote: "It appears we are not to see one another any more—I have not many days, the Dr. says. . . I never have known a better friendship than ours has been & there can't be a greater happiness than to

think of that." At the very end he admonished his brother, "Don't let Mary suffer while you are alive."

In the aftermath of this tragedy, Olmsted turned to his work at Central Park, first as superintendent and, after winning the design competition in 1858 with Calvert Vaux, as codesigner and director of construction. "There was no hope on earth that I would not have sacrificed to my desire to hold that position," he later wrote to Calvert Vaux: "I am capable of stronger passions than many men and I never had a more desperate passion than that. . . . A great deal of disappointed love and unsatisfied romance and down trodden pride fastened itself to that passion." The construction of Central Park engaged all his energies from the spring of 1858 to the spring of 1861, and he succeeded in carrying out much of the plan that he and Vaux had devised. This dedication came at the expense of his social life. Even before the painful collapse of his engagement to Emily Perkins, the niece of Harriet Beecher Stowe, in 1851, he had feared that he would die without finding "true love." In June 1859 he abandoned any hope of finding it and married his brother's widow, Mary Perkins Olmsted, assuming responsibility for her two small children.

Although he had found the profession that he would pursue for the last thirty years of his professional life, Olmsted's *wanderjahre* were not over yet. Even though he had shared the designing of Central Park with Vaux, he viewed himself primarily as an administrator. It was the realization of the plan on the ground, not its creation on paper, that he valued most: the management and planning of the steps that would execute the concept. For several years thereafter he continued to feel that it would be "blasphemous" for him to claim the title of artist.

THE CIVIL WAR

The outbreak of the Civil War drew Olmsted away from Central Park and gave him a new career as an administrator. With his strong opposition to slavery and his belief in the Union, Olmsted was determined to play a role in supporting the Lincoln administration. A near-fatal carriage accident in early 1860 had broken his leg and left him limping and lame. He thought that he might still serve in the navy, where his nautical experience would be of use, but instead his reputation

as an administrator gained him the position of executive director of the U.S. Sanitary Commission. A private organization with official recognition from the Lincoln administration, the commission was responsible for the sanitary condition of all volunteer troops in the Union army. Agents of the commission inspected army camps and coordinated relief supplies to the troops.

In a few brief months Olmsted created a national system of relief, drawing from sources throughout the North and providing medical supplies where they were needed. During the two years of his work he oversaw the collection and distribution of hundreds of thousands of dollars worth of food, medicine, and supplies to the volunteer troops. The work was demanding and intense: the head of the commission observed that Olmsted was "fanatical about his duty," and indeed he pushed himself to the brink of exhaustion many times in those two years. In the process he demonstrated aspects of his character, including his "artistic temperament," in a different light than they would appear in civilian life. He showed a remarkable ability to conceive a general plan and then evolve an administrative structure and series of actions to achieve a particular end. That combination of overall concept and mastery of detail, together with the energy to oversee the realization of a plan, would appear time and again during his thirty-year design career.

Olmsted also showed the same effective relationship with subordinates and intolerance of official superiors that characterized his twenty years as an employee of the New York City Parks Department. He continually clashed with the members of the Sanitary Commission, particularly with the executive committee that sought to direct the commission's affairs. His total command of the details of the situation usually forced the commissioners to back down. The commission's chairman, Henry W. Bellows, still a great admirer of Olmsted's talent, gave this opinion in a letter: "You ought not to work under anybody. . . With subordinates you have, and would have, no difficulties. It is only with peers or superiors (official) that you cannot serve."

The writer Katharine Prescott Wormeley, a coworker and subordinate of Olmsted's when he directed the hospital steamboat service in the Virginia tidewater during the Peninsula campaign of 1862, was equally struck with his character and wrote in her book *The Other Side of War:*

I think he is a man of the most resolute self-will —generally a very wise will . . . born an autocrat, however, and, as such, very satisfactory to be under. . . there is a deep, calm thoughtfulness about him which is always attractive and sometimes—provoking.

As the war progressed, Olmsted's struggle to make the commission truly national, with power concentrated in his own hands, led to increasing conflict with the executive committee. One member, the New York banker George Templeton Strong, gave a vivid description of the way that Olmsted drove himself to control the commission's demanding activities:

He works like a dog all day and sits up nearly all night, doesn't go home to his family for five days and nights together, works with steady feverish intensity till four in the morning, sleeps on a sofa in his clothes and breakfasts on strong coffee and pickles!!!

As for Olmsted's character, Strong noted: "Talent and energy most rare; absolute purity and disinterestedness. Prominent defects, a monomania for system and organization on paper (elaborate, laboriously thought out, and generally impracticable) and appetite for power. He is a lay-Hildebrand." Bellows echoed the thought: "He has an indomitable pride of opinion, habit of self-reliance, and passion for improvements. If he were a priest, he would be worse than Hildebrand or Laud; if a monarch he would rule with a rod of iron." Olmsted's antagonists in the Midwest, who wanted their relief contributions to go only to soldiers from their own states, were more concise: they referred to him as the "Great Mogul."

By the summer of 1863 the final crisis in his relationship with the members of the Sanitary Commission occurred. Convinced that he could never secure the unified administration of the commission that was essential to its success, Olmsted looked for other employment. He could not return to Central Park, because he and Vaux had resigned their position as landscape architects to the park commission earlier in the year. One possibility was to take part in planning governmental policy regarding the slaves who would be freed by Lincoln's Emancipation Proclamation. Olmsted had already written the legislation for one of the first federal programs, the Port Royal experiment, which affected freed slaves in the Sea Islands of South Carolina while under occupation by Union troops. He hoped to be put in charge of the freedmen in the Sea Islands in order to implement the policy, but bureaucratic realignments rendered that impossible. Later, one significant group of abolitionists

urged him to become head of the Freedman's Bureau, an appointment that went instead to General Oliver O. Howard. Olmsted did receive an offer to run the Freedmen's Aid Commission, a private organization dedicated to assisting freed slaves in the South, but he refused any such role during the period of Reconstruction. He was sick of trying to work with commissions and the "humbugging compromise" that such employment too often required.

Still, another possibility was to return to journalism. He enlisted Edwin L. Godkin to help him found a magazine that would support the Lincoln administration's program for abolition of slavery and educate the public to accept Federal protection of the freed slave's civil rights. Funds did not become available to finance that venture until 1865, however, and by that time Olmsted was in California. So it fell to Godkin to become editor of *The Nation*, a position he held for the next thirty-five years.

MANAGING THE MARIPOSA ESTATE

Instead of reentering the publishing world Olmsted spent the period from 1863 to 1865 as an administrator. But this time he was running neither a park nor a philanthropic agency but a California gold-mining company. New York investors had just purchased the great Mariposa Estate of John C. Fremont. The 44,000-acre estate was located in the foothills of the Sierra Nevada Mountains just west of what is now Yosemite National Park. Olmsted was apprehensive about what he would find on the California mining frontier. "I hate the wilderness & wild, tempestuous, gambling men, such as I shall have to master," he wrote his wife, "and shrink from encountering them as few men would."

The society of Bear Valley, the settlement that served as his headquarters, confirmed his apprehensions. He reported to his wife that of the thirty men buried behind the inn at Bear Valley, all but one had died the natural death of the region, "cold lead on the brain." His description of one of his first Sundays there reflected the character of the place and his reaction to it. There were no churches in Bear Valley, but there was a horse race in the main street at noon, with heavy betting. The Italians spent the day gambling "in the Roman way—loudly," and Chinese prostitutes ostentatiously plied their trade. "Evening services consist of a dog-fight," he concluded, and "a deep interest is felt by the whole population."

His experience with the California gold-mining frontier reinforced Olmsted's belief in the importance of domesticity. He was forcibly struck by the rootlessness, the lack of attachment to place, that prevailed on the Mariposa Estate. "In this part of the State," he told Henry W. Bellows, "I do not know a man, woman, or child, except such as are essentially savage in their habits and intentions, who intends . . . to be settled on the ground or among the people or under the local institutions with which they are now associated." Accordingly, he concluded that the surest sign of civilization was "the enjoyment, the comfort, the tranquility, the morality and the permanent furnishings, interior and exterior, of a home."

His time at Mariposa also reinforced Olmsted's appreciation for community. He was appalled by the lack of concern of his neighbors for the common good. It led him to reassert the ethic of service that had always been an important standard for judging society. "The highest point on my scale," he decided, "can only be met by the man who possesses a combination of qualities which fit him to serve others and to be served by others in the most intimate, complete and extensive degree imaginable." He called this characteristic "communitiveness"; looking around him, he declared, "I find not merely less of a community but less possibility of community, of communitiveness, here among my neighbors of all kinds than in any other equal body of men, I ever saw."

Olmsted's response to this situation was characteristic: he set out to bring in "new, decent people with families" to counteract the bachelor character of the population. He would create a stable community based on the ties and responsibilities of domestic life to replace the miscellaneous "squatterations" that existed on the estate. Before he could do so, however, the Mariposa Company collapsed. The aftermath made it clear that the major gold veins on the estate had been mined out before he took over and that the main intention of the owners had been to unload their Mariposa stocks while keeping up the appearance of profitability.

Olmsted's hope for a long period of financial success was dashed, and he did not know where to turn next. He contemplated starting a newspaper in San Francisco and also secured landscape design commissions for a park system for that city, for the campus of the College of California in Berkeley, and for a cemetery in Oakland. Instead, his old partner Calvert Vaux prevailed on him to return to New York. Vaux had

regained for the partners their old position with Central Park and in addition had secured the commission to design Prospect Park in Brooklyn. He needed Olmsted's assistance, he said, not so much for planning or even carrying out the details of the design but rather for the overall conception—"the translation of the republican art idea in its highest form into the acres we want to control," as he put it. Though still doubtful about his ability as an artist and placing greater confidence in his skills as an administrator, Olmsted set sail for New York in October 1865 for what proved to be thirty years of landscape-architecture practice.

A CAREER IN LANDSCAPE ARCHITECTURE

Olmsted was returning to the relatively civilized society of the Eastern seaboard, but he was setting out to conquer yet another frontier. This was not the frontier created by slavery in the South, which which he had contended for over a decade, nor the mining frontier of the far West: instead, it was the newest and most dangerous frontier. As he observed:

We are too apt to regard the great towns in which so many newcomers are held as old towns—old settled towns, but we have nowhere on the western frontier a population newer to its locality and so little socially rooted or in which it is possible for a man to live so isolatedly from humanizing influences and with such constant practice of heart-hardening and taste smothering habits as that to be found in our great Eastern cities.

The social and aesthetic contributions of the landscape architect would work to reverse this tendency. With his return to New York in the fall of 1865 Olmsted had changed roles for the last time. After twenty-five years of demonstrating what one of his friends called the "stability of change" in his professional life, he finally settled on the work to which he would dedicate himself fully and consistently. Henceforth he pursued by means of landscape architecture the general improvement and civilizing of American society that he had always had in view. Through that profession he provided urban Americans the scenery that he so loved himself; and in designing schools, villages, and estates he provided for the middle class a physical environment intended to promote the community, domesticity, and taste that were central to his concept of civilization. All this was an expression of his early and intense love of nature. It also made use of skills that he had acquired. In his professional reports he utilized the literary talents that he had developed as a writer and publisher, while in overseeing construction of his designs he drew from his administrative experience with the U.S. Sanitary Commission, Central Park, and the Mariposa Company.

His final change of profession also required that Olmsted learn new skills and find ways to explain his landscape designs to his patrons. In the process he articulated an original theory of landscape design and played the leading role in forming the profession of landscape architecture in the United States. Throughout his career he displayed the same originality of thought and intensity of commitment that had marked his earlier work.

The Art of Landscape Design

EARLY EXPERIENCES OF SCENERY

WHEN OLMSTED returned to New York from California in 1865 and began his practice as a landscape architect, he still considered himself primarily an administrator rather than an artist. His wide variety of experiences, however, had laid the basis for much that was distinctive in his landscape art.

The most important of these elements, and the one that most determined his approach to landscape, was the exposure to natural scenery that he received in his youth from his father. During the family's yearly "tours in search of the picturesque" he developed predilections that never left him. "The root of all my good work," he wrote to Mariana Griswold Van Rensselaer, the popular interpreter of

his ideas, in 1893, "is an early *respect* for, regard and enjoyment of scenery ... and extraordinary opportunities for cultivating susceptibility to the power of scenery." That scenery, as his father sought it out in the Connecticut valley and further afield, was "not so much grand or sensational scenery as scenery of a more domestic order. Scenery to be looked upon contemplatively and which is provocative of musing moods."

Moreover, Olmsted's parents' love of nature was not "such as [may] be shown in admiration of flowers in a vase, or even in admiration for a *hortus sicens* or a botanic garden," but rather a love that led them "to take quiet drives upon meadow and woodland roads, for the most part regarding the scenery silently and never in a way to lead to exclamations." Both the choice of scene to view and the manner of doing it provided an approach from which Olmsted never varied, despite all his later thinking and writing about the subject.

Connecticut River Valley, near Haverhill, New Hampshire. Preceding pages: Springfield, Vermont.

One characteristic that Olmsted saw in his father was a reverential attitude toward nature. John Olmsted had never had a religious conversion, and contact with nature was the closest and most immediate experience he had of God. His father's reverence stayed with Olmsted ever after. The first time it occurred was on one of the rides that he took mounted in front of his father's saddle. It was evening, and they were crossing a meadow. "I was tired," Olmsted remembered, "and he had taken me in his arms. I soon noticed that he was inattentive to my prattle and looking in his face saw in it something unusual. Following the direction of his eyes, I said: 'Oh, there's a star.' Then he said something of Infinite Love with a tone and manner which really moved me, chick that I was, so much that it has ever since remained in my heart."

Olmsted later became a freethinker, but there were three aspects of nature that led him to respond in a way reminiscent of his father's attitude. One was mystery, caused by deep shadows and the play of light and shadow; a second was bounteousness, displayed in richness of foliage and lushness of growth; and a third was peacefulness, as evoked by gently rolling meadows with scattered shade trees or small bodies of water that reflected trees and sky. In time these scenic features would become the most important elements in the landscapes he created and the emotional responses he sought to produce through them.

The predilections that Olmsted developed in his early years were also evident during his first trip to England in 1850. His strongest response was to the lushness of the English countryside. He described his first view of it as "green, dripping, glistening, gorgeous!" His way of taking in the scene was also reminiscent of his family's tours: ". . . there we were, right in the midst of it; long time silent, and then speaking softly, as if it were enchantment indeed. . . ."

Westmoreland, Vermont.

A more general predilection that affected Olmsted's response to scenery and gardening of all kinds was his lack of interest in plants themselves. "The most interesting general fact of my life," he reminisced late in his career, "seems to me to be that it was not as a gardener, a florist, a botanist or as one in any way especially interested in plants and flowers" that he was drawn to landscape architecture. This characteristic was already well formed by 1850, he wrote to Van Rensselaer, and led him when he first saw English parks and gardens to view them "as an amateur of scenery," causing him "to look upon trees and plants and weeds less from regard to their beauty as such, than from regard to their value as elements of compositions of scenery." He later taught that "trees, turf, water, rocks, bridges" should not be thought of "as things of beauty in themselves. In landscape gardening they are as little so as warp & woof in a brocade."

In addition to the influence of his family Olmsted received guidance in his travels from the books he had read. In this respect the English landscape tradition had begun to influence him long before his tour of 1850. While still a youth, he had discovered Uvedale Price's *Essays on the Picturesque* and William Gilpin's descriptions of his "picturesque" tours of the British Isles. He considered them the basic texts for gaining an understanding of scenery and landscape design. They were, he admitted, the work of a previous century, but he found that nothing written later was so effective and reliable in "stimulating the exercise of judgement in matters of my art." In later years, when he took apprentices into his office for professional training, he gave them copies of these books and said, "You are to read these seriously, as a student of Law would read Blackstone."

From William Gilpin, *Observations on the River Wye*, 1800.

THE PSYCHOLOGICAL EFFECT OF LANDSCAPE

The writings of English theorists remained an important source for Olmsted's principles of design, but they did not provide him with the materials to build a firm foundation for his art and profession. Characteristically, he did not look to past canons of taste or the rules of particular gardening styles for his basic approach. His earlier concern with aesthetic questions and the encouragement of taste had been based primarily in nonaesthetic considerations. As an agricultural reformer and gentleman farmer he had seen taste as a basis of civilization. From his career as a farmer through his years with the Sanitary Commission, elements of the sanitary-reform movement of the period were crucial to his concerns. Once he became a landscape architect, he had to formulate a new conception of his role; in the process he created a comprehensive body of theory about landscape design that was so original that few of his contemporaries grasped its full meaning. His emphasis on the psychological effects of scenery gave his design principles a firm base independent of the "battle of the styles." Not aesthetic theory but the very health of the human organism became the touchstone of his art.

The experience of scenery was visual, and as he developed his own concepts Olmsted wrote of the relation of sight to the wellbeing of the whole person. In one of his most concise statements he asserted that "A man's eyes cannot be as much occupied as they are in large cities by artificial things . . . without a harmful effect, first on his mental and nervous system and ultimately on his entire constitutional organization." Landscape provided a relief from the "rigidity and confinement and protrusion of art of the ordinary conditions of the city." It was able "to refresh and delight the eye and through the eye, the mind and the spirit."

Only part of the strain of city living was visual, however; there were many other sources of tension and fatigue that natural scenery could soothe and heal. Urban life and the pressure of business required great and tiring concentration. To avoid permanent damage, it was necessary to engage in activities that restored spent energy. The best possible course was to present "a class of objects to the perceptive organs, which shall be as agreeable as possible to the taste, and at the same time entirely different from the objects connected with those occupations by which the faculties have been taxed."

In describing the effects of scenery Olmsted used such terms as "sanative" and "restoring" and spoke of his parks as "sanitary institutions." He insisted that in doing so he was not speaking metaphorically. He was sure that "the charm of natural scenery is an influence of the highest curative value; highest, if for no other reason, because it acts directly upon the highest functions of the system, and through them upon all below, tending, more than any single form of medication we can use, to establish sound minds in sound bodies."

Olmsted laid great stress on the restorative psychological effect of scenery. By the early 1850s he was describing it as something that occurred by an unconscious process. In *Walks and Talks of an American Farmer in England* he wrote, "Gradually and silently the charm comes over us, the beauty has entered our souls; we know not exactly when or how." One could not directly pursue this feeling, he cautioned: "Dame Nature is a gentlewoman. No guide's fee will obtain you her favor, no abrupt demand; hardly will she bear questioning, or direct, curious gazing at her beauty." The most important implication of the unconscious operation of nature's restorative power was that the effect could not be achieved and would indeed be hindered by specimen planting, spots of brightly colored flowers, or any use of plant that called attention to itself and evoked a specific, conscious response. Nor could striking vistas accomplish this purpose. What Olmsted sought to promote, especially in his design of parks and other urban places, was what he called "*unconscious* or indirect recreation." "Objects before which people are called to a halt, and to utter mental exclamations of surprise and admiration," he taught, "are often adapted to interrupt and prevent, or interfere with the processes of indirect or unconscious recreation." A corollary of this truth was that "the highest value of a park must be expected to lie in elements and qualities of scenery to which the mind of those benefitting by them is liable, at the time the benefit is received, to give little conscious cogitation, and which, though not at all beyond study, are of too complex, subtle and spiritual a nature to be readily checked off, item by item, like a jeweler's or a florist's wares." In search of a fit analogy, he noted that "Landscape moves us in a manner more nearly analogous to the action of music than anything else." At another time, in a similar vein, he wrote that "the chief end of a large park is an effect on the human organism by an action of what it presents to view, which action, like that of music, is of a kind that goes back of thought, and cannot be fully given the form of words."

To illustrate his views, Olmsted compared the effect of a common wildflower in a bank of mossy turf with that of a gaudy hybrid of the same genus, imported from Japan and blooming under glass in an enameled vase. The hybrid was rare and would attract immediate attention, he said, but "the former, while we have passed it by without stopping, and while it has not interrupted our conversation or called for remark, may possibly, with other objects of the same class, have touched us more. . . may have had a more soothing and refreshing sanitary influence." This single comparison summed up the difference of intent, design, and effect between the horticulturist and gardener on the one hand and the landscape architect on the other.

In Olmsted's judgment, the truth of his design concepts required the rejection of much gardening practice of his time. The mid-nineteenth century saw a revolution in horticulture that introduced hundreds of new flowers and shrubs. At the same time many plants and trees began to be imported from Japan, China, and other distant parts of the world. The result was the development of highly decorative displays of exotic flowers and plants. Even as early as his third trip to England in 1859 he discovered that much of the old landscape tradition was giving way to a style that emphasized botanical interest at the expense of coherent scenery. It was a style, he observed, in which "the peculiar landscape beauty of Old English places & in which England excels all the world is sacrificed to botanic beauty and variety and the interest of frequent contrasts & surprizes." Each visit to England revealed further encroachments on the old parks and gardens. It was not in Hyde Park or Kew Gardens that Olmsted now found landscape gardening that pleased him but in neglected estates and country towns where the new fashions had not taken hold and the old plantings had grown undisturbed. By the 1890s he complained that "almost everywhere & most in the newest work, the landscape end is confused with & subordinated to other ends—Japanese ends."

Olmsted objected to much of the specimen planting and flower-bedding by gardeners of his time because it went against the "spirit of place" and thus against his perception of good taste. His main criterion for tastefulness was that a design element should be "fitting" and proper in its setting, not clashing and incongruous. He often drew his illustrations from other fields where standards of propriety were more clearly defined.

In one instance he criticized the treatment of a "smooth green hillside in the surface of which there was much of the beauty of a young woman's dimpled cheek" because its owners had "thought it a gain to spot this surface with circular beds of ephemeral foreign plants prepared for the purpose in hotbeds." Such a course, Olmsted declared, was "more defiant of local propriety than ball dresses at a picnic." In a more general vein he wrote that "it is offensive to good taste to see things of life and growth and motion and constant development, and of beauty dependent on these qualities, made use of in a way that disregards and obscures these qualities."

One illustration of his approach can be found in his opinion of the G. N. Black estate Kragsyde in Manchester, Massachusetts. The North Shore was becoming a summer community for the wealthy of Boston in the 1880s. When Olmsted visited the area, he saw the importance of demonstrating the proper way to landscape the grounds of a house in so rugged a place as the rocky shores of Lobster Cove. To his dismay and that of his young apprentice Charles Eliot, he found that nearby owners had "smoothed up" all their land with green lawns and ribbon beds of bright flowers and colored-foliage plants—all in the midst of rough, rocky shoreline sites. Olmsted remarked to Robert S. Peabody of Peabody and Stearns, the architects of Kragsyde, "I wish Mr. Black would put his place into my hands, and let me show these people that a satisfactory result can be obtained without resorting to these 'public garden' things." "Why, what would you do?" asked Peabody, and Olmsted replied, "I would not attempt to change the very pleasing natural character— I would take this present character and work it up."

The "working up" that Olmsted had in mind did not preclude ambitious changes of contour and addition of vegetation, but always it sought to express the "genius of the place" and to avoid decoration and embellishment that bore no natural relation to it. As he commented to his old partner Calvert Vaux late in their careers, "The great merit of all the works you and I have done is that in them the larger opportunities of the topography have not been wasted in aiming at ordinary suburban gardening, cottage gardening, effects. We have 'let it alone' more than most gardeners can."

Olmsted's aesthetic canon thus required harmony between the natural setting of the place and the work of the landscape architect. In this respect he followed the teachings of earlier theorists of landscape design. He believed with them that it was essential to recognize and enhance the natural character of the site. This was the first principle taught by Humphry Repton, who began his *Sketches and Hints on Landscape Gardening* by stating, "All rational improvement of grounds is, necessarily, founded on a due attention to the character and situation of the place to be improved. . . ." The most famous formulation of the view was expressed by Alexander Pope in his "Epistle to Lord Burlington":

Consult the Genius of the Place in all,
That tells the Waters or to rise, or fall,
Or helps th'ambitious Hill the heav'ns to scale,
Or scoops in circling Theatres the Vale,
Calls in the Country, catches opening Glades,
Joins willing Woods, and varies Shades from Shades,
Now breaks, or now directs, th'intending Lines,
Paints as you plant, and as you work, Designs.

A crucial aspect of such landscape design drew on what Olmsted called the "narrative power of scenery"; that is, its ability to express a single quality or mood:

Scenery takes hold of the imagination chiefly in the degree that it tells stories or makes an impression of character. Thus scenery may be cheerful or gloomy, rude or refined, hospitable or forbidding, prosaic or romantic, sweet or bitter, stirring or reposeful, one or another of these or of scores of other descriptive terms long applied to it according to the manner in which it acts on the imagination. The stories told by scenery may also be wholly of nature moving in wind and flood and the round of the seasons; in ice, fire and brute life, or largely of man; man simple, modest, domestic, peaceful, orderly, refined, or of man, the fop, the purse-proud Philistine, the Bohemian, the ruffian, the brute.

Olmsted's aim was to create scenery that told the best of these stories in a single, consistent impression. In all fine art, he asserted, "there is found a strong single purpose, with a variety of subordinate purposes so worked out and working together that the main purpose is better served because of the diversity of these subordinate purposes. The first secures the quality of unity and harmony; the others, that of a controlled variety."

THE PASTORAL AND THE PICTURESQUE

The first decision to make in choosing a narrative theme, the English theorists taught, was to decide which of the trilogy of landscape qualities was dominant in the site: the beautiful, the picturesque, or the sublime. The model of beautiful scenery was the pastoral: spacious stretches of turf, quiet streams, and open groves of trees. The picturesque had wilder, rougher qualities. The sublime rarely came within the scope of landscape gardeners, although they were sometimes called upon to make a foreground setting for it: it was great and awesome, like high mountains, great cataracts, or the open sea. Having determined the category, the improvers of a site were expected to create a design that heightened the natural qualities of the scenery, stripping away distracting elements and realizing the essence of the place more clearly than nature had done unaided.

Olmsted adopted this intellectual framework and grafted onto it the landscape qualities and resulting emotions that he found most powerful. As a landscape architect in an urban age, he found in the beautiful, or "pastoral," style the most important qualities of all. To describe this style, he turned to the Bible, suggesting an association between God and scenic qualities:

It consists of combinations of trees, standing singly or in groups, and casting their shadows over broad stretches of turf, or repeating their beauty by reflection upon the calm surface of pools, and the predominant associations are in the highest degree tranquilizing and grateful, as expressed by the Hebrew poet: "He maketh me to lie down in green pastures; he leadeth me beside the still waters."

This scenery brought peace and refreshment to the city dweller and evoked in some guise the "peace that passeth understanding."

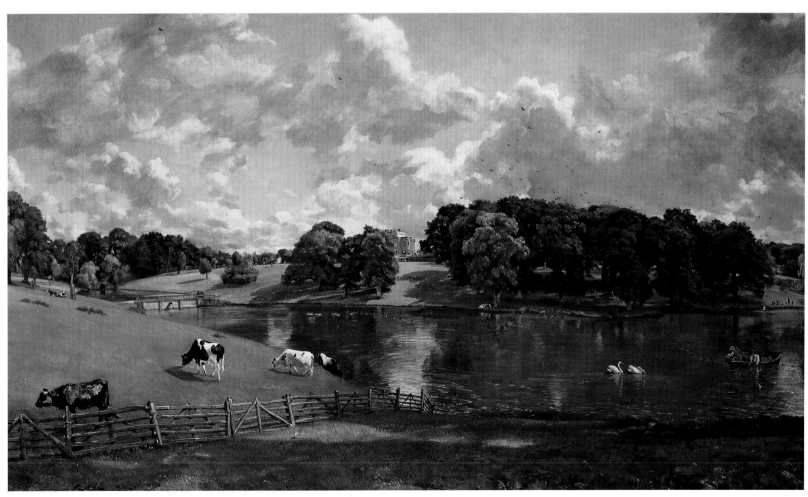

John Constable, *Wivenhoe Park, Essex*, 1816.

Olmsted emphasized the indefinite edge of a space, the sense of a great extent beyond, and the gracefulness of the gently modulated terrain. He was convinced that the appeal of the pastoral was due to basic elements of the human psyche and not simply to the shifting tides of fashion. It was for him the most important of the landscape styles, the heart of the parks he designed.

Pastoral scenery was especially beneficial for the city inhabitants of nineteenth-century America not only because of the artificiality of the built-up city, but also because of the intensity of stress in urban life:

Civilized men, while they are gaining ground against certain acute forms of disease, are growing more and more subject to other and more insidious enemies to their health and happiness, and against these the remedy and preventive cannot be found in medicine or in athletic recreations but only in sunlight and such forms of gentle exercise as are calculated to equalize the circulation and relieve the brain.

This remedial process he called, in a curious phrase, the "unbending" of faculties that had been "bent" by pressure and exertion. In this he was using an analogy drawn from an old tale about the life of Aesop. One day, so the story goes, Aesop was engaged in playing games with some young children when a group of more serious Athenians chastised him for such frivolous activity. In response, he took a bow and bent it, observing that if not soon unbent it would lose all spring and flexibility: men must occasionally "unbend" as well, or suffer the same fate.

Pastoral scenery, more effectively than anything else, made such relaxation possible. Olmsted's own experience convinced him that there were fundamental factors at work in this. To illustrate his view, he described the journey on horseback that he and his brother John Hull Olmsted made across the prairies of West Texas in early 1854. In some places the scenery so reminded the brothers of English estates, Olmsted recalled, that "we sometimes questioned whether if an Englishman had been brought blindfolded to our tent, and the scene disclosed to him would be readily persuaded that he was not in some one of those old parks." Their camping places in that hospitable landscape, with its graceful rolling meadows dotted with live oaks, were just the places that settlers in that country chose to build their houses. It was the kind of terrain that had offered a nurturing combination of shelter and prospect, wood, grazing area, and water to human beings for thousands of years. Camped

on the Texas prairie, Olmsted sensed how beneficent such pastoral places had been for mankind and would continue to be.

The second style in which Olmsted designed scenery was the picturesque. The emotional impression that it provided was that of the mystery and bounteousness of nature and of its creator. Olmsted left a more extensive record of his thoughts about it than about the pastoral. Describing the scenery of the southern shore of the Isle of Wight during his first trip to England in 1850, he wrote of "dark, picturesque rugged ravines . . . sublime rock-masses, and soft, warm, inviting dells and dingles; and . . . a strange and fascinating enrichment of half-tropical foliage, so deep, graceful, and luxuriant, as I never saw before any where in the world."

Olmsted's most intense experience of the picturesque occurred during his passage across the Isthmus of Panama on the way to California in the summer of 1863. To his wife he testified that "simply in vegetation it is superb and glorious and makes all our model scenery very tame and Quakerish. I think it produces a very strong moral impression through an enlarged sense of the bounteousness of Nature." His response approached a religious experience: "I am thoroughly enchanted with the trees & vines," he wrote, "But cane and palms are not trees or vines or shrubs or herbs. They are Gloria in Excelsis with lots of exclamation points, thrown in anywhere, in the grand choral liturgy."

These were the emotional responses that Olmsted designed most of his "passages of scenery" to produce. Acutely aware that there must be unity of design to achieve power of effect, he always made sure to avoid an "incongruous mixture of styles" that would weaken the psychological power of his work. He also subordinated all elements of the design to the overall effect. He particularly sought to exclude objects that would call attention to themselves for their individual beauty or interest and distract from the landscape as a whole.

He followed this principle of subordination even when he was not creating passages of scenery. When planning the grounds for great structures like the U.S. Capitol or the Court of Honor at the World's Columbian Exposition of 1893, he subordinated the plantings to the buildings, using his skills as a designer to heighten the grandeur and dignity of the architecture. No statuary or decorative gardening was allowed to distract attention from the central structure.

George Bannon, *Head of Shanklin Chine, Isle of Wight.*

Finally, Olmsted recognized that it was beyond the purview of the landscape architect to create the "sublime." The role of the landscape architect, as Olmsted demonstrated in his planning of the scenic reservations of Yosemite and Niagara, was to provide access to such scenery without destroying it. Not that he was indifferent to scenery that personified power and grandeur: he wrote evocative descriptions of the beauty of El Capitán half obscured in clouds and the falls of Niagara enveloped in mist and spray. Most touching of all was a memory of Italy that spoke of the role that a well designed setting for a view could play:

. . . of the four occasions in which landscape has produced a surge of emotion with me, coming I know not whence or how, though it almost choked me and almost brought me to my knees, one was, when I was upon a terrace, to look over and between stone walls of Ilex, across a passage of low land to a distance in which snowy peaks were not to be at once distinguished from soft golden clouds that might be the gates of heaven.

Martin Johnson Heade, *South American River.*

Olmsted and his brother John camping in Texas.

39

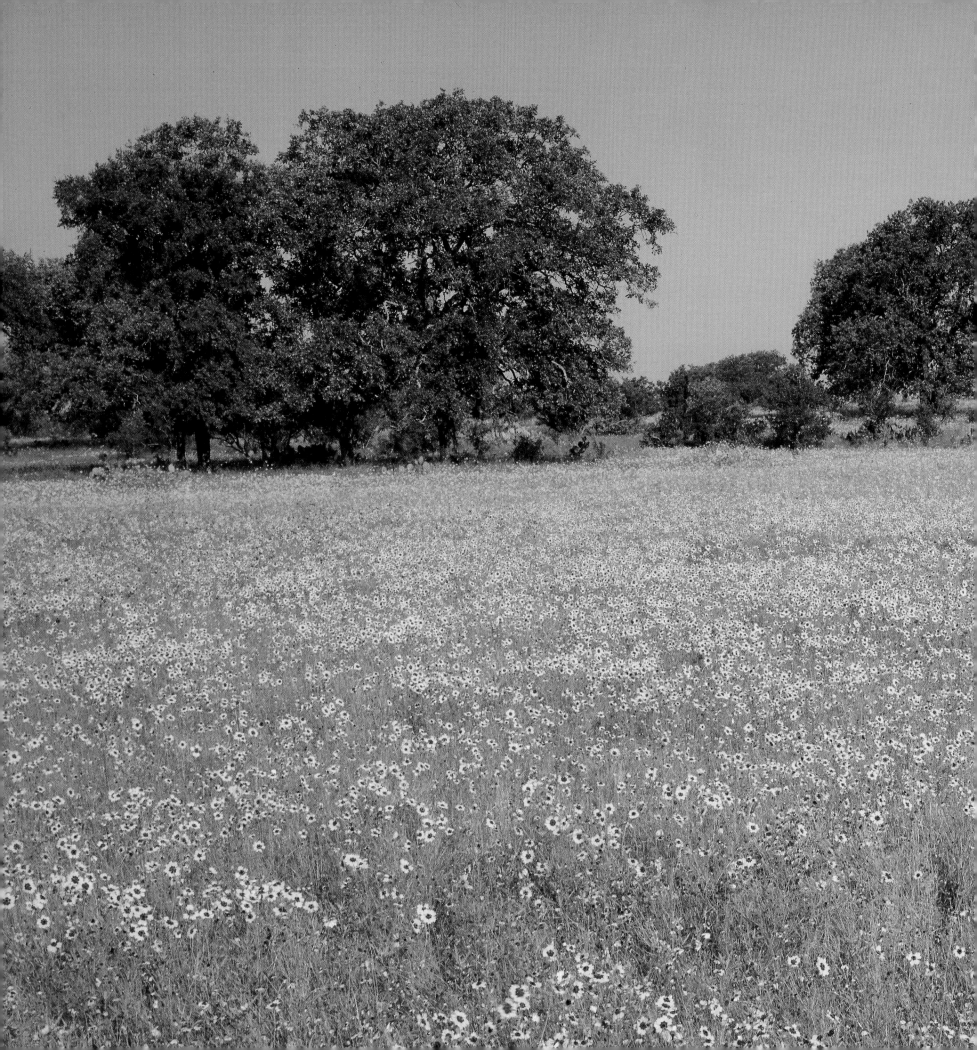

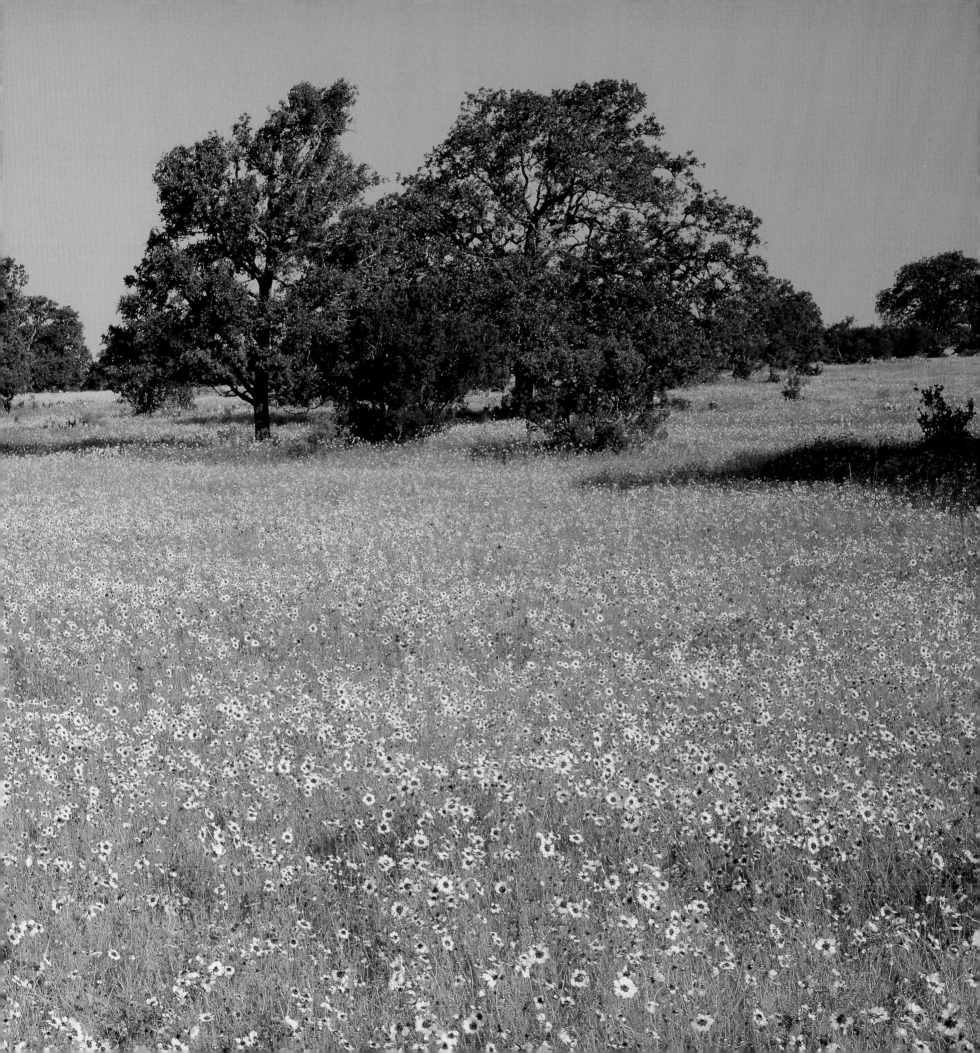

GARDENING AND LANDSCAPE ARCHITECTURE

Despite the clear difference that Olmsted saw between gardening and landscape architecture, it was difficult to create an awareness of that distinction in the popular mind. Yet the distinction was a crucial one, and he struggled throughout his career to make it clear. Late in life he warned Van Rensselaer:

Nothing can be written on the subject with profit in my opinion in which extreme care is not taken to discriminate between what is meant in common use of the words garden, gardening, gardener, and the art which I try to pursue. I am tired almost to death in struggling with the confusion of mind which is manifest in this confusion of terms, and I know that the fight is not yet fairly begun and that I shall die before it does begin.

The great difference between gardening and landscape architecture was the element of design, the creation of a consistent whole in which the parts were subordinated to an overall conception. In the long debate through which he and Calvert Vaux settled a name for their profession, he finally accepted the term "landscape architecture." Awkward though it was, it helped to "establish the important idea of the distinction of my profession from that of gardening—as that of architecture from building—the distinction of an art of *design.*"

Another element that distinguished landscape architecture from gardening was that it, like landscape painting, made use of space and perspective. Indistinct and hazy views produced a sense of "mystery and infinity." The term "scenery," Olmsted insisted, "is not naturally used with regard to any field of vision in which all that is to be seen is clear and well-defined in outline. . . .It is rarely used, if ever, except with regard to a field of vision in which there is either considerable complexity of light and shadow near the eye, or obscurity of detail further away." In fact, these qualities were the distinctive elements of his two principal landscape styles, the pastoral and the picturesque. It was the lack of a clear boundary, or "obscurity of detail further away" that produced the special quality of pastoral landscape, and it was the profuse planting of plant materials with many tints and textures that produced "complexity of light and shadow near the eye" in picturesque scenery.

Elsewhere Olmsted further elaborated on this theme: "The quality of beauty in scenery lies largely in the blending in various degrees of various

Preceding pages: Texas hill country.

42

elements of color, texture and form and often more largely than in anything else in the obscurity and consequent mystery, giving play to fancy, of parts of the field of vision. . . ."

"DELICACY" AND "SERVICE"

The indefiniteness that Olmsted insisted on in his landscapes was important in another way as well. Central to his concept of taste was the quality of delicacy. Taste was the means to and the test of gentility, and delicacy was its key element. The subtle differentiation of texture, color, and form in his own designs was a living demonstration of the quality of delicacy. He indicated its importance in this way: "the test of prosperity is the advance of civilization; the test of civilization is delicacy." No landscape that he designed lacked this special quality.

Olmsted also objected to much of the current horticultural and floral display because it served no deeper purpose than decoration. True landscape art, he believed, always did more than simply give pleasure by its appearance: "Service must precede art," he wrote in one of his clearest and most severe formulations, "since all turf, trees, flowers, fences, roads, walks, water, paint, plaster, posts and pillars in or under which there is not a purpose of direct utility of service are inartistic if not barbarous. . . . Gardens are planned not for service but for savage display and fashion. So long as considerations of utility are neglected or overriden by considerations of ornament, there will be no true art." John Ruskin had eloquently preached this doctrine, and it was at the heart of the writings of Humphry Repton. It was a view that Olmsted, with his strong sense of the social purpose of art, had early been prepared to accept. The psychological benefit of his landscape designs, he was convinced, far exceeded in service anything that the work of gardeners might achieve.

Both the superficial nature of purely decorative gardening and its lack of relation to its natural surroundings heightened Olmsted's perception of such work as "artificial." On the other hand, he viewed his own landscape designing as a process of working with and enhancing nature and therefore as natural. He preferred to create designs that appeared to have

evolved through the action of natural forces. If he wanted to create a sheltered valley, he shaped it to look as though it had been formed by a stream. If he wanted the approach road to a house to curve so as to avoid too early a vista of the house, he ran it behind a natural rise and then piled up rocks and earth to make it appear that the natural landform had dictated the course of the road.

At the same time, Olmsted was willing to destroy natural features that were too prominent and interfered with the overall composition and general character of the scene. Once, while landscaping a railroad line in the White Mountains of New Hampshire, he was annoyed because tourists flocked to view the stone profile of the Old Man of the Mountain in Franconia Notch. "I have no doubt at all about the misfortune of the profile," he wrote his client, "and stand ready to contribute to blow its nose off with gunpowder without waiting for an earthquake. . . .That is precisely what landscape gardening should do, I think, make improvements by design which nature might by chance make through the action of earthquakes, storms, frosts, birds and insects."

Olmsted's selection of plant materials followed the same principles. It was the landscape designer's task "to so select the material of planting, or the native material to be left growing, that. . .the principle upon which Nature, unassisted, proceeds in her selections . . . shall be emphasized, idealized, or made more apparent in landscape quality."

This did not mean, however, that only plants native to the site should be used. Some of his friends, especially the dendrologist and horticulturist Charles S. Sargent, opposed the use of other than native plants, but Olmsted had much less exclusive standards. In his selection of plant material, as in his general cultural approach, he was willing to draw from sources worldwide if he could turn them to good account. His lack of systematic training in plant materials and horticulture and general lack of interest in plants themselves strengthened this orienta- tion. The standard that Olmsted used for selecting plants was basically one of taste: a plant should be "fitting" for its situation and usable without evident inconsistency. The presence of non-native plants was permissible so long as their exotic character was evident only to experts in horticulture.

In discussing the selection of plants for the lagoon district of the World's Columbian Exposition in Chicago, for instance, he instructed the superintendent of planting that "the thing is to make it appear that we *found* this body of water and its shores and have done nothing to them except at the landings and bridges. They were rich, rank, luxurious, crowded with vegetation, like the banks of some tropical rivers that I have seen on Louisiana bayous. The vegetation must appear spontaneous and thoroughly wild (to all unlearned visitors)."

The most important reason for Olmsted's eclecticism in his plantings is evident in these instructions. The native plants of the region were such as to make the scene too "tame and Quakerish," whereas Olmsted wished to express a bounteousness greater than was naturally found in the place. In that sense his designs were the result of a kind of pantheism that saw in lush vegetation and the play of light and shadow an expression of the strength and mystery of the life force.

A THEORY OF LANDSCAPE ART

Although Olmsted's theory of the psychology of perception formed the basis of his landscape designs, he realized that few people understood either the theory or its implications for landscape art. Nor did scientific research touch very often on the phenomena that he considered so important. In 1881 he confessed to Charles Eliot Norton that "I have no reason to suppose that half a dozen men have yet read anything I have written, and as far as argument goes it all tells for nothing." The few people who were familiar with his views, he said, always seemed to feel "that I have original & peculiar ideas and am not what I only want to be, the expounder, indicator and applyer of views which are—not views at all but well established science."

At times this situation profoundly discouraged him. "A doubt of my own sanity in keeping at it often comes upon me," he confessed to Norton, "but I cannot help it . . . Is it absurdly incomplete to say as I do that the prime object of art is to affect the emotions." Even in his last year of professional practice he felt isolated and lacking support from scientific writers. In a report to the city of Hartford, which twenty-five years earlier had rejected his recommendations, he admitted to the unsatisfactory state of the theoretical science of landscape design:

The objective point of the practice of the art, the commodity which its practitioners undertake to supply is a certain effect or class of effects on the human mind. There must be a psychological science of the subject and you may have reasonably expected me to teach you the outlines of this science. But I have to tell you that after much study & discussion I am satisfied with no presentation of it that has come to me. In the larger part, my practice has been based on the teachings of personal observation and experience that certain conditions being attained certain effects follow.

From his firm conviction that art should perform a social service, his early experience in responding to scenery, and his psychological theory of the unconscious influence of nature, Olmsted devised a set of fundamental beliefs about the practice of his art. The search for unshakable principles founded in reason had characterized his approach to the great questions of life long before he became an artist. In his late twenties he agonized over the question of the divine inspiration of the Bible and finally rejected it because he could not reconcile such doctrine with rationality. "My own reason must pilot," he wrote Frederick Kingsbury, "and if she runs down the Bible, my own heart & my own friends—I cannot take the helm from her."

How important a role his basic principles played in his designs and how powerfully he argued from them was given striking testimony in an assessment that his protégé and partner Charles Eliot wrote after Olmsted's retirement from practice:

. . . he attacked each problem as it was set before him with clear eyes and an unbiased mind, and solved it by a process of reasoning as straightforward as that which guided the work of the men who wrought the landscape of the Connecticut meadows and villages which he knew so well. His work has been praised as remarkably imaginative and original, but it was original only in the sense that it was reasoned, whereas most work in the same field merely follows the pattern of whatever happens to be considered the usual, fashionable, or proper thing . . . His appeal, even in verbal discussions, was always to fundamental principles, and so firm was his grasp upon them that he could not be shaken from the conclusions to which they led him.

Eliot indicated the distance that separated Olmsted from the gardeners who sacrificed overall composition to colorful detail and chose display over "service:"

On the whole the most valuable legacy which he has left to his revived profession and all fellow artists, is his new demonstration of the old truth that reasoned adaptation to circumstance and purpose is the natural and surest foundation of beauty, and that when this foundation is well laid, elaborate decoration, which he never resorted to, is as unnecessary as it is impertinent.

Parks and Park Systems

THROUGHOUT HIS FORTY YEARS as a landscape architect Olmsted pursued the social goals that he had formulated by the mid-1850s. He intended his parks to be public institutions of recreation and popular education that would demonstrate the viability of the republican experiment in America. In the rest of his work, designing residential communities and institutions and planning the grounds of single-family homes, he sought to promote the values of community and domesticity that he had earlier defined as the mainstays of civilization.

The period during which Olmsted worked as a designer and planner was one of rapid urbanization in the United States. The 1850s saw the growth of eastern urban centers as a result of railroad expansion, industrialization, and greatly increased immigration. He recognized the dangers posed by such rapid growth and concentration of population and observed that the great cities were the newest frontier, the newest society in the country. He saw the problems posed by the "dangerous classes" taking form in the great cities—the irresponsible nouveaux riches and the poor and uneducated immigrants. He was also concerned about the increasingly artificial environment and the debilitating increase in the pace of life that seemed endemic to the metropolis. Still, he was convinced of the promise of urban life and the improved conditions that the great city of the nineteenth century could offer its inhabitants.

He welcomed the "townward movement of population," by which cities grew rapidly while rural areas barely held their own. And, with his strong faith in the importance of community life as epitomized in the New England town, he became the prophet of a metropolis that would retain some of the values of older and smaller urban forms. The fearsome aspects of seventeenth- and eighteenth-century European cities, such as terrifying epidemics and fires, he felt, had been laid to rest by the progress of the nineteenth century. Modern technology and science made the large city a safe place to live, and he foresaw continued increase in urban size and health. In fact, it was in the city that he found the greatest promise for social advance.

The modern city made possible to the fullest extent in history the division of labor and proliferation of services that was one of Olmsted's chief standards of progress. Only where large numbers of people lived close together could there be a truly effective division of labor, and only in such cities were there adequate resources for the best possible

institutions of medical science, education, and the arts. "The greater the division of labor at any point," he wrote in 1870 in an echo of what he had said in the 1850s about the South, "the greater the perfection with which all wants may be satisfied." Speaking to a group of Bostonians in 1870, he declared that even the servant girls of their city had finer schools, libraries, and facilities for the fine arts than did the richest people living in the country.

Developments in technology, too, opened up new amenities for city dwellers far more quickly than for rural folk. Road surfaces like macadam were replacing rough cobblestone paving, while country roads were still deep in dust in dry seasons and muddy sloughs when it rained. Improvements in water supply and sewerage benefitted the health of cities and increased their comfort and safety. The popular provision for education and the arts and the multifaceted sanitary reforms were hallmarks of the nineteenth century's progress in the quality of living, and they were preeminently urban developments.

At the root of Olmsted's faith in the future of the city was his belief that the most important of the "conditions under which the evils of large towns have diminished" was the change toward planning cities in a "more open way." Overcrowding and inadequate space, air, and sunshine had caused the terrible health problems of the past. The improved health and longer life expectancy of city dwellers in the mid-nineteenth century, he believed, were due primarily to "the abandonment of the old-fashioned compact way of building towns, and the gradual adoption of a custom of laying them out with much larger spaces open to the sun-light and fresh air."

The traditional row houses and gridiron system of streets that prevailed in the older cities of the country were both relics of a distant and barbarous past. They were an inheritance from the era when cities existed to provide military protection and where street systems "were formed either to strengthen or to resist a purpose involving the destruction of life and the plunder of merchandise." A custom was formed at that time, Olmsted wrote, of "regarding the wants of a town, and planning to meet them, as if its population were a garrison, to be housed in a barrack." The gridiron plan adopted in 1811 for Manhattan below 155th Street had a disastrous effect on the development of the city, he felt. The lots were so deep that they made freestanding houses uneconomical and forced the

proliferation of row houses "not much wider than the hovels of other cities," with poor light and ventilation.

Through the years even the rich continued to build such houses, and in the 1870s he scoffed at the new brownstone row houses in expensive residential areas as an admission of the impossibility of building a civilized residence on a New York City lot. He ridiculed the residences of the urban rich—as twenty years earlier he had deplored the isolation of slaveholders' mansions: the plan of a brownstone row house, he said, was "more nearly that of a lighthouse built upon a wave-lashed rock, than of a civilized family home." A home should merge natural and artificial elements in a pleasant and healthful way, whereas the wholly artificial nature of the urban row house seemed to him a denial of the most important aspects of nineteenth-century progress in the domestic arts.

High, closely built structures were desirable in commercial sections, but residential areas should be open and separate. The new urban domesticity that he sought to encourage had two elements: clear separation of the place of residence from the place of work and residential areas designed to meet the special needs of domestic life. He hoped that in time all residential areas would consist of freestanding single-family houses. The new combination of urban and rural elements that the landscape architect would help achieve would permit urban residents to make full use of the opportunities of the city while enjoying elements of space, sunshine, and fresh air that had previously been available only to people in the country.

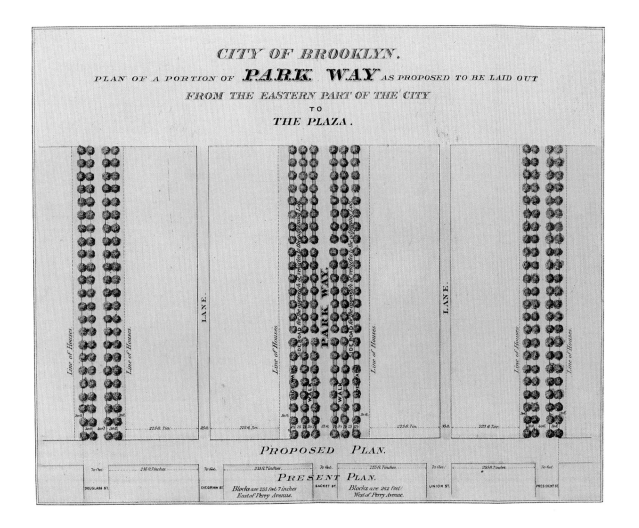

THE PARKWAY

As he developed his solution for the American metropolis, Olmsted gave distinctive form to a series of institutions. In collaboration with Calvert Vaux, he set the pattern for the urban park in America, provided a concept and rationale for the urban park system, designed and named the parkway, and created the country's first significant examples of greenways.

The most influential innovation was the parkway. As proposed by Olmsted and Vaux, it would provide a continuous public pleasure ground that kept the character of neighborhoods near it residential. Olmsted and Vaux first developed the concept in a report to the Brooklyn park commissioners in 1868. They proposed a series of boulevards running through the major residential sections of the city. These parkways would connect public recreation grounds and would also extend the amenity of a parklike green space throughout the city.

The parkway also met the need for a special kind of road surface for the light spring-carriages that were rapidly increasing in cities. In Olmsted's view such carriages illustrated how the division of labor in modern society produced a "more perfect adaptation to the various purposes of life of many instruments in general use." In order to realize its potential as a means of fast and pleasant movement through the city, the carriage needed a separate route of travel. Such separation of ways was a hallmark of Olmsted's designs, beginning with the sunken transverse roads of the Central Park "Greensward" plan. Thus in addition to walkways, trees and shrubs, and roads on either side for heavy carting, Olmsted's parkways introduced a new element, a smoothly paved roadway in the central section for the sole use of light carriages. This roadway he termed the "park-way."

Olmsted had been impressed during his European trip of 1859 with the Avenue de l'Impératrice in Paris, in which a central carriageway, a pedestrian promenade, and a bridle path were flanked by hundred-foot-wide strips of lawn and scattered trees. Outside these strips were access roads serving the residences fronting on the street. Olmsted seized on the separation of carriages from carts and other heavy traffic as the key element of the parkway.

In many places the parkway would replace the inflexible gridiron street system with major thoroughfares that followed the contour of the land. The leveling of hills and filling in of valleys required by the gridiron could thus be avoided. The desire to work with existing topography led Olmsted to expand the parkway concept to include streams, as in Boston. In a number of cities he urged the reservation of stream and river courses for parkways and public grounds. His justification was the need to preserve the most attractive of natural features in a city for public enjoyment, rather than obliterating them, and he argued that such a process would be far less expensive than filling in valleys and forcing streams into underground culverts. The utilization of existing landforms as elements in the cityscape rather than reducing the whole to a flat checkerboard of squares and rectangles was one of his most consistent themes.

THE PUBLIC PARK

Olmsted believed that a more openly built city, with the provision for neighborhood recreation grounds, would create a far more pleasant urban form. City inhabitants would always need public open spaces where they could escape completely from urban sights and sounds, where they could find tranquil surroundings that would act as an antidote to the pressures and tensions of their workday life. The landscape park would meet the modern condition that John Ruskin described when he wrote, "This is an age in which we grow more and more artificial day by day, and see less and less worthiness in those pleasures which bring with them no marked excitement; in knowledge which affords no opportunity of display." The public park gave Olmsted an opportunity to counteract this tendency. It was also a means to carry forward the program of public recreation and education that he had defined for himself as a result of his journeys in the South. Then, too, his experience in England had strengthened his desire to create for the citizens of the American republic the public institutions that monarchical Europe possessed in abundance.

Part of Olmsted's effort to educate the American public on the importance of parks was to show how all classes would benefit and how they could serve as a meeting ground for citizens of different backgrounds. Large parks were often opposed by representatives of the working class because they were used by the wealthy for horseback riding and carriage driving. But Olmsted believed that the large urban

park was especially important for the poorer citizens, who had no immediate prospect of leaving their tenements for villas along parkways or in suburban villages nor of leaving the city for a vacation at the seashore or in the mountains. It was the role of public authority to make adequate provision for the poor. Olmsted declared that ". . . the most important purpose of a park . . . is at that season of the year when the fewest visitors come to it in carriages, when all citizens who can, have gone to the country."

Olmsted designed his parks to be beneficial to the poor. When he was vice president of the New York State Charities Aid Association during the 1870s he sent circulars to all the doctors and ministers in the city with directions to Central Park by the street railways and a description of the facilities for convalescents. He did the same in Brooklyn for Prospect Park, and in both cities he posted notices in tenement houses and had thousands more widely distributed. In Brooklyn he encouraged an annual picnic of children's church groups that became a tradition and helped to introduce children to the park.

The working poor had special need for the relaxation the park could provide. They had little property and were oppressed, Olmsted felt, by "an anxious and narrowly dogged habit of mind and a strong incitement to persistent toilsome industry." The benefit they gained from the park would serve the city well. As early as his walking tour of England in 1850 he had seen how poor young men turned to crime because they saw no way to better their condition. "Do your duty to them, " Olmsted had warned in the book describing his English travels, "or they will not do their duty to you."

Olmsted was particularly troubled about the lot of the wives of working men. Most of them were tied to petty household chores day after day and badly needed the relaxation and broadening experience that a park could provide. "In the nervous fatigue that comes upon them," he warned, "it is easier to go with the current habit than to make the exertion necessary to find and secure opportunities of relief and refreshment." Too often this had an unfortunate effect on their domestic influence, a "narrowing, stinting, materialistic, and over-prosaic educative tendency. . ." He hoped that women would learn to spend entire days in the parks with their younger children, especially during the warm months, and that they would be joined for picnic suppers by their husbands and working

children. The effect that such frequent use of a park would have on the largest class of a city's inhabitants was, Olmsted believed, incalculable.

The park should also provide for the needs of the rich. The city's leaders, people of enterprise and wealth, were more subject to the debilitating effect of intense work than any other group. Their value as community leaders and creators of wealth was such that it paid a city well to provide them with facilities for relaxation and leisurely activities. Since a well-designed park created a desirable adjacent residential area and offered easy access to miles of carriage drives, Olmsted argued, its presence would help to keep the rich in the city and stem the flight to the suburbs that robbed it of both leadership and taxes. "The fact seems to be," he wrote late in his career, "that such a park adds so much to the pleasure of life in a city that many people are reconciled to remain in it with their property who would otherwise move away, and many more are drawn to come to it with their property who would, but for the park, have remained elsewhere."

Olmsted fervently hoped that the great urban park would become a place where all classes would meet and mix. The atmosphere of the park would help to counteract the "heart-hardening" effects of city life. "As a means to education and grace, of sweetness and light," he asserted, "it is worth more to those who can resort to it than literature or the fine arts in any and all forms." It was "an educative and civilizing agency, standing in winning competition against the sordid and corrupting temptations of the town."

The design of Olmsted's parks took into account two social impulses—the "gregarious" and the "neighborly"—that he considered universal. Gregarious activities were those in which people mingled in large groups for relaxed recreation. His fellow native New Englanders generally viewed such gatherings as "childish and savage," he observed, since they offered little intellectual gratification, but he saw many social customs even there—such as visiting graveyards—that were driven by the gregarious impulse. Gregariousness, he felt, should be "admitted to be a distinct requirement of all human beings, and appropriately provided for."

Olmsted had felt the pleasure of such activity most keenly in the Champs Elysées in Paris, and other European promenades had strengthened his conviction of the importance of providing for it. He designed sections

49

of his earliest parks for the purpose, such as the Mall in Central Park and the Lookout and Concert Grove terraces in Prospect Park. As a result, he could boast in 1870 that there were only two cities in the country

where, in this eighteen hundred and seventieth year after Christ, you will find a body of Christians coming together, and with an evident glee in the prospect of coming together, all classes largely represented, with a common purpose, not at all intellectual, competitive with none, disposing to jealousy and spiritual or intellectual pride toward none, each individual adding by his mere presence to the pleasure of all others, all helping to the greater happiness of each. You may thus often see vast numbers of persons brought closely together, poor and rich, young and old, Jew and Gentile.

It did people great good, he was sure, to come together thus "in pure air and under the light of heaven."

In contrast, neighborly recreation was "essentially domestic and secluded," to be pursued in small gatherings of family or friends. It enhanced "a pleasurable wakefulness of the mind without stimulating exertion," while at the same time keeping alive "the more tender sympathies." In his parks such activity took the form of picnic outings, and he provided space for hundreds of small groups to gather without inconvenience to each other.

Since urban parks were used by large numbers of people, often in large groups, the process of park design was a constant balancing act:

That scenery which would afford the most marked contrast with the streets of a town, would be of a kind characterized in nature by the absence, or, at least, the marked subordination of human influences. Yet, in a park, the largest provision is required for the human presence. Men must come together, and must be seen coming together, in carriages, on horseback and on foot, and the concourse of animated life which will thus be formed, must in itself be made, if possible, an attractive and diverting spectacle.

Accordingly, areas must be set aside for large gatherings, and they must be arranged so that crowds would not cause damage nor intrude on the areas set aside for more solitary enjoyment of natural scenery. With the sole exception of Central Park, Olmsted placed facilities for gregarious activities on the periphery. The Concert Grove in Prospect Park and the Greeting in Franklin Park are examples of this approach. Additional concourses for carriages and pedestrians were situated at high vista points in parks.

Nonetheless the single greatest benefit that large urban parks could provide, the one amenity that smaller public spaces could not, was immersion in scenery. This was the central lesson that he taught time and again during his long career as America's leading designer of parks.

Olmsted was well acquainted with the park movement that swept Europe in the mid-nineteenth century. He had seen its beginning when he visited Paris in the 1850s and toured the new parks and boulevards. He had also witnessed the park movement in England. At Birkenhead Park, in particular, he found a park designed specifically for the use of the inhabitants of the town, rather than the partial adaptation of royal and noble parks that had previously served quite different purposes. He believed, moreover, that the park movement of his time was not simply a fashion set by the transformation of Paris under Napoleon III. Rather, it was a direct and crucial response to the problems raised by rapid urbanization. It was the result of "a self-preserving instinct of civilization" and an expression of the "great development of interest in natural landscape and all that pertains to it" that accompanied industrialization and urbanization in the nineteenth century.

The impulse toward park making, however, needed careful guidance to produce the proper result. Olmsted's conception of the function of the park in modern life and in the structure of the city gave it a precise purpose that went beyond that of parkways, pleasure grounds, and playgrounds. The park should serve as a soothing interlude of rural scenery in the midst of the city. Activities that would be intrusive or distracting to that purpose should be provided for elsewhere:

A park is a work of art, designed to produce certain effects upon the mind of men. There should be nothing in it, absolutely nothing—not a foot of surface nor a spear of grass—which does not represent study, design, a sagacious consideration & application of known laws of cause & effect with reference to that end.

Olmsted spent his entire professional career trying to educate park boards and city voters concerning the true function of a park as he conceived it. In this effort he received little support even from European examples. Many city parks in Europe had originally been game preserves for kings and nobles and had undergone incomplete and piecemeal changes to meet modern needs. In 1850 both the great parks of Paris, the Bois de

Boulogne and the Bois de Vincennes, were still imperial forest and hunting grounds.

Once the parks were opened to public use, it was unclear how they were to be used. The Bois de Boulogne contained a racecourse, while the Bois de Vincennes served as a place for artillery practice and there were military parades in London's Hyde Park. These activities reduced the effectiveness of parks in fulfilling their proper purpose.

But the broad concept of what a park was caused Olmsted constant trouble. Since he had a stricter definition of that term than any of his predecessors or contemporaries in landscape design, he found it difficult to clarify the indefinite ideas on the subject held by most people.

The problem was aggravated in the case of Central Park, with which he was officially connected for seventeen years. Then, as now, there was a constant flow of proposals for facilities to be added to the park. Large buildings were frequently proposed where they would obliterate the most important landscape features; there was pressure to use the open spaces of the park for advertising displays, steeple chases, circuses, and other activities that would bring large crowds. It was proposed to bury distinguished citizens there, to construct a great ecumenical cathedral, and to arrange large sections of the park to illustrate geological processes or make it a "living cabinet of botany" and a "living museum of geology."

To explain the inappropriateness of such proposals, Olmsted used an architectural analogy. The new court house of New York City, which had been built by the Tweed Ring at extravagant expense, had been the subject of much discussion, he said, but no demand had been made to fit up some of its rooms with billiard tables or for religious services or public demonstrations in anatomy. Moreover, he observed,

the lack of a convenient carriage way to the roof or to the lunch-counter has not been complained of, nor has it been proposed to remedy the present cramped, inconvenient and unattractive arrangements for refreshments by devoting the more spacious of the court rooms to this purpose.

Acceptance of these proposals would ruin the court house for the purpose for which it was constructed, but propositions "quite as fantastic" were frequently made concerning Central Park without the

absurdity being recognized. "The only solid ground of resistance to dangers of this class," he concluded, was a general conviction

that the Park throughout is a single work of art, and as such, subject to the primary law of every work of art, namely, that it shall be framed upon a single, noble motive, to which the design of all its parts, in some more or less subtle way, shall be confluent and helpful.

In order for the experience of scenery to be as intense and restorative as possible, all engineering and architectural elements in the scenic sections of the park must enhance the landscape experience. One example is the circulation system: it was necessary to have walks and drives; they made it possible to enjoy the landscape without destroying it. A special aspect of Olmsted's genius lay in the way that he designed the circulation system to be a positive element in the visitor's enjoyment of the park. The easy curves of walks and drives in Olmsted's parks looked attractive on the plan, but the test was how they worked on the ground itself. Their gradual grades and curves kept exertion to a minimum for both horses and pedestrians. By avoiding sharp turns and right angle intersections Olmsted led the visitor through the space with a minimum of demand on the conscious mind. Walkways and roadways were hard-surfaced and well drained so that they could be used in all kinds of weather. While the principal walks were wide, their easy curves mirrored the gracefulness of the terrain and their width made it possible for small groups to pass without fear of collision.

As Olmsted instructed:

A drive must be so prepared that those using it shall be called upon for the least possible exercise of judgment as to the course to be pursued, the least possible anxiety or exercise of skill in regard to collisions or interruptions with reference to objects animate or inanimate.

The same subordination of constructed elements to the prime purpose of the park applied to statuary and structures. Olmsted relegated statues to areas like the Central Park Mall and Prospect Park Concert Grove where they would not be a distraction in the landscape. He imposed the same discipline on even the largest buildings in his parks. They should exist only to meet the needs of park users and should in no way stand out as objects of beauty or ornament. The resulting unity of design was a special characteristic of all his parks.

Central Park

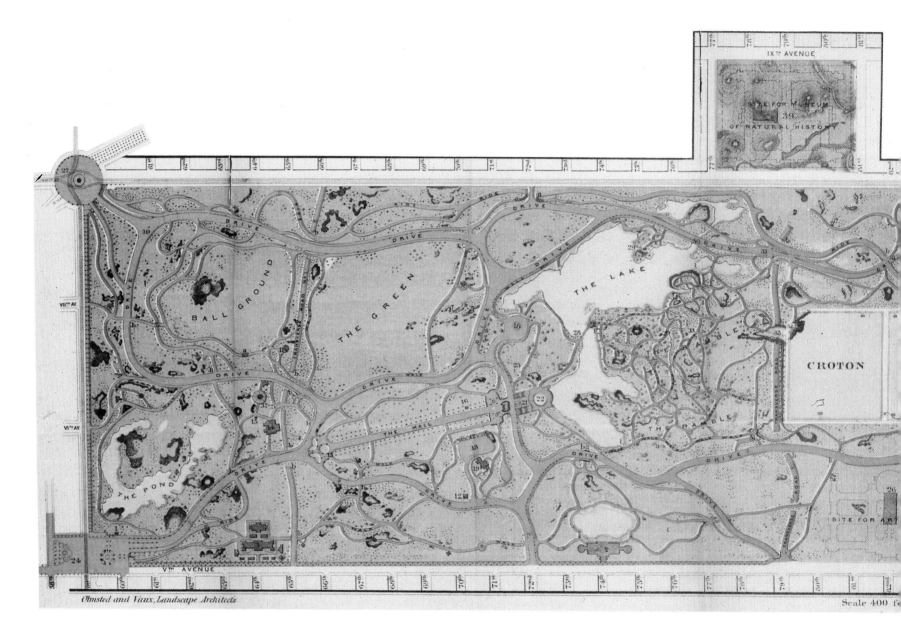

Olmsted and Vaux, Landscape Architects

Scale 400 fe

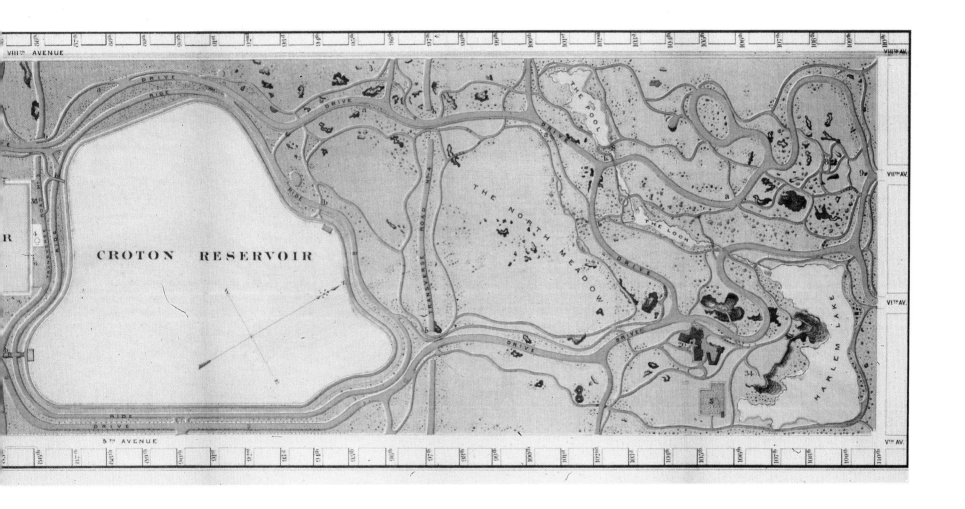

53

CENTRAL PARK, OLMSTED'S MOST FAMOUS PROJECT, was the first park that he designed. It marked the beginning of a fifteen-year collaboration with his codesigner, the English architect Calvert Vaux. The success of this design quickly gave the two men a national reputation as park planners. Olmsted was impressed by the influence the park could have. Soon after winning the competition to design the park, he wrote a friend: "It is of great importance as the first real park made in this country—a democratic development of the highest significance & on the success of which, in my opinion, much of the progress of art & esthetic culture in this country is dependent."

Although he became superintendent of the park at the same time that its commissioners decided to hold a design competition, Olmsted played no role in the preceding six-year campaign. That campaign effectively began with Andrew Jackson Downing's call in 1851 for a great park in New York City. Had he lived, Downing would have been the logical choice to design the park, very likely in collaboration with his then partner, Calvert Vaux. Soon after Downing's death, Vaux moved to New York City and played a significant role in convincing the park commissioners to hold a design competition.

Vaux had previously met Olmsted at Downing's home, and he proposed that they enter the competition together. In his role as superintendent Olmsted had gained a detailed knowledge of the site, while Vaux had valuable experience as an architect and landscape gardener from his two years as Downing's partner. At first Olmsted declined, fearing to offend his superior, the Central Park engineer Egbert Viele, who had formulated a plan for the park for the previous commission. But when Viele made his indifference contemptuously clear, Olmsted accepted Vaux's offer. Through the winter of 1857–58 they labored over their plan in the evenings, gradually developing a unique set of solutions to the design problems posed by the site. And problems there were. Olmsted later observed, "It would have been difficult to find another body of land of six hundred acres upon the island. . . which possessed less of . . . the most desirable characteristics of a park, or upon which more time, labor and expense would be required to establish them."

The original site had been Jones Wood, an attractive area on the East River near the present location of the United Nations. The midisland site finally selected was long and narrow, with two large reservoirs that took up most of the area between Seventy-ninth and Ninety-seventh streets, and its terrain was rocky and uneven. While there was a section of gently rolling meadow above Ninety-eighth Street, there was no such area in the lower park.

To rectify this imbalance, Olmsted proposed extensive blasting and filling on the west side of the lower park to create two open meadows. One became a ball field for the use of schoolchildren; the other, thirty acres in extent, was a parade ground that would also serve as a "great country green or open common." This space came to be called the Sheep Meadow. Its construction required leveling the ground and adding two feet of soil, and it cost more than any other landscape feature of the park. These meadows gave Olmsted and Vaux's plan more pastoral landscape than any of the other thirty-two competition entrants. They emphasized this quality by naming their plan Greensward.

Another element that set the tone for Olmsted's later parks was the emphasis on scenery and the limited provision for structures devoted to other purposes. The general expectation was that the park would be the setting for a range of public festivities and institutions. Even Andrew Jackson Downing had conceived of a great New York City park in those terms. In addition to being a place for communing with nature it would contain "noble works of art, the statues, monuments, and buildings commemorative at once of the great men of the nation, of the history of the age and country, and the genius of our highest artists." There would be great "winter gardens of glass . . . where the whole people could luxuriate in groves of the palms and spice trees of the tropics" in cold midwinter, and there would be zoological gardens and exposition buildings for horticultural and industrial societies.

The rules for the Central Park competition, in fact, required the inclusion of an observatory tower, a hall for concerts and exhibitions, and a flower garden of two to three acres. Although the Greensward plan included these features, none of them remained when Olmsted and Vaux redesigned the park after winning the competition. The history of the park from that time on, however, was full of attempts to introduce structures and activities that would replace what had been constructed according to Olmsted and Vaux's plans. The principal building that they did include in their plan was a refectory overlooking the Lake near the west-side entrance at Seventy-second Street. Olmsted always wished to

satisfy the need of the users of his large parks for refreshments, and felt that by serving beer and wine he could forestall the proliferation of bars nearby.

One of the most imaginative aspects of the Greensward plan involved the four roads running across the park from east to west which the competition rules required. Olmsted and Vaux were the only designers who proposed to sink these transverse roads for crosstown traffic below the line of sight. Their plan emphasized long vistas and an enhanced sense of space in any case, but tradition has it that their inspiration came from seeing a fire engine and its retinue crossing the park on an existing street.

Few of the other competition plans have survived, but it is unlikely that any special visual quality of the Greensward plan itself accounts for its success. Like all the other competition plans, it was 122 inches long and drawn in india ink and sepia. No brighter colors were permitted. The rather murky original now hangs in the offices of the commissioner of the New York Department of Parks and Recreation. It has little of the beauty of color and flow of line that characterized later plans drawn up by the two men. The nine "before and after" studies that accompanied the plan, including three lovely paintings showing the "effect proposed," may well have made the entry stand out above the others.

On the other hand, Olmsted and Vaux may have won the competition for other reasons. Political considerations and connections had enabled Olmsted to be selected as superintendent of the park in September 1857. He was a Republican but not active in local politics, while the board had a slight Republican majority and could not afford to offend its Democratic members by a highly political appointment; he also had strong support from leading figures in the New York literary world, including Washington Irving. The same forces may have been at work in the design competition. When the winning entries were selected, three of the four prizes were awarded to employees of the Central Park commission itself.

Whatever the reason that Olmsted and Vaux won the design competition in March 1858, it was not long before their plan underwent a major revision. The Greensward plan had met the requirement that competition entries cost no more than $1.5 million to construct. Soon after Olmsted and Vaux won the prize, the commissioners decided to extend the

northern boundary of the park from 106th to 110th Street. In their plan for the enlarged park the two men created a much more complex system of paths and drives for the 640 acres outside the reservoirs.

They extended to this interior circulation system the separation of ways

Transverse road in Central Park, c. 1860.

that in the Greensward plan applied only to the transverse roads. As constructed, Central Park had three circulation systems—pedestrian paths, bridle paths, and carriage drives—each separated from the others by bridges and underpasses. This change in plan required the construction of some twenty additional bridges. The result was that users of the park could enjoy the scenery without real or apprehended danger of collision with those using a different mode of travel.

Central Park has by far the most complex system of separation of ways of any park that Olmsted designed. Others, like Prospect Park and Franklin Park, provided pedestrian access to the open landscape at the heart of the park only through a few arches over the circumferential carriage drive. But the narrow and rugged terrain of Central Park required a far more extensive and expensive arrangement. Olmsted and Vaux's drives through that terrain were one of the most visually exciting works of design on the land that either ever accomplished.

From May 1858 to the spring of 1861 Olmsted was architect-in-chief of Central Park, charged with hiring and firing laborers and directing construction. Work continued at a frantic pace for most of that time. During some periods there were as many as four thousand employees and

Olmsted pressed his engineers to labor long into the night to supply needed working plans. The amount of engineering work was immense. Olmsted proposed to install drainage tile under five hundred acres of the site, while the blasting and filling necessary to create the meadow areas, the formal Mall, the sunken transverse roads, and other route separations required major reshaping of the land. He later estimated that the amount of rock and soil moved during construction of the park was nearly five million cubic yards, "or nearly ten millions of ordinary city one-horse cart-loads, which, in single file, would make a procession thirty thousand . . . miles in length." This was equivalent to altering the level of the entire surface of the park by four feet.

Olmsted drew attention to this extensive and costly alteration of the site for landscape purposes when he was later faced with attempts to put sports facilities and buildings in reshaped areas. How successful he was in creating an apparently natural landscape for Central Park was confirmed by Horace Greeley, editor of the *New York Daily Tribune*, when he finally visited the park. After examining the park in some detail he sighed in relief, "Well, they have let it alone better than I thought they would!"

While the Central Park site offered few areas of meadow adapted to pastoral scenery, it abounded with the steep, rocky areas well suited to the picturesque style. The scenic heart of the park, the passage of scenery that was the focus of its lower section, was the Ramble on the hillside between the Lake and the reservoir at Seventy-ninth Street. There Olmsted created the most complete and expansive of all his picturesque landscapes. Photographs from as early as 1863 show how quickly the plants and watercourses he introduced developed into coherent scenery. One in particular shows the planting of rhododendron and laurel along the stream known as the Gill, which created an "American garden" landscape. Other old photographs show dense plantings of ivy and brambles on outcropping rocks; even yuccas and other drought-tolerant plants were introduced to create an effect of richness and profusion on exposed rock. While most of the original plant material has long since been lost, the circuitous paths and rocky setting of the Ramble still evoke some of the landscape experience intended by Olmsted and Vaux.

The Ramble, c. 1863.

The principal design feature between the park entrances at Fifty-ninth Street and the Ramble was the pedestrian Mall and water terrace. This was the only time that Olmsted or Vaux introduced a formal allée as an integral part of a park's circulation system. They apologized in their original report for doing so, citing the narrowness of the park and the need for a promenade where visitors could "see and be seen." Moreover, the Mall is aimed directly at the Ramble, a principal scenic element. As visitors passed along the Mall, the central focus of their vision was not a statue or an artificial object but instead the green hillside of the Ramble itself. Atop the Ramble the designers proposed to place a simple Martello tower to mark the visitor's final destination. They also took pains to prevent the formality of the Mall from intruding visually on the naturalistic scenery around it. Indeed, the success of their attempt can still be appreciated today. Despite its formal character, the Mall was to be simple in treatment. In time a few statues were introduced at its southern end and an ornate bandstand and overlooking arbor near the north end, but none of these additions greatly altered the original conception.

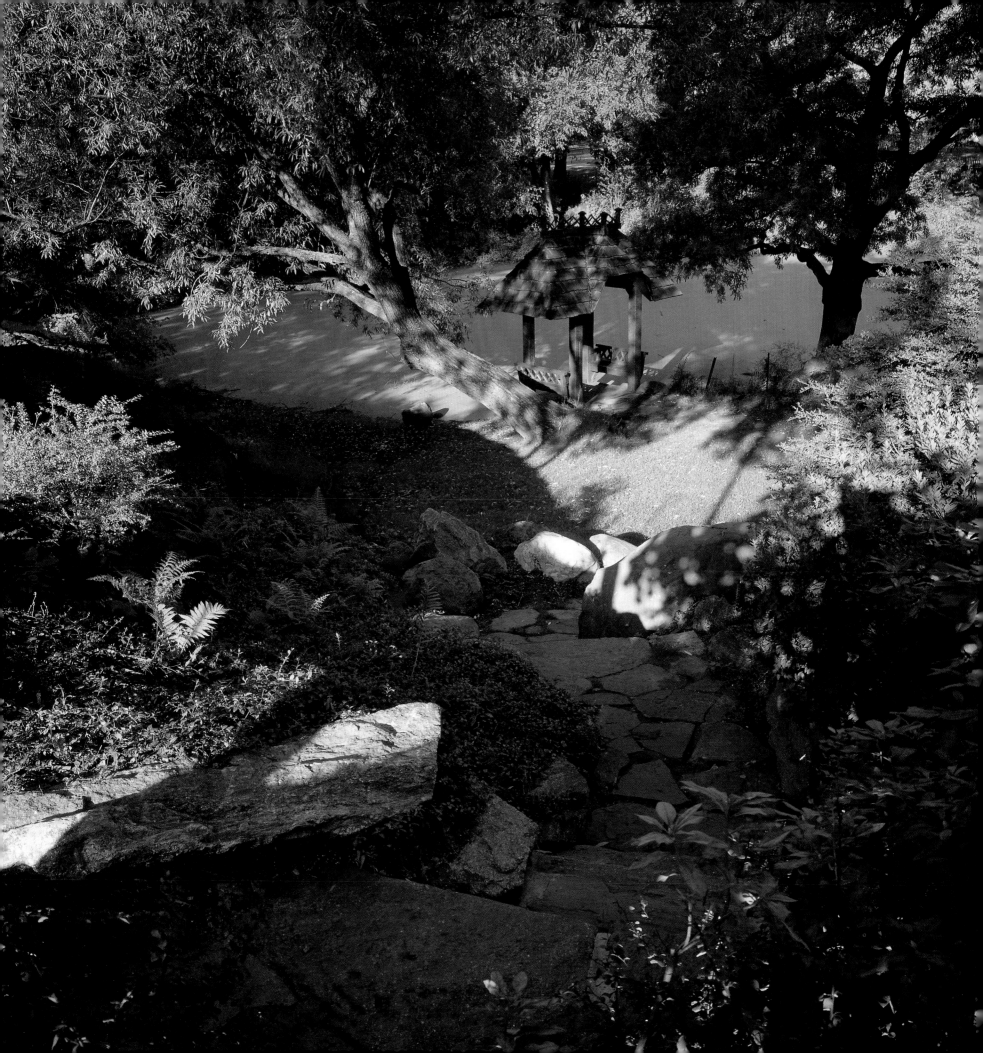

Architectural ornamentation and even splendor were planned for this section of the park, but they were concentrated on the Terrace at the end of the Mall, at a lower level and not visible from it. Only from the Terrace itself could one see the ornate tiles of the pedestrian archway under the carriage drive, the imaginative carvings of birds and animals on the stone stairways descending from the drive, the fountain, and the colorful banners flying from flagpoles at the water's edge.

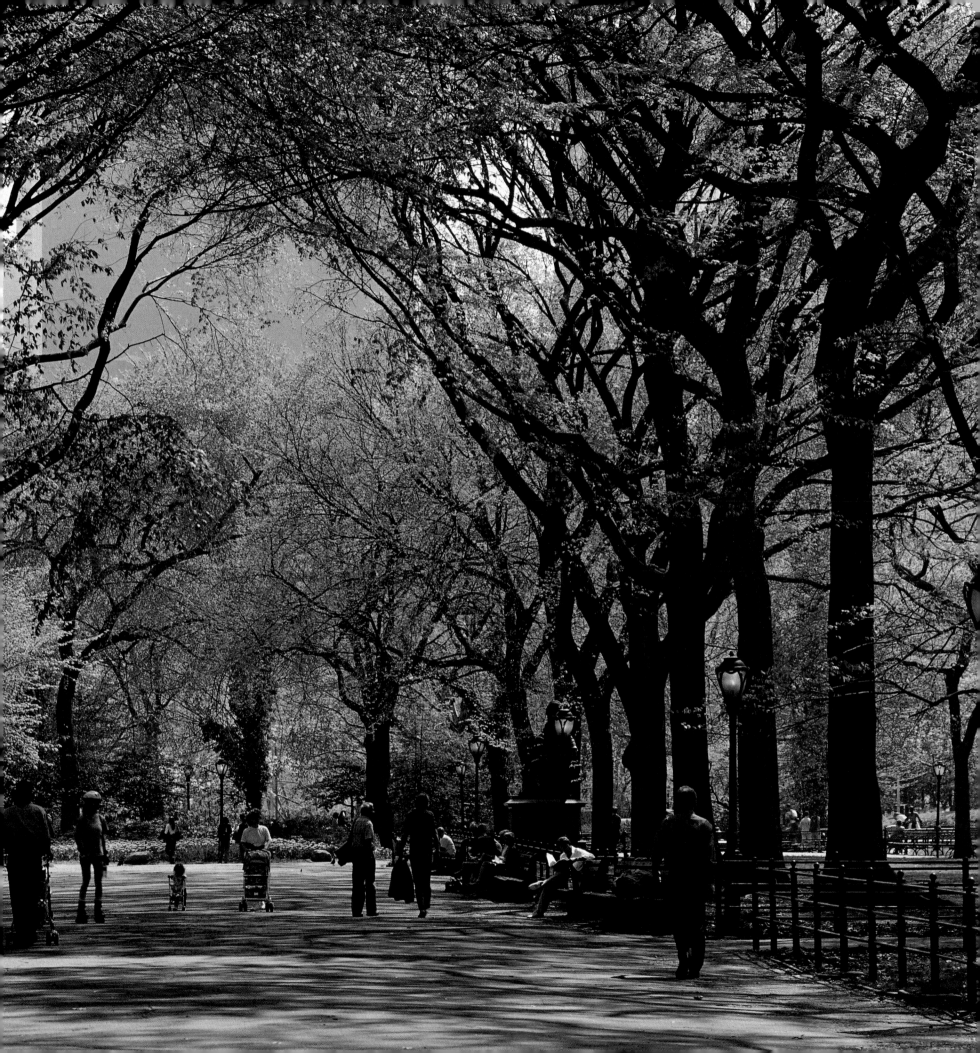

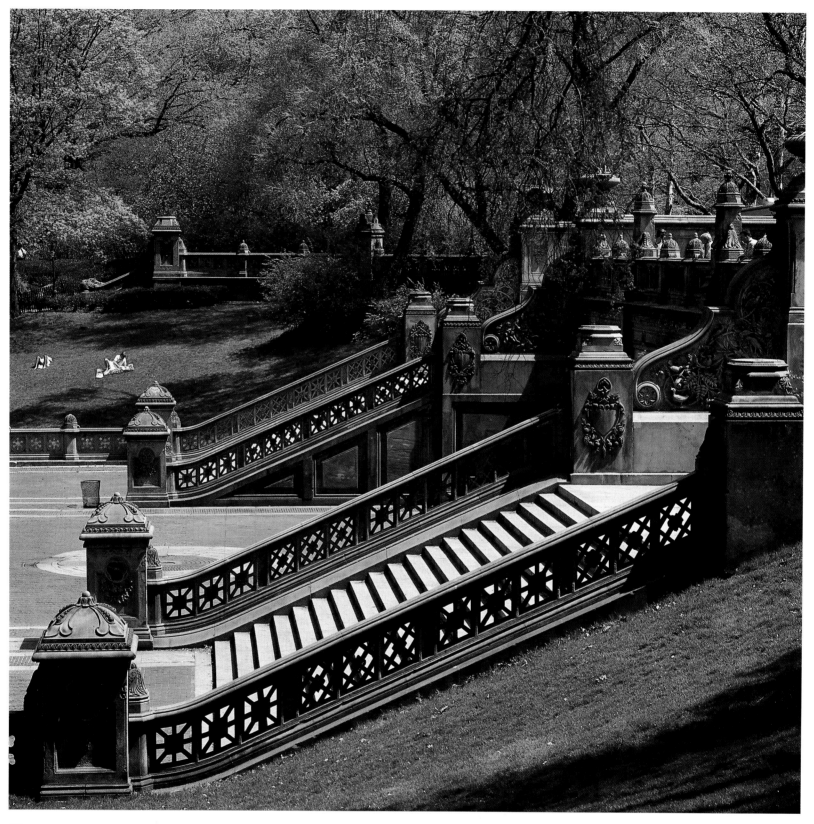

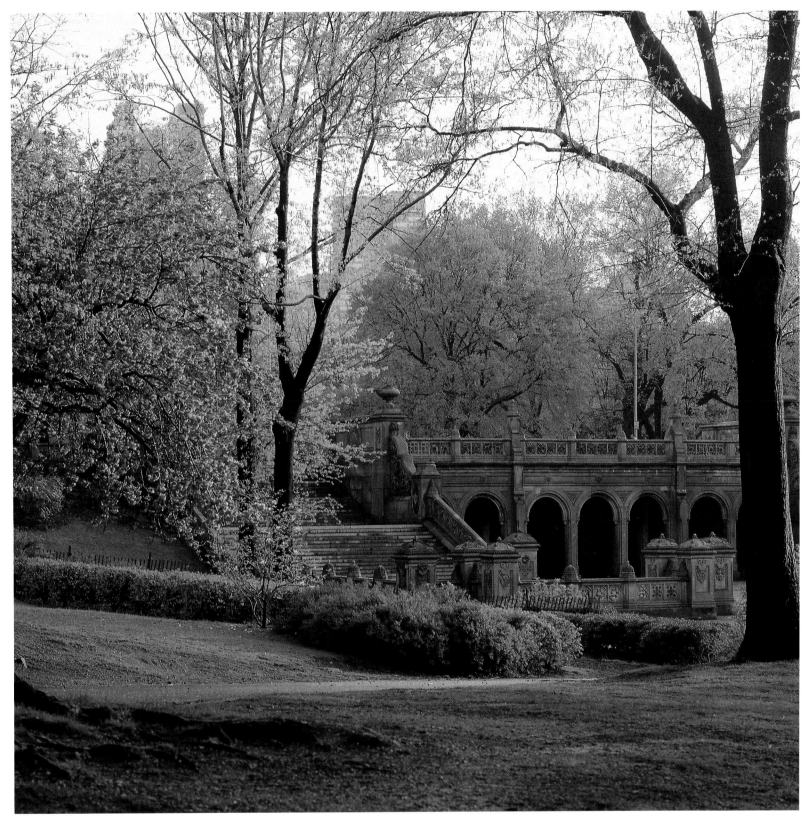

In this small area, Calvert Vaux and his talented assistant, English architect Jacob Wrey Mould, created an elegant and festive space for the citizens of New York. The central visual element in the original composition was the spray of the fountain in the middle of the circular basin. In the 1870s this fountain was replaced by a more serious and symbolic feature, the statue of the Angel of Bethesda, designed by Emma Stebbins, sister of the chairman of the park commission.

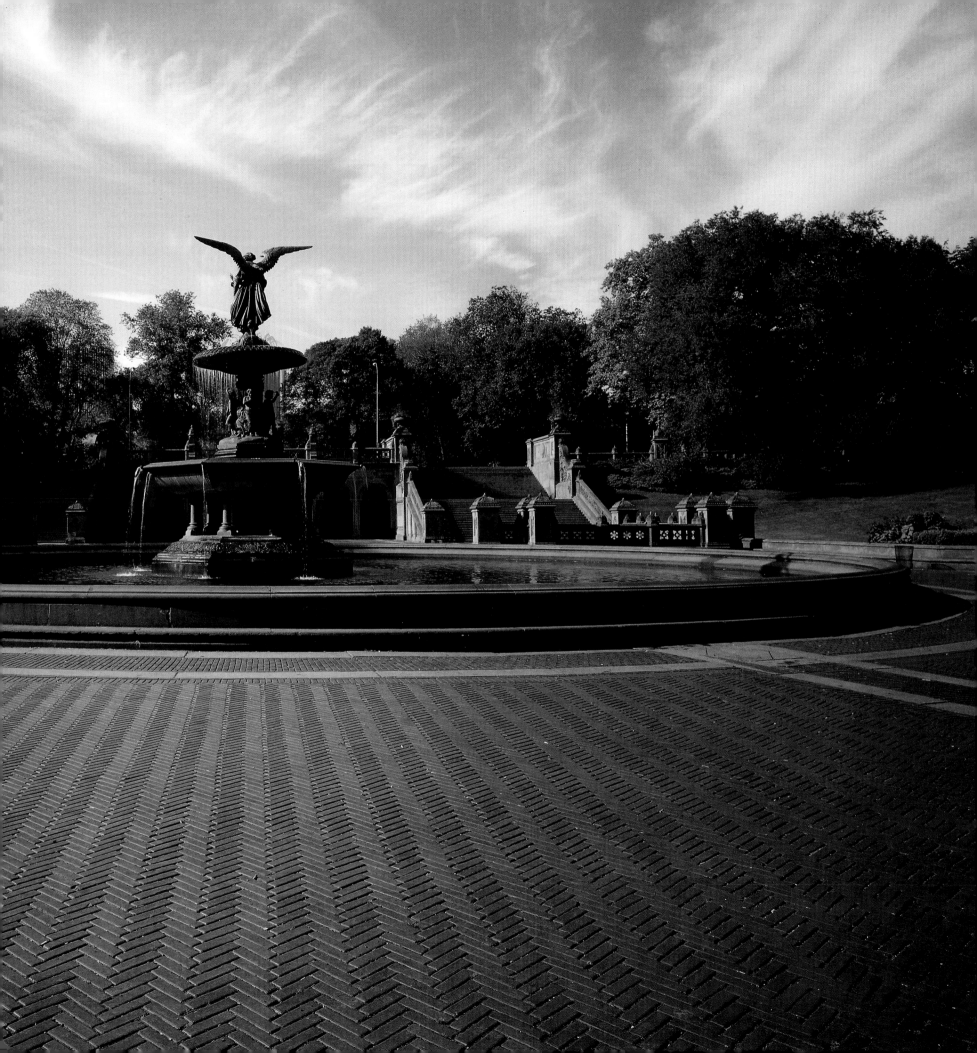

After passing the Mall and Terrace the visitor follows the paths along the lakeshore to the Ramble. Bow Bridge, one of Vaux's crowning achievements, provides the most pleasant and direct route to the circuitous pathways of the Ramble. The bridge did not appear in the Greensward plan, which required visitors to proceed along the east shore of the Lake in order to reach the Ramble from the Terrace. Along most of the lakeshore opposite the Terrace there are no paths so that the monumental structure is obscured in the distance when viewed from that side of the Lake.

In the early days numerous rustic wooden shelters were constructed on rock outcroppings throughout the lower park. These were supplemented by small, roofed boat landings along the shore of the Lake. Later, more ornate structures such as the Boathouse and Ladies Pavilion were added.

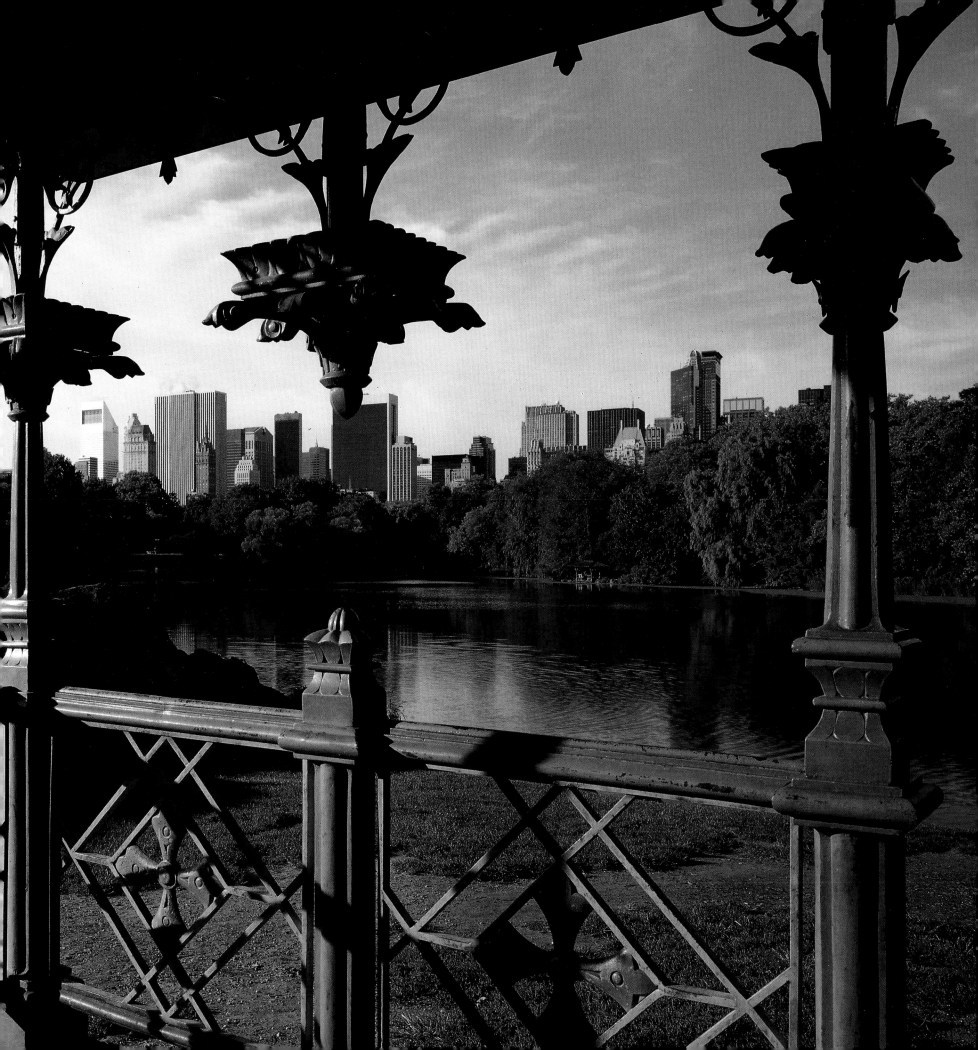

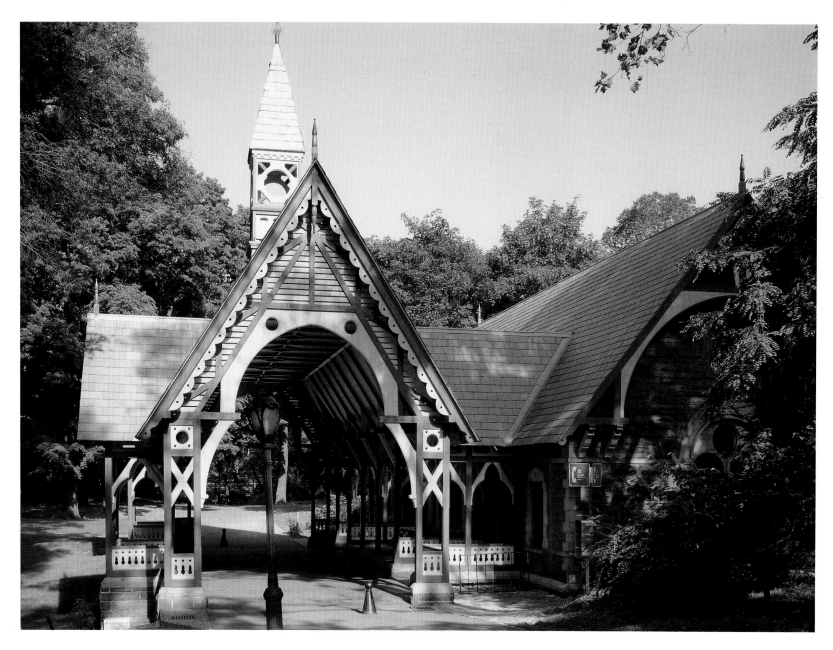

One of the few buildings that Vaux designed in the early years of the park to support a special function was the Dairy, located just south of the Sixty-sixth Street transverse road at the top of a grassy dell. It overlooked the northern arm of the Pond in the southeast corner of the park. From the Dairy "a bay of this water, with a bold dark shore opposite, rising to an eminence crowned with firs, was looked down upon, over a narrow glade of turf." Vaux designed a stone structure with a decorative wooden gallery on its south side. Its purpose was to supply milk and other refreshments and playthings for children who would

frequent the area. It was the closest sheltered, south-facing slope within the park to the built-up city, and Olmsted and Vaux planned it as a secluded retreat for children and convalescents. Next to the building they intended to have a cow or two, a ewe with lambs, and a few chickens for the amusement of the children. The area was accessible only on foot, and plantings shielded it from the view of carriages on the drive. Supplies reached the Dairy itself directly from the transverse road. Dogwood, sumac, and bittersweet grew on the nearby outcroppings, creating "a pretty bit of natural scenery, having a somewhat wild and secluded character."

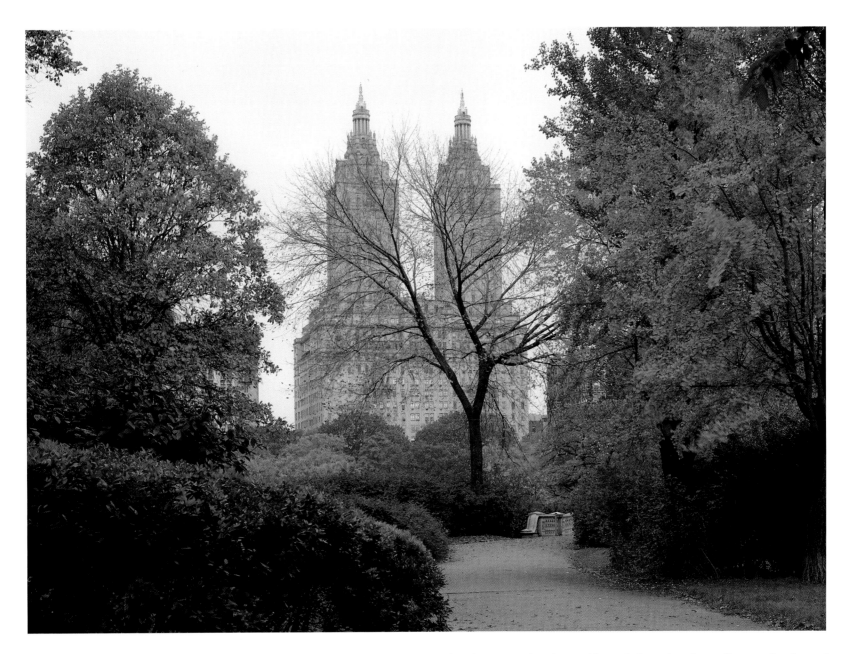

The area retained this character until the Tweed Ring's park commissioners took over the park in 1870. They turned the Dairy into a restaurant for all park users and complained bitterly about the lack of direct carriage access to it. They declared that it was inexplicably "hidden from direct view . . . *difficult of access*; and no direct path leads to it from the main drive; so that the criticism is often popularly made that a Dairy building intended for general use of persons frequenting the Park, has been placed, as much as possible, out of sight and reach." They quickly remedied this oversight by thinning and trimming the trees near the Dairy and putting the plantings and rocks, as Olmsted phrased it, "partially out of sight, and wholly out of countenance by rows of prim garden-shrubs." Instead of the cows and sheep Olmsted encountered an "old Kerry bull" tethered to a stake and pawing the turf to dust. The result of the Tweed Ring's efforts was to destroy both the appearance and function for which Olmsted and Vaux had designed the place. "If the building had been levelled and all the ground around had been plowed and salted," Olmsted declared, "a willing ignorance of the real elements of value in all the work of the neighborhood . . . could not have been more distinctly manifested."

Even more troubling was their treatment of naturalistic plantings. As Olmsted complained, "in parts of the Park in which intricacy of low growth and picturesque obscurity had been required by the design, the natural underwood has been grubbed up, the original admirably rugged surface made as smooth and meadow-like as ledge-rock would allow, and the trees, to a height of from ten to fifteen feet, trimmed to bare poles." This was all the more galling because of the difficulty that Olmsted had encountered in bringing the plantings to a finished state. All too often his superiors on the park board, particularly the money-conscious comptroller Andrew H. Green, saw no reason to spend time and funds in areas that looked sufficiently finished to them. In an impassioned appeal to the board in 1861 for more freedom to pursue his design concepts, Olmsted said, "No one but myself can feel, and without feeling no one can understand, *at the present time*, the true value or purport of much that is done on the park, of much that needs to be done." Thus far, the work had only been a preparation for the final stage of raising the park's landscape to the level of art, to the level where it could have the intended impact on park users:

On this foundation I have now to build: this canvas I have to paint, this rough-hewn head to chisel and rub into the delicacy and crispness of life—these rude brown & grey slopes, poles and sticks, to nurse and tend and train and direct toward that ideal for which & for which alone they have been shaped and planted in these three years.

Unfortunately, Olmsted was not able to continue this work during the Civil War, and when he returned in 1865 he was no longer architect-in-chief or even superintendent of the park. He was simply, with Calvert Vaux, landscape architect to the park board, potentially involved in design decisions but not in the daily work on the park. In fact, it was ten years before he again oversaw the park's gardening force. Between the spring of 1875 and his dismissal in December 1877 he had one brief opportunity to direct the park's plantings toward the artistic goals for which he had worked in the period 1858 to 1861.

Despite his intense involvement in the design and construction of Central Park, the role that Olmsted felt to be uniquely his own was the education and protection of the public in the use of the park. To promote this cause, he established a force of park keepers as soon as he became architect-in-chief. He later declared that he would never have designed the park as he did had he not expected to train a group of employees who would function both as police and as guides. He required the keepers at all times to treat park users respectfully. At the same time they had to maintain a military bearing and an air of vigilance that gave them the appearance of effective keepers of the peace.

Olmsted's twenty years of involvement with Central Park engaged him in more aspects of its design and operation than did any of his other parks. The act of making the plan was simply a first step, to be followed by daily dedication to directing the execution of the thousands of details by which the design was to be realized and maintained. No other park offered the same exhausting opportunity for the exercise of the whole range of his talents. He gave unmeasured energy and devotion to the task.

70

Prospect Park

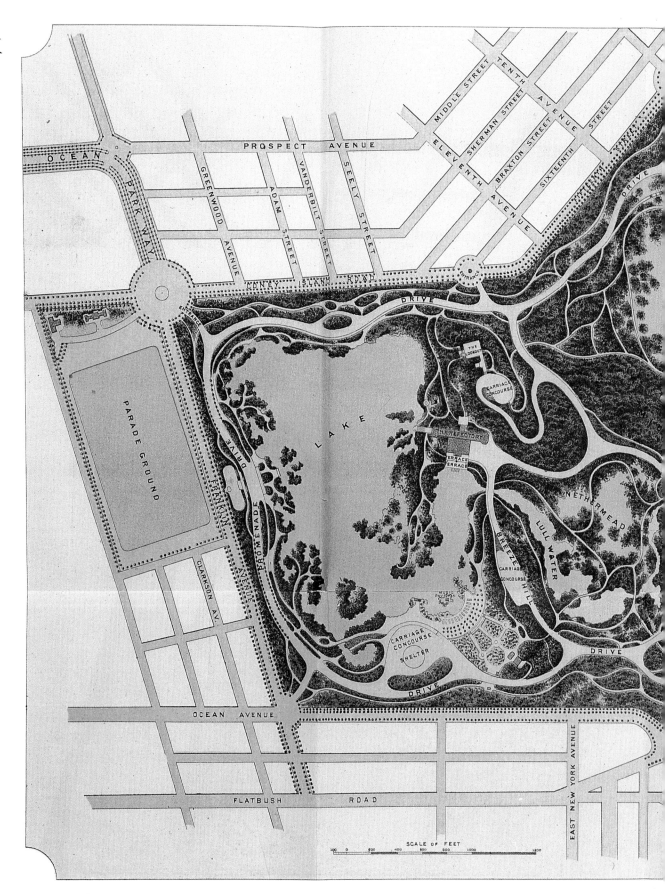

DESIGN FOR

PROSPECT PARK

IN

THE CITY OF BROOKLYN.

1871.

OLMSTED VAUX & CO, LANDSCAPE ARCHITECTS.

J. Y. CULYER, CHIEF ENGINEER.

TWELFTH STREET

ELEVENTH STREET

TENTH STREET

NINTH STREET

EIGHTH STREET

SEVENTH STREET

SIXTH STREET

FIFTH STREET

FOURTH STREET

THIRD STREET

SECOND STREET

FIRST STREET

MACOMB STREET

MONTGOMERY STREET

CARROLL STREET

PRESIDENT STREET

UNION STREET

SACKETT STREET

DEGRAW STREET

DOUGLASS STREET

FLATBUSH AVENUE

LONG MEA

WEST DRIVE

WILLOW

DRIVE

PRINCIPAL ENTRANCE

PLAZA

PLATFORM

VANDERBILT AV

FLATBUSH AVENUE

RESERVOIR

JAMAICA PARKWAY

GROUND RESERVED FOR PUBLIC BUILDINGS

FOR SALE

FOR SALE

DOUGLASS STREET

BUTLER STREET

BALTIC STREET

WARREN STREET

UNDERHILL AVENUE

GRAND AVENUE

WASHINGTON AVENUE

MONTGOMERY ST

CROWN ST

CARROLL ST

PRESIDENT ST

CLASSON

JAM. PARK WAY

AVENUE

AVENUE

N.Y. Lith & Engr. & Print. Co. 16 & 18 Park Place.

PROSPECT PARK was the the focus of Olmsted's activity for eight years after he returned from California in late 1865. He took great satisfaction in what he accomplished there. When the work was well advanced, he wrote the president of the Brooklyn park board, James T. Stranahan, that the park in most areas was "thoroughly delightful and I am prouder of it than of anything that I have had to do with." Both the terrain and the plan that he and Vaux devised for it stand as a classic example of their concept of a great urban park. The quality of the site owed much to Vaux, who had begun work on it while Olmsted was still in California. The original site was divided by Flatbush Avenue and contained only part of what is now the Long Meadow and none of the flat area containing Prospect Lake. Vaux convinced the commissioners to adopt the present boundaries before Olmsted joined him. That configuration made possible the Long Meadow, which was the largest expanse of pastoral scenery the partners had yet created, and it added other areas that were well suited for contrasting landscape effects.

The Prospect Park plan is the most pleasing that they created during their collaboration. The flow of the walks and drives is particularly graceful and elegantly demonstrates their basic approach to a circulation system. The carriage drive encircles the park near its borders, leaving large expanses in the interior for the unimpeded use of pedestrians. The plan shows five places where arches would permit visitors on foot to pass under the circuit drive and into the interior of the park. Three of these exist today—the Endale and Meadowport arches near the Grand Army Plaza entrance and the Eastwood arch near the upper lake, or Lullwater. In the interior of the park the Nethermead arches and the Cleftridge span provide further separation of access ways.

The pattern of the carriage drives on the Prospect Park plan illustrates the sinuous course by which Olmsted and Vaux led visitors through the park, gently curving so that it constantly opens up new views and avoids the predictability of long, straight vistas. There are no right-angle or oblique turns so that one is led to the principal destination points with minimal need for conscious decision about the route to follow. At the same time the drive does not intrude visually on the main pedestrian area, the Long Meadow. Indeed, this is true of the paths of the Long Meadow itself in many places. Even without the screen of trees shown on the plan between the path and the meadow, the former is often invisible from the interior space, so careful was the grading of the land.

Long Meadow, c. 1900.

The Long Meadow is the special triumph of Olmsted and Vaux's plan. It provides the sense of unfolding space, the "range," that Olmsted identified as the most therapeutic quality of pastoral scenery. The space opens constantly before one, and there is always the promise of further space beyond the boundary of trees. The classic photograph of the Long Meadow, taken around 1900, embodies the indefiniteness of edge, the "obscurity of detail further away" that was for Olmsted a special quality of pastoral scenery.

The Long Meadow also provides a classic illustration of other attributes that Olmsted ascribed to park scenery. One of these was ease of movement:

It should be a ground which invites, encourages & facilitates movement, its topographical conditions such as make movement a pleasure; such as offer inducements in variety, on one side and the other, for easy movement, first by one promise of pleasure then by another, yet all of a simple character.

Olmsted applied the term "hospitality" to this quality in a park, saying, "The more unlimited the degree of hospitality of landscape, the more unmeasured the welcome which the broad face of your park can be made

to express, the better will your purpose be fulfilled." The result of these elements of grace and hospitality in the landscape, the gentle undulation of the ground and the indefinite boundary of the space, was an experience that nurtured the human spirit. Olmsted instructed the workers engaged in building Prospect Park that:

We must study to secure a combination of elements which shall invite and stimulate the simplest, purest and most primeval action of the poetic element of human nature, and thus remove those who are affected by it to the greatest possible distance from the highly elaborate, sophistical and artificial conditions of their ordinary and civilized life.

Thus it must be that parks are beyond anything else recreative, recreative of that which is most apt to be lost or to become diseased and debilitated among the dwellers in towns.

Today, one can still experience the landscape of the Long Meadow by first passing under the Endale arch as it frames the view of the upper meadow, then moving along the gracefully flowing paths as they reveal more and more of that remarkable space. There are few places where one can recapture more of the sense of place that Olmsted intended in his designs than in the Long Meadow of Prospect Park.

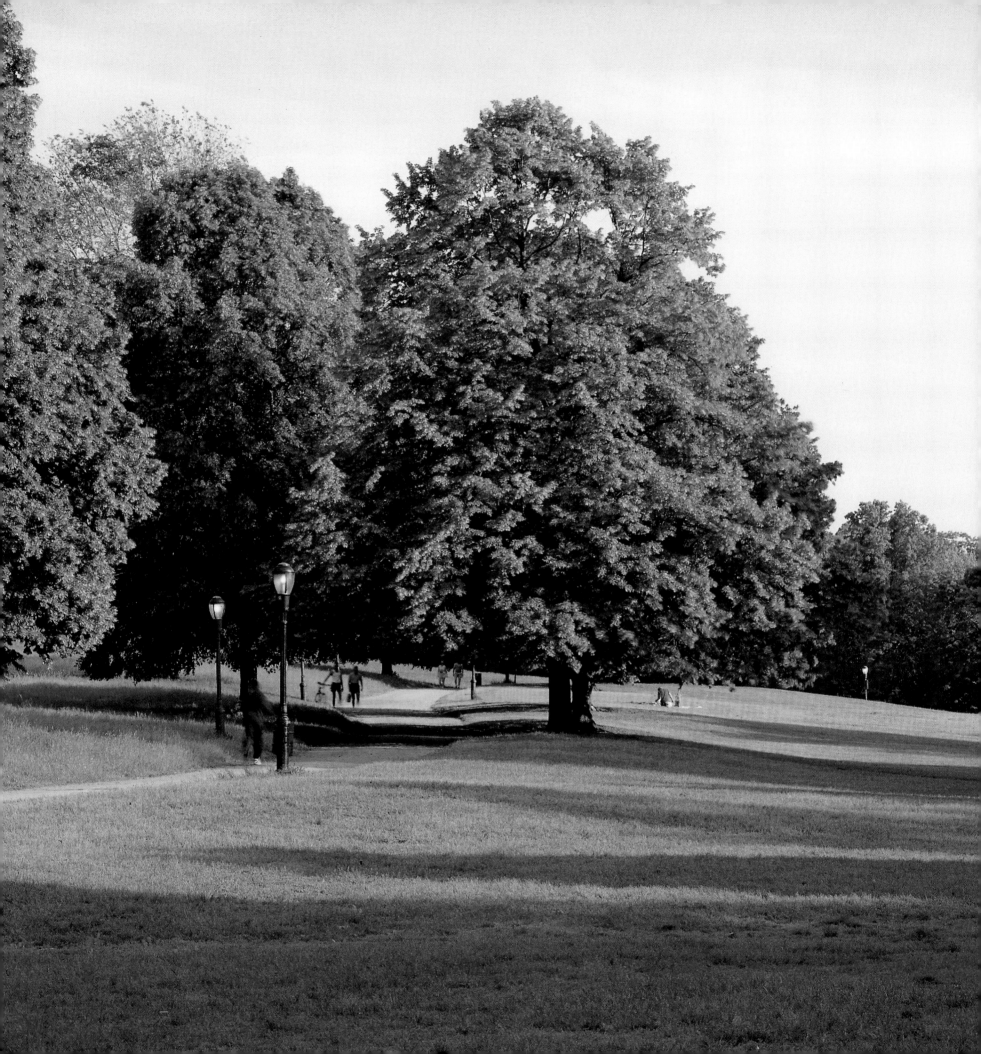

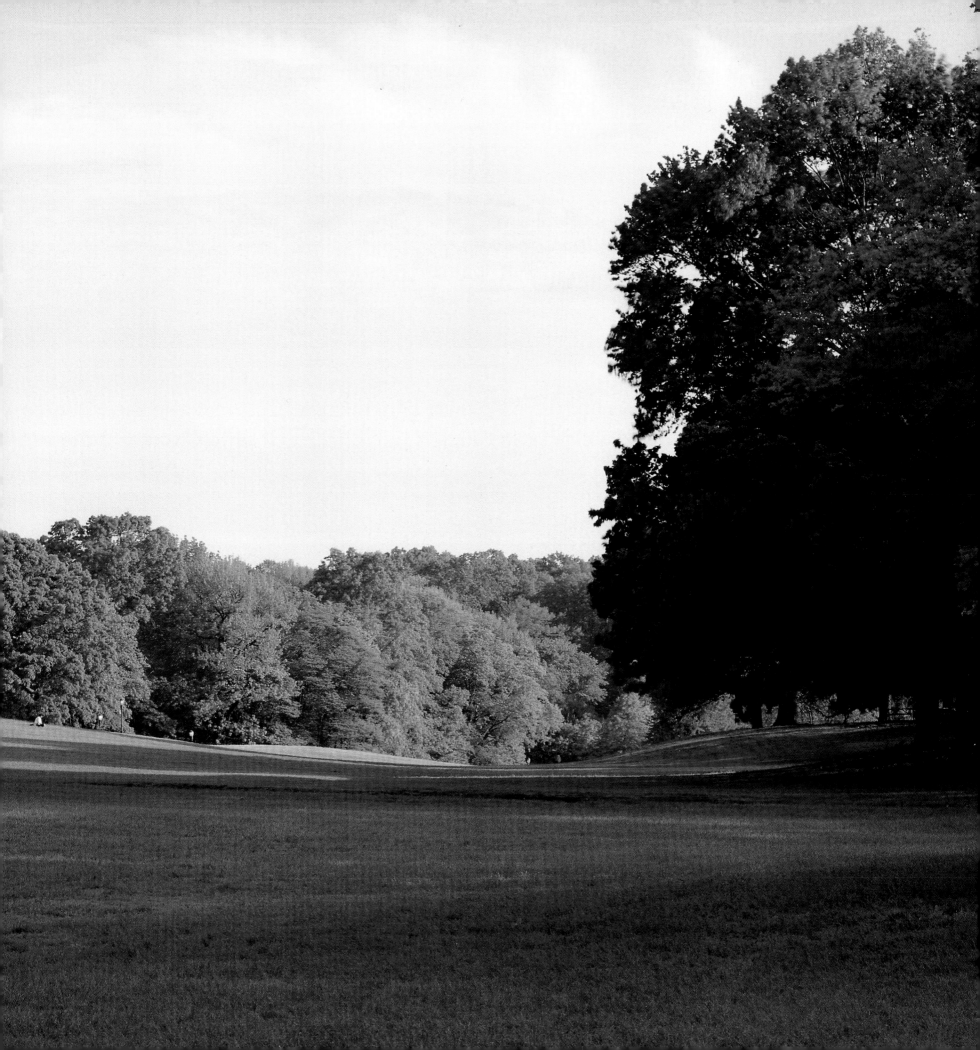

The Ravine, c. 1870.

The Vale of Cashmere, c. 1875.

In striking contrast to the Long Meadow was the Ravine section, descending from the meadow to the Nethermead and Prospect Lake through a steep-sided gully that Olmsted and Vaux carved out of the hilly section of the park. The central feature is a series of ponds and a stream that the designers created by means of a steam-powered pump that constantly circulated water through the artificial water features. The Ravine was one of Olmsted's most elaborate passages of picturesque scenery. Historical photographs show both the rocky outcroppings and the delicacy and profusion of foliage that proliferated in such landscapes.

Another picturesque landscape that survives in a more intact state is a small, steep-sided valley just below the Long Meadow near Flatbush Avenue. Olmsted and Vaux developed this section as a children's area, with an array of play equipment near the avenue and a pool for toy boats in the adjacent valley. They planted the valley sides densely with rhododendron and other shrubs and supplemented them with a particularly lush profusion of what Olmsted called "semi-tropical" planting on the shores of the pool. The intent evidently was to create an

atmosphere of bounteousness and mystery reminiscent of the tropics, as Olmsted so often sought to do in similar situations. In this case he seems to have succeeded all too well. The richness of effect was so great that park users called the area the Vale of Cashmere, much to his dismay. As a result, of course, much of the intended effect was lost. A children's play area planted with a rich variety of vegetation might work its quiet effect if it were anonymous, but the popular designation raised such expectations of the exotic that any "unconscious influence" of the landscape was virtually impossible.

Below the Ravine the open expanse of the Nethermead provides a separate meadow landscape, bordered on one side by the narrow Lullwater and on the other by Lookout Hill with its overlook. Prospect Lake was designed to provide for boating and for a skating area even larger than the lake in Central Park. Over the years that Olmsted and Vaux developed the plan and as they oversaw construction of the park, the bays and headlands of the lakeshore became increasingly intricate in shape and more extensively planted.

78

The most elaborate provision for large gatherings of visitors was the concert area on the northeast corner of the lake. It consisted of two carriage concourses, one on the lakeshore and one on Breeze Hill, separated by a concert grove for visitors on foot. In planning this feature, Olmsted and Vaux sought to combine two previously disparate outdoor concert traditions, one of performances for audiences in carriages and the other of more intimate concert settings for people on foot. The grove consisted of semicircular rows of plane trees on a terrace near the lakeshore, with an informal grove further back.

There was a small island for the band or orchestra so that the sound of the music could travel over the water. Along the shore there was also a space for listeners who gathered in boats. As had been the case with the Bethesda Terrace in Central Park, the designers masked this formal space with planted headlands and with the island so that the architectural character of the terrace was not evident from any other part of the lake.

The elegantly carved stone balustrades that Calvert Vaux designed for the concert grove are charming pieces of decoration. Today, in company with the surviving plane trees, they create an atmosphere both quiet and elegant.

On the upper level of the terrace stands Vaux's recently restored Oriental Pavilion, which was the architectural centerpiece of the concert grove when it was constructed in 1874. It is one of Vaux's most festive and decorative structures.

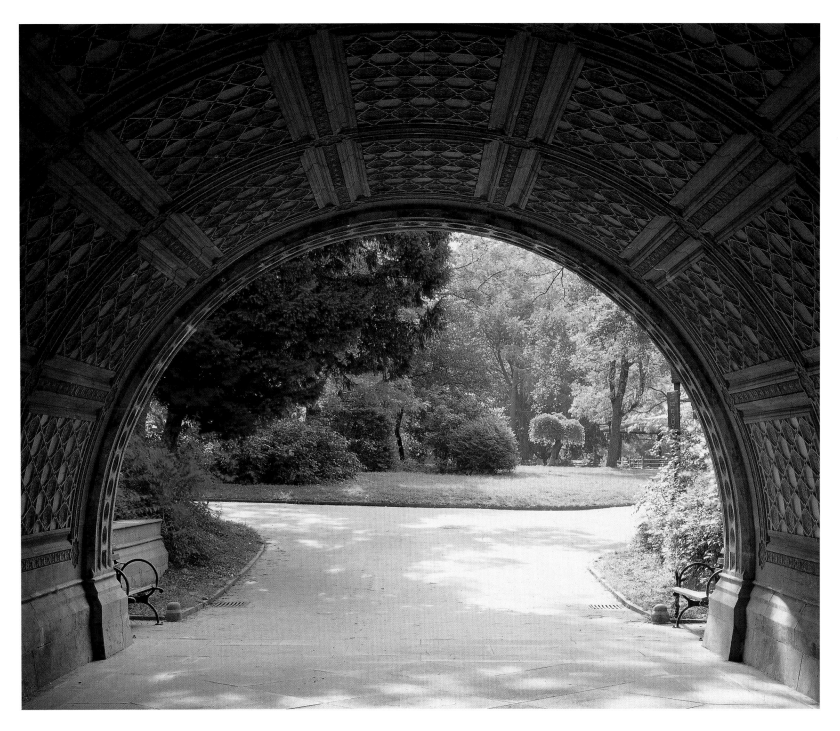

At the end of the terrace the Cleftridge span provides access for pedestrians between the concert grove and the Lullwater region. An example of Vaux's interest in experimental materials, the interior of the arch is constructed of an artificial stone called Beton Coignet. Only three different molds were used to produce the complex pattern of the arch's interior surface, allowing a more permanent decorative element than the park commission would otherwise have been able to afford. This surface adds one more element of interest to the remarkable *ensemble* of features that Olmsted and Vaux concentrated in the separate concert space at the head of Prospect Lake.

South Park, Chicago

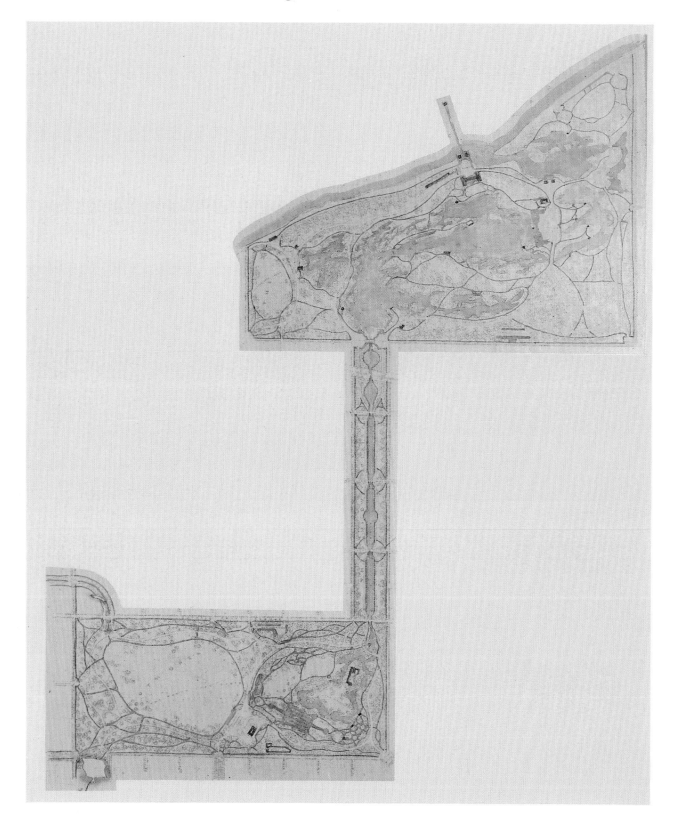

DURING HIS PARTNERSHIP with Calvert Vaux, Olmsted found in the city of Chicago a remarkable opportunity to be involved in the development of a metropolitan center. The sixteen-hundred-acre village of Riverside, which he began to plan in 1868, was the most extensive and completely realized of any of his community designs. Moreover, the thousand-acre South Park, which he and Vaux designed in 1871, was to be the great metropolitan park of Chicago. It would have a preeminence even greater than that of Central Park in New York City.

Olmsted had been intrigued for several years with the opportunity for park development that Chicago offered. William Bross, senior editor of the *Chicago Tribune*, was a member of a party led by Speaker of the House of Representatives Schuyler Colfax that was present in the summer of 1865 when Olmsted presented his report to the Yosemite commission. On the return trip to San Francisco a prime topic of conversation was Central Park in New York. Bross recalled that "both Colfax and Olmsted agreed with me that nothing was needed to make Chicago the principal city of the Union but a great public improvement of similarly gigantic character." This remained Olmsted's intention throughout the remainder of his career. When his firm undertook a revised plan for the Chicago park following the World's Columbian Exposition of 1893, he reiterated that it could be the finest domestic boating park in the world.

The park was unusual in that it was in fact two parks, one inland and one on the lakeshore, connected by a narrow strip that Olmsted and Vaux proposed to develop as a boulevard and canal. The numerous features and structures that they included demonstrate how complex and comprehensive the park's recreational facilities were to be. The inland section, which came to be called Washington Park, contained the Southopen Green for sports and gatherings as well as a pavilion ground that included a refectory, courts, garden, and galleries with an adjoining carriage concourse. Also planned was another pavilion with a quarter-mile mall and four areas for picnics, a mounded and thickly planted Ramble, a deer paddock, and a pond with boat landings. The narrow Midway Plaisance connecting the two larger sections of the park was to contain formal canals flanked by walks, drives, and rows of trees. The lakeside section, which came to be called Jackson Park, included a formal concourse where the Midway meets the lagoon, a long pier on the lakeshore with adjoining concourse (one of five carriage concourses of two acres each planned for the park), and the Belvedere, a refectory with an

enclosed lawn. At the inner end of that lawn Olmsted and Vaux proposed an extensive promenade and concert grove with an island for the band or orchestra, as at Prospect Park.

The 165-acre lagoon, the principal landscape feature of this section of the park, had a dozen boat landings with shelters. Some of the islands in the lagoon were to be refuges for wild birds, serving as part of what the designers envisioned as the finest living ornithological collection in the world. The designers also suggested constructing a natural-history museum, which could display bison, elk and bears, seals and sea lions. South of the lagoon there was to be an extensive sheltered area for boating that was directly accessible from the lake. A thousand-foot pier would protect its entrance. Two additional areas were to be kept open and lighted at night, providing facilities for athletics and team sports for the neighborhoods adjoining the park to the north and south. One was the twenty-six-acre Lakeopen Green at the northern end, where the Field Museum was eventually sited. The circulation system of the South Park was ambitious as well. There were to be fourteen miles of interior drives and thirty miles of paths, as compared to nine and twenty miles, respectively, in Central Park.

While the South Park plan proposed many constructed elements that met a variety of recreational needs, its central purpose was to provide scenery for the enjoyment of Chicagoans. According to Olmsted's theories the kind of landscape to be provided there should be drawn from the "genius of the place," utilizing a perceptive interpretation of ideal forms of the kinds of scenery found on the site. But Olmsted found the soggy, wind-blown prairie section of the site unappealing and later referred to the marshy area behind the lakeshore dunes as "a swamp without beauty." There was only one element of the local scenery that he truly appreciated. That was Lake Michigan itself. Its grandeur would compensate for the lack of varied terrain on the site. He was delighted to have the lake as a scenic adjunct and means of access to the park and admitted that no artistic effort could make it more grand. While the artist's hand could not improve upon the sublime, such a feature as the lake could add immeasurably to the park. Indeed, this was the only time when he was able to associate passages of his favorite styles of park landscape, the pastoral and the picturesque, with an expanse of the sublime. Only South Park brought together the three distinct styles of natural scenery that he recognized in his professional thought and work.

As Olmsted had made clear in his earlier park reports, pastoral scenery was the most valuable for counteracting the debilitating influences of urban life. The flat prairie of South Park offered no barrier to creating such passages of scenery, although he felt no assurance that the wet, cold soil could ever produce splendid specimens of shade trees. The pastoral style became the key to the design of the inland section. The hundred-acre Southopen Green was, moreover, one of the largest open meadows that he ever designed. It was not, however, a prairie; rather, it was a version of the universal natural landscape that he considered an essential part of any urban park.

Still, it was not meadow scenery but water—the water of Lake Michigan—that provided the unifying element of the South Park design. The Mere of Washington Park connected to the formal waterway of the Midway Plaisance, which flowed into the Lagoon of Jackson Park and thence into Lake Michigan. It was in the water section of the park—the Jackson Park Lagoon—that Olmsted found the most exciting opportunity for creating scenery.

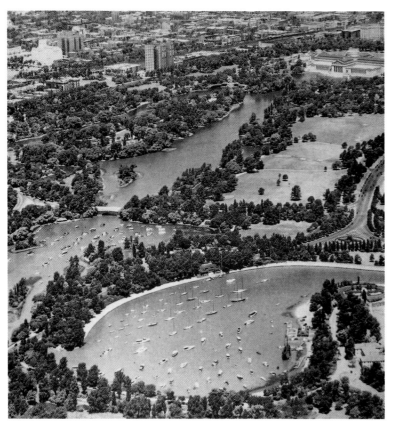

Aerial view of Jackson Park, 1930s.

Turning to an analogy that he often used—that of basing a landscape design on the actions of nature in producing scenic effects—he observed that if geologic and climatic conditions had been somewhat different, a kind of landscape would have developed behind the lakeshore dunes that was "of a most interesting and fascinating character, that, namely, of the wooded lagoons of the tropics." The entire lagoon of islands and circuitous waterways would have this character. But the inspiration for the scenery was not the swamps of the Lake Michigan shore but rather the lush bayous of the Gulf Coast and the rain-forest waterways of Panama that had so impressed Olmsted in his travels.

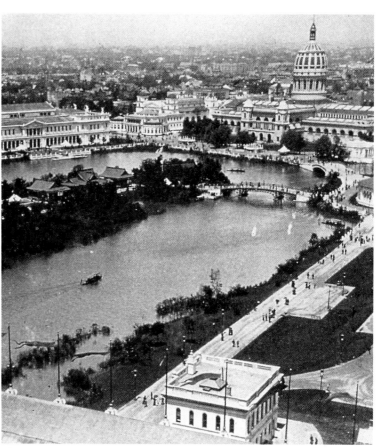

The Lagoon, World's Columbian Exposition, 1893

In the picturesque scenery of the South Park, as in its pastoral scenery, Olmsted responded to the opportunity to create a landscape that would produce a response of an elemental kind. He had experienced the awe, the sense of profusion and of mystery, provoked by semitropical landscapes, the "profuse careless utterance of Nature," in those southern places.

He welcomed the opportunity to evoke the same response in this northern site with different plant materials, as he had welcomed a similar opportunity in the Ramble of Central Park and the Ravine of Prospect Park. He summed up his case in the Chicago South Park report:

You certainly cannot set the madrepore or the mangrove at work on the banks of Lake Michigan, you cannot naturalize bamboo or papyrus, aspiring palm or waving parasites, but you can set firm barriers to the violence of winds and waves, and make shores as intricate, as arborescent and as densely overhung with foliage as any. You can have placid and limpid water within these shores that will mirror and double all above it as truly as any, and thus, if you cannot reproduce the tropical forest in all its mysterious depths of shade and visionary reflections of light, you can secure a combination of the fresh and healthy nature of the North with the restful, dreamy nature of the South that would in our judgment be admirably fitted to the general purposes of any park, and which certainly could nowhere be more grateful than in the borders of your city, not only on account of the present intensely wide-awake character of its people, but because of the special quality of the scenery about Chicago in which flat and treeless prairie and limitless expanse of lake are such prominent characteristics.

Olmsted's concept was not realized during the first two decades of construction, but selection of Jackson Park and the Midway Plaisance as the site of the World's Columbian Exposition of 1893 breathed new life into the proposals of 1871. As he set out to plan the exposition, Olmsted revived the concept of a lagoon with wild, profuse plantings on its verge:

The thing is to make it appear that we found this body of water and its shores and have done nothing to them except at the landings and bridges. They were rich, rank, luxurious, crowded with vegetation, like the banks of some tropical rivers that I have seen on Louisiana bayous.

The Wooded Island and the Lagoon of the Exposition were the first fully realized demonstrations of the prairie-river landscape that became such an icon for the prairie landscape school of the Midwest in the following years. Olmsted's achievement was impressive for its size as well as for the extensive use of native plants gathered from nearby swamps. He later calculated that 100,000 small willows were planted on the shores of the lagoons of the Exposition, along with seventy-five large railroad flatcars filled with aquatic plants taken from the wilds, 140,000 other aquatic plants, and 285,000 ferns and other perennial herbaceous plants.

In all, the plants numbered over one million.

The simpler concept of greensward, groves, and ponds in Washington Park, ably carried out under the supervision of H.W.S. Cleveland in the early 1870s, had been disrupted in the 1880s by the immensely popular plant sculptures of the superintendent. The popularity of this artificial

The Lagoon, Jackson Park.

garden art led Cleveland to conclude grudgingly "that we need two systems of parks—one for the comparatively few who really want seclusion and the beauty of nature—another for the multitude who can only enjoy solitude in crowds—to whom any work is artistic in proportion as it is artificial."

The idea of a canal in the Midway Plaisance, though revived and replanned by the Olmsted firm after the Exposition, has never been realized. However, plans for redevelopment of Jackson Park after the Exposition closed were for the most part carried out. Considerable areas that had been filled in to provide space for the exposition buildings were allowed to remain, with the result that the lagoons were less extensive and their shores and islands less intricate than in the original Olmsted and Vaux plan of 1871. The Fine Arts Building also remained in place, dominating the northern end of the park in its new role as the Field Museum.

Mount Royal & Belle Isle

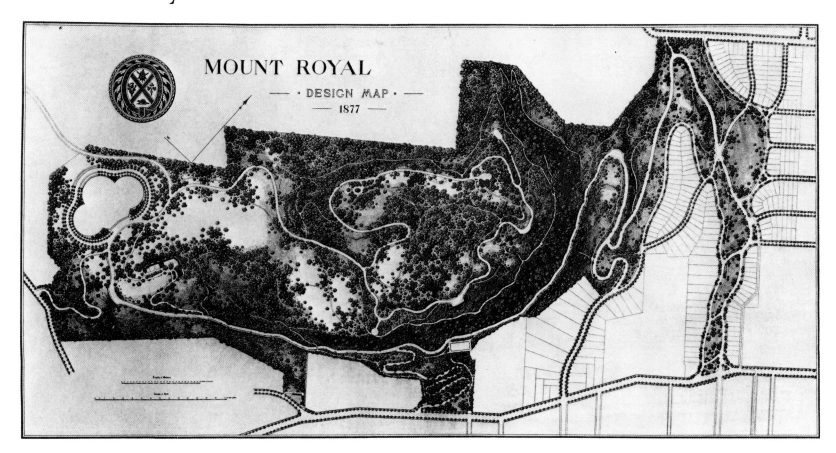

THE FIRST TWO PARKS that Olmsted designed after the end of his partnership with Calvert Vaux were on difficult sites that tested his ingenuity in identifying the "genius of the place" and "working it up." One was Mount Royal, the backdrop of the city of Montreal. Its terrain was steep and rocky, the site exposed, and the climate severe. The other, Belle Isle, was on a low-lying island in the Detroit River.

At Mount Royal, where Olmsted began to work in the fall of 1874, his solution was to emphasize the "mountain character of the site," enhancing the natural scenic quality of each part of the mountain in order to achieve a range of landscape types. In the process he proposed to exaggerate the size of the mountain, making it more mountainlike through his choice of vegetation. At the bottom of the carriage drive that ran up the mountain, in an area he called the *Côte Placide*, Olmsted recommended planting shade trees to produce a landscape resembling that of valleys further south. Here the drive would run through residential neighborhoods he designed, and the real estate sales would help defray the cost of

developing the rest of the mountain as a public park. For the section above, the Piedmont, which had somewhat rougher terrain, he proposed to plant deciduous trees native to lower elevations that would form "soft and harmonious outlines together." In contrast, the very top of the mountain, the Upperfell, would be made to appear even more wild and forbidding through the use of scrubby pines, firs, "lesser birches, hornbeams, and thorns." In between there would be several other vegetational zones that, Olmsted declared, would make the mountain "more mountain-like, gaining withal, a natural and appropriate element of variety."

After leaving the Piedmont the visitor traveling up the mountain on the carriage road would pass through the Crags section, with rocky cliffs on the right and a precipice on the left. Olmsted wished to keep the rock outcroppings visible rather than hidden by dense tree growth. This would secure some "grandness and sublimity of effect." In the Crags section he planned extensive use of sumacs, which would add a cheerful element of color to the gray rocks, supplemented by yews for their dark, mysterious

88

character. Further up the mountain the cliffside of the Crags gives way to a steep, broken ground that Olmsted called the Brakenfell. He proposed to treat the area as a series of ferny openings among groves of maples, pines, and birches.

Between this area and the exposed Upperfell was the sole section where Olmsted felt that he could secure a passage of pastoral scenery in the form of a series of glades with something of the character of mountain meadows. In the flattest section near the northwest corner of the park he envisioned a lake of four or five acres in the midst of "a piece of truly park-like ground, broad, simple, quiet and of a rich sylvan and pastoral character, forming a harmonious, natural foreground to the view over the western valley and all in striking contrast to the ruggedness of the mountain proper." To his dismay the city decided instead to construct a twenty-acre reservoir there. The scale of the reservoir would have destroyed the character he had envisioned for the site, and he had no faith that engineering considerations would in the end permit a natural-appearing body of water. Accordingly, he planned a severely geometrical form for the reservoir. Around it he designed a grand promenade with separate passage for pedestrians, equestrians, and carriages.

He had originally intended to have a quarter-mile-long promenade near the top of the mountain; by moving this feature to the reservoir area he was able to provide for freer pedestrian use of the Upperfell. He then proposed that the fifty acres of the upper section be kept open for public use at all times. The rocky surface would permit sitting, picnicking, and play with little destruction of vegetation. He also had the architect Thomas Wisedell draw up plans for a shelter and refectory at the top of the mountain. Set in a saddle of rock and with an exterior of unpainted, "axe-finished" timber and shingle, the building would be inconspicuous. Still, it was to have a crown-shaped vista tower sheathed in metal, which indeed looked like the "crown of the mountain" from the surrounding countryside. The tower would be just high enough to allow a complete panoramic view.

While Olmsted sought to emphasize the rockiness and exposed character of the Upperfell, he intended in lower areas to have plantings of wide variety and delicacy. He sternly warned against introducing flower beds or "floral embroidery" into the park, since they would clash with the natural beauty of the place. Nonetheless, there was a place for the "refinement of grace, delicacy, color, and incense" of flowering plants. If one gardener

were employed to tend the plantings, there were hundreds of places on the mountain, he said, where "if you can but persuade yourselves to regard them as sacred places and save them from sacrilegious hands and feet, the original Gardener of Eden will delight you eyes with little pictures within greater pictures of indescribable loveliness." The Underfell and Brackenfell could be dotted with such plantings. The fragility of vegetation would, however, require restrictions on the use of these areas. This would cause some inconvenience to users and place additional burden on the staff, he admitted, sardonically adding, "So does any soundly economical management of any of your business. So does every advantage which civilized men possess over barbarians."

Having planned a series of different landscape zones along the four-mile carriage drive, Olmsted wished visitors to move successively through the passages of scenery he proposed to create. "There are those who would have thought it a triumph of art to whisk people up to the highest eminence of the mountain, give them a big mouthful of landscape beauty, and slide them back to town in the shortest possible way," he observed, but this was a cruel misconception. To find the best way to experience the mountain, he declared:

. . . let any man ask himself whether the value of such views as the grandest the mountain offers, is greater when they are made distinct spectacles or when they are enjoyed as successive incidents of a sustained landscape poem, to each of which the mind is gradually and sweetly led up, and from which it is gradually and sweetly led away, so that they become a part of a consistent experience. . . .

That experience should involve as little exertion as possible, so that full immersion in the scenery could occur. Olmsted designed the drives and walks, even on a mountain, with this goal in mind. For those in carriages the easy grades and gradual curves of the carriage drive would promote this experience. For those on foot and in wheelchairs he designed a four-mile circuit path running up the mountain and down again with easy grades and no stairs. As he explained, "thoughtful attention to the feebler sort of folk" led to design decisions that made the park more pleasant for all users. The resulting improvements in design represented "that refinement of judgment which is the larger part of the difference between good and poor art."

While the Mount Royal plan is a remarkable example of Olmsted's fertile imagination at work, he was not to see his concepts realized. The city of Montreal suffered hard times in the wake of the Panic of 1873. The park commissioners were so anxious to put people to work that they built the carriage drive up the mountain in midwinter without consulting Olmsted's detailed construction plans. No further funds for construction were available for several years. Wisedell's crown-shaped tower was not built, nor was the reservoir. In the twentieth century a formal pavilion was constructed near the site of one of Olmsted's proposed overlooks in the Upperfell area, and in the late 1930s the present-day Lac au Castors was built in the area of Olmsted's reservoir. Olmsted's suggested plantings were never done, nor was his path system constructed. Today, however, with automobile traffic banned from the carriage drive (now called chemin Olmsted), a tour of the mountain by wheelchair similar to that envisioned by Olmsted has become possible.

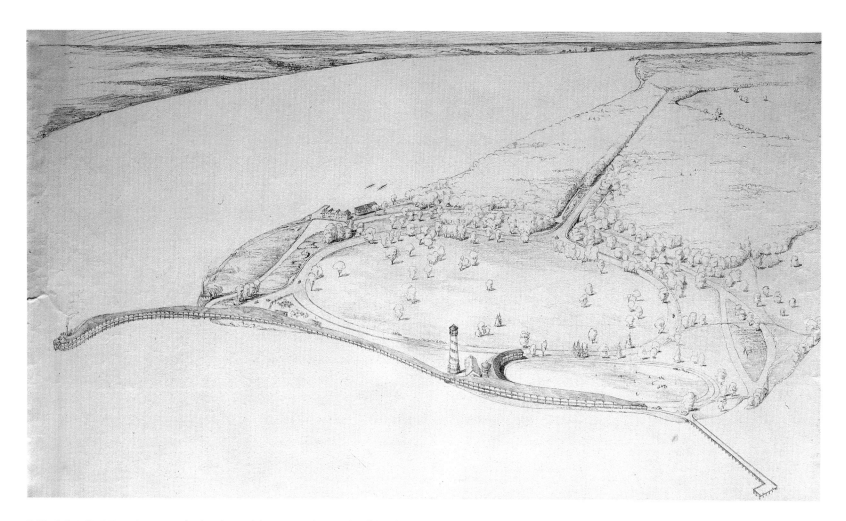

DETROIT'S BELLE ISLE, which Olmsted began to plan in the fall of 1881, offered a very different set of conditions from Mount Royal. The two-mile-long island lay in the Detroit River, two miles from the center of the city. It was flat, rising little above water level, and the soil was saturated. Moreover, the city's aldermen feared that the designer of Central Park would propose a comparably expensive scheme for Belle Isle. In response his plan stressed simplicity and economy. "You must have a few simple, distinct objects in view," he advised the people of Detroit, "and must provide for these in a liberal, strong, quiet, and thoroughly satisfying way."

His solution was to emphasize the existing landscape conditions of the site. He based his design on the large area of existing woods—covering, he claimed, an area larger than the wooded sections he had planted in Central Park. With proper clearing of underbrush and thinning of stunted and decrepit trees, he predicted, Belle Isle in ten years could have "elements of sylvan scenery of a far nobler type and character" than New York had managed in Central Park in the same space of time at a cost of a million dollars. "A motive of nobler ambition cannot be found," he declared as he warmed to the subject, "than that of a forest, the elements of which shall be so ordered, that, through the silent persuasion of nature, it shall for centuries be growing, year after year, richer in sylvan picturesqueness and sylvan stateliness."

At the same time he used the condition of the Belle Isle forest to warn against the flower gardening that he feared might soon intrude into the park. The woods were so dense that few trees could ever attain graceful shape and proportion; instead, most would keep the mark of their stunted early growth. This meant that the scenery of Belle Isle would always be incompatible with "lawn like luxury, dressiness and fine accomplishments." As he so often did, Olmsted emphasized the "genius of the place" as the basis of his design and used it to guard against the introduction of gardening effects that would clash with it.

The other natural condition with which he had to deal was the swampy character of much of the island. In order to make the site usable for a park and to guard against the danger of malaria, he proposed a canal system that ran the length of the island. Across the center of the island, on his plan, two sinuous canals ran on either side of a straight drive. At the east end the two canals encircled the largest area of woods. The outlets of the canals were to have locks and windmill-powered pumps so that when needed they could be pumped dry. The saturated soil would then drain into the emptied canals.

In addition to the woods the park would have an eighty-acre area of greensward that would serve as both a parade ground and a country green. The center of the island and the east woods would be treated with the utmost simplicity, and a flock of sheep would provide most of the required maintenance. On the west side of the island, nearest the city, Olmsted proposed to create a City Fair where concession stands and active sports would be concentrated. A loop canal would separate this

high-maintenance area from the rest of the park. The most remarkable feature of this section was the sixteen-hundred-foot gallery that Olmsted designed for the western shore of the island. It was a great shingle-style structure that encompassed within its flowing form a shelter from storms, an arcade from which parents could watch their children swimming and playing on the beach, a sports stadium, and two multilevel ferry docks. The design must have benefited from the advice of Henry Hobson Richardson: the two had recently become near neighbors in Brookline, Massachusetts, when in 1883 Olmsted drew up the plan in his new office. But the basic elements were expressions of Olmsted's distinctive design approach: a graceful flow of line, an integration of form and function, and an avoidance of architectural decoration.

However, opposition to the structure soon developed. One group of opponents jeered that Olmsted had placed his ferry dock in shallow water and that any ferry attempting to reach it would run aground. The fact that he had used the most recent surveys of the Detroit River in order to place the dock in deep water made no impression. In response he provided a clear demonstration of the viability of his plan. On a windy day in May 1884 he set out on the largest steamer of the ferry line with a pilot unfamiliar with the shore, directed the ship to a buoy that he had placed at the end point of the pier, and, with a handmade lead-line contrived of spun yarn and scrap iron, found twice the needed depth of water.

Other opposition was more difficult to counter, as mounting newspaper articles derided his expensive "shed" as a "colossal folly." Despite his pleas that park visitors would need a large shelter near the ferry docks during the summer thunderstorm season, only a six-hundred-foot dock was constructed from his plans. The concentration of buildings at the west end of the island was not adopted: instead structures were scattered throughout the park. Nor was Olmsted's drainage-canal system implemented. The straight allée across the island was built, but with no accompanying canals, and the low-lying areas on the edge of the island were made into lakes. The sole remaining element of his proposed water system is the loop canal at the western end, where canoeists still make the circuit that he designed.

Buffalo Park System

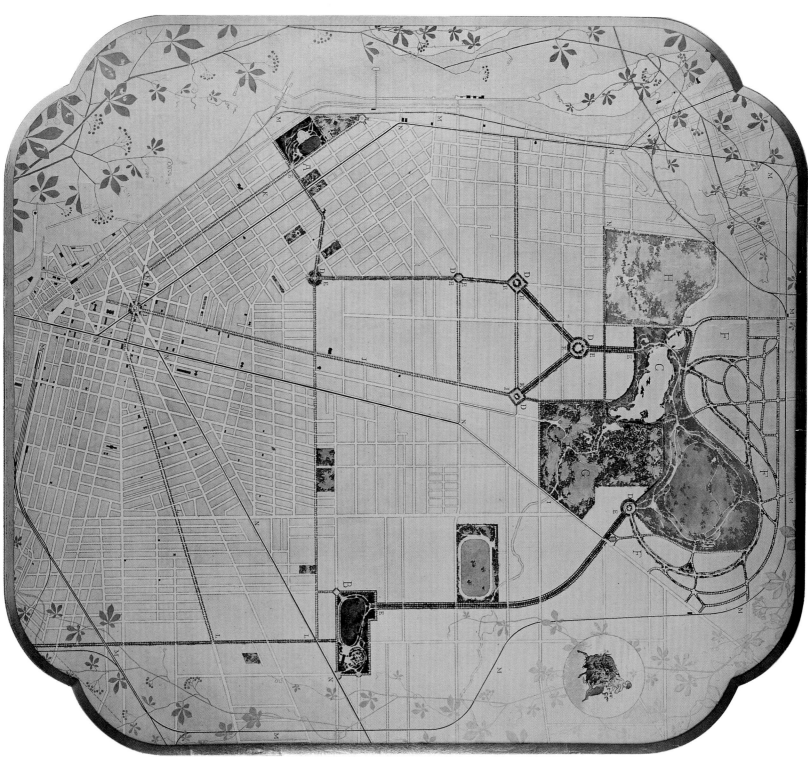

IN THE FALL OF 1868 Olmsted and Vaux began work in Buffalo on their first integrated system of parks and parkways. During his first visit a group of leading citizens guided Olmsted on a hurried examination of the three sites under consideration. One was on the shore of Lake Erie where it begins to narrow to form the Niagara River; another was on a height of land overlooking the city and the lake: while the third was the valley of Scajaquada Creek three miles north of the city center. Olmsted promptly recommended acquisition of all three sites. For the single large park in the system, the 350-acre Delaware Park, he proposed to make a lake by damming the creek. Then, on adjoining farmland, he planned a large "meadow park" with 120 acres of greensward in the center.

Each of the three elements of the Buffalo park system was to serve a particular recreational function for the whole city. The Parade on the high inland site and the Front on the lake provided for activities that were incompatible with the quiet enjoyment of scenery. The Parade had space for military maneuvers and civic gatherings. The designers also developed a children's playground with many facilities, including gymnastic equipment and a carousel. The elegant Parade House, two stories high and three hundred feet long, with open galleries extending at right angles from each end, contained a restaurant and a large dance hall. The Front provided a striking view—"a river effect such as can be seen, I believe, nowhere else," as Olmsted described it, "a certain quivering of the surface and a rare tone of color, the result of the crowding upward of the lake waters as they enter the deep portal of the Niagara." The viewing terrace also served as a carriage concourse and for ceremonial gatherings. An adjoining playground area was intended for games and picnics. Visitors in both spaces could listen to concerts played on the bandstand between the two sections.

With so many activities provided for in the Parade and Front, Olmsted and Vaux were free to devote Delaware Park to the enjoyment of landscape. Accordingly, their plan was unusually simple. The only structure of any size was the boathouse that Vaux designed on the shore of the lake.

The final element of the Buffalo system consisted of parkways extending out from opposite ends of Delaware Park. Most impressive was Humboldt Parkway, which ran to the Parade (now Martin Luther King, Jr., Park) two miles away. With eight parallel rows of trees and a width of two hundred feet, it exceeded most of the famous boulevards of Paris in both respects. The three-spoked parkway system at the western end of Delaware Park created an adjacent neighborhood, while specially landscaped city streets continued on to the Front and the city center. In this way Olmsted extended through the city the amenity of parklike open space that he had proposed in his first report:

Thus, at no great distance from any point of the town, a pleasure ground will have been provided for, suitable for a short stroll, for a playground for children and an airing ground for invalids, and a route of access to the large common park of the whole city, of such a character that most of the steps on the way to it would be taken in the midst of a scene of sylvan beauty, and with the sounds and sights of the ordinary town business . . . removed to some distance and placed in obscurity. The way itself would thus be more park-like than town-like.

The park and parkway system planned by Olmsted and Vaux was grafted onto the original Buffalo city plan drawn up by Joseph Ellicott in 1804. Olmsted admired that plan, with its system of major streets radiating from the city center. It was a welcome relief from the usual gridiron pattern of American cities. The combination of these two city planning efforts made Buffalo, in his view, "the best planned city, as to its streets, public places and grounds, in the United States if not in the world." He proudly displayed a plan of the city at the Centennial Exhibition in Philadelphia in 1876 and won an honorable mention at the Paris Exhibition of 1878.

Olmsted's second period of park designing for Buffalo began in 1887. He especially welcomed the new opportunity, since the park commissioners were planning to build a park on the lake four miles south of the city center. He had wished to create a lakeshore park in the 1860s, but the almost universal response from Buffalonians was that they hated the lake with its exposed shore and chill winds. Now he proposed a park that would have much of the landscape character that he and Vaux had earlier envisioned for Jackson Park in Chicago. There would be bathing on the shore of Lake Erie and a large interior lake with islands for picnicking and a four-mile circuit for small boats. In order to provide a foil for Delaware Park and to protect the peacefulness of its meadow and lake, he included a space for "parades, exhibitions, balloon ascensions, and public ceremonies." Adjoining it he planned an athletic ground with running and cycling tracks and an outdoor gymnasium. In this way he proposed to meet the needs of those who wanted recreation grounds "by which gayety, liveliness, and a slight spirit of adventure are stimulated." Presumably with the same purpose in mind, he suggested that a narrow strip of the park on the far side of a railroad embankment could be used as a firing range for the local militia during most of the year and by the general public for skating in winter. Finally, he proposed to connect the park with the city by dredging a canal along the lakeshore and building an embankment on its west side. This would create a promenade and route to the park for pedestrians, carriages, and public horsecars, while the canal would permit sheltered travel to the park by private boats and commercial launches.

Much to Olmsted's disappointment, the park commissioners declined to

carry out his plan. Instead, they acquired two sites on the south side, which he considered too large for local playgrounds and "too narrow and broken up" for parks. In the smaller of these, Cazenovia Park, he dammed the creek running through it and created a small and simple version of the boating park that he had planned for the lakeshore. The dam was removable so that the water level could be lowered during the winter for skating. The commissioners' desire to have the 155-acre South Park serve as an arboretum provided the central design theme for that space. Today the small lake that Olmsted included in the plan, with its densely wooded islands and naturalistic shore, is one of the least disturbed of the water features in the parks that he designed.

The Boston Park System

FENS AND RIVERWAY

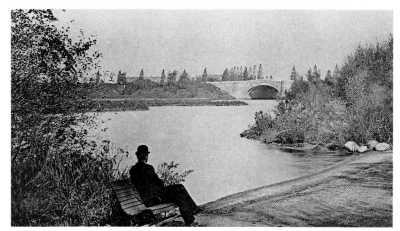

Back Bay Fens, 1892.

JUST AS CENTRAL PARK was the public work with which Olmsted was closely associated during the first twenty years of his career in landscape architecture, the Boston park system was the project to which he and his firm devoted continuous attention over his last twenty years of practice. During this period his most important associate in the firm was his adopted stepson John Charles Olmsted. John provided important assistance on numerous projects after joining the firm in 1875. In 1884 he became a partner, and the firm's name changed from Frederick Law Olmsted and Company to F.L. and J.C. Olmsted. He carried heavy responsibility for the firm's park planning during the remaining eleven years of Olmsted's career, and from 1895 until his death in 1920, he was the senior partner of the firm.

The city of Boston established a park commission in 1875, and from the beginning it sought Olmsted's advice. For the first few years, however, his relationship to the commission was anomalous. As the commissioners worked to select sites for a park system in 1876, he complained that they simply asked him to comment on places that they had already selected. "I have given you no complete service as yet," he wrote as they completed the process of selection, "In fact I have not felt sure that you regarded my visits thus far as 'business.'"

The first project the commissioners were authorized to undertake was a park in the Back Bay area. Without consulting Olmsted, who was in Europe at the time, they held a design competition. When he returned, the commissioners appealed to him to help judge the entries. He declined to do so, and they awarded the prize to an amateurish design whose author felt no stake in executing. They then abandoned the competition plan and turned to Olmsted, at last, as their professional advisor.

Olmsted had not been comfortable with the idea of creating a highly finished and decorative park on the mud flats and marsh of the proposed Back Bay site. He saw the problem as one of sanitary engineering and consistently refused to employ the term "park" in connection with the project. He called the area the Back Bay Fens and referred to the later design for the stream that flowed into the Fens as the "Muddy River Sanitary Improvement." From the beginning he worked closely with the city engineer of Boston to find a viable solution. Much of the site was a noxious, sewage-soiled mud flat when the tide was out on the lower Charles River. It was possible to keep water permanently in the area by creating a basin with a tidal gate, but the two major streams that fed into the Fens would cause devastation to the basin if they flooded. An affordable solution was for the streams to bypass the Fens through conduits that could carry the ordinary rate of flow and to plan the fens to handle the overflow during freshets. The simplest plan would have been to surround the basin with a stone wall, but Olmsted strove instead to find a more attractive design.

In order to create a soft, vegetated edge around the basin, he had to solve two problems: how to provide adequate space to hold the flood waters and still have room left for natural growth, and how to protect a natural shoreline from erosion by surf during storms. His solution was to make gradually shelving banks and to construct wide islands only slightly above the usual water level. These would be planted with high-growing cattails, sedge, and other marsh vegetation. In flood conditions a full fifty acres would be covered by water, but the plantings would slow the development of surf. The water in the basin would be extremely high only at high tide on the river, after which a gate would allow the water level to fall as the ebb tide drained the river. Since storm water in the basin would be mostly fresh rainwater, Olmsted felt that a wide variety of hardy shrubs could survive on its edge.

These considerations formed the basis of his opposition to creating a formal park in the Back Bay Fens. The landscape effect of the Fens depended on elements of scenery and vegetation usually associated with "the margins of salt creeks and harsh, weather-beaten headland," which required a truly natural appearance and not "the affectation of rusticity, sometimes playfully introduced in close association with polished and elegant conditions." There must be no nicely kept turf, he insisted, and no flower gardening. This viewpoint was consistent with his longstanding demand that a given design have a single "leading motive." It also enabled him to make a virtue of necessity and to exclude the kind of floral display that Bostonians had come to love in the Boston Public Garden. His plan for the Back Bay Fens was the first of many attempts on his part to wean the citizens of his new home from their attachment to the decorative use of plant materials.

Once his basic concept was assured, Olmsted turned his attention to the recreational potential of the site. From the beginning the city council had demanded that public streets should circle the area, so he designed a system of walks, drives, and bridle paths around it. For the basin itself he turned to elements of the plan that he and Vaux had earlier worked out for Chicago's Jackson Park. The "rushy glades and bushy islands" of the Back Bay Fens were ideal for raising a large variety of waterfowl, he observed, and he studied the possibility of developing a kind of outdoor aquarium as well. Widespread boating and picnicking would interfere with these features, but he wanted some recreational activity. An efficient system of launches that made the three-mile circuit of the basin in half an hour would meet the public's needs without destroying wildlife and its habitat.

The plan that Olmsted devised evoked the scenery of nearby salt marshes, but a great deal of engineering underlay the apparent naturalness. His scheme provided ingenious solutions to a series of problems involving sanitary engineering, traffic engineering, recreational facilities, and institutions for scientific education.

The sequel to Olmsted's Back Bay plan was the next link in Boston's Emerald Necklace, the Muddy River valley between Back Bay and Jamaica Pond. This project gave Olmsted his first opportunity to preserve streamways in the midst of built-up areas, as he and Vaux had proposed many times during their partnership. The park system proposed by the Boston park commissioners had not included the Muddy River valley, but Olmsted made an eloquent appeal for it.

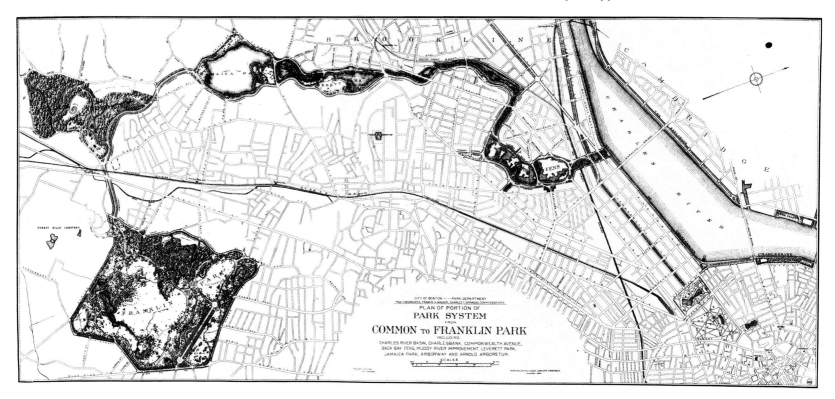

He warned that the usual solution to the problem of such a river—burying it in an expensive underground conduit—would be long in coming. In the meantime the valley would become increasingly obnoxious, retarding residential development. In his first report in 1881 he proposed to narrow the river valley in some places, make the river follow a more graceful and sinuous course, and create "a chain of picturesque fresh-water ponds" in the upper valley. On the Boston side of the valley he planned a ninety-foot-wide public way that continued the walk, drive, and ride system of his Back Bay design. On the other bank, which lay in the town of Brookline, he allowed more space for planting along the walks and drives and proposed a carriage drive with a more scenic setting. The plan went through numerous revisions, and it was the early 1890s before the concept for the entire distance from the Fens to Jamaica Pond had fully evolved.

Olmsted was dubious, saying that "a park and an arboretum seem to me to be so far unlike in purpose that I do not feel sure that I could combine them satisfactorily." Despite the difficulty of achieving broad effects of scenery while arranging plantings for scientific study, he agreed to make the attempt. It was three years before anything came of the proposal, and by that time Olmsted had begun to help the Boston park commissioners plan their system. With its good soil, beautiful stands of hemlocks, and fine vistas, the arboretum now appealed to him as a supplement to Franklin Park. But the land and funds available to it were severely limited. Olmsted's solution was for the university to transfer its 120 acres to the city of Boston; in return the city would lease that land plus 40 adjoining acres to the university for a thousand years at a nominal fee. The city would build a drive and walk through the grounds and provide police protection and water. In turn the university would open the arboretum

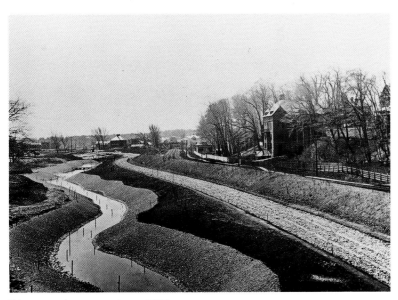

Riverway under construction, c. 1892.

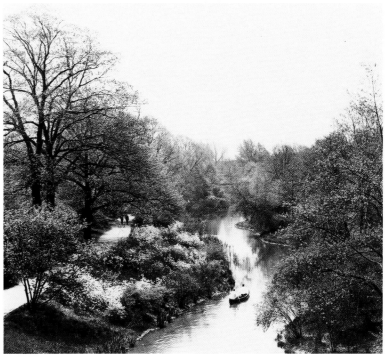

Riverway, c. 1920.

Between Jamaica Pond and Franklin Park Olmsted extended the walk, drive, and ride system by means of the Arborway, a multilaned parkway. The most important public space along the Arborway was the Arnold Arboretum. Its director, Charles S. Sargent, had approached Olmsted when Harvard University established the arboretum in 1874, requesting his help in designing a scientific collection that was parklike in treatment.

to the public. Sargent claimed that at first he and Olmsted were the only people in the Boston area who favored the plan, but it survived several close calls, and in 1882 the arrangement was completed. The two men then proceeded with design and construction, with Sargent selecting the plants and Olmsted producing the desired landscape effect.

The professional collaboration between Olmsted and Sargent was reasonably successful when each had authority in his own sphere, as at the Arnold Arboretum. The case was different, however, with selection of plant materials for the Brookline side of the river. Sargent was a noted gardener, a horticulturist and arboriculturist with a national reputation, and the director of one of the country's leading arboreta; he was also the dominant figure on the Brookline park commission. On his side of the riverway he was determined to use native plants almost exclusively. Olmsted, on the other hand, wished to employ a broader palette, including exotics, to achieve richness of effect and subtle variation of color, texture, and form. He intended to plant both sides of the river in the same way, but Sargent ordered his own plants for the Brookline side. Olmsted left for a European trip before planting began in spring 1892. A few days after his departure, Sargent descended upon the firm's office, commandeered the planting list from John Olmsted, and deleted most of the foreign plants as well as numerous other trees and shrubs that he disliked. In all he excised a third of the trees on the list and a quarter of the shrubs. When John objected, Sargent threatened to terminate the Olmsted firm's connection with the Brookline park commission. While no such dramatic rift took place, Sargent had his way. He ordered the plants he wanted and saw that they were planted. Among them were only two foreign species—Japanese barberry (*Berberis thunbergii*) and the European brier rose (*Rosa eglanteria*).

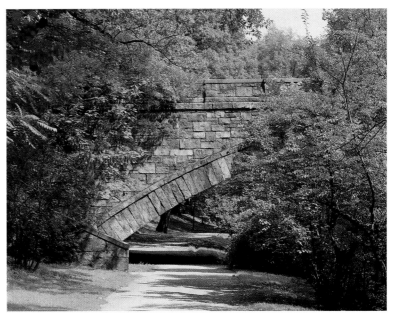

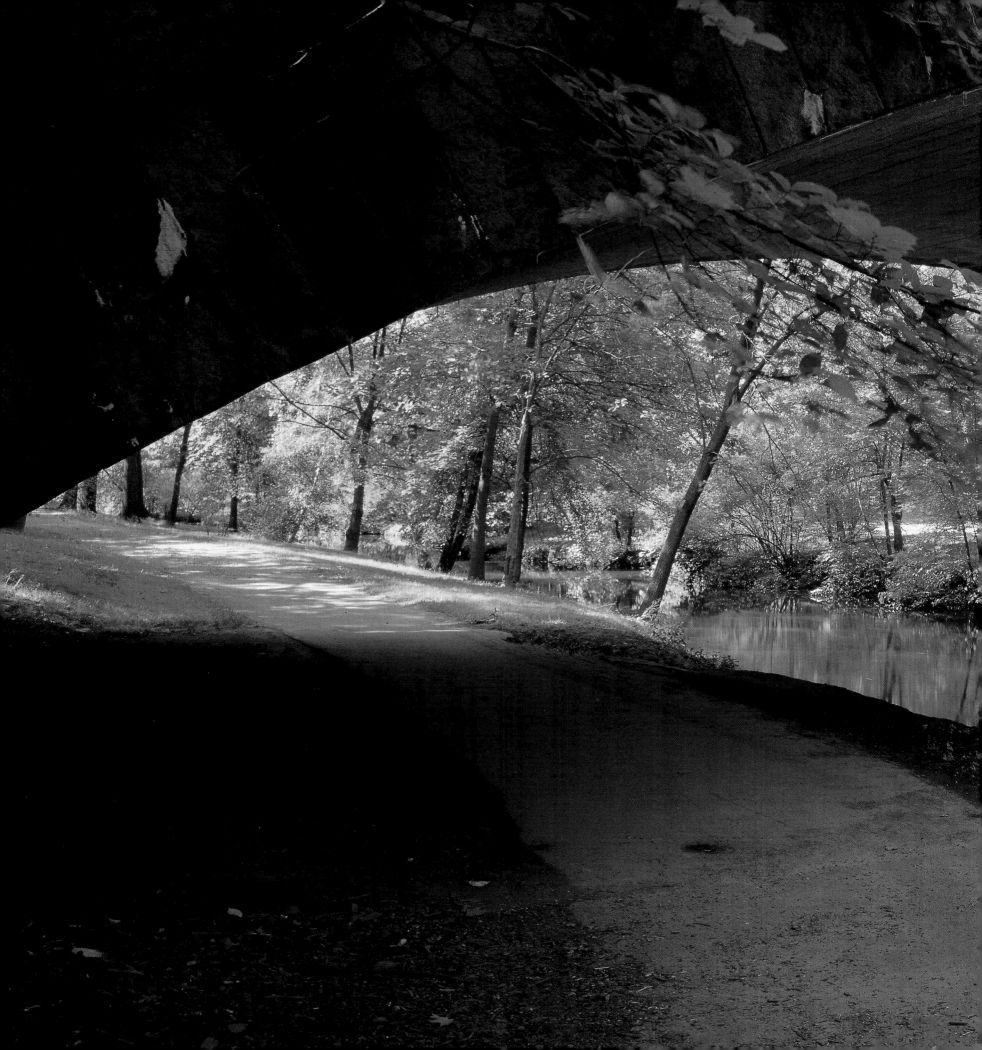

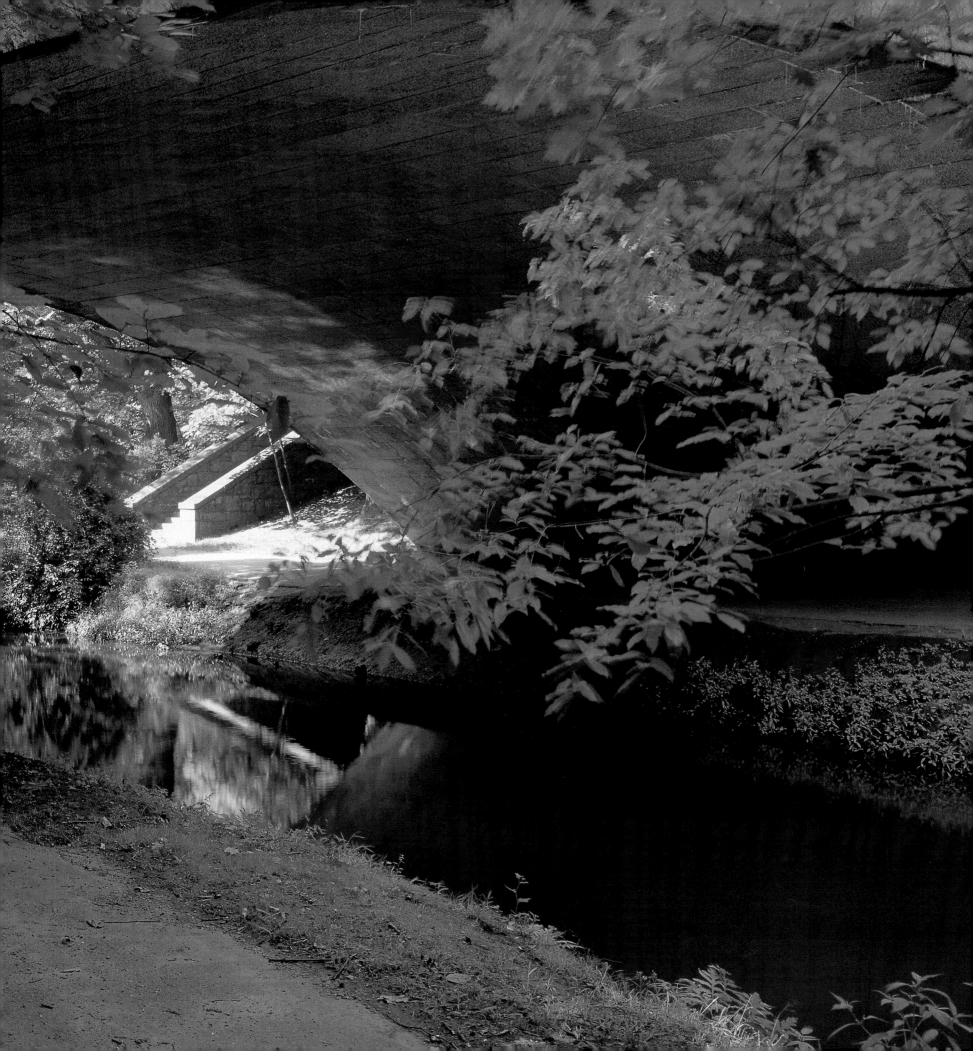

FRANKLIN PARK

The one space in the Boston system that Olmsted was willing to call a park was five-hundred-acre Franklin Park. He described its central feature as "a lovely dale gently winding between low wooded slopes, giving a broad expanse of unbroken turf, lost in the distance under scattered trees." Aware of the concern of Boston taxpayers that the park would be expensive and extravagant, he made simplicity the key element of his design approach. As he had done with the Back Bay Fens, he cited the natural conditions as reason enough for avoiding decoration or elegant treatment. The soil was thin and rocky and could not sustain, except at great expense, either fancy gardening or turf thick enough to withstand athletic sports. This justified devoting the largest portion of the space to what he called the Country Park. Little more than the clearing of rocks and planting of scattered trees would be needed to achieve the simple landscape that he envisioned. His original plan of 1885 contained no water features, thereby saving the expense of creating the pond—Scarboro Pond—and the attendant streams and pools that appear in the later plan.

The most unusual aspect of the rustic simplicity that Olmsted planned for Franklin Park was its structures. He planned small shelters with "the general aspect of the simplest style of English rural cottages," with sturdy walls and overhanging thatched roofs.

Ellicott Arch, 1892.

Likewise, the arch providing access under the carriage drive to the Country Park in the Ellicottdale section was made of large boulders partially masked by shrubs and vines. There was none of the architectural elegance of the arches Calvert Vaux had designed for Central and Prospect Parks. On Schoolmaster Hill Olmsted designed rough stone picnic bays sheltered by simple wooden arbors. Next to these was a fieldstone dairy building for which he sketched a thatched roof with eccentric pitch, curves, and twists ("curve and quiddle, twist, undulation, hog's back, dormers, gable and pent," as he described them). From the shelter and picnic arbor one could look toward Scarboro Hill across the narrow valley that separates Ellicottdale from the main valley of the Country Park and out across the expanse of the larger valley.

View through Ellicott Arch, c. 1892.

Schoolmaster Hill, c. 1900.

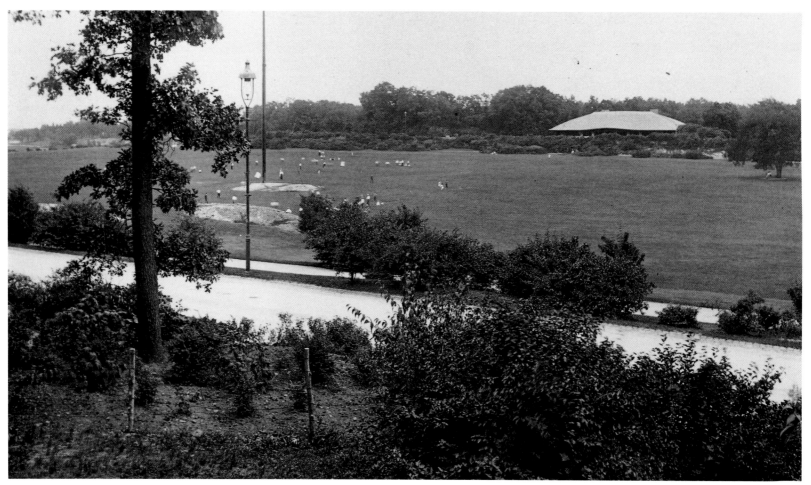

Playstead with Overlook terrace and shelter, c. 1900.

Olmsted extended this rough architectural treatment to the Playstead, an area hidden from the Country Park that was to be lighted and used for athletic events. The Valley Gate dividing the two areas consisted of metal gates separated by small fieldstone lodges with tile roofs. Overlooking the thirty-acre area of playing fields was a terrace measuring 500 by 300 feet that was faced with a wall of boulders. At one end of the terrace was a carriage concourse for spectators; at the other end was the Playstead Overlook Shelter, a remarkable structure for whose design Olmsted was primarily responsible. Measuring 120 by 60 feet, it served as a locker room, shelter, and restaurant. The walls were of fieldstone and shingle—creating a varied texture that, combined with the shadows cast by the overhanging dormers and roof, had the effect of camouflage. Indeed, the surface of the building had the same "considerable complexity of light and shadow near the eye" that characterized Olmsted's plantings in the picturesque style. One result was that the building

appeared less massive than it really was. Above the shelter rose the shingle roof that one observer described as "quiet and gray in tone like a huge rock, and with gentle convex curves." Viewed from the Playstead, the roof appeared much like one of the many rock outcroppings scattered throughout the park.

While simplicity was Olmsted's theme in designing Franklin Park, its simplicity as constructed was greater than he had wished, because the Greeting, the proposed site for numerous activities not compatible with the Country Park section, was never built. In the ten-mile circuit of public spaces from the Charles River to Marine Park on Boston harbor, which Olmsted was designing, the only facilities for children's play or a promenade were at Charlesbank, beyond the Back Bay Fens, and those were intended for the residents of the tenement district in the West End.

Opposite: Playstead Overlook Shelter, 1889.

106

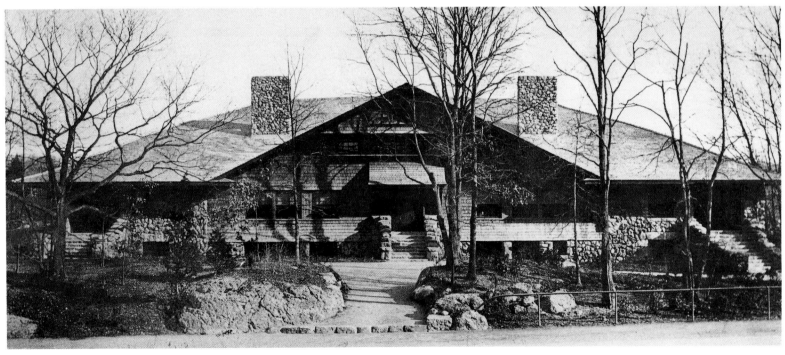

In the section of Franklin Park between the Playstead and the entrance nearest the built-up city, Olmsted undertook to remedy this lack. As it appeared in his plan, the Greeting contained a promenade half a mile long—nearly twice as long as the pedestrian Mall in Central Park—and three hundred feet wide. It had a wide central carriage drive flanked on each side by a walk and a bridle path. A deer park and small athletic field took up the space between the Greeting and the park boundary, while along the other side ranged the Little Folks' Fair and the Music Court. (This area is now the site of the Franklin Park Zoo.)

Franklin Park today, too, is simpler than Olmsted intended. All his structures have long since been destroyed by vandalism, and a promising effort to rescue his Boston park system from decades of neglect, begun a decade ago, has only begun to make an appreciable difference. However great was the bitterness Olmsted felt when his position on the New York parks commission was abolished in 1877, he now would find that there has been a higher level of stewardship of his works in that city than can be claimed by the city to which he then turned with so much hope and promise.

Rochester Park System

DURING THE LATTER PERIOD of his work on the Boston park system, Olmsted had the opportunity to design comprehensive park systems for two mid-size cities—Rochester, New York, and Louisville, Kentucky. They were remarkable because of the size of the spaces that both cities set aside for major parks. The limited ability of these cities to fund ambitious construction programs or expensive architectural features led Olmsted to pursue a policy of frugality and rustic simplicity even more persistently than he had in Boston. The three parks in Rochester totaled more than six hundred acres, and Olmsted warned the commissioners that no other city of its size in the world had ever entered upon so large an undertaking "in the 'park' way."

Highland Park, c. 1900.

In Rochester Olmsted's principal concern was preservation of the scenery along the shores of the Genesee River. Although there was much local support for a park on the rolling farmland just south of present-day Highland Park, he insisted on a pastoral location on the meadows along the Genesee River further west. An open meadow with a carriage drive circling it was the key element of Genesee Valley Park as he designed it. Adjoining the meadow he proposed another simple, pastoral element, a deer park. The meadow has long since become a golf course, but the deer park remains one of the few open spaces in any of his parks that is still available in large part for informal games and picnicking.

The meadow park and deer park sections are now separated by Red Creek, which the later Olmsted firm made into a major water feature early in the present century after a new dam raised the Genesee River by several feet. At the same time a barge canal was built across the park. Between the meadow and the northern end of the park, Olmsted planned a picnic grove with an adjacent play area for children. And, following his principle of separation of conflicting uses, he located boathouses and athletic facilities in an area on the opposite bank of the river.

The scenery of the other riverside section of the system, Seneca Park, is very different from that of Genesee Valley Park. It consists of three miles of the steep-sided gorge of the Genesee River below the falls. In the northern section of the park the cliffs are bold and rugged, while further down the river the scene is quieter, with marshy vegetation extending from less abrupt banks. There is a narrow strip of parkland along the top of the bluffs, which Olmsted used for carriage drives and paths. He planned overlook concourses, formal promenades, and informal driving and walking sections, as well as several flights of stairs leading down the side of the gorge to roofed shelters at the river's edge. Here, as in his other scenic reservations, he solved the problem of providing access to natural scenery without destroying it.

The third park in the Rochester system, Highland Park, encompasses one of a series of high hills on the southern edge of the city. It commands a panoramic view over the city toward Lake Ontario. On the highest point a local citizen donated a viewing pavilion dedicated to the children of the city. It was designed by the firm of Shepley, Rutan and Coolidge, the successors of Olmsted's friend Henry Hobson Richardson, who had died two years before he began his work in Rochester. Much of the park site had been donated by the noted Rochester nursery firm of Ellwanger and Barry. Although the firm wanted to make an arboretum of the park, Olmsted insisted that the collection should consist primarily of shrubs. In this way the superb view would be preserved, while the unusual shrub arboretum would make Rochester a center for nursery business in shrubs and, he assured the donors, "greatly advance the popular practice of the planting art throughout the country."

Olmsted's plans for the three parks were carried out under the watchful eye of Calvin C. Laney, the dedicated superintendent of parks in Rochester. Between 1892 and 1908 the Olmsted firm also prepared designs for several small parks and squares in the city.

Louisville Park System

LOUISVILLE, KENTUCKY, was the site of the last comprehensive park system that Olmsted undertook and his first significant public design project in the South. He played a leading role in conceiving the designs for three principal parks—Shawnee, Iroquois and Cherokee—and planned the configuration and planting scheme for Southern Parkway, which leads to Iroquois Park. The later firm did further parkway planning and designed numerous additional parks, including Chickasaw, Seneca and Algonquin. Beginning in Olmsted's time the firm also designed several small public squares. The firm's involvement in the Louisville park system lasted for thirty years, and during that time John C. Olmsted and others carried out numerous private commissions in the city. Of special note are the residential subdivisions that the firm planned in the vicinity of Cherokee Park.

Olmsted's planning of the park system began in 1891. In his first report he urged that the city define "large and comprehensive controlling purposes or motives of design." Using one of his favorite analogies, he warned that "to plan features and details first . . . would be as foolish a way of going to work as to build the chimney pieces and buy the carpets and wall papers of a dwellinghouse before planning its walls and partitions." As with his earlier park systems he wished each of the three parks to serve a particular function for the whole city. They should not be simply local recreation grounds. The variety of scenery, topography, and size of the three sites made Olmsted's task easy in this respect. Shawnee Park, situated on bluffs overlooking the Ohio River at the west end of town, was well suited for meeting the city's needs for "gregarious" recreation. Olmsted proposed a formal terrace and carriage concourse on the bluff, combined with a music court and bandstand. On either side of the music area were to be sunken flower beds that would add to the atmosphere of festivity. They would not, however, be visible from other parts of the park.

On the inland side of the concourse and overlooked by it was a "great public play-ground" of over twenty acres. It was to be used for large public gatherings, military parades, picnicking, and informal field sports. Near it was a large picnic grove. There would also be access to the river

for walking, picnicking, and swimming. In effect, Shawnee Park with its two hundred acres could serve the purposes planned for both the Front and the Parade in the Buffalo park system, whose combined acreage was less than half that available in Shawnee Park. The major difference was that in Louisville there was to be no expenditure for such architectural features as Vaux's Parade House.

The other two parks in the system were to be devoted exclusively to the enjoyment of scenery. Iroquois Park consisted of a wooded hill south of the city. Of Olmsted's previous commissions the site most closely resembled Mount Royal, but while Iroquois Park had six hundred acres to Mount Royal's four hundred, it was only 250 feet high. Olmsted made detailed proposals for planting the lower reaches of the hill, which were mostly open fields, to provide "grassy glades and groves of fine broad-spreading meadow trees" that would contrast with the "wild and rugged woods of the steep hillside" above. He wished to encourage the growth and increase the variety of native herbaceous plants within the park. Flowering plants, including wild roses, were also scattered on the lower slopes near the circuit drive. Other slopes were to be covered by "Maple-leaved Viburnum, Bitter Sweet, Moon Seed and masses of native herbs." Further up the hill in shaded enclaves Olmsted wished to vary the scenery with plantings of dark green evergreens—rhododendron, laurel, hemlock, and pine. But the key element was to identify the dominant vegetation and landscape character of each section of the park and emphasize them through planting and forest management. This was very different from the ambitious stretching of the mountain's range of landscape that he had proposed for Mount Royal. Iroquois Park was to be primarily a scenic reservation. Its scenery would be accessible by a system of footpaths and by two carriage drives—a lower circuit drive around the base of the hill and a second drive ascending the hill, circling its summit, and descending by another route.

The third park of the system, Cherokee Park, was to be the pastoral landscape of greensward, groves, and water that was Olmsted's park ideal. The terrain consisted of the bowl of hillsides surrounding Bear Grass Creek, which flowed through the park.

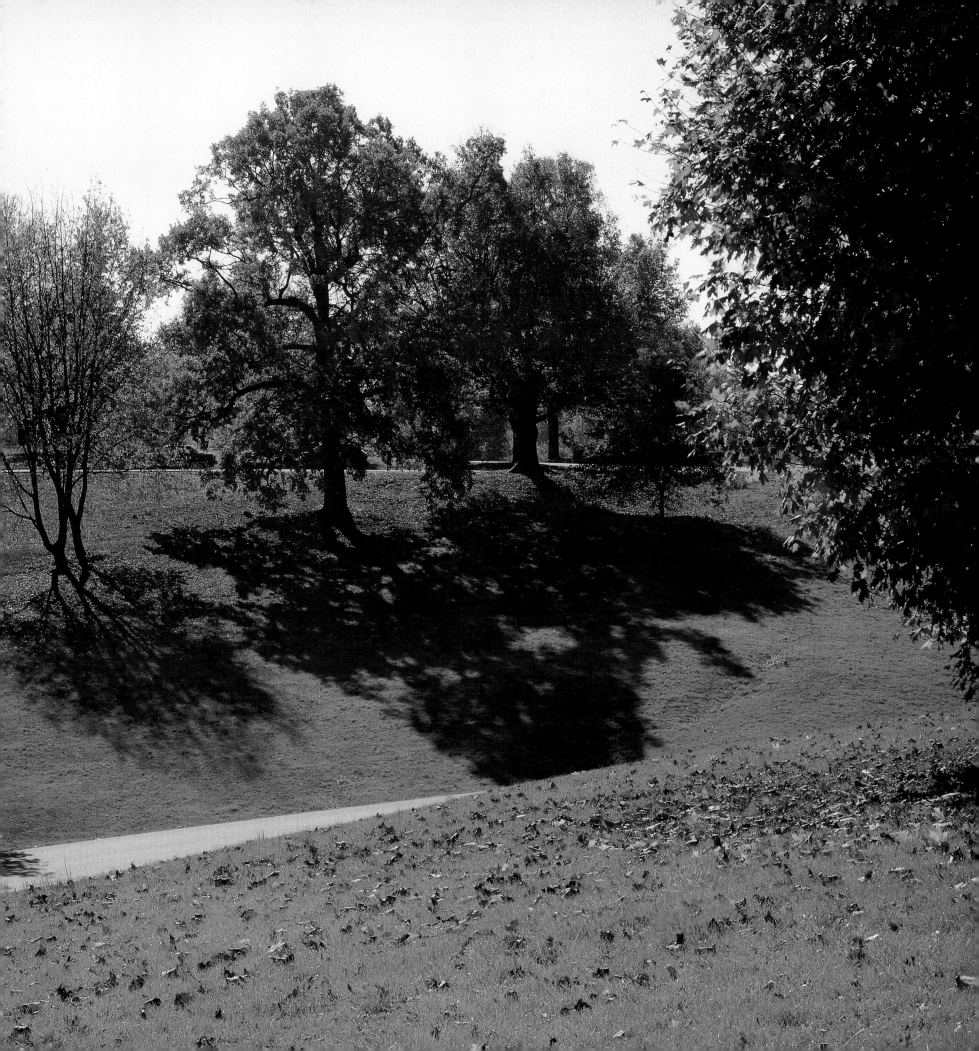

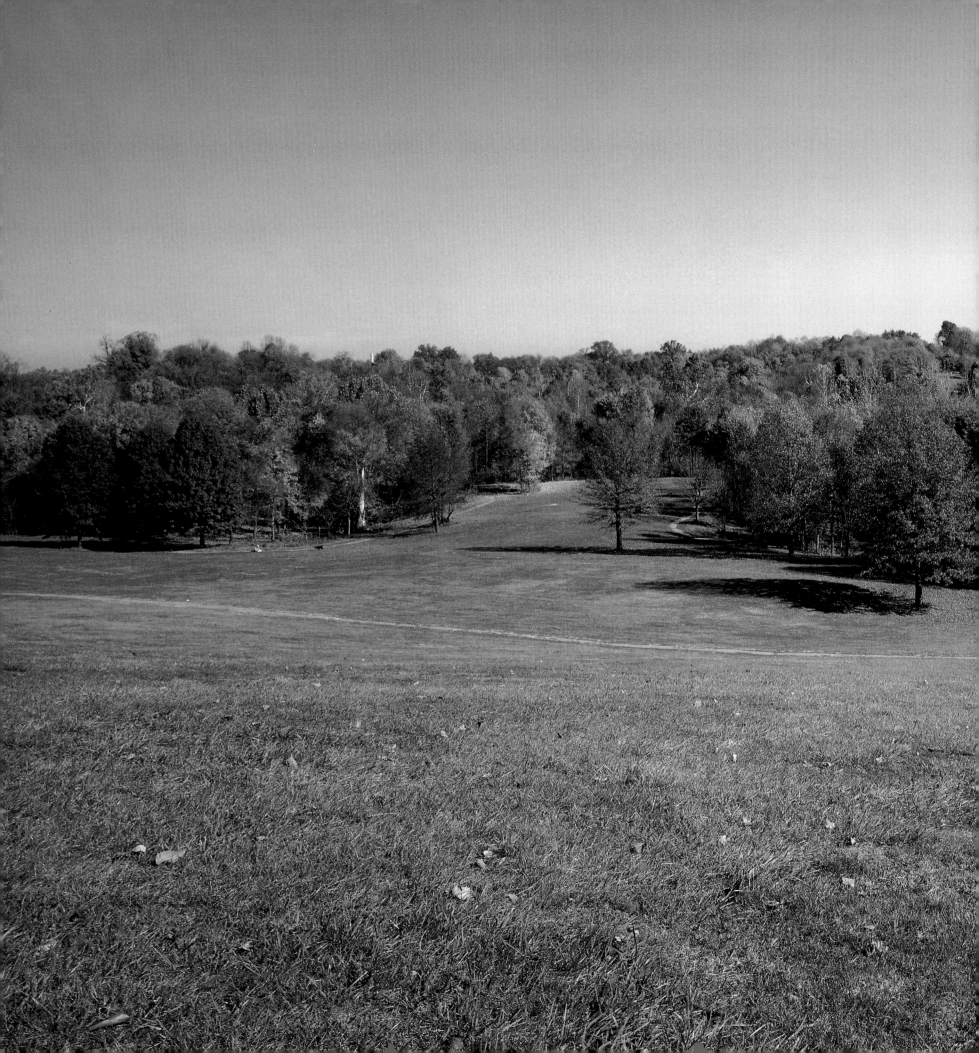

Both of these qualities were crucial for establishing the residential communities that Olmsted wished to see created. Only with such permanence could the necessary elements of domestic life be sustained. The problem was particularly evident to Olmsted during his years in New York City. There he saw the uptown march of commercial centers destroy one prime residential neighborhood after another. He and Vaux had an opportunity in 1860 to plan a residential district in the Fort Washington section overlooking the Hudson River in upper Manhattan. But the city did not act on their proposals, and they had to look elsewhere to provide a demonstration of their ideas.

Olmsted was eager to find new technological inventions that could serve the needs of the suburb and help to achieve the more perfect adaptation of means to ends that justified its existence. In 1870 he predicted that use of the telegraph and the pneumatic tube would greatly reduce the time and energy spent in shopping. "By the use of these two instruments," he said, "a tradesman ten miles away on the other side of town may be communicated with, and goods obtained from him by a housekeeper, as quickly and with as little personal inconvenience as now if he were in the next block." He was also intrigued by experiments in distributing hot air through pipes, providing inexpensive heating of houses from a single source. Communal facilities that lightened the tasks of the individual household appealed to him. Americans still did many tasks "in a desultory way, wasteful of human strength," while many small towns in Europe had public laundries, bakeries, and kitchens, which were lacking in America's best cities. When he visited the Liverpool suburb of Birkenhead in 1850, he was impressed by the public baths and public slaughterhouse.

In planning a suburban village, roads and walks were of the first importance. The streets should be smoothly paved and well drained so that carriages could move easily along them in all seasons. The curvilinear street system that was the hallmark of Olmsted's suburban designs served the practical purpose of discouraging through traffic; it also enhanced the domestic atmosphere of the village by creating an enclosed, intimate space. A complete system of sidewalks was essential as well. Otherwise women who moved out of the city found themselves more restricted than before.

To achieve the desired effect, Olmsted wrote in his first extended statement on the subject, the roads and walks of a neighborhood

must be neither muddy nor dusty, nor rough, nor steep, nor excessively exposed to the heat of the sun or the fierceness of the wind. Just so far as they fail in any of these respects, whatever is beautiful in the neighborhood, whatever is useful—churches, schools, and neighbors included—becomes in a certain degree disagreeable, and a source of discomfort and privation. No matter what a neighborhood may be in all other respects, therefore, if it fails in these it must be condemned as unfit for a civilized residence.

The streets and walks of the village should be part of a public space that demonstrated the existence of true community in the village. Some of the best scenery should also be reserved for public use: stream valleys, groves of trees, or places with fine views. In that way all residents rather than a few individuals would benefit.

Olmsted demonstrated his concept of the suburban residential community most fully in Riverside, Illinois, on sixteen hundred acres along the Des Plaines River west of Chicago. There, in a brief period of two years beginning in the fall of 1868, he and Vaux designed and laid out the most fully developed community of either man's career. Olmsted inspected the site, wrote the principal report, and designed a large section of the plan while Vaux was out of the country at the close of 1868.

Securing an adequate amount of public space for recreation and safeguarding the most scenic areas for use by all residents were special concerns, and the plan for Riverside made ample provision for them. The designers wished to reserve the entire floodplain and banks of the Des Plaines River within the village. They also set aside two large areas of upland as public green space—Scottswood Common and the Long Common.

Their concern for public space extended well beyond Riverside itself. The first improvement that Olmsted called for in his report was the construction of a shaded parkway connecting Riverside with the city of Chicago. The Chicago, Burlington, and Quincy Railroad ran through the village and provided quick access to the city, but Olmsted believed that even businessmen commuting to town would benefit from a more leisurely carriage drive. He was appalled by the condition of the roads to the city, which had deteriorated since the introduction of the railroads. Pleasant and swift access to the city by carriage would be a necessary amenity for those living in the new community.

The proposed parkway would also serve a larger public purpose: it would be the first extended carriage drive for residents of Chicago itself. The city badly needed such a democratic meeting ground, beneficial as it was to "a healthy civic pride, civic virtue and civic prosperity." Use of the parkway as Chicago's promenade would stimulate development of a prosperous residential neighborhood along it and increase the pleasure of visiting the city for residents of Riverside. Despite the ambitious nature of this proposal, several miles of the parkway were constructed over the next few years. It had a central carriage drive flanked by a sidewalk and a bridle path, with roads for carts and wagons on the outside.

The drives within the community of Riverside were equally important and Olmsted planned them with equal care. Provision of first-class roads was one of the major differences between the suburbs that Olmsted designed and those of his contemporaries, many of whom constructed streets with inadequate foundations, grading and drainage. That failing nullified what he viewed as the "greatest value to people seeking to escape the confinement of the town"—access to scenery. He was convinced that "frost-proof, rain-proof wheelways and footways, let them cost what they will, should, in selecting the site of a suburban residence, be the first consideration; in planning a suburb, the first requirement to provide for."

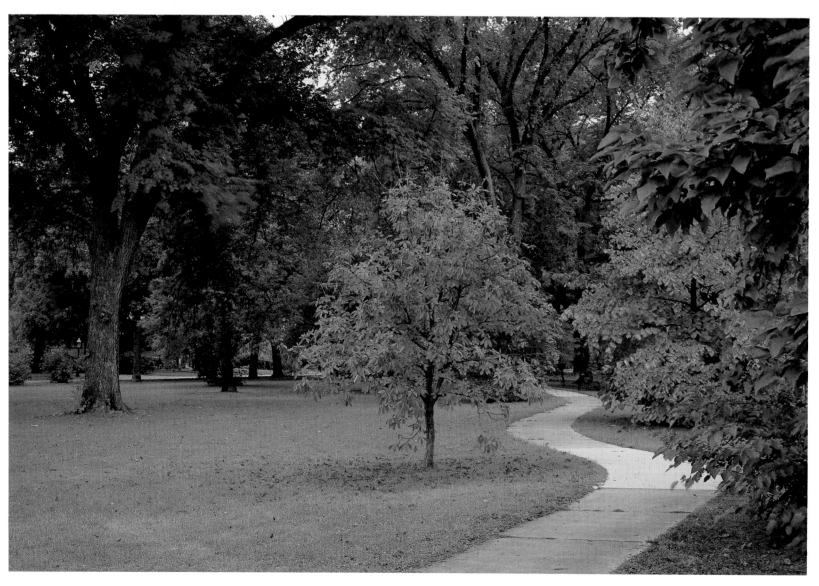

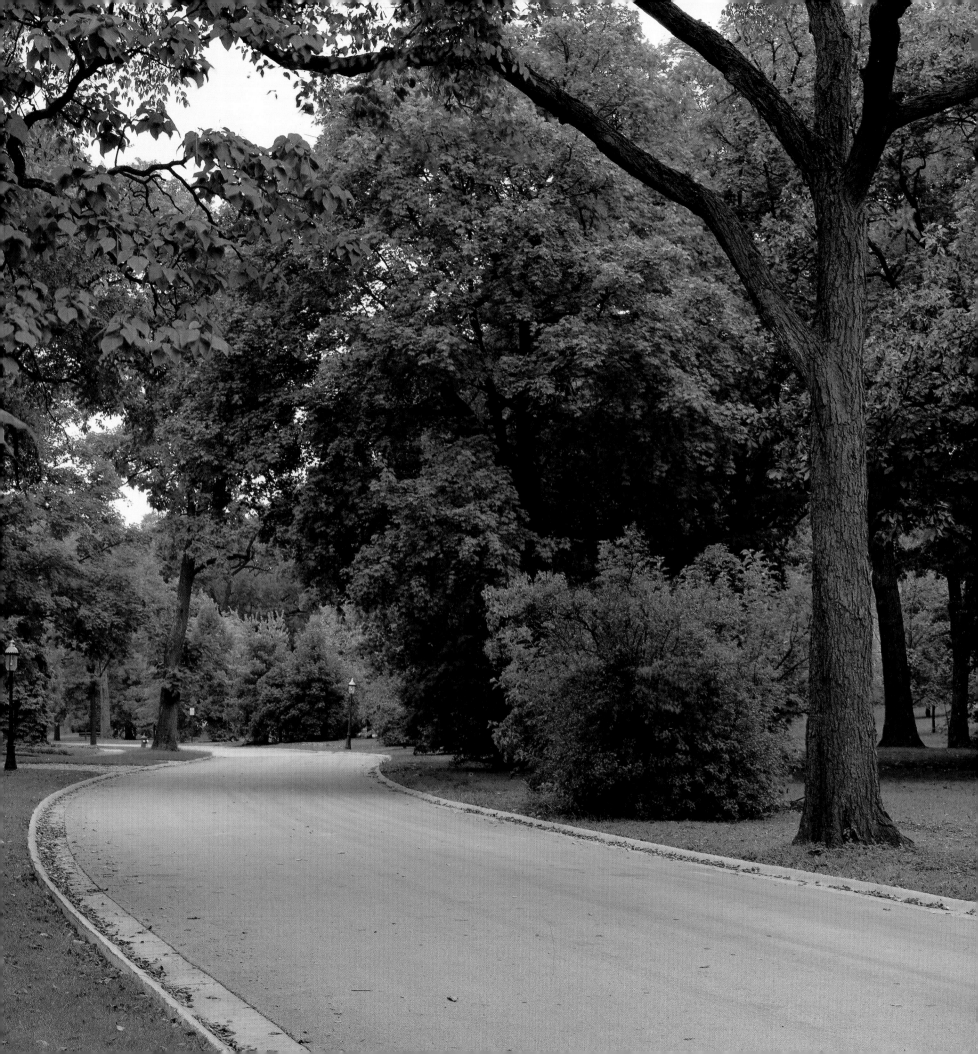

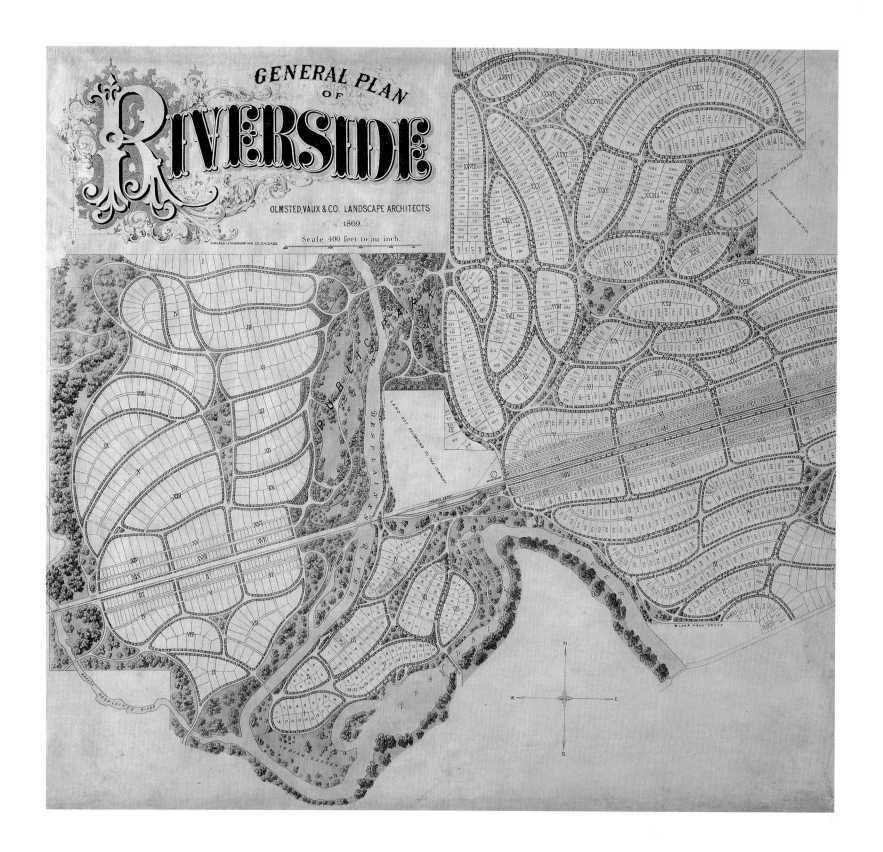

The roads that he and Vaux constructed at Riverside had deep, solid foundations and a surface of fine crushed gravel that was smooth and quiet for pleasure carriages, soft and cool for horses' hooves, and so firmly packed as to be virtually waterproof. Drainage was secured by an elaborate system of paved gutters with frequent gratings and underground silt basins leading to drainpipes. The wide sidewalks were paved, and there was ample space on the road's edge for grass and trees. Such a road and sidewalk system was expensive, but the expense was worthwhile, since in Olmsted's view "a road suitable for pleasure-driving is one of the greatest common luxuries a civilized community can possess."

In achieving the desired quality of community the course of the street system was as important as its construction. The key element in Olmsted's designs was the curvilinear flow of the streets. In some of his subdivisions curving streets followed the contours of the land, reducing the grade. (A good example is the series of residential streets at Point Chautauqua on Lake Chautauqua, New York, where the road was to enter near the lakeshore and then run gradually up a hill to the individual house lots.) The level terrain of the Illinois prairie made this consideration of little importance, but even so the curvilinear streets at Riverside served to create the proper setting. The streets formed an enclosed setting for the village, in contrast to the rectilinear gridiron street system of Chicago: ". . . as the ordinary directness of line in town-streets, with its resultant regularity of plan would suggest eagerness to press forward, without looking to the right hand or the left," Olmsted explained in the report, "we should recommend the general adoption, in the design of your roads, of gracefully-curved lines, generous spaces, and the absence of sharp corners, the idea being to suggest and imply leisure, contemplativeness and happy tranquillity." This psychological basis for Olmsted's decision explains the distinctive street pattern on the plan of Riverside.

The curving streets and the avoidance of right-angle intersections created a number of triangles that added to the public space of the community. Most houses were within six hundred feet of a triangle, and nearly all were within a thousand feet of one. They were to serve as neighborhood play areas, and Olmsted intended to furnish them with "croquet or ball grounds, sheltered seats and drinking fountains, or some other object which would be of general interest or convenience to passers-by."

The streets with their sidewalks and roadside trees, the large public recreation grounds, and the small triangles made up the public landscape that produced the overall structure of the Riverside community. It was the communal setting for the private domesticity of the individual family homes, both fostering and expressing "the harmonious association and cooperation of men in a community, and the intimate relationship and constant intercourse, and interdependence between families." Public recreation areas, drives, and walks made up some seven hundred of the sixteen hundred acres covered by Olmsted and Vaux's plan.

The space between the public roads and the houses was private property with a public function. It was the transition zone between the communal and the domestic. Olmsted required setbacks of thirty feet so that private houses, especially poorly designed ones, would not intrude too closely on the streetscape. To separate the two realms further, he required that each householder plant and maintain two trees between the sidewalk and the house.

There was also a question as to whether the boundaries between house lots should secure private seclusion or show a sense of community. Olmsted felt that the treatment of property lines should express both elements and disapproved of open lawns with no mark of division. He was equally opposed, however, to "high dead-walls, as of a series of private mad houses, as is done in some English suburbs." Instead, he preferred using hedges and fencing in a way that created "private open-air apartments" of the home without too great an expression of unsocial withdrawal.

By these various means Olmsted planned the space along the roads of the village to express the fact, as he said, that its inhabitants "enjoy much in common, and all the more enjoy it because it is in common." This demonstrated "the completeness, and choiceness, and beauty of the means they possess of coming together," to which he attached so much importance. It is pertinent to note that most of the lots on the curvilinear streets were approximately one-half acre with a frontage of one hundred feet. There were also three hundred small lots on tiers of streets running parallel to the railroad, which measured fifty by one hundred feet. Economically, at least, Riverside residents were to have much in common.

Another communal feature was the town center of Riverside, where Vaux's partner Frederick Withers designed a community chapel and a business block for stores and offices near the railroad depot. The town's deep-well water system provided a water tower near the depot, while a municipal gasworks lit the lights that lined the streets. Finally, a comprehensive drainage and storm sewer system helped guarantee the healthfulness of the village.

Olmsted's relations with the developer of Riverside, Emery Childs, deteriorated as time went on. Within a year Olmsted described the business part of the operation as "a regular flyaway speculation."

In October 1869 Childs decided to build his own house in the middle of the Long Common but finally abandoned the project after Olmsted vehemently protested. A year later Olmsted and Vaux terminated their business relations with Childs. Their plan was carried out only in the thousand-acre section east of the Des Plaines River, and in a small area west of the river so that the largest section of parkland was lost to the community. In time a considerable number of the half-acre lots were sold and built upon, but the majority were divided into two lots. While the public space of the community retains much of its intended character, the space allotted for the houses is more restricted than Olmsted had wished.

Olmsted was involved in planning some forty-five additional communities and subdivisions during his career, a dozen of which were summer resorts. An ambitious plan that he and Vaux drew up for a nine-hundred-acre site in Tarrytown Heights, New York, in 1871 reached the stage of road construction, but it did not survive the panic of 1873. The largest of all his projects was the Bronx street and rapid-transit system developed in the 1870s after the borough's annexation to the city of New York. The plans that he and engineer J. J. R. Croes drew up were officially adopted by the city. In some places, particularly the Riverdale section along the Hudson River, Olmsted planned to secure a permanent residential community. In other areas he did little to alter the existing gridiron. When the street system was actually constructed, only scattered areas followed his plans with any degree of accuracy. He also planned several subdivisions north of Delaware Park in Buffalo, but little of that area's layout corresponds to his designs.

The town where Olmsted designed the most subdivisions was Brookline, Massachusetts, where he lived after 1881. Still, of the six subdivisions he planned there, only two were carried out, and in neither of them did the developers provide public recreation space. Olmsted set great store by the prospect of residential planning in the Boston area, however. He bequeathed the enterprise to his son when he retired, calling the comprehensive improvement of the suburbs in that region "by far our most important work."

One interesting example of Olmsted's subdivision planning in the region is World's End in Hingham, now owned by the Trustees of Reservations. His street system for this peninsula was laid out and the adjoining trees were planted, but the lots were never sold. It now provides a study in Olmsted's method of subdividing a site of special scenic beauty.

Another informative study is Sudbrook, Maryland, outside Baltimore, which Olmsted planned in 1889. Its central area retains his proposed street configuration and lot size. As in numerous other instances, however, the eight acres that he reserved as a village green was instead divided into residential lots. Sudbrook was also significant because of the set of restrictions that Olmsted wished to impose in order to achieve the visual quality he desired for the community. To guard against speculative holding of lots, he wanted to require construction of a house worth $3,000 within two years of purchase. He proposed a forty-foot setback from the street

After Olmsted and Vaux parted company with Childs, other problems arose. The Chicago fire in October 1871 destroyed the records of the Riverside Improvement Company and the plans that Olmsted and Vaux had drawn up. A temporary settlement of refugees from the fire created overcrowding and led to an outbreak of malaria that gave the village a reputation for being unhealthy. Childs's legal complications and the panic of 1873 resulted in bankruptcy of the company. As with most of Olmsted's residential communities, it took several decades and several business cycles before full settlement was achieved. The crucial accomplishment was early layout of the system of streets and public grounds so that the integrity of the plan could be preserved as the population grew.

and a ten-foot setback from the sides of the lot. The houses must be "distinctly in a rural and not an urban style," and no trade, manufacture, or business could be carried out. Fences or hedges could not be over four feet high. And purchasers must pledge to connect to communal systems for water, sewerage, gas, and electricity when they became available. These restrictions were to remain in effect for thirty years.

Olmsted's last major community design was Druid Hills in Atlanta. The commission came from Joel Hurt, the entrepreneur who also commissioned John Wellborn Root to design Atlanta's first skyscraper, the Equitable Building. Development of the fourteen-hundred-acre property lapsed for nearly a decade following Olmsted's retirement, but by that time he had planned the curving course of Ponce de Leon Avenue, with six narrow public spaces strung alongside, through the subdivision. On the opposite side of the public spaces from the avenue a more informal carriage drive offered a quieter route through the community as well as access to the residences alongside it.

The six public spaces form a linear park system two miles long. For the second and last time Olmsted was able to plan a generous amount of public recreation area in a community and make it easily accessible to the residents. The pastoral quality of the first five spaces contrasts with the largest and easternmost, the densely forested stream valley of Deepdene. Additional variety was to come from damming two streams to create two ponds, Widewater and Lullwater, whose banks would be reserved as park space. The ponds were never constructed, but the six park spaces were formed when John C. Olmsted resumed work on the project in 1902. The plan of 1906 shows both the public spaces and their relation to the subdivided lots.

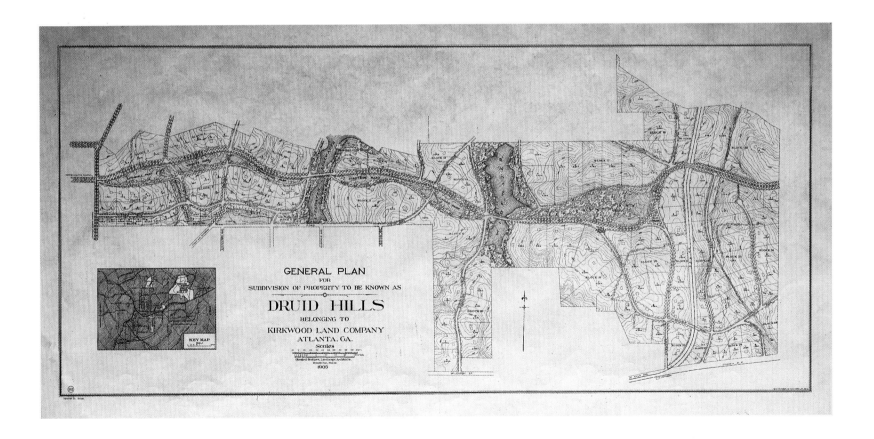

GENERAL PLAN
FOR
SUBDIVISION OF PROPERTY TO BE KNOWN AS

DRUID HILLS

BELONGING TO
KIRKWOOD LAND COMPANY
ATLANTA, GA.

Academic Campuses and Residential Institutions

OLMSTED'S PURPOSE in planning the grounds of residential institutions was closely related to his other work in landscape design. The same themes of domesticity and community played an important role in the plans that he developed for academic institutions. He sought particularly to arrange campuses so that they gave students experience that would be valuable to them as citizens in later life.

He was also acutely aware of the shortcomings of traditional schooling. Having had only a passing exposure to higher education, he set considerable store by the nonacademic knowledge he had acquired while his close friends were attending college. To a schoolmaster friend he once listed fifty-five skills not usually taught in classrooms, which his students and also students in land-grant colleges should acquire. They included care and handling of boats and horses; swimming and lifesaving techniques; survival under difficult conditions; prevention and cure of malaria; and care of houses, turf and trees, simple machinery, and clothing. Students should also develop a habit of walking; any young person who would not prefer to take a walk of ten to twelve miles whatever the weather, rather than stay indoors all day, "must be suffering from disease or a defective education."

The Civil War increased Olmsted's sense of the effect that education had on the way people met the challenges of daily life. The usual curriculum did not seem to prepare people for the actual problems they would encounter or dispose them to apply their intelligence to them. During the summer of 1862 he wrote to Charles Loring Brace in anguish about what he encountered in dealing with officers and soldiers of the Union Army. "Men with great responsibilities are careless about them," he mourned,

"will not take the trouble—apparently cannot—study carefully and thoroughly how they can be best executed, but *Get along somehow & guess it will do. Guess it will do* when the life of the nation & much more may depend on it. I have seen hundreds of lives lost which would have been saved by half as much expenditure of brain-power as would be needed to comprehend the simplest problem of Euclid. What is our educational system worth, if this is the result."

The land-grant colleges established by the Morrill Act of 1862 held great promise for improving this situation. In 1866 Olmsted prepared plans for the colleges of both Maine and Massachusetts and published a version of the latter report entitled *A Few Things to be Thought of before Proceeding to Plan Buildings for the National Agricultural Colleges.* The campuses of the two colleges gave him his best chance to improve life in rural areas. He wished the college campus to introduce students to the best examples of community and domesticity. They would be responsible for the upkeep of their dwellings and the communal space around them, learning skills that they would hopefully apply in later life. He disliked large dormitories, preferring houses accommodating twenty to thirty students. There they would receive training in "the art of making a farmer's home cheerful and attractive." He also called for small classroom buildings that could be adapted to new uses as needs changed and that would contribute to the village *ensemble* of the campus.

In all his academic plans he sought this expression of community. To the founder of Colgate College, for instance, he criticized the original buildings, objecting that they had been placed so far apart that they appeared rather as "a series of independent edifices than as a group

cooperative to a central purpose." Among the institutions for which he did campus planning were American University in Washington, D.C., Amherst College, Bryn Mawr College, Columbia University, Cornell University, Gallaudet University, Groton School, Trinity College in Hartford, Connecticut, and Yale University.

The two most extensive campus planning commissions of Olmsted's career were Lawrenceville School in New Jersey and Stanford University in California. In both cases the funds available were adequate for completion of the campus being planned.

At Lawrenceville the million-dollar endowment of John Cleve Green led to a transformation of the school. The new headmaster, James Cameron Mackenzie, adopted many of the reforms that Thomas Arnold had introduced at Rugby in England, including replacement of the barrackslike old dormitories along the public street with buildings that were more domestic in size and appearance. The architects for the new campus were Peabody and Stearns, with whom Olmsted worked effectively on several projects. The engineer was J. J. R. Croes, his collaborator in planning the streets of the Bronx in the 1870s. Olmsted began his work there in 1883.

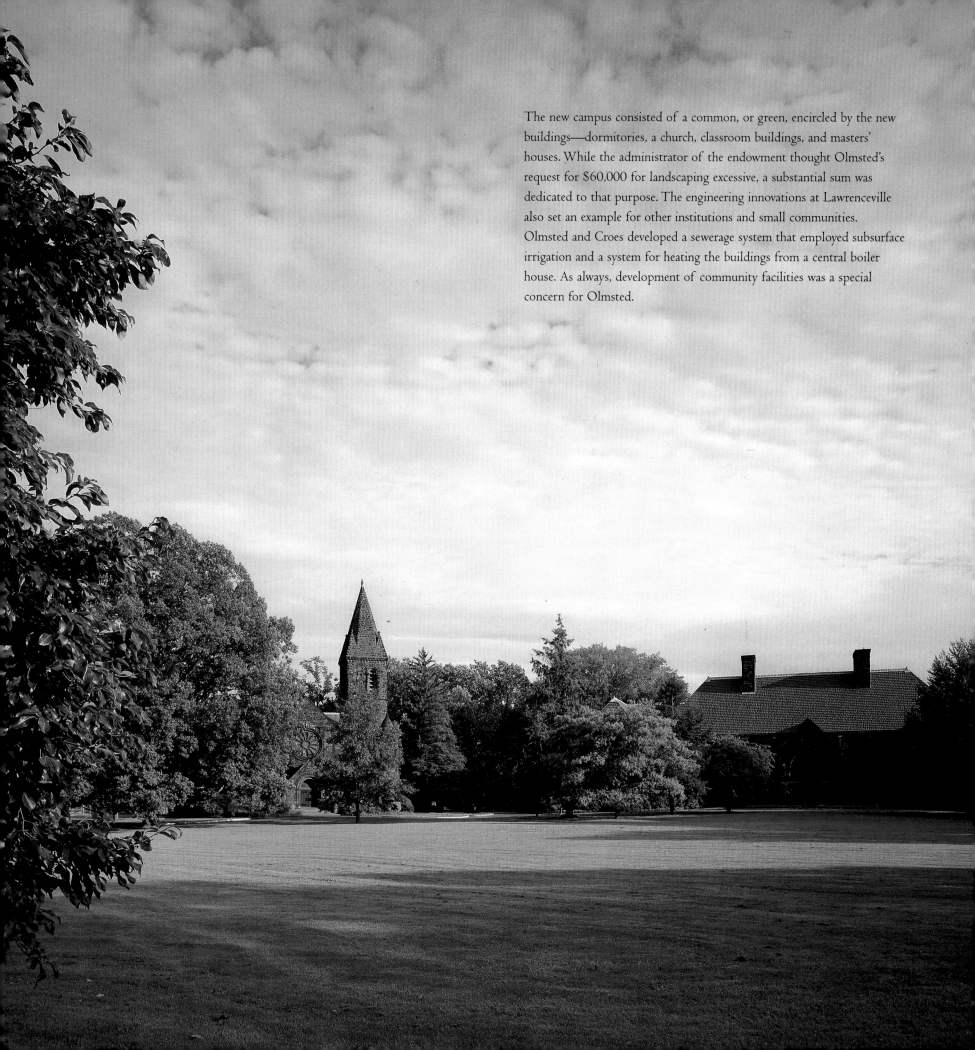

The new campus consisted of a common, or green, encircled by the new buildings—dormitories, a church, classroom buildings, and masters' houses. While the administrator of the endowment thought Olmsted's request for $60,000 for landscaping excessive, a substantial sum was dedicated to that purpose. The engineering innovations at Lawrenceville also set an example for other institutions and small communities. Olmsted and Croes developed a sewerage system that employed subsurface irrigation and a system for heating the buildings from a central boiler house. As always, development of community facilities was a special concern for Olmsted.

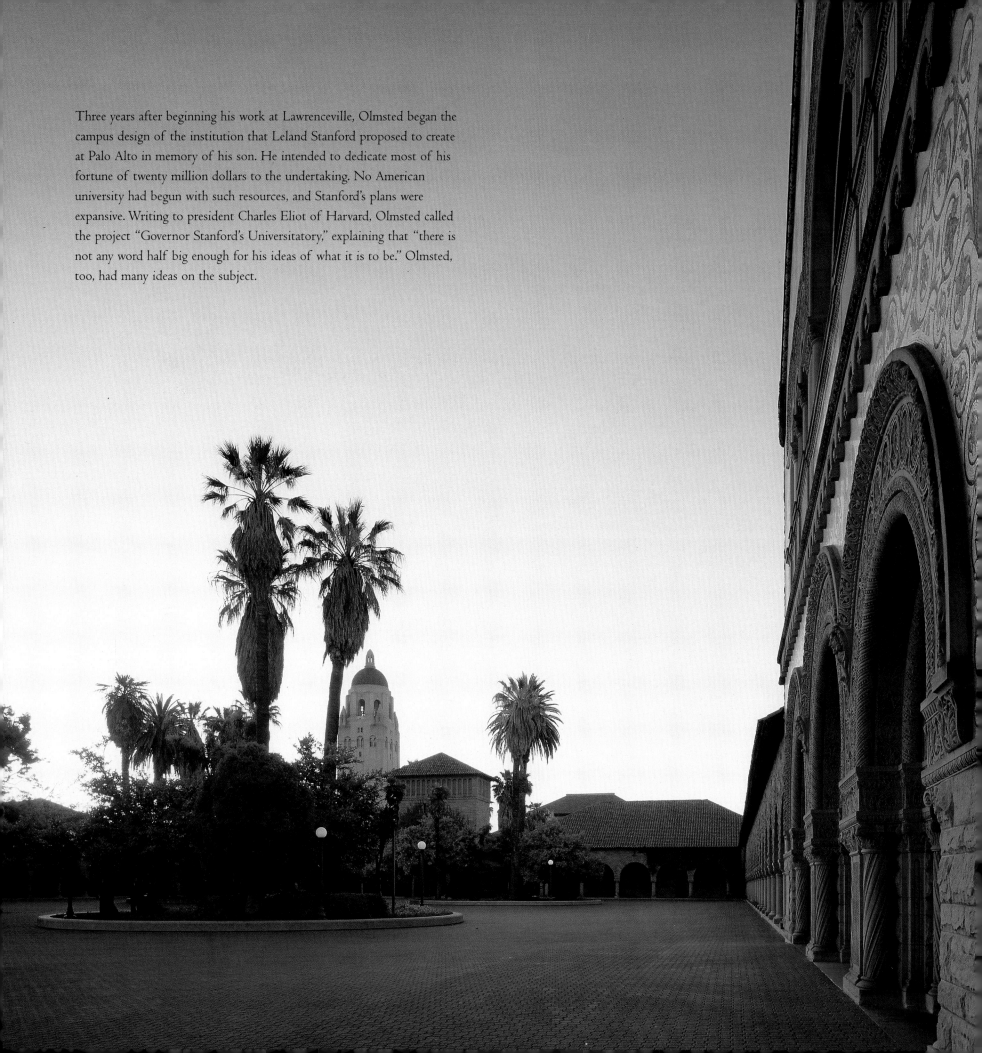

Three years after beginning his work at Lawrenceville, Olmsted began the campus design of the institution that Leland Stanford proposed to create at Palo Alto in memory of his son. He intended to dedicate most of his fortune of twenty million dollars to the undertaking. No American university had begun with such resources, and Stanford's plans were expansive. Writing to president Charles Eliot of Harvard, Olmsted called the project "Governor Stanford's Universitatory," explaining that "there is not any word half big enough for his ideas of what it is to be." Olmsted, too, had many ideas on the subject.

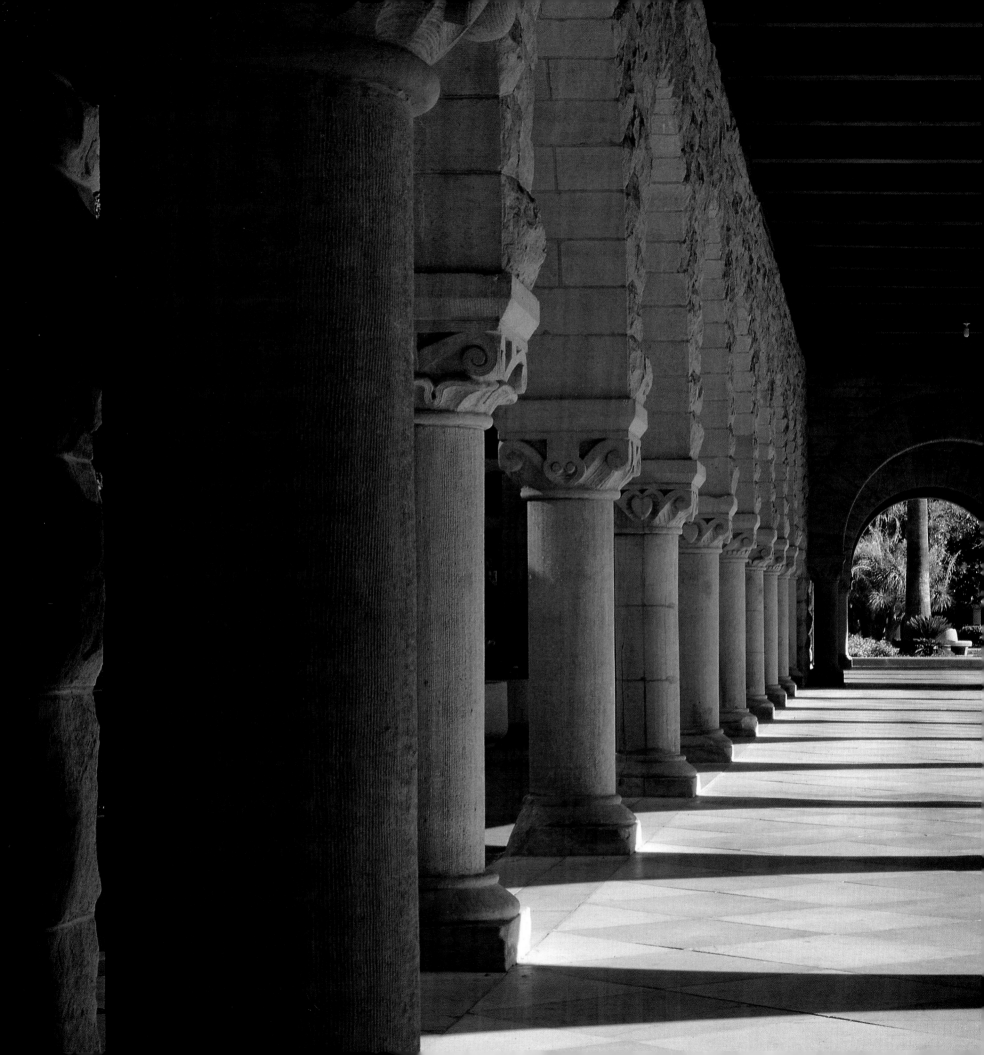

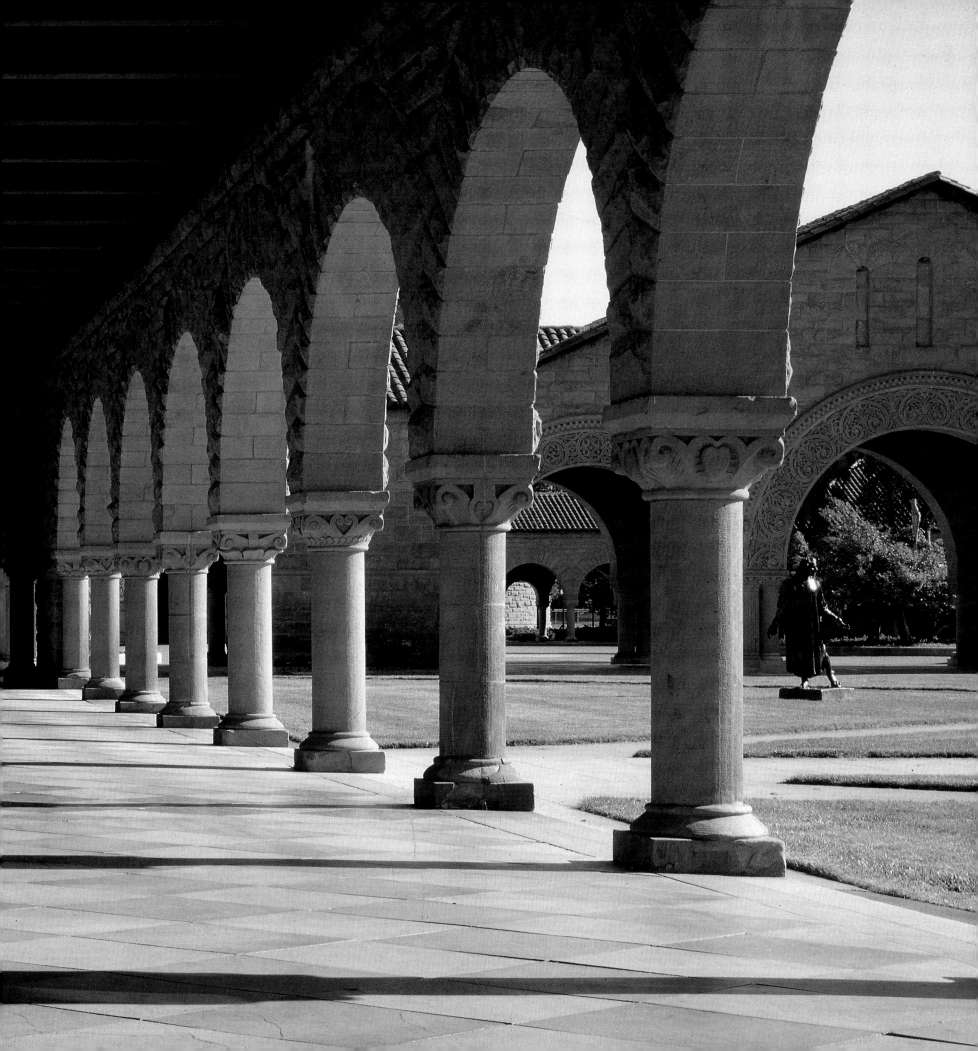

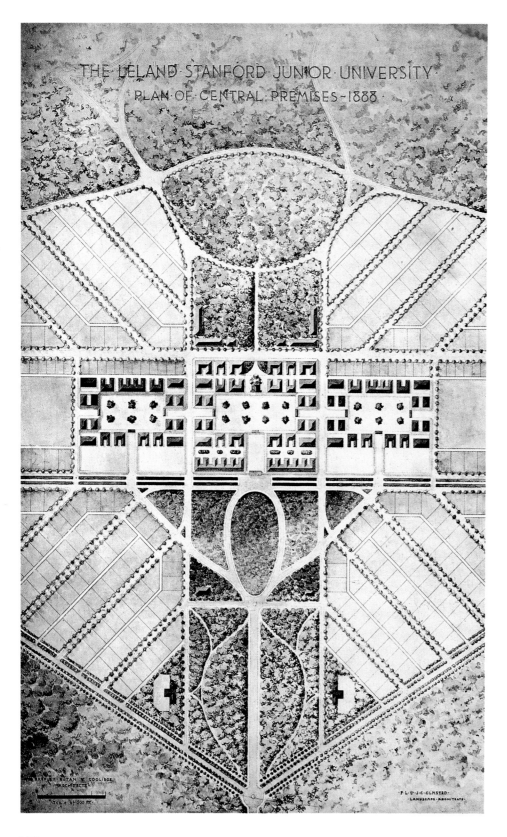

From the beginning Olmsted argued against Stanford's desire for a campus that replicated a New England college, elm trees, lawn, and all, in the California climate. Such an arrangement would be expensive to irrigate, Olmsted warned, and almost surely would fail to be properly maintained. There must be a more compact arrangement, especially at the center of the campus. Otherwise, there was a danger that the students would spend four impressionable years "in an establishment the outward aspect of which is expressive of an illiterate and undisciplined mind, contemptuous of authority and that is essentially uncouth, ill-dressed and ill-mannered."

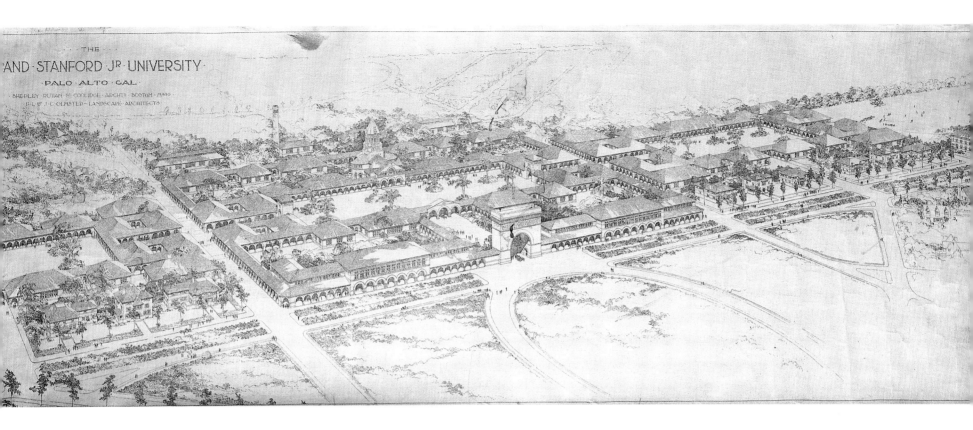

Olmsted's associates in planning the campus were Amasa Walker, the president of the Massachusetts Institute of Technology, who developed the first report on the architecture of the university, and the firm of Shepley, Rutan, and Coolidge, the successors of H. H. Richardson. At the outset Olmsted and Walker favored the idea of a central quadrangle of one-story buildings with a continuous interior arcade that would connect the buildings and provide shelter from sun and rain. In his letters to Stanford, Olmsted emphasized the importance of securing "compactness of arrangement" at the center of the campus. Planted areas should also be few and compact: for precedent he pointed to the forecourt of St. Peter's Basilica at the Vatican, where there was "not a tree, nor a bush, nor a particle of turf." These arguments helped to produce the architectural quality of both the outside and the inside of the central quadrangle of the campus.

Predictably, Olmsted was also concerned about issues of community. In the plan that evolved over the next two years, an area adjoining the three central quadrangles was reserved for residences—small dormitories for students, houses for professors, and a number of residences for persons unconnected with the university who wished to live in an academic setting. The students in turn would benefit from living near well designed and landscaped residences and in something approximating a suburban village. Olmsted had proposed such an arrangement for the private College of California in Berkeley when he planned its campus twenty years earlier, but the state land-grant university soon took over the site and developed its own plans. Leland Stanford eventually rejected Olmsted's ideas and erected Encina Hall as the single dormitory building.

133

Olmsted also planned a number of mental institutions. Given his belief in the therapeutic qualities of landscape in counteracting the stress of daily life, he undoubtedly had a concept of the type of surroundings that would benefit those suffering from mental disease. Unfortunately, no statement on this matter survives from his work on a half-dozen institutions. These were the Hartford Retreat; two sites for the Bloomingdale Asylum, one on the present site of Columbia University in Manhattan and the other in White Plains in Westchester County; the Hudson River State Hospital in Poughkeepsie; the Buffalo State Hospital for the Insane; and McLean Asylum in the Waverly section of Belmont, Massachusetts.

The record of Olmsted's work at the Hartford Retreat is the most suggestive that we have. He and Vaux began to improve the grounds of the institution in 1861. The principal area to be designed was a twenty-five-acre field in front of the main building. The director, John S. Butler, recalled that "much of it was rough, and a broad swale of low land extended through the center of the lot, most of the year wet and always impassable, especially for ladies." The trees had been haphazardly planted. Olmsted examined the area with Butler and made suggestions concerning both the landscape treatment and the purpose of the institution itself. When Butler retired in 1872, he wrote to thank Olmsted for his contribution. His advice had been "the 'punctum saliens,' the starting point of the advancement of the Retreat," Butler declared:

They gave the impulse from which has resulted its entire reconstruction. . . . They made such a deep impression on my mind—they gave such a distinct shape and direction to the indefinite plans and longings of years that I went that day to my desk and drew the outline of the scheme of future operations.

The key to Olmsted's program was "Kill out the Lunatic Hospital and develop the Home!"

The main structure of the Buffalo Asylum, designed by H. H. Richardson between 1870 and 1872, was hardly homelike. It consisted of a central building with two high towers from which five connected three-story buildings extended out on either side, each set back a full building width from its neighbor. With the McLean Asylum (1872-75) Olmsted had more opportunity to propose a "domestic plan, in distinction to that of a public institution." He proposed a more modest version of what Richardson had planned at Buffalo. There would be a crescent-shaped central building of two stories connected by passageways with three additional residence buildings on either side, each housing thirty patients. The whole series of buildings would be eighteen hundred feet long with a continuous, common basement for heating and ventilating pipes and a tramway. This would enable central facilities to serve the entire series while permitting separation of different kinds of patients. The separation of buildings would lessen the danger of spreading fire or disease, while the curved shape of the whole would permit proper ventilation and provide every room with south-facing windows.

The kind of outdoor setting that Olmsted thought would most benefit inmates in these institutions can be discerned to some extent by two surviving plans. One is the plan that Olmsted and Vaux prepared for the Hartford Retreat in 1860. A walk encircles an area in front of the building, but the plantings offer somewhat more sense of enclosure and less expanse of open space than one would expect in a public park designed by the two men. The same quality is found in Olmsted's plan of 1877 for the "pleasure ground" in front of the Buffalo State Asylum. There is an oval walk around an open greensward, and dense groves of planting create enclosed passages that alternate with short sections crossing open lawn.

Olmsted's only surviving written statement occurs in a preliminary report for McLean Asylum in 1872. He observed that "the most desireable qualities in the home grounds for a retreat for the insane are probably those which favor an inclination to moderate exercise and tranquil occupation of the mind, the least desirable those which induce exertion, heat, excitement or bewilderment." The terrain of the Waverly site needed only some judicious thinning of the woods into groups and glades and construction of "walks of long curves and easy slope" to achieve the desired conditions. The site provided scenic variety and "incitements to tranquilizing and recreative voluntary exercise for convalescent and harmless monomaniac patients." Olmsted little suspected when he wrote these words that he would spend the last five years of his life as a patient at the McLean Asylum.

Hartford Retreat, now Institute for Living.

Designing for Domesticity

AN IMPORTANT RESULT of the suburban communities that Olmsted designed was the fostering of domesticity. The community provided the public setting and the means of going and coming from the family "homestead," but of even greater concern was the setting to be created within its bounds. This concern was an expression of values that Olmsted had worked out before the end of the Civil War. From the time that he became a gentleman farmer, he set himself the task of promoting domesticity; and when he had occasion to examine his beliefs more carefully while in California, he decided that it was the finest and truest expression of civilization. As he wrote Henry Bellows while at Mariposa, he felt that the chief sign of civilization, as opposed to the barbarism that he found on the California frontier, was the desire to have "the enjoyment, the comfort, the tranquility, the morality and the permanent furnishings, interior and exterior, of a home." When he planned the campus of the College of California at Berkeley the following year, he asserted that "manifestations of refined domestic life" were "unquestionably the ripest and best fruits of civilization."

Olmsted intended that the more openly built city would make possible a kind of domesticity superior to anything before achieved in America. He hoped particularly that Americans would begin to make the outdoors more a part of their households. Early in his career he had seen how much more the English and Germans lived in the open air than did his countryfolk. His book on England praised this tendency, and he wrote Andrew Jackson Downing soon after his return that he was pleased by the "social outdoor life" he observed in Germany. As a landscape architect he later called for an extension of the traditional concept of the boundaries of the household to include the grounds around it and urged that all residences have a variety of "attractive open-air apartments" that would enable the residents to move many of their domestic activities outdoors and provide outside shelter from sun, wind, and rain.

He favored small yards or patios connected with the kitchen, parlor, and dining room of the house, while further away he sought to provide other spaces to meet a variety of needs: "there should be turf on which young children can walk, and fall without injury, on which young girls can romp without soiling their dresses," he wrote. "There should be a dry walk for damp weather, a sheltered walk for windy weather, and a sheltered sitting place for conversation, needle work, reading, teaching and meditation." Without such outdoor spaces, he warned, the inhabitants of even well-built houses would be "almost certain, before many years, to be much troubled with languor, dullness of perceptions, nervous debility or distinct nervous diseases." A house that did not have such outdoor apartments could not adequately counteract the tension and strain of urban life, which made the more open city form so necessary.

There were social as well as sanitary reasons for such a redefinition of the home and of domestic life, since it would make the former far more attractive and effective as a center of social activity. It would counteract the tendency of city dwellers to be drawn into unsocial and unhealthy leisure-time activities. Deprived of domestic alternatives, they developed "a disposition to indulge in unhealthy excitements, to depraved imaginations and appetites, and frequently to habits of dissipation." To counteract these reversions to barbarism caused by the stress of urban life and the failure to develop social institutions to deal with the problem, the home was to be the place where leisure activities of an improving and civilizing sort would occur.

Just as Olmsted saw domesticity as the finest expression of civilization, he viewed the development of taste as the finest mark of domesticity. Accordingly, he devised his concept of the new suburban home to fit that image. With the help of the landscape architect, its residents would create tasteful surroundings for themselves and their children.

At the same time they would improve their own taste by exercising the aesthetic discrimination that embellishment of a house and grounds would require. They would provide a demonstration of Olmsted's dictum that the "true and last and only safe measure" of prosperity in the United States was the extent of "the willingness of the people to expend study and labor with reference to delicate distinctions in matters of form and color." For the same reason he declared that "the true wealth of our country is in its homesteads. The rest is mainly rubbish, the more barbarous for the deceitful glaze which much of it has." Not only would the proliferation of domestic garden art enhance taste and achieve a fuller degree of civilization in America; it would also realize the promise of gardening as the most democratic of the fine arts. It was the art, Olmsted believed, that people of limited education could most successfully pursue—the one most readily available to the mass of society. As he observed:

In none of the arts as surely as in gardening can a man of moderately poetic temperament, moderate capacity of study, moderate command of time for the purpose, produce works of a distinctive character that shall be thoroughly respectable. The effort which it has already cost some millions of Americans to obtain a wretchedly small degree of success in versifying, music, acting, drawing, painting, carving, embroidering, or a hundred of the smaller decorative arts, if it had been given to study in gardening would have secured a distinguished success.

The prospect that many Americans would learn to practice gardening in a creative way was one of Olmsted's fondest hopes, and it formed the basis of his designs for family homesteads. Such a development would be good in what it led Americans to reject as well as what it taught them to value. It would lead them away from extravagant display and the tasteless, brash materialism that such display involved, since gardening had "little drift to prodigality; pride of purse, venom of competition, bigotry or any other form of intemperance." It would also lessen the temptation to use leisure time for vicious pursuits: "It is little liable to lead to debasing associations," he wrote; "it fosters delicacy of perception and of sentiment, strengthens family ties and feeds the roots of patriotism." Domestic garden art, in short, would be a principal means by which the new suburban yeomanry would acquire the "mental and moral capital of gentlemen."

Olmsted considered one acre a minimum for the grounds of a freestanding house. Still, the rules of composition and subordination

of detail to overall effect that governed his park designs were equally applicable to the limited grounds of a family home. He made this clear in the few articles that he wrote for the periodical *Garden and Forest* on planning small suburban lots. In "Plan for a Small Homestead," which described a property in East Greenwich, Rhode Island, he stated that the first concern was to heighten the fine distant view from the house by planting a foreground of dark foliage.

As a result, he instructed, "the light gray and yellowish greens of the woods of the river bottom will appear of a more delicate and tender quality, and the grassy hills beyond more mysteriously indistinct, far away, unsubstantial and dreamy." Such an approach would achieve the "indefiniteness of edge" that Olmsted saw as an integral part of scenery; at the same it enhanced the mystery of the scene and increased the apparent extent of space involved. In this instance the plantings near the building should be of a "complementary or antithetical character." The owner should not "provide a series of objects the interest of which will lie in features and details seen separately, and which would be most enjoyed if each was placed on a separate pedestal." No matter how small the space, there must be the basic element of design, of subordination of detail to a coherent whole. In this article, Olmsted offered a classic approach to producing landscape beauty in a limited space:

It may be accomplished by so bringing together materials of varied graceful forms and pleasing tints that they will intimately mingle, and this with such intricate play of light and shade, that the whole body of them is under close observation, the eye is not drawn to dwell upon, nor the mind be occupied with, details. In a small place much cut up . . . a comparative subordination, even to obscurity, of details . . . is much more conducive to a quiescent and cheerfully musing state of mind than the presentation of objects of specific admiration.

This was the message that Olmsted continually provided to his residential clients. To the owner of a home in Brookline he noted that he was proposing a large variety of trees for a limited space; but, he observed, "they are carefully graded to avoid abrupt contrasts & the gradual transition of tone & texture will be agreeable."

The clearest test for a designer's doctrines concerning residential grounds is how he treats his own home, and Olmsted's design for the backyard of his row house at 209 West Forty-sixth Street in Manhattan during the 1870s was certainly a challenge. Yet the recollections of his son, Frederick Law Olmsted, Jr., indicate that he indeed followed his own precepts even in so restricted a space. In order to create a perspective effect and sense of distance, Olmsted designed a paved area in the center of the yard that narrowed as it approached the back fence. This made the yard seem longer than it was. He then created the variety of foliage and play of light and shadow that he so valued: "The planting space at the rear of the lot was much broader than was possible along the sides," his son recollected. "It was enough, with the small scale of many of the plants that were used, to give some suggestion of mystery and depth." This rich planting effect and the open center of the yard were in striking contrast to the neighbors' "conventional arrangement of a narrow bed against each fence with a narrow flagstone path next to it, the center being occupied by a foot-worn grass plot with four clothes poles at the corners."

Arrangement of the backyard of Olmsted's Manhattan row house, 1870s.

138

Part of Olmsted's hope for his kind of gardening was that it would bring variety to the deadening sameness that he found in most residential grounds. This concern was of long standing. While still a gentleman farmer he had embraced John Ruskin's teachings on the subject. In his book of English travels of 1852 he exclaimed, "I think, with Ruskin, it is a pity that every man's house cannot be really his own, and that he cannot make all that is true, beautiful, and good in his own character, tastes, pursuits, and history manifest in it."

At the same time Olmsted wanted the grounds of homesteads to improve the taste of their residents. In order for this to occur, they must succeed in producing what he called "positive beauty." The key to this beauty was delicacy and a sensitivity to subtle gradations of color, texture, and form. An essential element was "gradual transition of tone & texture," as he expressed it to his Brookline neighbor R. J. Goddard. Such beauty, he said, was "beauty which is good in itself and not beauty the good of which is dependent on its fitness for or expression of something else that is good, as light, air, warmth, and so on."

Accordingly, there was no place in Olmsted's designs for personal tastes and idiosyncrasies that intruded on unity of design, delicacy, and "positive beauty." Yet problems with recalcitrant clients bent on expressing their own preferences frequently occurred. "I design with a view to a passage of quietly composed, soft, subdued pensive character," he complained, "come back in a year and find—destruction; why? 'My wife is so fond of roses' 'I had a present of some large Norway Spruces' 'I have a weakness for white birch trees—there was one in my father's yard when I was a boy.'"

Olmsted took great pains in working out his designs for homesteads, devising solutions that would function well, ensure healthful surroundings, and provide "positive beauty." He sought to learn his clients' wishes and needs, but his plans often involved considerations of sanitation, psychology, and aesthetics that went beyond their experience and understanding. Once a client accepted a design, Olmsted expected to be free to carry it out in all particulars. As he informed one client who strayed from his plan, "I am a designer, which I should not be if I did not know better than any one else what is and what is not essential in my designing."

Ground cover and a single birch at Fairsted.

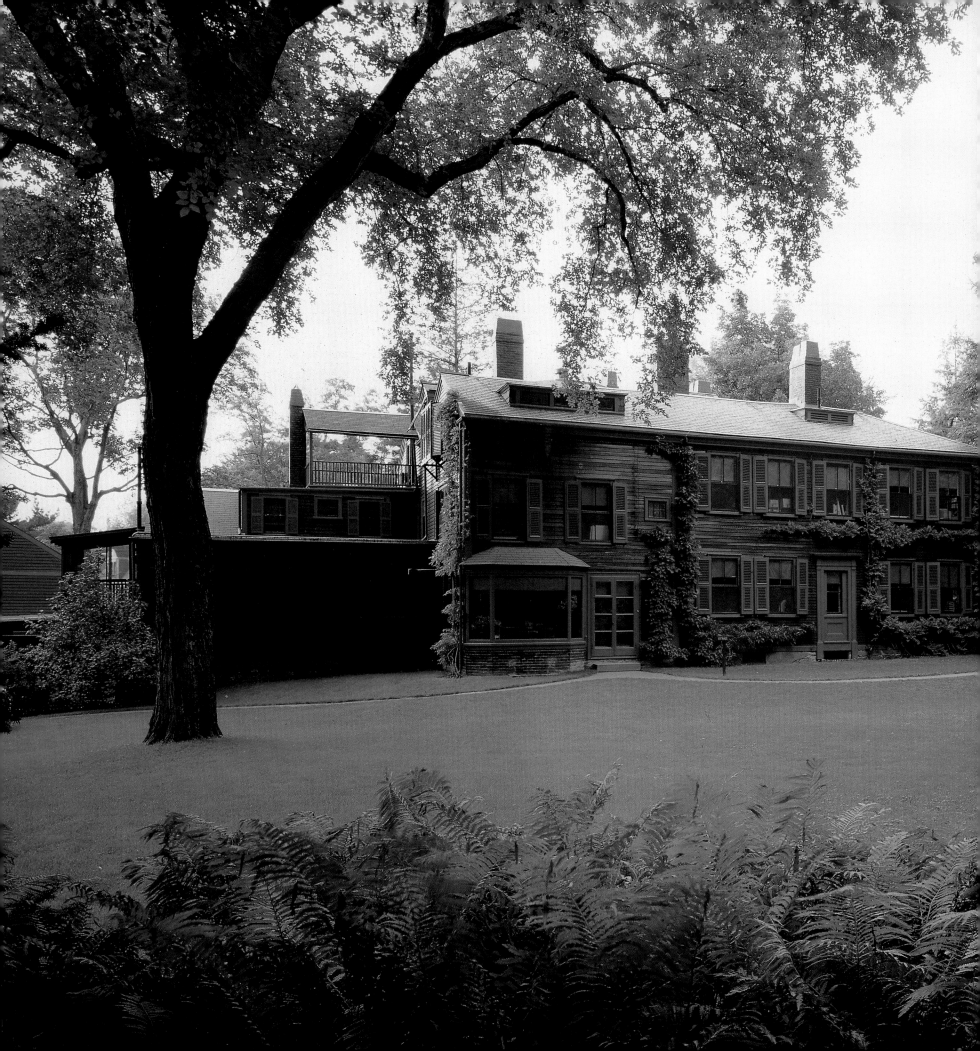

Fairsted

THE BEST EXAMPLE of Olmsted's approach is his own home, Fairsted, in Brookline, Massachusetts. He purchased the old farmhouse at 99 Warren Street in 1883, despite his friend Henry Hobson Richardson's offer to design a new house next to his home half a mile away. Since the planning of the grounds of Fairsted required little correspondence, few documents survive that explain his design intent. The most telling statement is found in a telegram that he despatched while work was underway. "I don't object to the cutting away of certain bramble patches if brambles are to take their place—or anything that will appear spontaneous & not need watering or care," he cabled John C. Olmsted. "More moving or dug ground I object to. Less wildness and disorder I object to."

Fairsted, c. 1900

Indeed, historical photographs of Fairsted show the remarkable wildness and profusion, the epitome of the picturesque style, that Olmsted achieved on the grounds. He buried the house under a thick layer of vines and creepers. However foursquare it had been before, he vigorously merged it into its setting. By means of this planting he achieved the goal that residences should "seem to be a part of nature herself, rather than objects foreign to the general character of the place." He directed that "no sharply defined lines mark the sudden transition from the formality of architecture to the irregularity of nature."

141

The Yard at Fairsted, c. 1900.

Olmsted's usual means of achieving this effect was with a terrace. But the old Warren Street house had no terrace to extend the building into its grounds, and Olmsted did not add one. In this case it was the enveloping vines that placed nature and architecture in such relation "that the one depending upon the other forms an harmonious whole." Olmsted added a conservatory room whose large windows projected the interior space into the open area of the lawn; climbing vines on the back wall brought the materials of the outdoors inside the house.

The key element for planting the grounds, as for the house, was the profusion of plant material around the edge of the lawn. The many species of plants made the Fairsted grounds a telling demonstration of subtle variations of form, color, and texture—the elements that for Olmsted made gardening so valuable a training ground in delicacy and taste.

Two separate areas of special character increased the variety of the grounds. One was a space beyond a corner of the lawn. It contained a path that curved around a hillock, which Olmsted enlarged to create visual separation. He planted it with laurel and other shrubs that now give it a shaded and enclosed character. Despite its small size the space is distinctive and has some of the quality of the Central Park Ramble and other heavily planted areas with circuitous paths on broken ground.

142

144

The other distinctly separate space is the Hollow between the street and the long office wing, which was added beginning in the 1890s. An old photograph shows the richness of planting in the Hollow; a table and chair increased its usefulness as an "open-air apartment." Set in a bank at the edge of the Hollow near the entrance circle is a fieldstone arch, a motif that he repeated on a grander scale at Moraine Farm.

Left: The Hollow at Fairsted, 1935.

146

The National Park Service, which owns and operates the Frederick Law Olmsted National Historic Site at Fairsted, is now carrying out a thorough restoration of the grounds to display Olmsted's concepts in a uniquely accurate way. Still, the present appearance gives the visitor a good sense of how Olmsted structured the space available to him on the site. In fact, he broke his own rules in his treatment of Fairsted. Along the street he erected a high wooden fence which, while definitely rustic, adds little of the openness to the community that he called for in his planning. Moreover, there was no separation between place of residence and place of work. Given his dedication to work, it is unlikely that this arrangement did much to enhance his own experience of domesticity.

148

Moraine Farm

THE FINEST EXISTING EXAMPLE of Olmsted's approach to planning a country estate is Moraine Farm in Beverly, Massachusetts, north of Boston. Beginning in 1880 he developed a comprehensive approach to managing the 275-acre property. In several respects the project anticipated the far more ambitious Biltmore Estate in North Carolina. Not content with simply arranging the grounds of a country house, he sought to have the estate of John C. Phillips serve a public purpose as well. As he would do at Biltmore and would attempt to do at Shelburne Farms in Vermont, he proposed to blend scientific farming and experimental forestry with a country retreat. He installed a drainage system in a forty-acre field to demonstrate how marginal lands could be brought into production. The result was "one of the best and most productive fields in Massachusetts," which still yields crops. He also planted seventy-five acres with conifers as a practical demonstration of how forestry could supplement the income of an old New England farm.

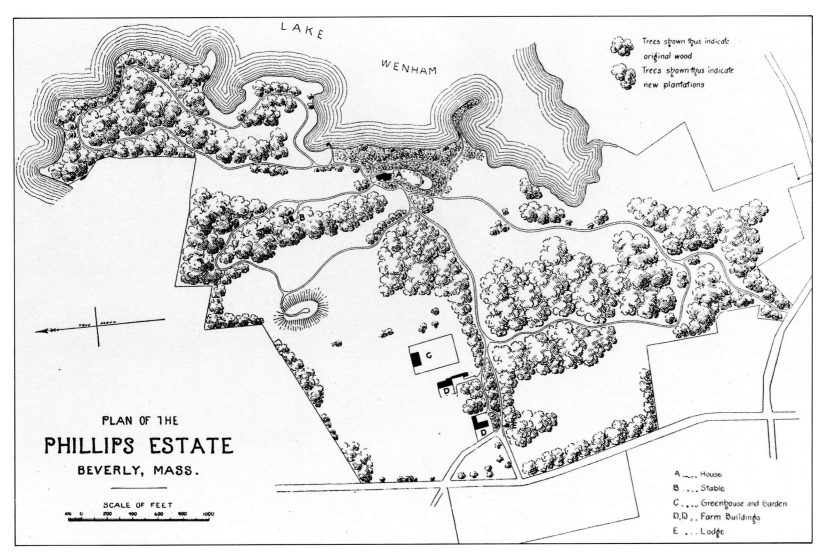

Trees shown thus indicate original wood
Trees shown thus indicate new plantations

PLAN OF THE
PHILLIPS ESTATE
BEVERLY, MASS.

SCALE OF FEET
100 0 200 400 600 800 1000

A House
B Stable
C Greenhouse and Garden
D, D ... Farm Buildings
E ... Lodge

LAKE WENHAM

TRUE NORTH

Mature pines being logged in the winter of 1995.

As the road nears the house the landscape changes dramatically. To the
right appears a rolling meadow a quarter-mile long with a sinuous border
of trees. At the same time dense rhododendron plantings follow the
roadside most of the remaining distance to the house.

Olmsted had intended to carry "dense foliage right up to and about the house." In this way he hoped to gain for the estate a "forest character with all its possibilities of forest beauty" and to make the woods "appear to have been found and not made." This would differentiate the place from other estates in the vicinity. "The difficulty to be always contended with," he warned, "is the ease of a costly commonplace result." However, Phillips wanted an open area of turf in front of the house, and Olmsted reluctantly compromised. The present owners have begun to restore the screen of trees with which Olmsted masked the view of the house from the approach.

Even without the dense forest close to the house Olmsted arranged plantings so that the approaching visitor received no hint of what lay on the other side. The visitor must pass through the house in order to experience the view over Wenham Great Pond that is the special feature of the place. To make the effect more powerful, Olmsted constructed a massive terrace that pushed the house out toward the lake. Along the east side of the house runs a paved terrace with a particularly graceful curving balustrade along its edge. The terrace wall below is made of rough fieldstone boulders. It appears as Olmsted wished, "boldly projected, following natural lines, 'country-made' and highly picturesque in its outlines and material," with "an aspect of rustic picturesqueness." It demonstrates Olmsted's willingness to alter a site extensively in order to secure the features and visual effect that he wanted.

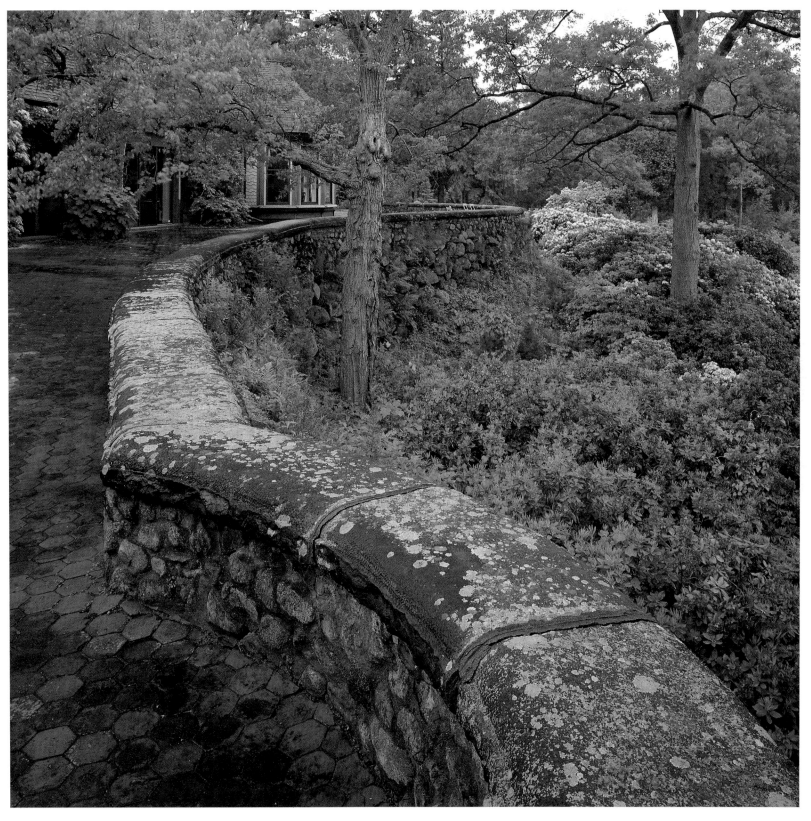

The house, designed by Peabody and Stearns in their first of several collaborations with Olmsted, was a picturesque structure with a first floor of stone and two shingled stories rising to a varied roof line that was accented by five chimneys. Olmsted pronounced it a "proper summer lodge" and commented that the stone was more charming in color and texture than any new stonework he had ever seen. Indeed, the contrast of rough boulders with door and window edgings of smooth and warm brownstone has a very pleasing effect.

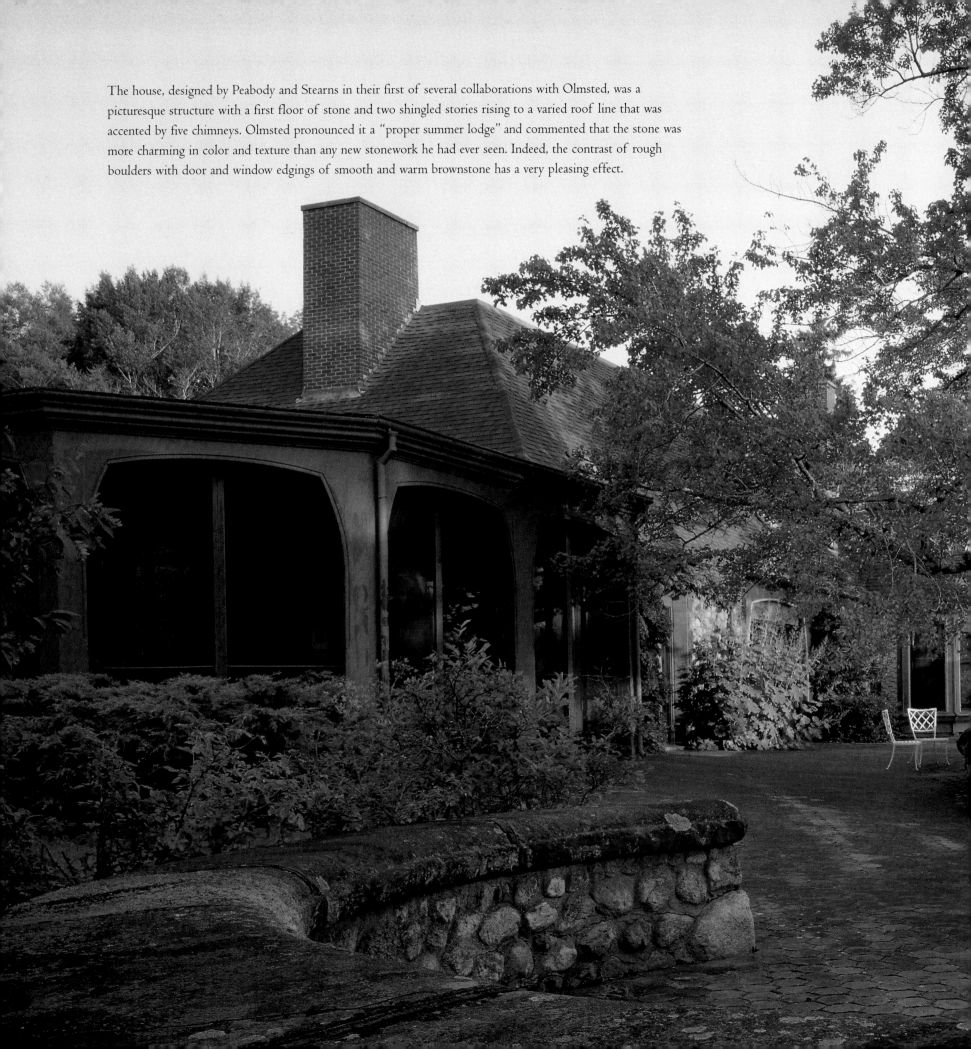

To the south, an open lawn extends out from the house and terrace. Like the house and viewing terrace, it rests on the great filled terrace that Olmsted had constructed on site. A parapet of vertical stones bounds the lawn on the east, and it is sheltered by a dense plantation of pine trees below and beyond the terrace. On the land side an "impervious thicket" of small trees and shrubs creates a visual barrier to the outside world.

This belt of plantings was to be of "hornbeam, hop-tree, dogwood, white birch, laburnums, Kohlreuteria, sassafras, mountain ash, moosewood &c. faced with bushy shrubs." On the lawn side of the thicket Olmsted suggested planting a formal hedge of hornbeam or, if Phillips preferred, "something more delicate or elegant," a hedge of privet, buckthorn, or Japanese quince.

162

The area of "domestic and confidential lawn & terrace" within these planted borders of trees and shrubs is the heart of the grounds, the "open-air apartments" of the house. Here Olmsted achieved his purpose

that the lawn, terrace & the part of the house opening upon them shall appear all one affair, refined, domestic and sharply separated, secluded and distinct in quality from everything else in the vicinity. So that in going or looking from it, you will seem to be everywhere going or looking outdoors into an outer world, essentially the lawn & terrace being apartments of the house, everything else the outside world.

At the end of the lawn is a one-room "pavilion" that Olmsted intended to be "not a mere shelter but a useful room, large enough for a coffee, reading or ladies-work room, with windows and shutters."

Beyond the pavilion at a lower level and visible only from it is the garden —separated as Olmsted always wished gardens to be from the spaces that he designed for broad landscape effects. Mrs. Phillips wished to have an "old fashioned flower garden." Realizing that it would contain "a class of perennials which at times have a sprawling habit and close under the windows of a house are apt to appear disorderly and a little out of place," Olmsted located the garden out of sight of the rest of the grounds. Here and here alone flower gardening was to be allowed. "If the gardener shows himself outside the walls," Olmsted warned Phillips, "'off with his head.'"

164

The garden is surrounded with the same vertical stones that line the outer
edge of the lawn above, adding to the effect of an "an oasis of ladies'
ground strongly but rudely and in forest fashion built into the wild
hillside" that Olmsted intended for the grounds on the great terrace.

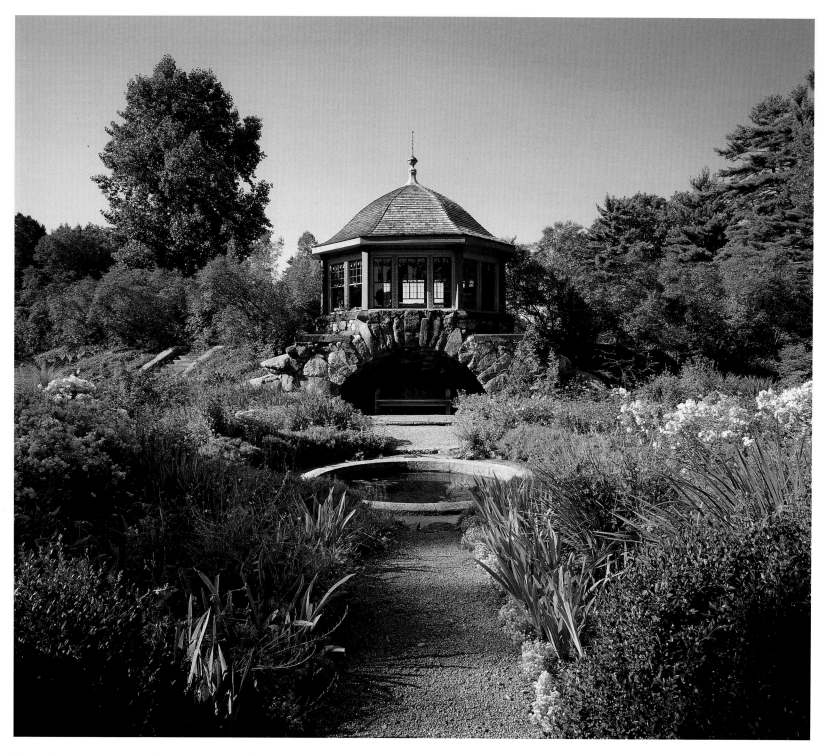

The rudest element is a fieldstone arch set in the wall directly under the pavilion and reminiscent of the most rugged stonework structures that he created with H. H. Richardson in the Boston region at this time.

Another landscape feature close to the house was the "wild garden,"
a densely planted ramble below the ten-foot terrace wall. It was to be
planted "with ferns and perennials seen among groups of low trees which
like the sumachs and dogwoods, and pinus Mugho appear to advantage
when looked down upon." The dogwoods still survive, and the dense
shrub plantation embowering the path now consists of masses of
laurel and rhododendron.

170

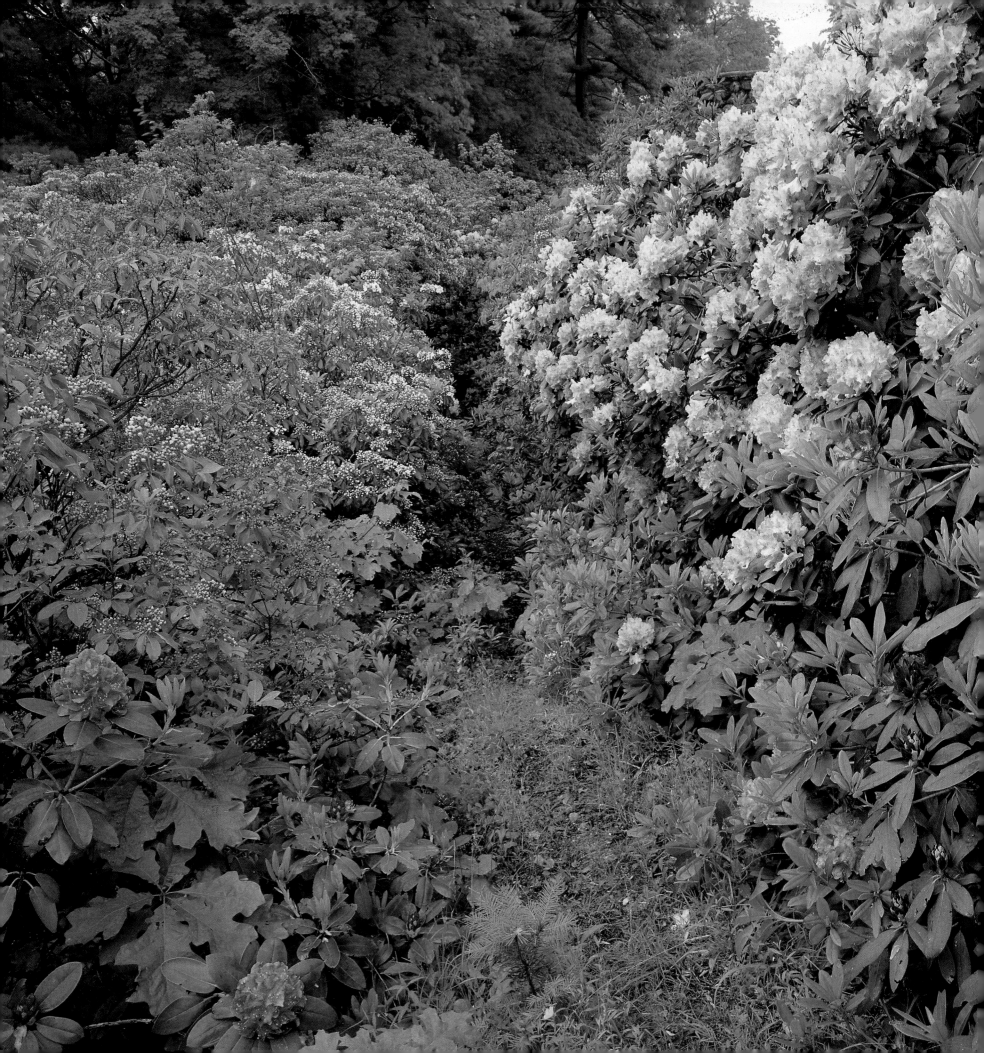

Extending out from the house Olmsted planned three loop carriage
drives that ran through most of the property not used for farming.
The south loop ran along the western edge of the lawn and garden, where
Olmsted's "impervious thicket" of trees and shrubs obscured the private
space beyond. It then passed in view of the lake and returned to the
approach road through the new forest plantation. The north loop circled
along the lakeshore and the narrow valley created by the glacial esker that
gives the farm its name. A third carriage loop ran to an overlook atop a
hill northwest of the house.

In all seasons Moraine Farm today offers the visitor a uniquely authentic
and convincing experience of an Olmstedian space.

The Collaboration with H. H. Richardson

THE MOST IMPORTANT FRIENDSHIP that Olmsted formed after the Civil War was with the architect Henry Hobson Richardson. In Richardson he found a fellow artist whose fertility of imagination and ingenuity of design equaled his own. He also found a warmth and camaraderie in this man sixteen years his junior that had been lacking in his life since the death of his brother, John Hull Olmsted, in 1857. To Richardson's biographer, Mariana Griswold Van Rensselaer, Olmsted gave a remarkable statement concerning their friendship:

I cannot express, or make those who did not know him even dimly understand, how much Richardson was in one's life, how much help and comfort he gave one in its work. It was not always that he could do much, but he would do what he could when other men would only have talked about it. And when he could not do anything he would yet take such an eager, unselfish, and really vital interest in one's aims and schemes, try so seriously to understand one's difficulties, and declare so imperiously that they must and should be overcome, be so intensely and intelligently sympathetic, give, in short, so much of himself, that he was the greatest comfort and the most potent stimulus that has ever come into my artistic life.

It is easy to imagine those encounters, particularly during the five years prior to Richardson's death in 1886 when both men lived in Brookline. Olmsted, in turn, offered Richardson great friendship and, inevitably, an intense and argumentative touchstone for his own artistic work. Mariana Van Rensselaer testified that Richardson "was constantly turning to Mr. Olmsted for advice, even in those cases where it seemed as though it could have little practical bearing upon his design."

Professional collaboration between the two men began soon after Richardson returned from his studies in France and settled on Staten Island in 1867. During the next year Olmsted helped him on a project to erect a monument to Alexander Dallas Bache, who had been superintendent of the United States Coast Survey and a member of the U.S. Sanitary Commission. In the early 1870s they worked together in Buffalo on the State Asylum for the Insane, and Richardson designed a soldiers' memorial arch for Niagara Square, which Olmsted was redesigning. Both men were members of the four-man Staten Island Improvement Commission of 1870, which under Olmsted's leadership developed a comprehensive regional plan for the island.

Their next important project was the New York State capitol in Albany, where in 1875 they began to serve with the architect Leopold Eidlitz as an advisory board. They faced many problems, including the uproar that met their proposal to abandon the Renaissance style of architect Thomas Fuller's first two stories and substitute a Romanesque style for the upper section. Olmsted was not particularly interested in debating which historical style to use for the exterior of a building. It was the ability to serve its function that concerned him most. "Architecture is the art of building, not merely of ornamenting nor in any way of veiling or covering up a building," he wrote in one of his reports on the state capitol. Architects should look to the past "not for forms but for the cause of forms," and should avoid "all useless construction and uncalled for ornament." Olmsted very likely provided a continuous argument on this theme, emphasizing simplicity of form, lack of ornamentation, and appropriateness of form to function, during those "all-night debates years ago in Albany" with Richardson and Eidlitz that he recalled years later.

175

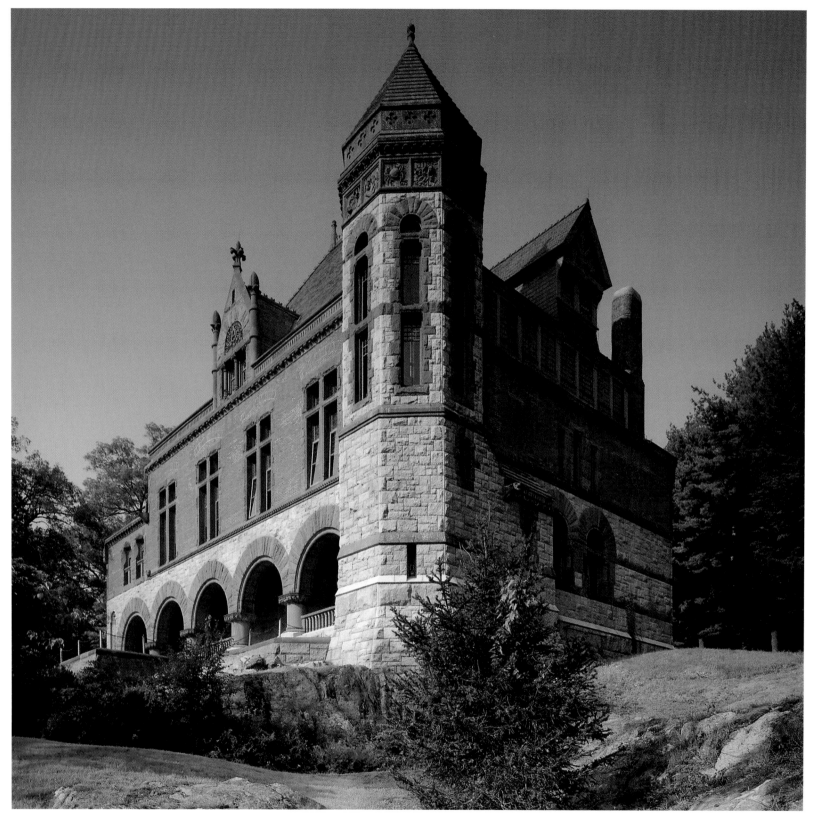

176

At the time of the controversy over the capitol, Richardson was beginning to transfer his practice from New York to Boston. In 1872 he received the commission for Trinity Church in Copley Square and in 1874 moved his family to Brookline. Olmsted began to spend part of the year in the Boston area in 1878 and moved to Brookline in 1881. The most important collaboration between the two men in the Boston region came through the patronage of the Ames family in North Easton. In all, Richardson designed five structures in the town, while Olmsted carried out seven commissions. The two major projects on which the two collaborated were the Oakes Ames Memorial Town Hall and Langwater, the Frederick Lothrop Ames estate with Richardson's famous gate lodge.

The memorial hall, begun in 1879, is the first example of Richardson's enthusiastic experimentation with building on rocky, picturesque sites in association with Olmsted. In planning the grounds Olmsted left bare the ledges on which the hall is set and even removed earth to increase the ruggedness of the site. He then planted pockets in the rocks with honeysuckle, juniper, yucca, and sedum to produce a low-massed and wild effect. Richardson spread out the base of his massive structure, extending it with basement walls, a terrace, and a broad staircase approach.

Next to the memorial hall Olmsted devised his most remarkable contribution to the landscape of North Easton, the great communal cairn to honor the townsmen who fought in the Civil War. The three-hundred-foot-long terrace supported a public walk with seats and shade trees and served in part as a gallery for concerts and public meetings held in front of the memorial hall. Its rough fieldstone sides were to be heavily planted. From the hall the cairn of boulders would appear "like the base of a round tower or an old warlike bastion half obscured by drapery of peace in the form of evergreens, vines, shrubs and flowering rock plants." Some of the oldest and most enduring monuments in the world had been constructed in this way, Olmsted said, and the plants that had taken root made them "far more interesting and pleasant to see than the greater number of those since constructed of massive masonry and elaborately sculpted."

The names of all the town's Civil War soldiers and sailors were to be inscribed on the monument, and around a flagpole would be set the names of those who died in the war. The monument would also be communal because children and old people would bring stones to build a cairn about the base of the flagpole. Children would be invited to help in setting plants and sowing seeds on the cairn and would have a role in annual observances. In this way they would play a part "generation after generation, carrying down the lessons of war and keeping green the memory of its heroes."

At the same time that work on the memorial hall and cairn was going on, Richardson designed the gate lodge for Langwater. The rough fieldstone exterior was a striking sight, although Olmsted intended to cover it with vines and creepers. Before beginning work on the building Richardson examined several of the arches of "rough-hewn stones and boulders" that Olmsted and Vaux had built in Central Park twenty years earlier. The purpose of creating such a rough surface, as Olmsted explained elsewhere, was not due to a desire to display the stone, but rather "because the beauty of the designed sheets of foliage is thought to be better exhibited, and to have a more natural effect when thus disposed over a backing of rough and deeply crannied, rather than of flat and dressed stone."

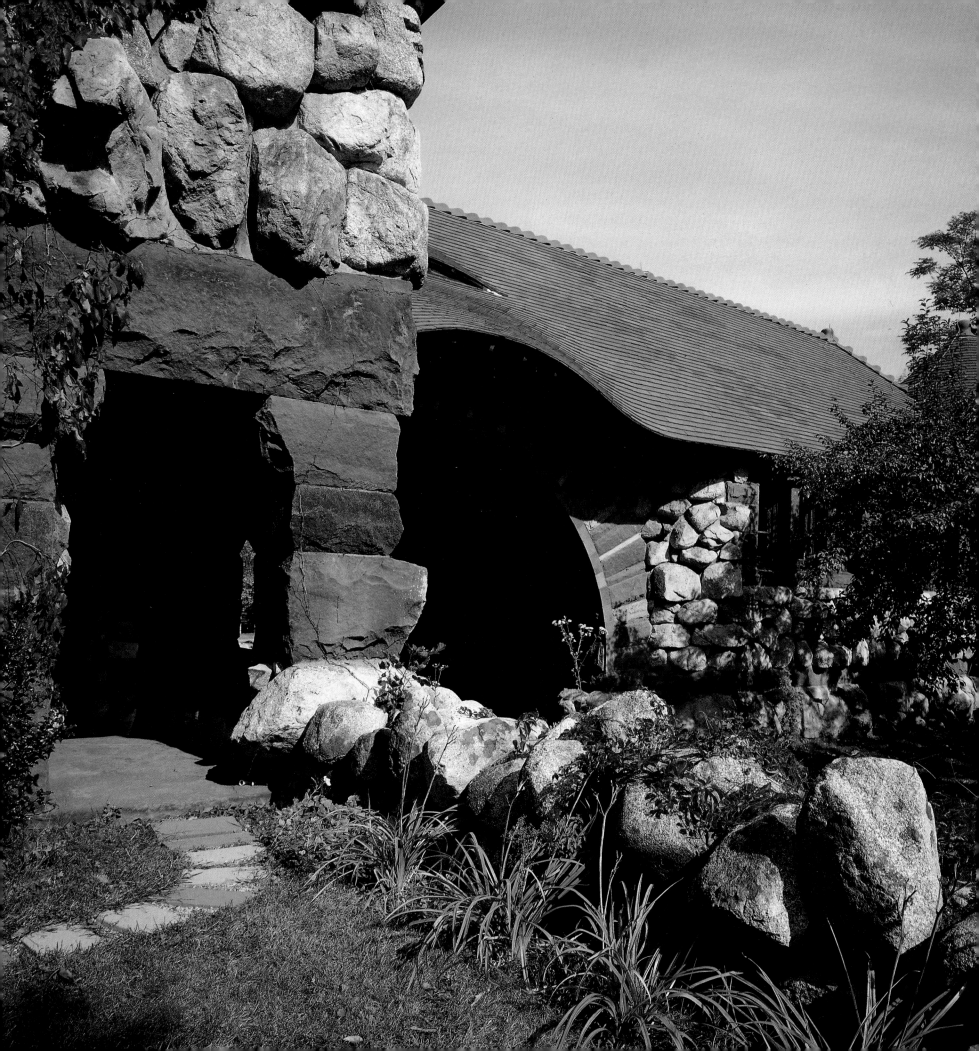

Richardson went along with Olmsted's approach, but one wonders if he did not sometimes feel a pang of remorse when his elemental boulder walls began to disappear behind Olmsted's plantings. In one of their joint commissions, the tower of Grace Episcopal Church in Medford, Richardson did use rocks that jutted so boldly from the wall that creepers could not cover them. "And he was proud that he had done so," Olmsted reported, "calling attention, admiringly, to these stones in the latter part of his life." The year after Richardson's death, Olmsted returned to Langwater to do additional landscape designing in the vicinity of the house and pond. Today that landscape provides a lovely setting for views of his friend's gate lodge, as well as an evocation of the restful moods of his own designs.

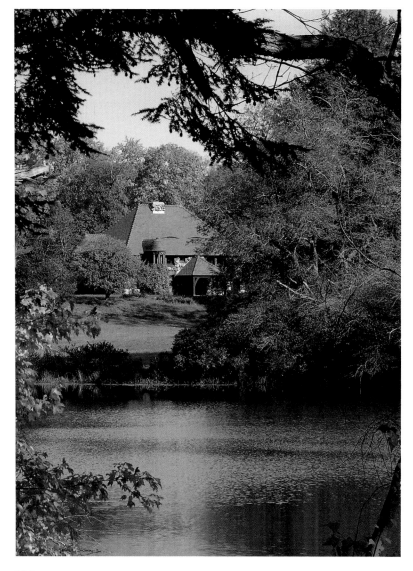

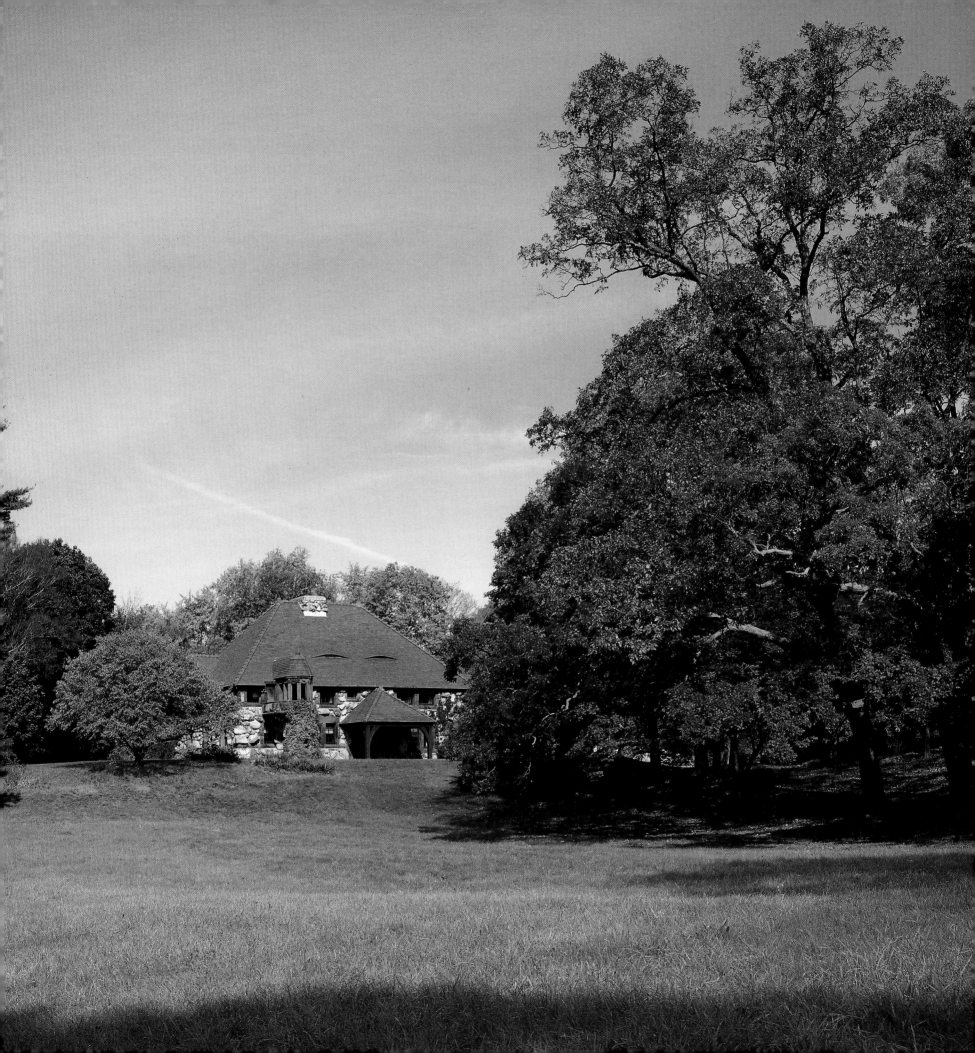

Another striking example of a Richardson all-boulder structure is the Ephraim Gurney House on a hilltop in Beverly Farms on Boston's North Shore. Like the Ames Memorial Hall, it is set solidly on massive ledge outcroppings that spread out like an extended base from the building and its boulder-faced terrace. In front of the house was a rough field with exposed ledges, extending to a sharp precipice.

From both the house and the grounds there was a spectacular view of Massachusetts Bay, with the nearest shore only a mile away. Olmsted's usual treatment of such a site was to emphasize its wild character by further exposing some of the rock outcroppings and planting masses of native shrubs. This variety and texture formed a dark green foreground for the distant view.

In 1884 Olmsted and Richardson also sited and designed an addition to the house of Robert Treat Paine in Waltham, Massachusetts. The addition is twice a large as the original building. It has a lower story and three two-story towers of glacial boulders, with shingles covering the remainder of the second story. Olmsted's special concern was the terrace adjoining the back of the new structure, which stands as one of his most effective "open-air apartments" in relating a building to its natural setting.

A project that illustrates Richardson's willingness to subordinate himself to Olmsted's direction is the Boylston Street Bridge in the the Back Bay Fens. It stands at the point where the northern end of the basin narrows to form a channel leading to the Charles River. Olmsted later declared that he had planned the general shape of the bridge's "single, simple, sweeping arch" before Richardson began his work, adding that his friend's first drawing for the bridge closely followed drawings prepared by Olmsted and his staff in which most of its features had been prescribed "as fundamental *landscape requirements of a bridge in that locality.*" Both men intended the bridge to be a major addition to their series of rough boulder structures. As Olmsted expressed it, "a natty, formal elegant" bridge at that central position in the Fens "would put all the rural elements of the Bay out of countenance. It would be a discord." In the end, the designers had to compromise and face the bridge with squared blocks of granite. Olmsted adjusted to the change but felt that it would have been more successful if it had not been "quite so nice."

In the Boston region, Olmsted and Richardson joined forces on several other projects. One was a house in Cohasset for Olmsted's son-in-law, John Bryant. The shingle-style house sits on a rocky outcropping overlooking the harbor and is supported for much of its length by a boulder basement story that provides a covered carriage entrance as well. On the F. L. Ames estate at North Easton Richardson designed a gardener's cottage that was such a perfect example of the simplicity Olmsted sought in modest suburban houses that it is inconceivable that he did not offer advice on the plan. Olmsted also landscaped the grounds of the Converse Memorial Public Library in Malden and the Thomas Crane Library in Quincy. He planned the grounds of Richardson's railroad station at North Easton, while Richardson designed several stations for the Boston and Albany Railroad for which Olmsted had commissions. Among these were the stations at Auburndale, Chestnut Hill, and Palmer. Next to the station in Palmer Olmsted designed a small park with a stone arch set into a bank at one end. It resembled arches placed during this period at Moraine Farm, Franklin Park, the Boylston Street Bridge, the Fairsted hollow, and the Ames gate lodge as he and Richardson proliferated their extravaganza of stone. Today the arch at Palmer, half buried in a storage yard, appears like a gray ghost from the past. It is a fragmentary reminder of the remarkable collaboration that Olmsted and Richardson began but were denied the pleasure of carrying to full fruition.

The United States Capitol Grounds

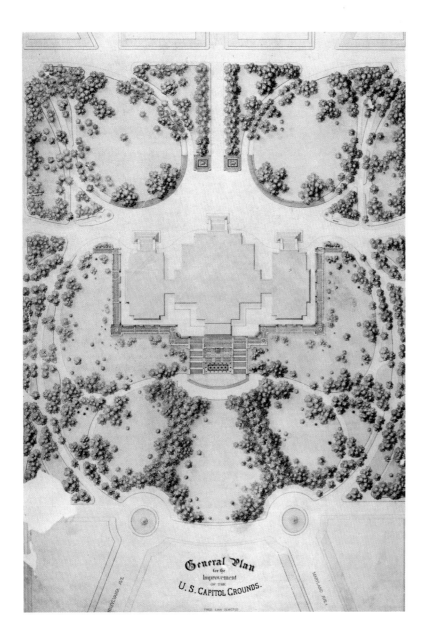

General Plan for the Improvement OF THE U. S. CAPITOL GROUNDS.

FRED. LAW OLMSTED.

IN MAY 1873 Senator Justin Morrill of Vermont, chairman of the Senate Committee on Buildings and Grounds, asked Olmsted to assume responsibility for planning the grounds of the U. S. Capitol. "I hope you may feel sufficient interest in this rather national object not to have it botched," Morrill wrote. Olmsted agreed: it was most desirable to have a properly dignified and tasteful setting for the republic's legislative halls. The Capitol and its grounds must help "to form and train the tastes of the Nation."

During the previous twenty years the new Senate and House wings and Thomas U. Walter's new dome had been added to the building, and the grounds had been expanded a full block north and south to Independence and Constitution avenues. The forty-six-acre extent of the new grounds was still too small for a park, and within that space the function of the Capitol itself took precedence in the design process. In his parks Olmsted subordinated architecture to the landscape, but in planning the grounds for a great structure like the Capitol, the landscape design was subordinated to the building.

One approach, Olmsted pointed out, would have been to plan the entire space in a formal and architectural style. But such an attempt to realize what he called "the grander and more essential aims of ancient gardening" would soon have been turned into a decorative display in the "gardenesque" style. Accordingly, he decided to plan the space in two different styles: formal, with a minimum of planting, in the area close to the building and naturalistic nearer the boundary. Nonetheless, it would be difficult to secure any breadth of landscape effect. Olmsted noted that twenty-one streets touched the Capitol grounds, while foot-paths and carriage drives entered at forty-six different points. Creation of a coherent circulation system would take up much of the design process.

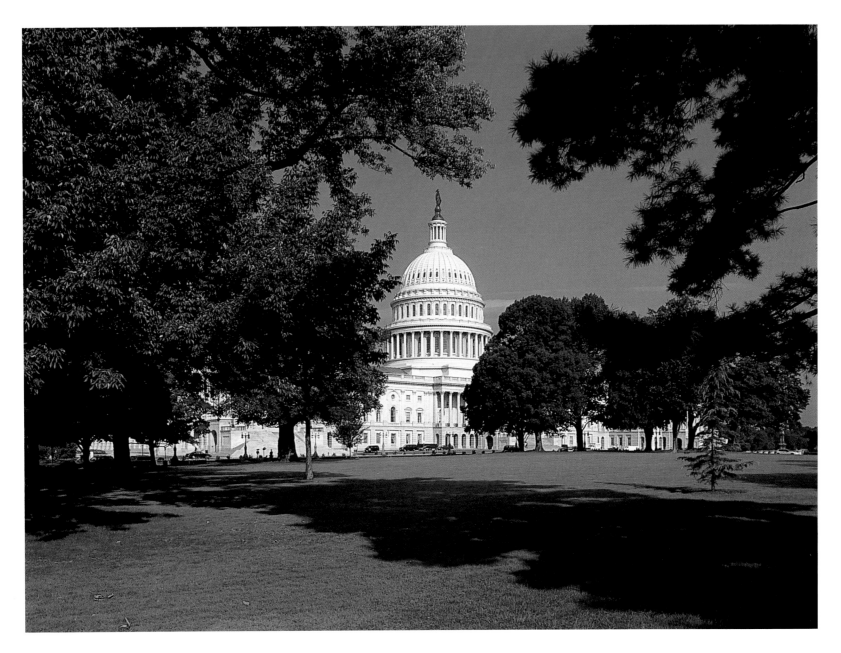

The eastern section of the grounds posed special difficulties: access to the building and a parking area were needed for visitors arriving in carriages; this space also had to accommodate large crowds during inauguration ceremonies. The extension of East Capitol Street into the grounds further fragmented this section. Olmsted drew and redrew his plan in order to create two spacious ovals on the east side, curving the drives on either side in order to secure an open area of gently modulated greensward with scattered shade trees. The ovals provide a peaceful interlude after entering the grounds, a moment of transition and preparation for viewing the building. Olmsted planted many new trees in the ovals, but he spared a few of the old trees that had been part of two barbeque groves—one for Whigs and one for Democrats—which had been introduced during Andrew Jackson's presidency. The surface of the east grounds ran uphill toward the east; where First Street had just been excavated, there was a ragged bank of clay eight feet high. Olmsted leveled the ground, enriched the soil, and installed a drainage system before replanting the area.

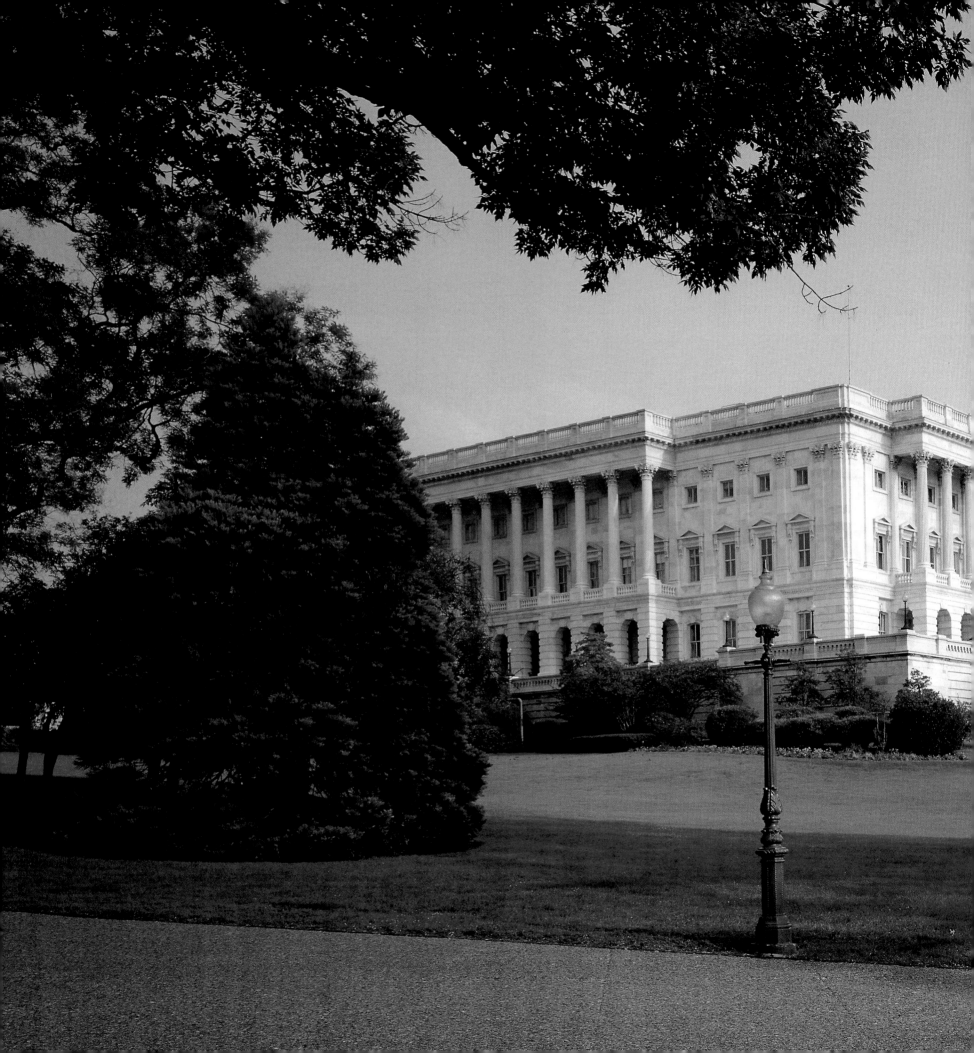

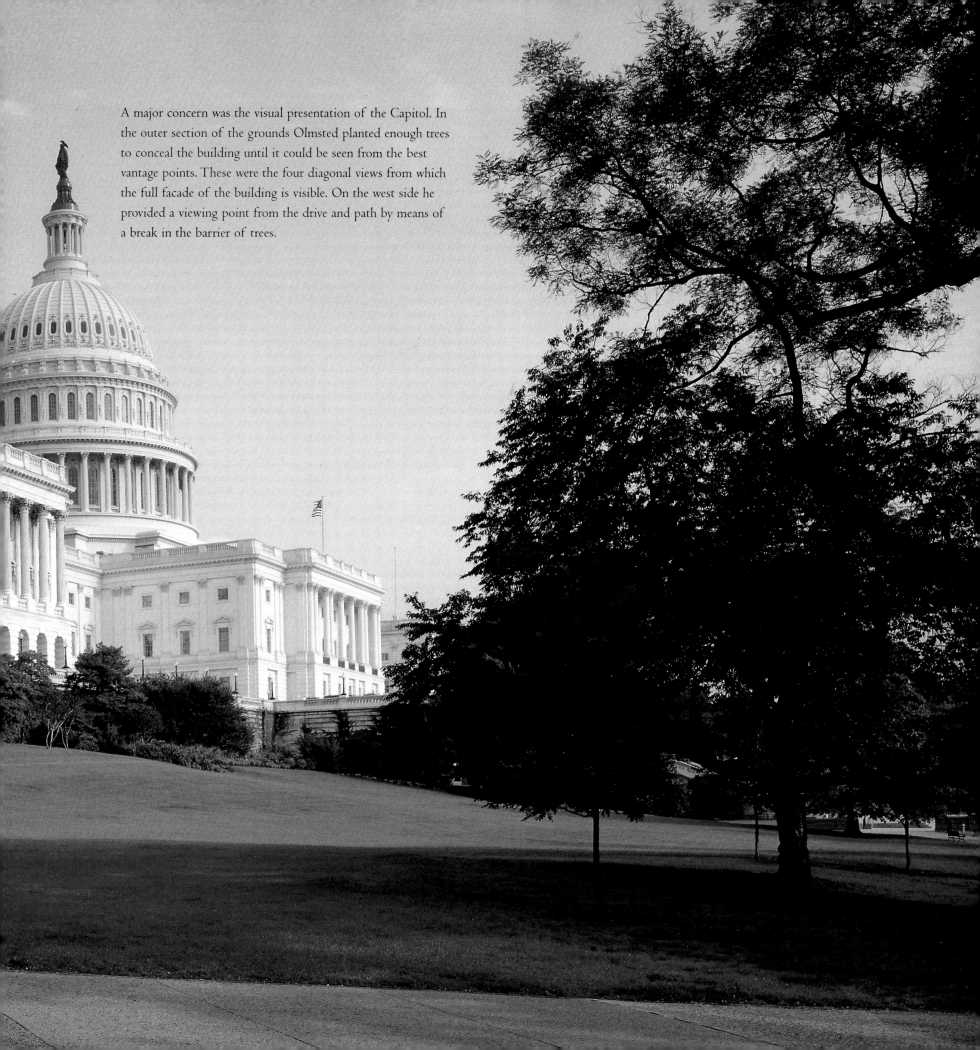

A major concern was the visual presentation of the Capitol. In the outer section of the grounds Olmsted planted enough trees to conceal the building until it could be seen from the best vantage points. These were the four diagonal views from which the full facade of the building is visible. On the west side he provided a viewing point from the drive and path by means of a break in the barrier of trees.

At the northeast and southeast viewing points he placed trellises of open ironwork construction where visitors could sit and view the full east facade. The trellises, or arbors, were to be covered with vines in summer, providing shade, while in winter the open network of iron would let in the sun. The arbors would thus not be visually intrusive in any season. Between each arbor and the Capitol Olmsted placed a triangular panel of grass and low-growing shrubs. The dense mass of shrubs in time grew high enough to block the sight of carriages passing across the line of view while serving as a dark green foreground for the building. Olmsted wished to heighten the dignity and monumentality of the Capitol, and he planned the view from the arbors to produce that effect. As he explained in a letter to the *New-York Daily Tribune*:

The principle of subordination to the building will prevent the introduction in any part of the ground of local ornaments, whether in flowers, leaf-plants, or other objects simply curious or beautiful in themselves. . . . nor will any decoration be such as to hold the eye of an observer when in a position to take a general view of the Capitol.

This quality has been lost in recent years. Today the panels Olmsted so carefully planned on the southeast side are planted with holly and angular crape myrtle, while beds of bright red cannas add a distracting touch of decoration during the summer. On the panel of the northeast diagonal a tree has grown up to block the view of the central section of the Capitol.

For the eastern grounds between the two viewing arbors a major design problem was to separate the green parklike space of the ovals from the bare carriage concourse. Olmsted bounded the edge of the ovals nearest the Capitol with a low wall with simple set-in seats of bluestone. These seats have a view of the full eastern facade: they begin at the point near the viewing arbors at which the entire dome comes into view.

At the end of the rows of tulip trees lining the extension of East Capitol Street Olmsted placed squares of red granite curbing and red granite light standards. The detailing and decorative elements of these features are the work of English-born architect Thomas Wisedell, whom Olmsted engaged as his architectural assistant for the Capitol grounds commission. In this area the sidewalks consisted of geometrically patterned pavement in subtle reds and blues.

The pavement added to the patriotic polychromy of red and blue stonework that Olmsted introduced in the transition zone between the outer grounds and the courtyard, and repeated on the west grounds as well.

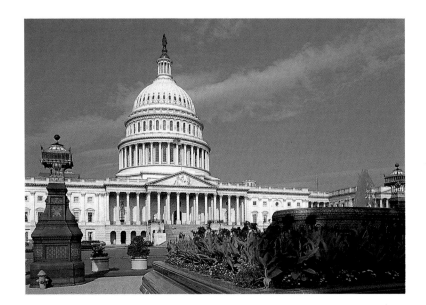

The curbed squares at the inner end of the rows of tulip trees provide additional variety and interest. They hold large tublike bronze vessels that were to be surrounded by plantings of broad-leaved evergreen shrubs in winter and more delicate plants—including callas and papyrus— in summer. As Olmsted envisioned the setting: "Above these, playing over an elliptical vase-like enclosure of bronze is to be a body of fine spray . . . which in sunshine will have a constant rainbow illumination, and at night will be softly lighted from within by concealed gas jets." The fountains would provide a softening element to ameliorate the hardness of surface and harshness of light in the open courtyard.

The major problem posed by the west side of the Capitol grounds was that the greatly expanded building seemed to be perched perilously on the edge of Capitol Hill. The building was surrounded by a berm of earth that had been dug out when the foundations of the new House and Senate wings were constructed. This arrangement, Olmsted felt, coupled with the new dome, caused the building to look top-heavy. Even in much smaller buildings he used terraces to unify the structure with its setting. Here he decided that a massive terrace was needed to give the Capitol an adequate foundation on the north, south, and west sides.

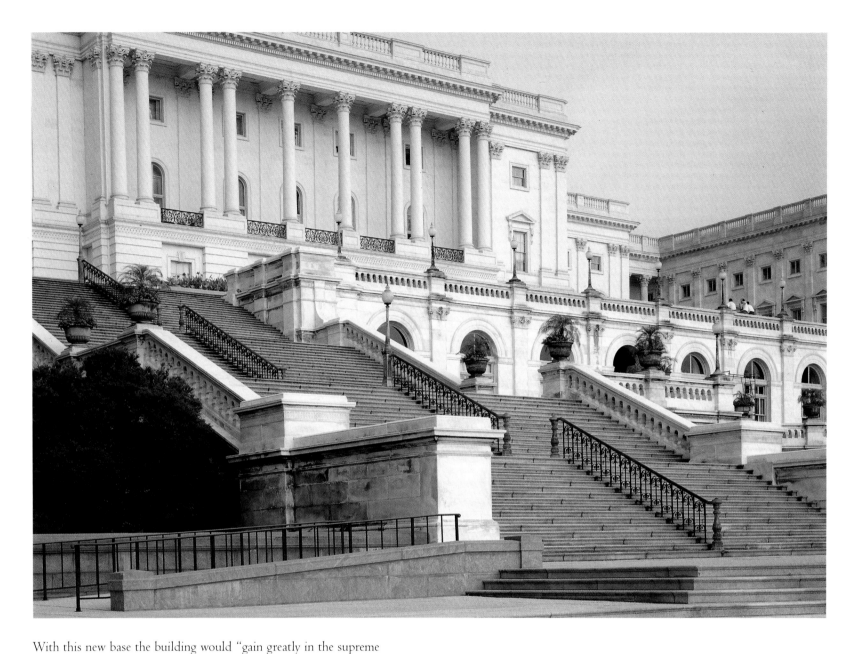

With this new base the building would "gain greatly in the supreme qualities of stability, endurance, and repose." The terrace would be an extension of the building, "partaking of its leading characteristics and extending its material" into the grounds. It would provide a fine view to the west and would establish a stronger visual relation to the city, which was expanding in that direction. "The larger part of the city, the Executive Mansion and the other government buildings will no longer appear to tail off to the rear of the Capitol," Olmsted explained, "but what has been considered its rear will be recognized as its more dignified and stately front."

In order for the terrace to be sufficiently wide and yet not block the view of the lower story of the Capitol, Olmsted designed it on two levels. A trench along the outer edge of the upper terrace was to be "planted and decorated in the Italian manner of gardening, consistently with the architectural style of the Capitol." He also spaced bronze vases of yuccas and evergreen plants along the balustrades of the staircases and terrace to merge structure and vegetation further. There was, however, to be no flower gardening on the terrace.

Since the Capitol grounds were not to serve as a public park, Olmsted placed seats only where the best view of the eastern facade could be enjoyed. But he realized that there should be some area for shelter and rest. His ingenious and elegant solution was to locate a summerhouse in the northwest section of the grounds. In order to make sure that it did not clash with the Capitol building, he set the low, circular brick structure into the hill, covered it with plantings, and surrounded it with shrubs and trees. In every detail of the summerhouse Olmsted strove to produce an effect of coolness, shelter, refreshment, and delicacy. Its center, open to the sky, provided a view of several overhanging trees selected for their delicacy of leaf—willow oak, cedrella, oleaster, aralia, and golden catalpa.

Around the interior walls and sheltered by a narrow roof are bluestone seats. Set in the walls are large stone screens that allow breezes to flow through, bearing "a faint perfume, but suggestive rather of aromatic foliage than the sweetness of flowers." The whole structure was to be mantled with ivy. Above the entrance arches were planters in which Olmsted proposed to plant yuccas, prickly pears, and evergreen shrubs.

One of the wall screens reveals an alcove with rocks of a "crannied, wrinkled, moss and honey-combed character" and a small stream running at their base. The alcove was to be "suggestive of the coolness of a grotto and adapted to the growth of plants found in cool and moist situations," including delicate ivies. The overflow of the central drinking fountain would run a small carillon that produced "sounds suggestive of melody but not a tune and not so distinct as to be always distinguished above the tinkling and murmur of the water falling into the cavity below." For construction of this ingenious feature Olmsted turned to Tiffany's in New York. An added element of delicacy was the decorative brickwork designed by Thomas Wisedell.

With all these subtle touches the carefully contrived interior space of the summerhouse offered refreshment of body and spirit to those trudging up Capitol Hill in the summer heat. It still does so in its present condition, a hidden surprise and delight for those touring the Capitol grounds. The design is a prime example of Olmsted's assiduous attention to every detail, his imaginative conception of the many elements that could be added to a design to make it achieve its full potential. It is possible to identify the myriad little touches by which he "worked up" his design for the summerhouse. In this instance he was not practicing the "art to conceal art," as he did when designing his parks. But the same imagination and attention to detail went into creating those landscapes.

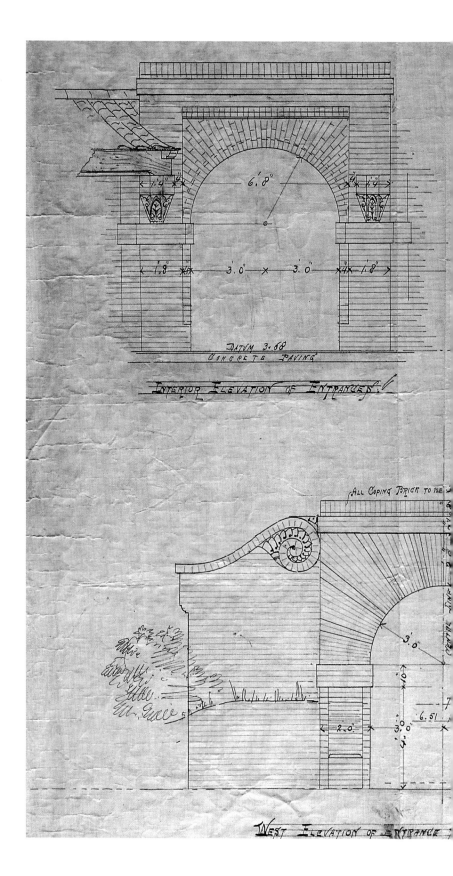

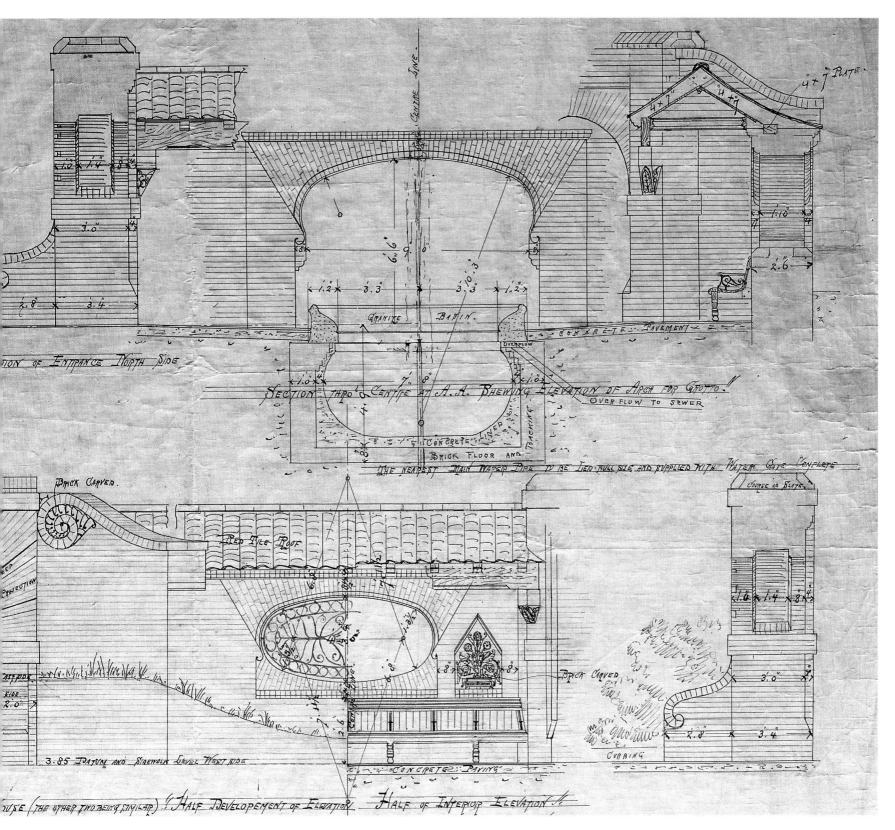

SECTION OF ENTRANCE NORTH SIDE

CENTRE LINE

GRANITE BASIN.

CONCRETE PAVEMENT

SECTION THRO' CENTRE AT A.A. SHEWING ELEVATION OF AREA FOR GROTTO.

OVERFLOW TO SEWER

CONCRETE LINER

BRICK FLOOR AND BACKING

THE NEAREST MAIN WATER PIPE TO BE LED FULL SIZE AND SUPPLIED WITH WATER GATE COMPLETE

BRICK CARVED.

RED TILE ROOF

COURSE OF SLATE

BRICK CARVED

CONCRETE PAVING

3.85 DATUM AND SIDEWALK LEVEL WEST SIDE

CURBING

HOUSE (THE OTHER TWO BEING SIMILAR) ½ HALF DEVELOPEMENT OF ELEVATION HALF OF INTERIOR ELEVATION

199

Scenic Preservation

NATURAL SCENERY was an important source of inspiration for Olmsted from the time of the early "tours in search of the picturesque" that he took with his family to the White Mountains and Niagara Falls. He was convinced of the importance of setting aside areas of special scenic beauty for enjoyment by the public and devoted considerable time and energy to that cause.

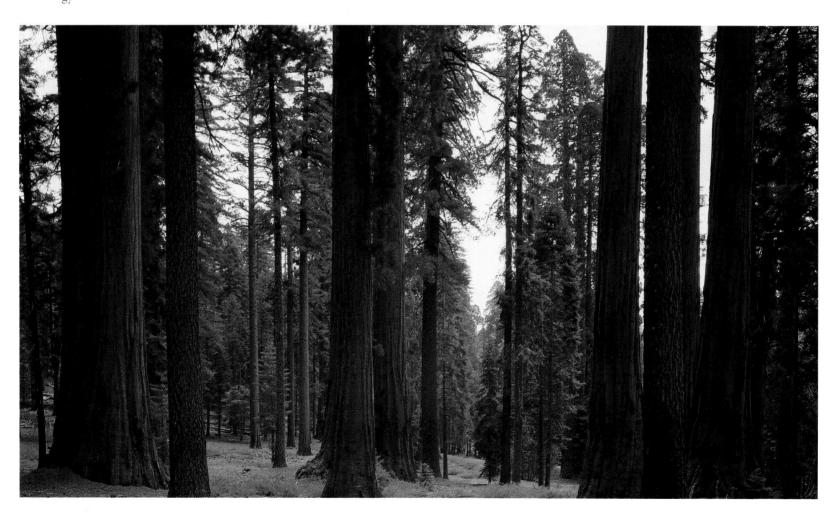

YOSEMITE

His first major role in scenic preservation came in 1864, while he was manager of the Mariposa Estate in California. Within a year of his arrival the federal government ceded Yosemite Valley and the nearby Mariposa Big Tree Grove of giant sequoias to the state for "public use, resort, and recreation." Olmsted played no known role in the campaign for the grant, but his reputation as a landscape architect led Governor Frederick Low to appoint him chairman of the commission in charge of its management.

When he began to explore the scenery of the Sierra Nevada in the fall of 1863, Olmsted was awed by the giant sequoias of the Mariposa Big Tree Grove. "They don't strike you as monsters at all," he wrote his wife, "but simply as the grandest tall trees you ever saw." He was pleased by their "remarkable color—a cinnamon color, very elegant. . . . You feel that they are distinguished strangers," he concluded, "who have come down to us from another world."

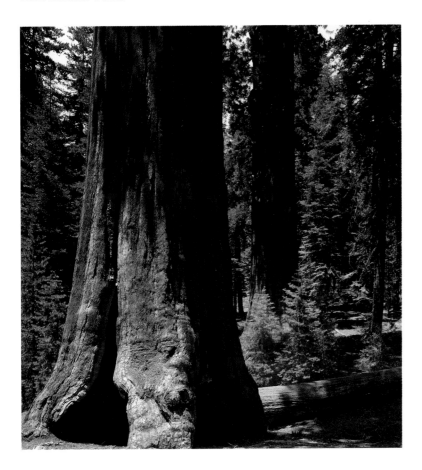

At another time he camped in the Fresno Grove of giant sequoias. The dramatic light cast by the blazing camp fire created a striking effect: "The stately trunks of two enormous sequoias a few hundred feet off lighted up and standing out in a clouded golden color amidst & against obscurity, perfect columns 170 feet, then lost in general obscurity of foliage."

Olmsted's response to Yosemite Valley was shaped by his love of the pastoral and picturesque in landscape. For him the unique scenic quality of the valley was not its towering cliffs and great cascades, which were its most impressive features. The special charm of the valley remained even when the cascades were nearly dry, he said, and it was conceivable "that any one or all of the cliffs of the Yo Semite might be changed in form and color, without lessening the enjoyment which is now to be obtained from the scenery."

What most pleased him was the lush greenness of the valley, where the cold waters of the Merced River keep foliage fresh well into the summer. "There is nothing strange or exotic in the character of the vegetation," he wrote; "most of the trees and plants, especially those of the meadows and waterside, are . . . not readily distinguished from those most common in the landscapes of the Eastern States or the midland counties of England." Of the Merced he wrote, "the stream is such a one as Shakespeare delighted in, and brings pleasing reminiscences to the traveller of the Avon or the upper Thames."

The key to the uniqueness of Yosemite was the special combination of scenic elements—a merging of the pastoral, the picturesque, and the sublime:

There are falls of water elsewhere finer, there are more stupendous rocks, more beetling cliffs, there are deeper and more awful chasms, there may be as beautiful streams, as lovely meadows, there are larger trees. It is in no scene or scenes the charm consists, but in the miles of scenery where cliffs of awful height and rocks of vast magnitude and of varied and exquisite coloring, are banked and fringed and draped and shadowed by the tender foliage of noble and lovely trees and bushes, reflected from the most placid pools, and associated with the most tranquil meadows, the most playful streams, and every variety of soft and peaceful pastoral beauty.

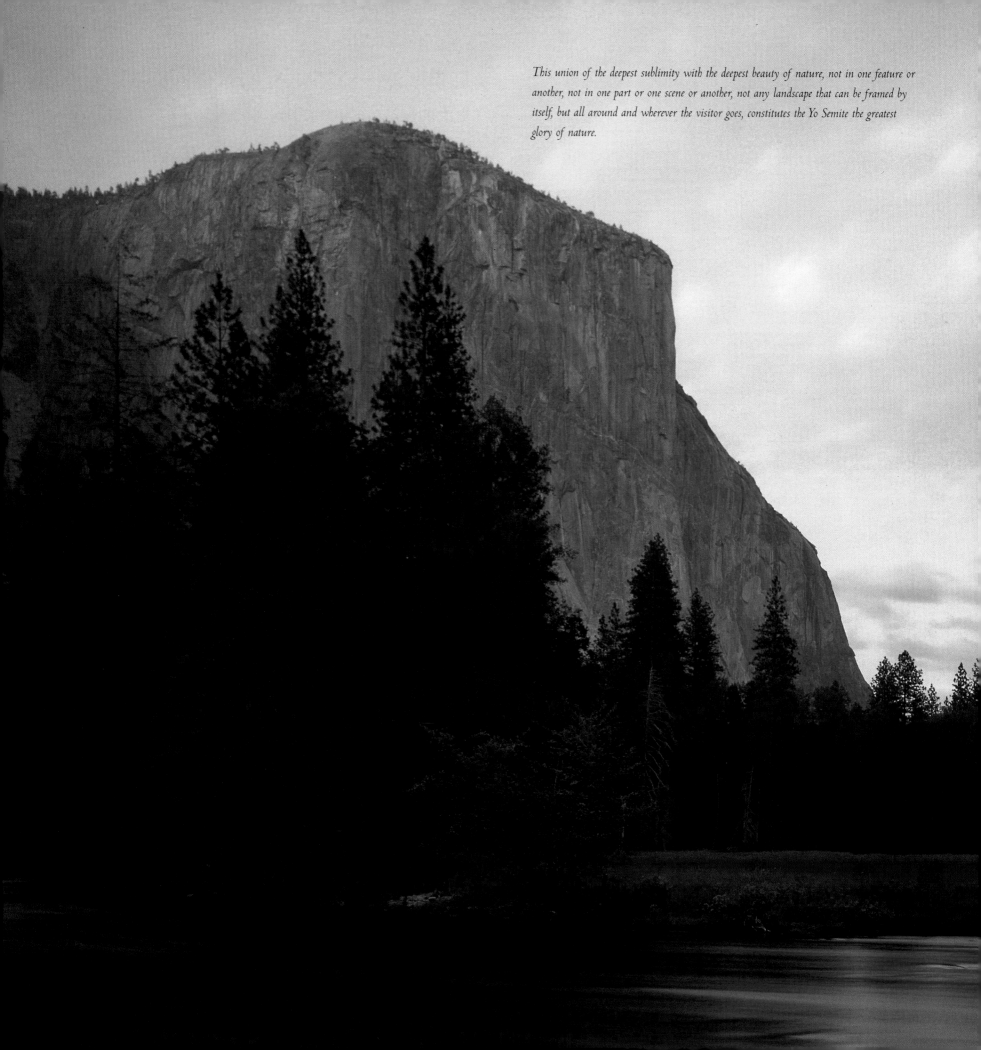

This union of the deepest sublimity with the deepest beauty of nature, not in one feature or another, not in one part or one scene or another, not any landscape that can be framed by itself, but all around and wherever the visitor goes, constitutes the Yo Semite the greatest glory of nature.

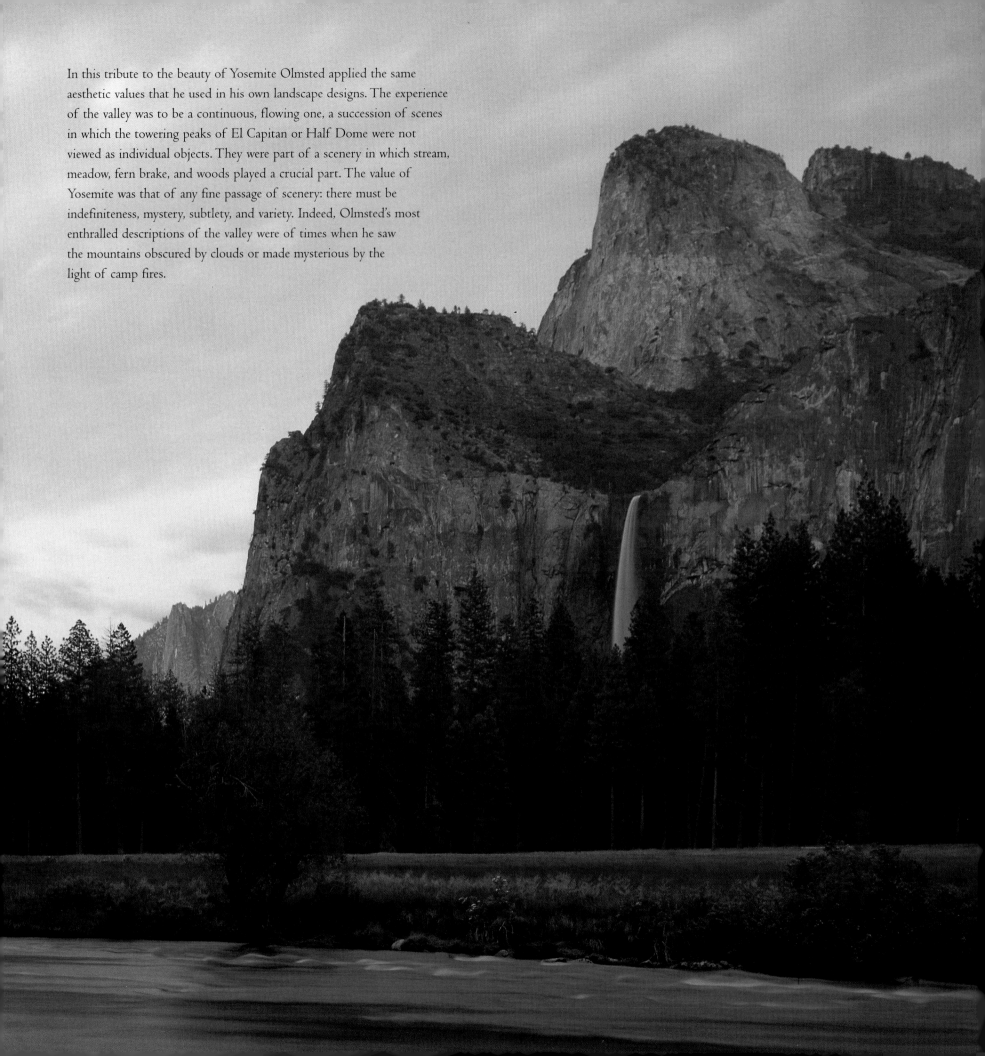

In this tribute to the beauty of Yosemite Olmsted applied the same aesthetic values that he used in his own landscape designs. The experience of the valley was to be a continuous, flowing one, a succession of scenes in which the towering peaks of El Capitan or Half Dome were not viewed as individual objects. They were part of a scenery in which stream, meadow, fern brake, and woods played a crucial part. The value of Yosemite was that of any fine passage of scenery: there must be indefiniteness, mystery, subtlety, and variety. Indeed, Olmsted's most enthralled descriptions of the valley were of times when he saw the mountains obscured by clouds or made mysterious by the light of camp fires.

As he examined the scenery of Yosemite, Olmsted also considered how the grant should be managed. For the report that he presented to the commission when it met in the valley in August 1865 he also drew up a statement on the importance of governmental preservation of scenic areas. In a republic like the United States, the richest citizens must not be allowed to monopolize the most beautiful areas for their own enjoyment. Such areas must be reserved for the public and then made available in a way that protected them from destruction by improper and excessive use.

For the Yosemite grant this meant protection of both the scenic and scientific resources found there. Olmsted proposed that half the commissioners of the grant should be landscape artists or natural scientists. It was of the utmost importance to preserve the grant in its natural state. There must be no lumbering, homesteading, or grazing. The botanist John Torrey told him that within sight of the trail used by visitors there were some six hundred species of plants, "most of them being small and delicate flowering plants." In a few acres of meadow Torrey had found three hundred new species native to California.

The fragility of much of the vegetation in Yosemite Valley dictated a management policy that would serve the needs of tourists in a simple way while protecting the vegetation and scenery as fully as possible. Olmsted proposed that a narrow carriage trail be constructed around the valley and that a few footpaths be built to viewing points. Since visitors could not at that time visit the valley without staying overnight, he recommended construction of five cabins near good camping places where concessionaires would provide a place to rest and rental of camping equipment. From this time on he emphasized that construction of facilities should be limited to the absolute minimum necessary to meet the basic needs of visitors.

His greatest concern, however, was to enable people to visit Yosemite without great expense; otherwise only the rich would benefit from it. The major appropriation he sought from the state legislature was for construction of a forty-mile carriage road from the valley to the nearest access road to the west. For most of the distance the route he planned would have run high on ridges and commanded the finest views. His plan was not adopted, and today one must follow dirt roads and jeep trails to gain a sense of the scenic beauty of the approach route he had in mind.

Olmsted returned to the East soon after presenting his report on Yosemite and retired from the commission the next year. No official action was taken on the report, but it did have influence elsewhere. A half-century later Frederick Law Olmsted, Jr., drew important ideas from it when he wrote part of the legislation creating the National Park Service.

207

NIAGARA

The creation of a public scenic reservation at Niagara Falls engaged
Olmsted's energies for a longer time than did his official involvement
with Yosemite. From the outset he was one of the leaders in the battle
for the reservation.

Despite the fact that the falls of Niagara, more than any other site in America, were supposed to awe the beholder with their size and power, Olmsted's interest focused on other qualities of the scenery there. As he expressed it in his final statement on the subject, the area of the falls had "beauty of a kind depending on refinement and delicacy, and subtle qualities of natural elements of scenery" that were for the most part independent of the falls. It was a beauty "in which the nearness to the eye of illumined spray and mist and fleeting waters, and of intricate disposition of leaves, with infinitely varied play of light and shadow, refractions and reflections, and much else that is undefinable in conditions of water, air and foliage, are important parts."

His first opportunity to explain his views came in 1879, when he helped to prepare a special report of the New York State Survey on the preservation of the scenery at Niagara Falls. His collaborator was James T. Gardner, director of the state survey, who in 1864 had surveyed the bounds of the Yosemite grant for him.

In his report Olmsted argued that in earlier years most of the people who came to Niagara remained for several days and spent much time exploring the area on foot, visiting and revisiting favorite spots. This was the kind of immersion in scenery, letting it work its soothing magic by a gradual and unconscious process, that Olmsted valued so highly. More recently visitors came for a single day and were "put through" the sights in carriages. They saw the most spectacular views of the falls but experienced little of other equally unique and pleasurable qualities of the place. What they missed, in particular, was the view of the rapids above the falls and the lush foliage along their banks.

For supporting testimony Olmsted turned to the statements of visitors who had been attuned to the variety of elements that comprised the scenery of Niagara. The Duke of Argyle had left an eloquent description of the spectacle of the rapids themselves: "It is impossible to resist the effect on the imagination," he wrote; "It is as if the fountains of the great deep were being broken up, and that a new deluge were coming on the world. . . . An apparently shoreless sea tumbling toward one is a very grand and a very awful sight." Olmsted also quoted the English gardener William Robinson, whose concept of the wild garden had strongly influenced his own use of flowers in the landscape. "The noblest of nature's gardens that I have yet seen," Robinson had testified, had been in the vicinity of Niagara: "Grand as are the colossal Falls, the Rapids and the course of the river for a considerable distance above and below possess more interest and beauty."

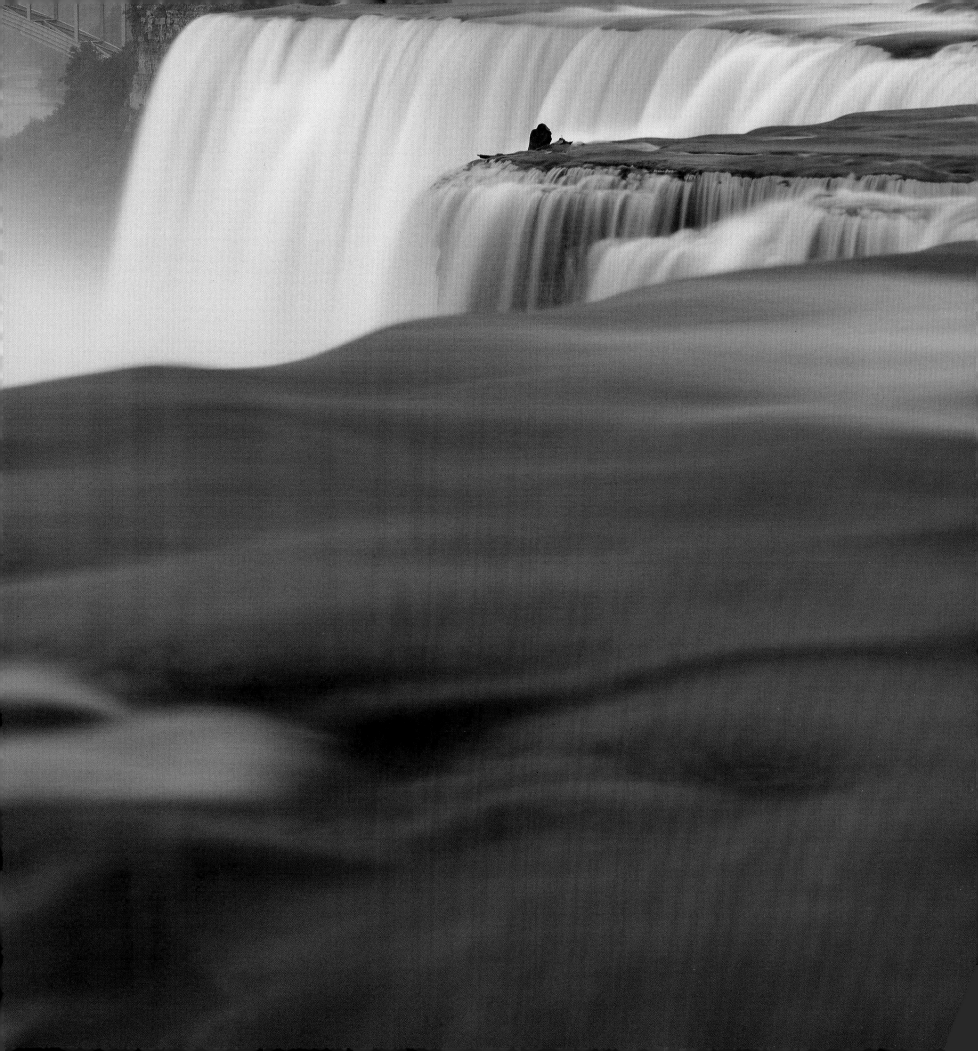

Both Robinson and the American botanist Asa Gray had stated that Goat Island, between the Canadian and American falls, had a greater variety of vegetation than any equal space of ground in Europe or in America east of the Sierra Nevada. Olmsted added that in his travels from one end of the Appalachians to the other he had never seen the same quality of forest beauty that once was common in the Niagara area and that could still be found on Goat Island. The lushness of the shrubs and vines on the cliffsides of the gorge were exceptional, too, always moist and made dense by the pruning action of freezing mist in winter. "All these distinctive qualities," he concluded, "the great variety of the indigenous perennials and annuals, the rare beauty of the old woods, and the exceeding loveliness of the rock foliage,—I believe to be a direct effect of the Falls, and as much a part of its majesty as the mist-cloud and the rainbow."

The key to preserving these elements of Niagara scenery was to protect Goat Island. The Porter family had owned it since 1806 and had preserved the integrity of the scenery. But the sale of the property was imminent, and many new and incongruous uses were being planned. One proposal was to run a canal down the middle of the island and line it with factories; others included a racecourse, a shooting range, and a military encampment.

Added to this problem was the condition of the American rapids. Bath Island, which lay in the middle, was covered with a pulp mill, while along the mainland shore structures proliferated. "In place of the pebbly shore, the graceful ferns and trailing vines of former days," Gardner wrote, "one now sees a blank stone wall with sewer-like openings through which tail races discharge; some timber crib work bearing in capitals a foot high the inscription, 'Parker's Hair Balsam;' then further up stream, more walls and wing dams." Further back from the shore stood an array of structures that included "glaring white hotels" and "an indescribable assortment of rookeries, fences and patent medicine signs." These intrusions must be removed before the scenic beauty of the American rapids and falls could be recovered.

During the next few years Olmsted played an important role in the Niagara reservation movement, circulating a petition that was signed by leaders in the United States, Canada, and Great Britain and directing a campaign in the popular press. Finally, in 1883 Governor Grover Cleveland signed a bill creating the reservation, and two years later a hard-won victory in the legislature provided funds to acquire the necessary land. Internal politics in the Niagara commission led to the joint selection of Olmsted and his old partner, Calvert Vaux, as planners of the reservation.

One of the improvements that Olmsted and Vaux proposed was removal of the intrusive structures along the shore of the rapids and on Bath Island. The other was to keep Goat Island as natural as possible while preparing it for the influx of many visitors. A system of carriage drives and footpaths should be constructed, they advised, with viewing concourses overlooking the American and Canadian falls.

A series of paths and bridges would lead to the three Sister Islands, with their remarkably unspoiled vegetation and spectacular views of the upper rapids. Visitors would be restricted to paths: already they were beginning to destroy the foliage on the Sister Islands and on Luna Island, close to Goat Island and overlooking the American falls. Without some restriction of movement the islands would become "barren rocks" within a few years. Aside from drives, paths, and bridges the only new structures on Goat Island would be two shelters in the woods for protection from inclement weather. Otherwise the natural scenery must remain sacrosanct. In a stern warning Olmsted declared that "nothing of an artificial character" that was not necessary to the enjoyment of natural scenery by large numbers of visitors "should be allowed a place on the property, no matter how valuable it might be under other circumstances."

This concept was so important to him that when he was asked in 1890 to comment on management policies for Yosemite, he repeated verbatim his statement from the Niagara report.

As for the treatment of Goat Island, he illustrated his views with a concrete example:

Suppose, for instance, that a costly object of art, like that of the Statue of Liberty, should be tendered to the State on condition that it should be set up on Goat Island, the precept to which our argument has tended would oblige a declension of the gift as surely as it would the refusal of an offer to stock the Island with poison ivy or with wolves or bears.

The place for new structures was at Prospect Point on the mainland, where a notorious amusement park would be replaced by a reception building and picnic areas. There, visitors could prepare for their encounter with the separate world of Goat Island. By such means the integrity of the reservation's scenery could be preserved from generation to generation.

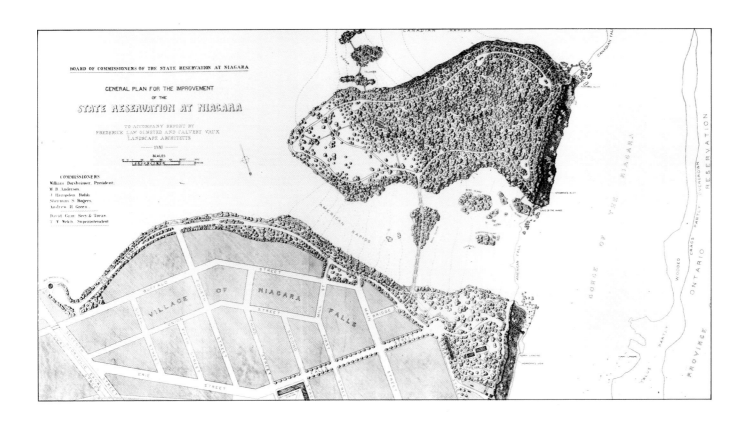

Landscape Architecture for the Semiarid West

MUCH OF THE POWER of the landscapes that Olmsted designed derived from a lushness of vegetation—dense, green turf and profuse growth of shrubs and vines—that he had first encountered in the British Isles. But few areas in the United States were conducive to such landscapes. South of Pennsylvania or west of Missouri rich expanses of greensward could not be sustained except with prohibitive cost of watering. The problem was even greater further west; as he neared the end of his last project there, Olmsted observed, "The absurdity of seeking for good pastoral beauty in the far West is more & more manifest."

In fact, the climate of the semiarid American West called for landscape architecture based on very different principles. For inspiration he turned to the practices of the Mediterranean. He found little contemporary work that was helpful, but the practice of ancient gardeners yielded much of value. The example of Roman villas like that of Pliny the Younger seemed especially relevant. The plantings around those villas provided decoration for the buildings, created a foreground and a middle distance for views from and toward them that was "fresh, green and grateful to the eye," and enhanced the ethereal quality of distant views. This precedent served as the basic concept for the landscape style that Olmsted adapted to the semiarid American West over a period of thirty years.

THE PUBLIC PLEASURE GARDENS OF SAN FRANCISCO

During his two years in California in the 1860s Olmsted began to work out a solution to the problem. From the outset he sought to concentrate vegetation in a way that secured richness and density of plantings without excessive use of water. Public recreation grounds posed a special problem. He was convinced that there should be no parks in California like those that he had designed in the East.

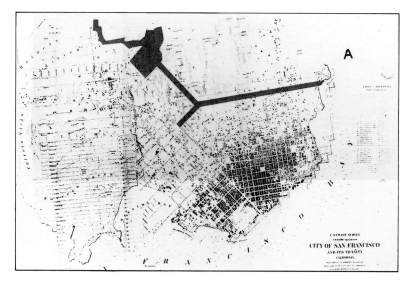

When he was commissioned in 1865 to design public recreation grounds for the city of San Francisco, the major element of the system he proposed was a sunken promenade along the line of Van Ness Avenue from the harbor to a point four miles inland. The promenade would be fifty yards wide, with space for a carriage drive, bridle path, and pedestrian paths. The sides of the promenade, twenty feet high, would be covered with plants that could be watered by hydrants ranged along the top of the bank. By this arrangement, "much less water would be required to keep the plants on the slopes in flourishing condition than would be needed if they were on the open ground, and the water would be distributed with much greater rapidity and economy." Most of the plants would be smooth-leaved evergreen shrubs and vines such as laurel, myrtle, rhododendron, Chinese magnolia, and ivy, which would provide a dense green setting in all seasons. An alternate approach was to use native small trees and shrubs, many of them gathered from nearby canyons. By setting the promenade below ground Olmsted provided shelter from the wind and cut off any view of dusty, unplanted areas in the vicinity.

At the inland end of the promenade he planned an open area for sports and public gatherings. Further away, in the sheltering enclosure of hills near present-day Buena Vista Park, he designed a small parklike area. There would be a "small clear lawn of turf sloping down to a pool of still water, on the other side of which there should be the finest display of foliage in natural forms which art could command." This was the irreducible minimum of lawn that the residents of the city needed, and they were to share it as a communal resource. Nearby there would be a small ramble area, "a surface of picturesque form, with rocks and terraces, and planted closely and intricately with shrubs and vines."

Olmsted's promenade was not constructed; when Golden Gate Park was commissioned, he tried to win its designer, William Hammond Hall, to his point of view. In response to Hall's requests for advice he replied, "I do not believe it practicable to meet the natural but senseless demand of unreflecting people bred in the Atlantic states and the North of Europe for what is technically termed a park under the climatic conditions of San Francisco." The experience of Persia, Turkey, Smyrna, Spain, and Portugal might yield helpful examples, but he believed that the region was unique and must be treated by original means and methods. "It requires invention, not adaptation," he stated. In following years he continued to urge Hall to devise a new form of recreation ground adapted to both the climate and the social conditions of San Francisco.

MOUNTAIN VIEW CEMETERY

The planning of a cemetery in Oakland presented Olmsted with a different challenge to his ingenuity. It was one of several commissions in the Bay Area that the landscape architect could design in a fashion appropriate to both its society and its climate. He wished it to serve as a model of community for the diverse and individualistic society of San Francisco. All elements of that society would be provided for, so that the community of the dead would be an object lesson for the community of the living. The site adjoined a Catholic cemetery whose entrance drive Olmsted extended through the main gate of Mountain View Cemetery. The drives then diverged—to the left for the Catholic cemetery, straight ahead for the small Jewish section of Mountain View, and to the right for the Protestant section. Close to the entrance was the site of a receiving tomb that would hold embalmed bodies of Chinese

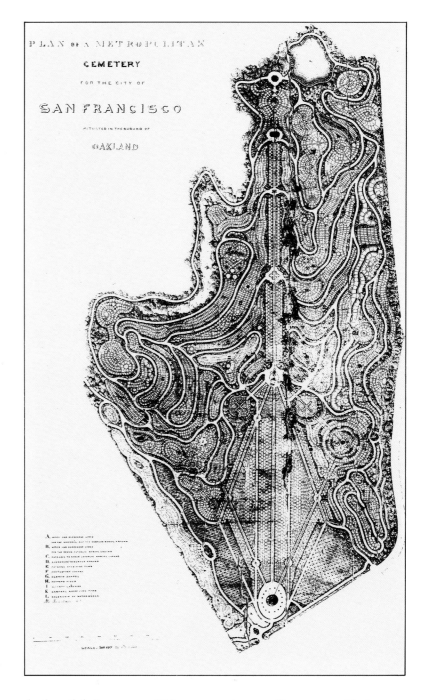

dead until their return to China, as was the prevailing custom. Having observed the number of fraternal organizations on the California frontier, Olmsted reserved numerous sections for them. There was a place even for the poorest citizens: he reserved two large areas near the entrance as potter's fields for the indigent dead. There were also places for individual grave sites.

217

But in keeping with his desire for the cemetery to be "a place of our common grief, our common hopes and our common faith; a place wherein we may see and feel our sympathy one with another," he urged that monuments commemorating important persons be neither conspicuous nor set apart. They should "group and associate in architectural harmony with all that surrounds them," he directed, since "a lonely grave suggests a dreary life and the absence of cordial affection, even when it is marked with stately honors."

Olmsted did not design cemeteries in the East, since he disapproved of placing gravestones in a parklike setting. The monuments broke up the breadth of landscape effect and destroyed any sense of restfulness. "I do not think I could lay out a burial place," he told the English gardener William Robinson, "without making conditions about monuments such as I fear few but Quakers would be willing to accept." In California there was no such difficulty: he simply organized the cemetery in small, enclosed sections without any expanse of lawn. He laid out the flat lower section of the site geometrically in the shape of a diamond and arranged the lots on the surrounding hillside on curving drives. A single, straight allée running the length of the property provided access to the sections on either side.

On the level ground rows of Oriental cypress trees (*Platycladus orientalis*) set ten feet apart were to line the drives and combine with shrubs planted about the lots to give a sense of enclosure. He defended such a formal arrangement of trees, saying that no naturalistic arrangement could be as appropriate in this case and that the trees were clearly subordinate to "the solemn purpose of waiting on the dead." On the hills above dense rows of small trees, or coppices, planted at right angles to the prevailing westerly wind would offer additional protection. Other trees to be planted were the cedar of Lebanon, the stone pine, the Monterey cypress, and an evergreen oak (*Quercus chrysolepis*). He warned against eucalyptus because of its shallow taproot and made no mention of palms. With the low mass of trees in the lines of coppice wood; the formal, pointed shape of the cypresses; and the broad mass of the other large trees Olmsted found the necessary elements for the landscape composition he had in mind. "The brooding forms of the coppices and the canopy of the cedars would unite in the expression of sheltering care extended over the place of the dead," he explained; "the heaven-pointing spires of the immortal cypress would prompt the consolations of faith."

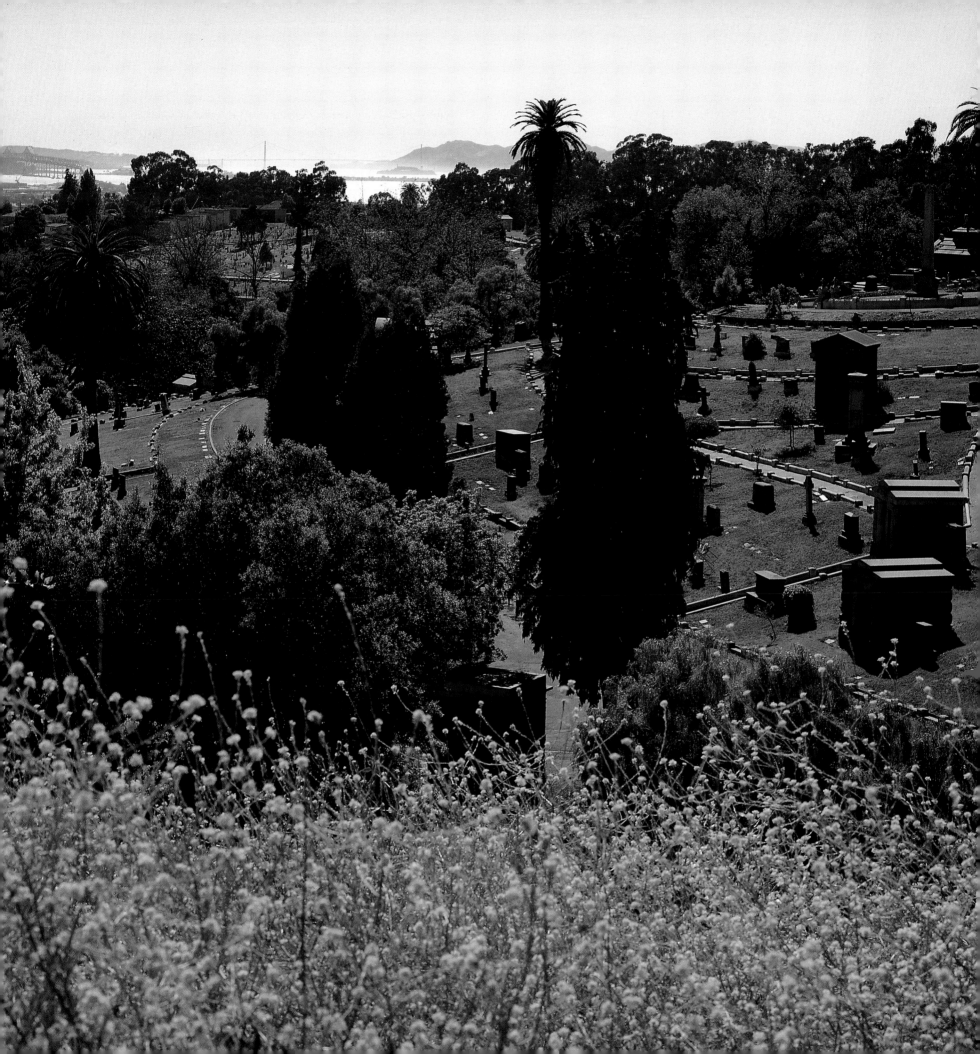

THE COLLEGE OF CALIFORNIA

The design of residential grounds was more common in California than
the planning of parks or cemeteries. Olmsted first addressed the issue in
his 1865-66 plan for the campus of the College of California in Berkeley.
The trustees of the private college knew how they wanted the buildings
arranged and simply wished Olmsted to lay out the rest of the campus as
a "park." He convinced them of the inappropriateness of such an
approach and drew up a comprehensive scheme for the whole site. He set
aside certain sections for college buildings and designated nearly two
hundred acres of the property for private residences. Some of the campus
received parklike treatment: he set aside twenty-seven acres of greensward
as a general pleasure ground. This left a great deal of open ground that
would be dusty and unsightly unless hidden by shrubs or vines. The
foreground of the natural landscape was "coarse, rude, raw," Olmsted
observed, while the surface beyond the near foreground was "hard, bare,
dead and bleak." His solution in San Francisco was to hide that surface
from view through a sunken promenade. At Berkeley he used the steep
hillside of the campus to solve the problem. The space immediately
surrounding each residence would be thickly planted, creating a pleasant
setting. At the same time the plantings would provide a dark green
foreground for distant views toward the Golden Gate. These foregrounds
would become in turn a green middle distance for residences overlooking
them from further up the hillside. Thus, a series of densely planted areas
of limited extent would counteract the general desolation of the
landscape in the dry season. The desired landscape beauty of foreground,
middle distance, and distant prospect would be achieved.

To further limit undesirable views, Olmsted proposed to plant the
roadsides with vegetation that would not require watering but would be
"thick, intricate, luxuriant, rich, and graceful, completely sheltering the
visitor from the sun." The dense vegetation along Strawberry Creek would
help to create this effect, and where possible carriage drives would run
along the edge of the creek and its branches.

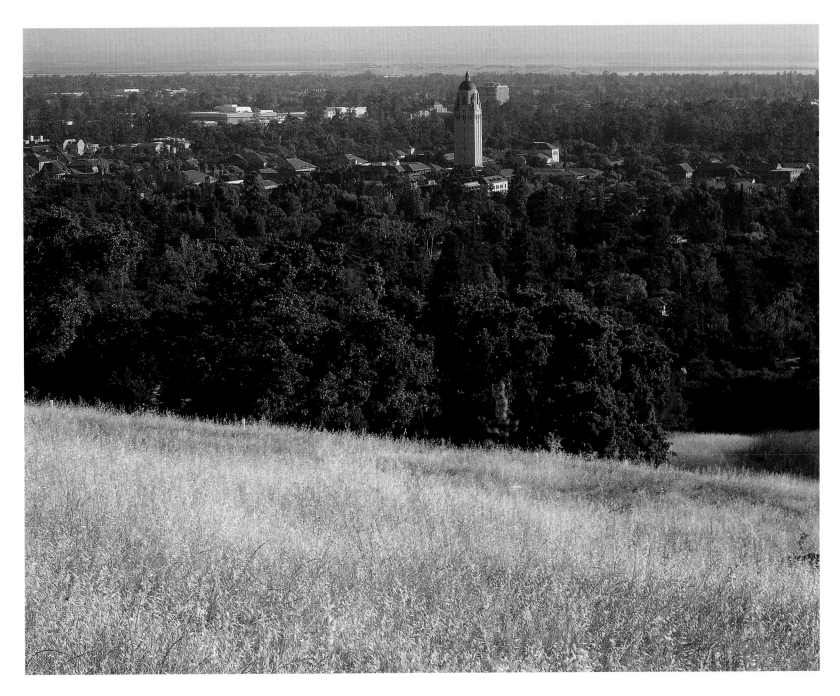

With the planning of the Stanford campus, beginning in 1886, Olmsted had his final opportunity to create an appropriate landscape design in California. His New York–born client's expectations were much like those he had previously encountered in the Bay Area:

I find Governor Stanford bent on giving his University New England scenery, New England trees and turf, to be obtained only by lavish use of water. The landscape of the region is said to be fine in its way but nobody thinks of anything in gardening that will not be thoroughly unnatural to it.

221

Leland Stanford intended to build the university on a level area in Palo Alto near his house. Olmsted attempted unsuccessfully to convince him instead to place the buildings on hills to the west. There, on a hillside with fine views across San Francisco Bay, he could have applied the design principles that he had evolved for the Berkeley site two decades before. Each building could have had surrounding plantings, forming a foreground for the distant view and providing a green middle distance for other buildings above. Governor Stanford refused to change his mind about the site for the campus, but he did come to accept some of Olmsted's ideas about its plantings.

The most distinctive element of Olmsted's planting plan was his treatment of the interior of the central quadrangles. His solution was to concentrate the plantings into a series of densely planted circles—eight in the central quadrangle and six in each adjoining quadrangle. There would be many layers of planting—ground cover, shrubs, and small trees, all entangled with vines and creepers. Here and there a spray of palm-tree foliage would add the effect of "Gloria in Excelsis with lots of exclamation points, thrown in anywhere, in the grand choral liturgy" that had so impressed Olmsted when he saw the tropical vegetation of Panama on his first trip to California in 1863. He had carried that image with him since, had attempted to reproduce its effects in his designs in the East, and now hoped to realize it in the climate of California. Outside the circles the surface of the quadrangles would be bare pavement, easily swept and kept neat.

Planting of the circles began in 1889, but Stanford almost immediately stopped the work. Only an urgent telegram from Olmsted led him to resume it. Even so, he soon forbade additional tall-growing plants in the circles so that eventually the palm trees rose high above the other plantings. Today many of the smaller trees and shrubs have been lost, and the circles retain little of the density and richness of foliage that Olmsted envisioned for them.

PERRY PARK

The final opportunity to demonstrate a new style of landscape design for the semiarid West came in Colorado. In 1889 Olmsted began to plan a summer resort in Perry Park, south of Denver. There he proposed to create a small lake and group eighty-two cottages closely around its edge.

The fifty-foot frontage of the lots would make affordable the various improvements that Olmsted wished to provide: water and sewerage systems, paved roads, retaining walls, planted areas on both sides of the road, and "above all, a high class of maintenance." The whole plan, he informed his client, was based on the conviction that "the settlement will, in the end, be a great deal more attractive if it produces very distinctly the impression of a *community.*"

The planting arrangement that Olmsted proposed was his final version of the concept that he had been developing since the 1860s. There would be dense planting around each cottage, maintained by the owner. The strip of land between the cottages and the lake would contain the road and other utilities. That land would be owned in common and would be planted with a belt of "peculiarly luxuriant trees, vines and creepers." The corporation would maintain the planted area so that no lapse by an individual would mar the continuous band of vegetation surrounding the lake. This circle of green would solve the problem of unsightly dusty areas in the western landscape. The belt of vegetation next to a cottage would provide a foreground for the view of the lake, while the plantings on the opposite shore would serve as a green middle distance for the view of the hills and mountains beyond.

Unfortunately, little of the Perry Park plan beyond construction of the lake was carried out. As Olmsted looked back at the end of his career, he admitted that he had not been able to complete any landscape design suited to the semiarid West. He bequeathed the task to his successors, advising his son in Colorado during the last weeks of his own career:

I need not say that the great puzzle of our profession for the future, for your period, is going to be how to deal satisfactorily with the difficulties of the more arid parts of our continent. . . . It is not improbable that the principal field for originality in our profession for what may be called a new school of L. A., will be found in the future, just where you are.

Biltmore Estate

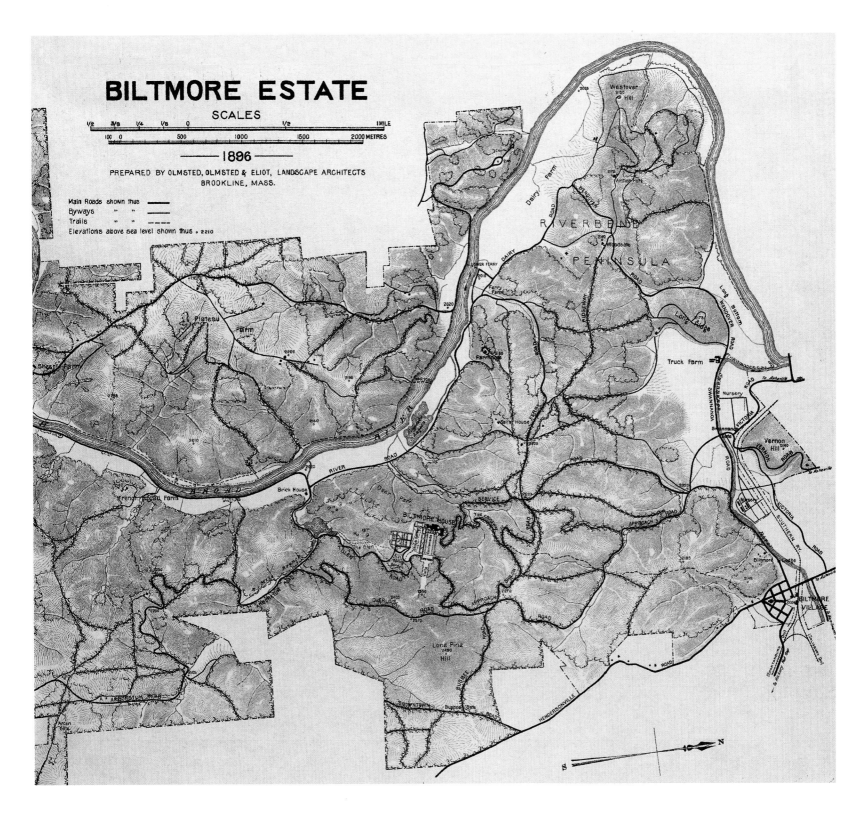

GEORGE W. VANDERBILT'S BILTMORE ESTATE near Asheville, North Carolina, was Olmsted's last great project; it dominated the last seven years of his professional career. It may seem strange that a career so noted for public commissions should end with planning the vast estate of a rich individual. Part of the appeal of Biltmore to Olmsted was the prospect of executing a major landscape undertaking quickly and completely. Vanderbilt had the resources to make that possible, and he took keen interest in Olmsted's work from the start. The grandson of Cornelius Vanderbilt, "the Commodore," and the son of William Henry Vanderbilt, Olmsted's erstwhile neighbor on Staten Island, young George W. Vanderbilt possessed a fortune of thirteen million dollars when he began to plan the estate in 1888 at the age of twenty-five. He was already an avid and judicious collector of books and works of art, and he intended to invest much time and money in creating his North Carolina retreat.

As Olmsted conceived it, the Biltmore commission had ambitious public elements. Early in its development he declared that "this is to be a private work of very rare public interest in many ways. Of much greater public interest—utility, industrial, political, educational and otherwise, very possibly, than we can define to ourselves. I feel a good deal of ardor about it, and it is increased by the obviously exacting yet frank, trustful, confiding and cordially friendly disposition toward all of us which Mr. Vanderbilt manifests."

Vanderbilt's intentions concerning the landscape had at first been simple and predictable. When he showed the site he had selected for the house to Olmsted, he described how he had vacationed for some time in the Asheville area and enjoyed the climate and the distant views. On one of his rambles he came upon the site and thought the prospect the finest that he had seen. He gradually acquired two thousand acres in the area and then asked Olmsted to lay out a park in the traditional manner of English estates. Olmsted, however, assured him that that the terrain was "unsuitable for anything that can properly be called park scenery"; it was "no place for a park." He suggested instead that Vanderbilt should plan a small park as a foreground for the distant view, build some gardens close to the house, and devote the rest of his acres to forestry. This would be a good investment of his capital. Moreover, Olmsted argued, "it would be of great value to the country to have a thoroughly well organized and systematically conducted attempt in forestry made on a large scale."

Vanderbilt took Olmsted's advice. In time he acquired 120,000 acres for his venture in scientific forestry. Eighty thousand of these acres became the basis of Pisgah National Forest, encompassing the "cradle of forestry" in the United States. Olmsted prevailed on Vanderbilt to hire young Gifford Pinchot, one of the first Americans to be trained in forestry in Europe, to oversee the undertaking. After three years at Biltmore, Pinchot left to pursue a notable career in conservation and forestry that included service as the first head of the U.S. Forest Service. The Biltmore School of Forestry, founded in 1898 by Pinchot's successor Carl Schenck, also increased the public significance of Olmsted's plan for the estate.

The other ambitious public scheme that Olmsted proposed for Biltmore was a great arboretum, which he envisioned as "better and *greater*, more comprehensive, than any existing Arboretum in the world." With Vanderbilt's acquiescence Olmsted planned, constructed, and began to plant a nine-mile arboretum road that wound from near the house down to the bottom lands of the French Broad River and back up again into the hills. Along the road he intended to plant all the trees and shrubs that could be expected to thrive in the region.

Approach road, 1892.

225

The arboretum was to serve as a comprehensive testing ground of the materials of landscape architecture in the American South. Olmsted intended to plant the desired species both as scientific specimens and in groups that displayed their landscape qualities. He wished particularly to demonstrate to the public the effectiveness in many situations of using shrubs and small trees rather than large shade trees surrounded by grass. As he explained, "there are, and are to be, a hundred places where the smaller trees and large shrubs may best be planted to one where the trees best known as 'Shade Trees' are desirable." The arboretum would also display species of trees desirable for forestry. With high expectations he declared that it "would serve much more to advance the science of dendrology; the business of forestry, and the art of landscape improvement" than anything that had been done or suggested by the national government or any public institution in the country. As work on the forest, the arboretum, and the grounds of the house progressed, he exclaimed, "It is a great work of Peace we are engaged in and one of these days we shall all be proud of our parts in it."

Selection of species for the arboretum that would make it a truly scientific collection was a continuing problem, however, and after Olmsted's forced retirement in the summer of 1895 the project languished. It was rather in the more private parts of the estate's planning—the approach road and grounds of the house—that Olmsted realized his concepts.

Here, too, there was a public purpose to be served. In all his private work Olmsted created examples of good taste that would demonstrate the superiority of his designs to the decorative gardening and ostentatious display that he encountered on so many estates of the rich. Biltmore would be visited by many potential tastemakers; its example would extend far and wide. As he had done on Boston's North Shore with Kragsyde and Moraine Farm, Olmsted intended to challenge the decorative "public garden" approach and instead proposed to take the natural character of the place and "work it up."

The three-mile approach road to the house at Biltmore was Olmsted's primary opportunity. The road ran briefly along the Swannanoa River, crossed an open stretch of pastoral scenery, then entered a narrow stream valley. In this valley Olmsted brought to bear all his genius for creating complex and powerful passages of scenery. Outlining his concept to Vanderbilt, he proposed that

the most striking and pleasing impression of the Estate will be obtained if an approach can be made that shall have throughout a natural and comparatively wild and secluded character; its borders rich with varied forms of vegetation, with incidents growing of the vicinity of springs and streams and pools, steep banks and rocks, all consistent with the sensation of passing through the remote depths of a natural forest.

Approach road, 1892

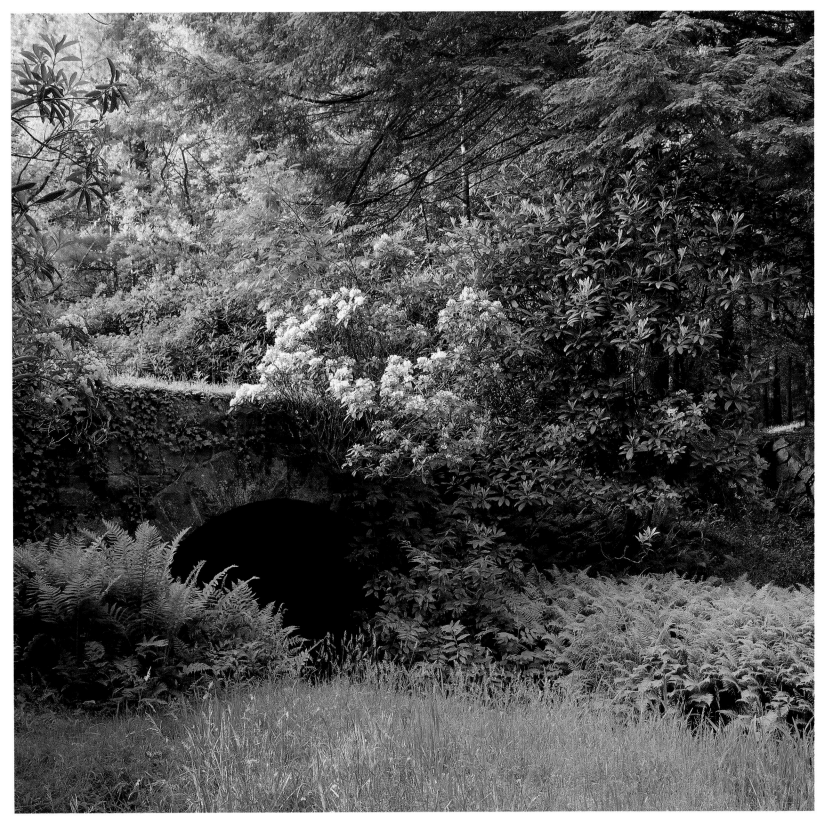

However, Olmsted was never content to recreate the same landscape experience that could be seen in other valleys nearby—valleys that his son enthusiastically described as having "great banks and hillsides of rich rhododendrons and glossy Kalmias ten and fifteen feet tall, with mats of galax leaves and tangles of leucothoe along the stream—all with dark, smooth evergreen leaves." The Biltmore approach road and George W. Vanderbilt's resources offered Olmsted an opportunity to create the most ambitious work of his career in the picturesque style. It was not simply the scenery of North Carolina that he wished to evoke: it was rather the overwhelming sense of the bounteousness and mystery of nature that he had experienced in the tropics. As he instructed the nurseryman Chauncey Beadle, he wanted to secure "an aspect more nearly of sub-tropical luxuriance than would occur *spontaneously* at Biltmore."

The basis of the plantings would be the native materials of the region: he urged Vanderbilt to collect thousands of *Rhododendron maximum* plants, raise them in a nursery for a few years, and then install ten thousand of them as the background planting for the approach road. In front of these rhododendrons he proposed a wide variety of plants, many of them evergreen, that would achieve the effect of richness, delicacy, and mystery that he desired. These would include five thousand "of the most splendid hybrid Rhododendrons (such as they exhibit under tents at the horticultural Gardens of London)," supplemented by Himalayan and Alpine rhododendrons. Among them should be scattered laurel, native and Japanese andromedas, Japanese euonymus, aucubas and mahonia. Along the edge of the brook and on the edge of the drive he planted a great variety of delicate vegetation including "the refined little Abelia rupestris with a cloud of most delicate bloom" and numerous low-growing evergreen plants, ivy, and euonymus. As time went on, he searched increasingly for plant materials that would provide variety of color and texture in winter. He sought hardy olives, evergreens with an olive tint, and more junipers, red cedars, and yews. He also increased the variety and intricacy of the scene with numerous "flowering beds of *little* waterside plants." As he finished the first section of the approach road, he called for more saxifrage, moneywort, sedums, and other low-growing plants.

Such plant materials increased the effect of "complexity of light and shadow near the eye" that was an essential element of his picturesque style. They also contributed to the illusion of extended space that he sought to create along the approach road. He wanted "low-growing, lustrous and fine-flowering plants" in the center of the valley, while on the steeper side slopes he planned "dense, towering walls of foliage." In order to heighten the sense of profusion and richness throughout, he covered the deciduous trees along the road with evergreen climbers. This would "increase the complexity—the screening tropical luxuriance of the scenery," especially in winter. In the vicinity of the larger pools along the road he proposed a body of foliage and deep shade with an opening "reaching back for a considerable distance above, with glints of sun-lighted bits of water, with enough low foliage to make it intricate and mysterious, and to exclude the idea of there being anything artificial in what is seen."

228

Throughout the three miles of the approach road the visitor would be immersed in a rich passage of scenery where the "art to conceal art" was consistently practiced. It would serve as a strong contrast with the first view of the mansion when, as Olmsted described it, "the visitor passes with an abrupt transition into the enclosure of the trim, level, open, airy, spacious, thoroughly artifical Court, and the Residence . . . breaks suddenly and fully upon him." Entering the Esplanade, the visitor sees the facade of the chateau to the right, set off by a foreground panel of grass with a circular fountain basin set low in the center. The two drives along the outer edges of the grass rectangle are flanked on the outside by rows of tulip trees, which frame the building and block any distant view. To the left a high wall with the *ramp douce* leading to the vista area above completes the sense of enclosure.

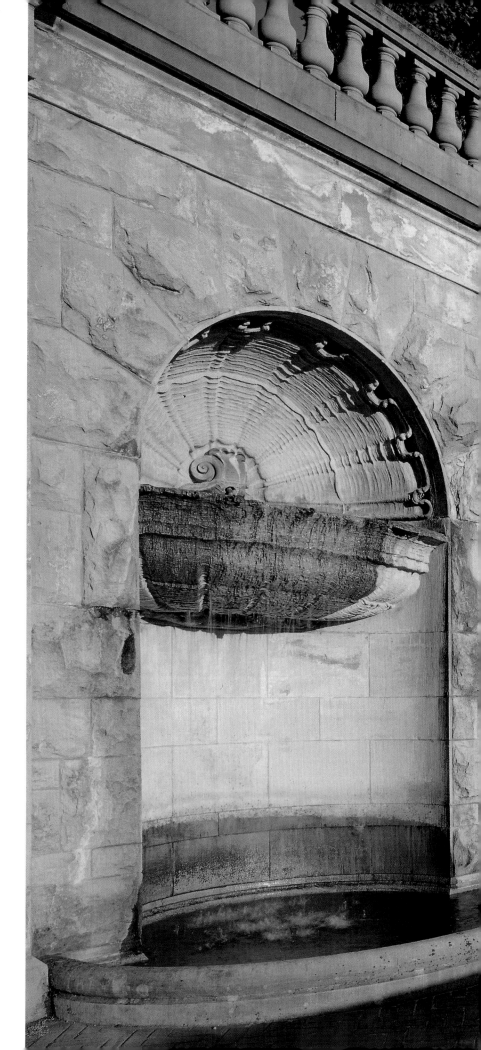

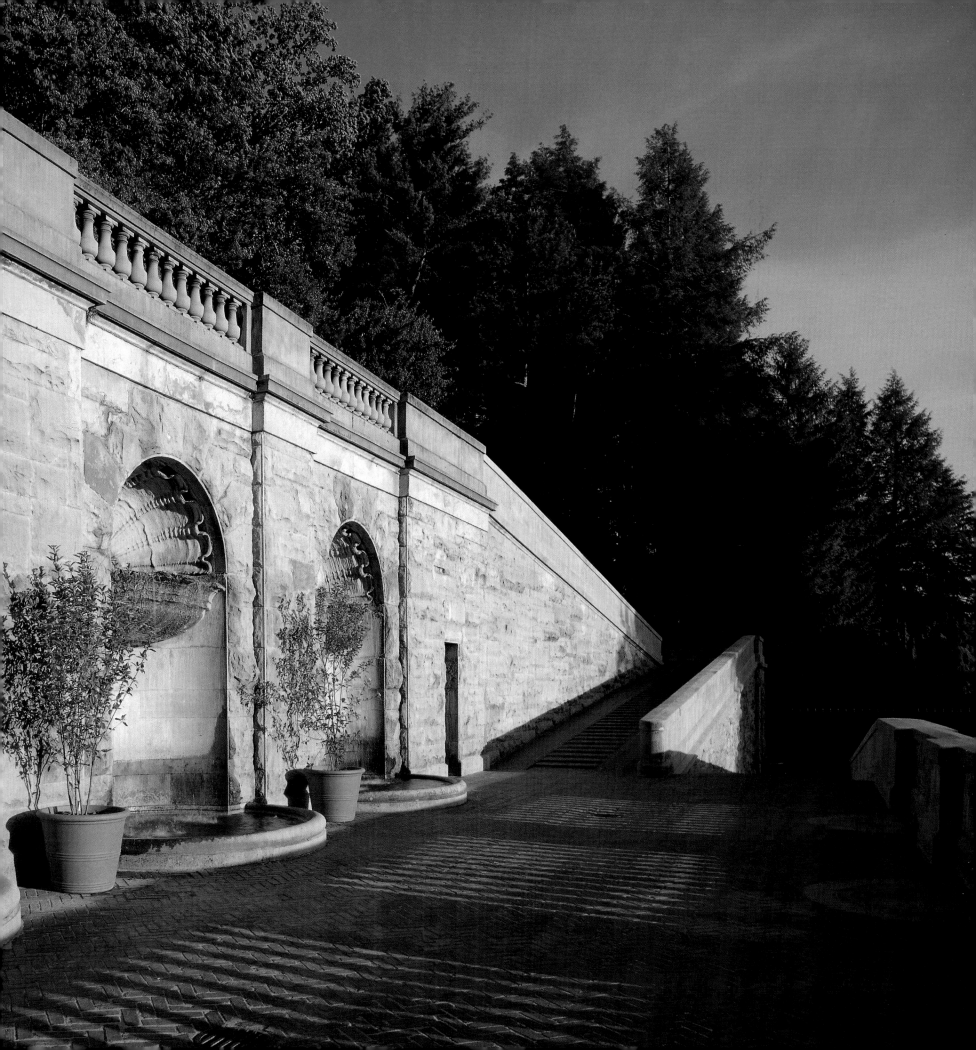

This arrangement of space is a classic demonstration of Olmsted's design principles. The sudden transition from the picturesque approach road to the formality of the Esplanade avoids the "incongruous mixture of styles" that he so disliked. The concealing effect of the allée of trees and the simplicity of the Esplanade create a space where all elements are devoted to the presentation of the building. As he had done so carefully in planning the grounds of the U. S. Capitol, Olmsted subordinated the materials of landscape architecture to the effect of architecture. From the front of the mansion, the visitor can view the full expanse of the allée formed by the Esplanade and the Vista above the *ramp douce* terminating at a distant statue. Olmsted designed this area to increase a feeling of spaciousness in the view eastward from the house.

Olmsted seldom intruded on the sphere of the architect with regard to the

general style of buildings whose grounds he planned, but he often made suggestions about the siting and arrangement of structures. At Biltmore he pressed for the construction of two features adjoining the mansion. One issue was the convenient arrangement of outbuildings: he proposed a complex of stables northwest of the house, primarily to shelter the entrance from northerly winds.

The stable is hidden from view by the row of tulip trees on the north side of the Esplanade and by a dense planting of pines adjoining it. Secondly, Olmsted urged construction of a terrace on the south to present the panoramic view in the most impressive way. He had taken pains to screen the western view from the approach road and the Esplanade. It was necessary to pass through the house in order to enter the loggia from which the vista could be enjoyed.

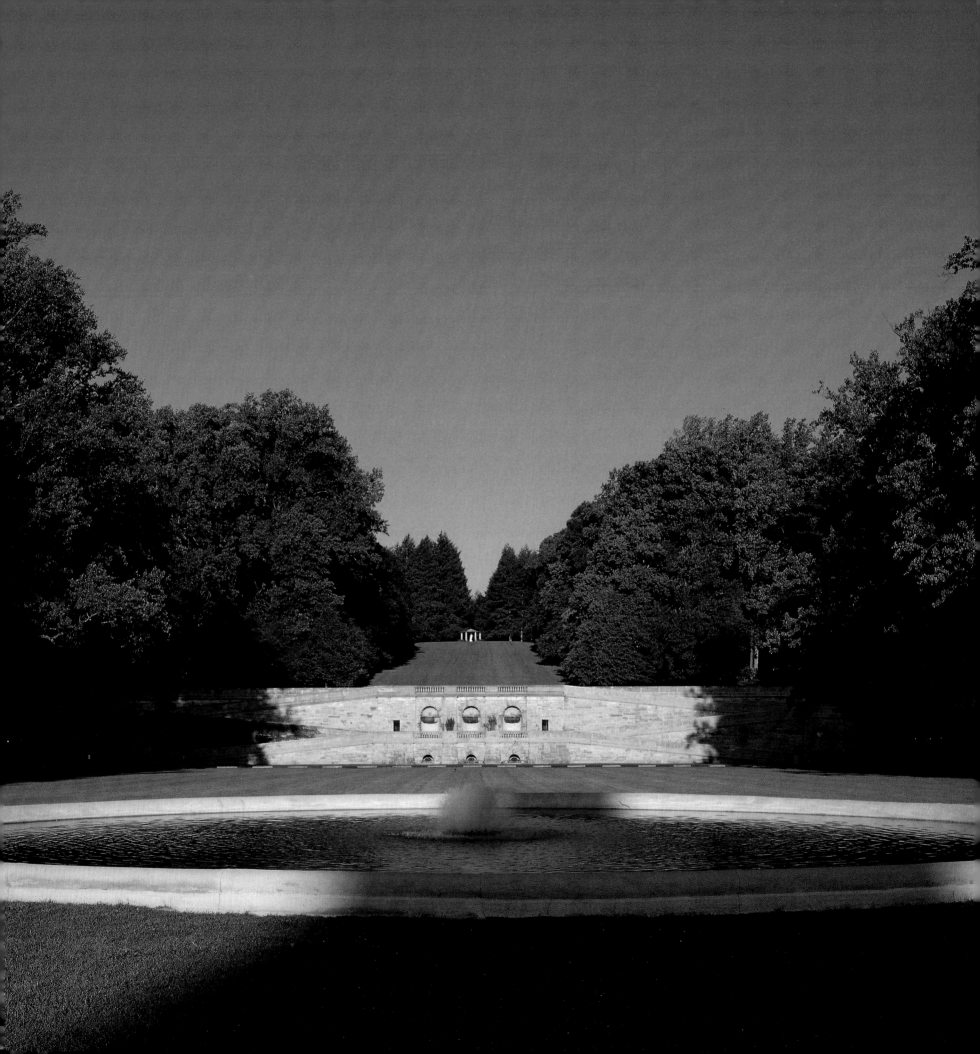

Olmsted also wanted a separate exterior room for experiencing the view. Standing on the terrace and looking across the Deer Park and the French Broad toward Mount Pisgah and the Great Smokies, one is not even aware of the mansion: instead, the visitor is projected into a space in which nothing need be visible but the view. In this way Olmsted made special provision for the one element of the site that had led George W. Vanderbilt to select it for his residence. At the same time he conceived the terrace as "a great out of door general apartment" for a variety of uses. He wished the Biltmore residence to illustrate the advantages of extensive outdoor living space. To John C. Olmsted he observed, "I have seen but one house that had anything like the amount of out of door living room that I think is desirable." Indeed, the terrace is as large as the area covered by the mansion. As part of this conception he proposed the tea house at the southwest corner. The terrace, therefore, is a more formal version of the terrace at Moraine Farm with its pavilion and is intended to serve the same variety of functions.

Descending the steep hillside south of the Esplanade, Olmsted also planned three areas that were invisible from each other and had no distant view. The first, running the length of the Esplanade on its south side but set several feet below it, was a narrow terrace designed in a formal style. As first proposed, it had three geometrically shaped basins, one for fish and two for aquatic plants. These water features were set between four parterres with plants arranged in geometrical patterns. The south wing of the house is visible from the garden, which reflects the formal French style of the mansion. This arrangement continued the formal treatment of the Esplanade, while introducing horticultural decoration that Olmsted would have viewed as too distracting for the foreground view of the house. The southern orientation of the formal terrace and the high sheltering and sun-reflecting wall along its northern side also created a more protected enclosure than was possible on the Esplanade. The final design consisted of three basins, with simple grass panels at each end. Historical photographs show none of the intricate parterre planting of Olmsted's original plan of 1892.

On the hillside below this formal terrace Olmsted created the Ramble which he described as "a glen like place with narrow winding paths between steepish slopes with evergreen shrubbery." Set in the lee of the house and the viewing terrace, this feature was intended to be a protected space where one could walk in relative comfort even in stormy weather. It came to be called the Shrub Garden. The treatment was unusual in that it was not thickly planted with ground cover right up to the edge of the paths, as was the case with the Ramble in Central Park and the Biltmore approach road itself. Instead, there were areas of turf between the paths and the masses of shrubs and small trees. In this respect the garden has the character that Olmsted planned for much of the Biltmore arboretum. It demonstrated an alternative to shade trees surrounded by lawn, a treatment he thought was used too often.

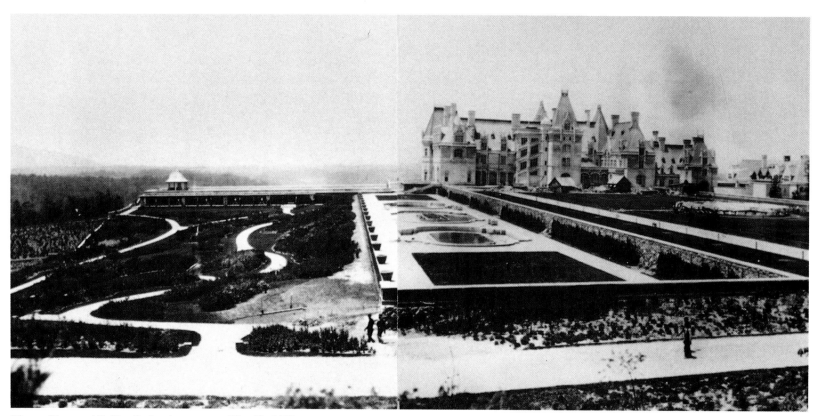

Biltmore House and Stables, Esplanade, terraces and Ramble, 1895.

A brick arch at the eastern end allowed the visitor to pass under the drive and into the more naturalistically planted vale at the top of the Glen. It consisted of a central lawn area with masses of shrubbery on its steep sides. This area came to be called the Spring Garden.

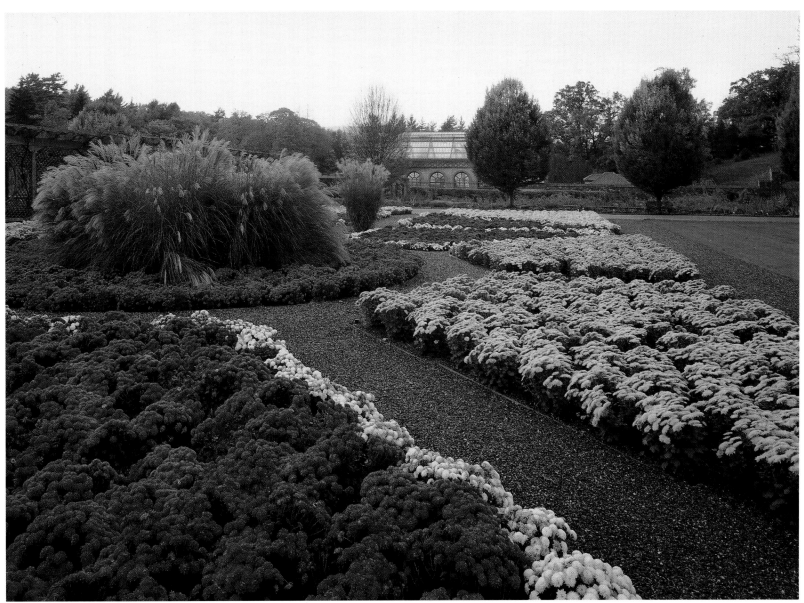

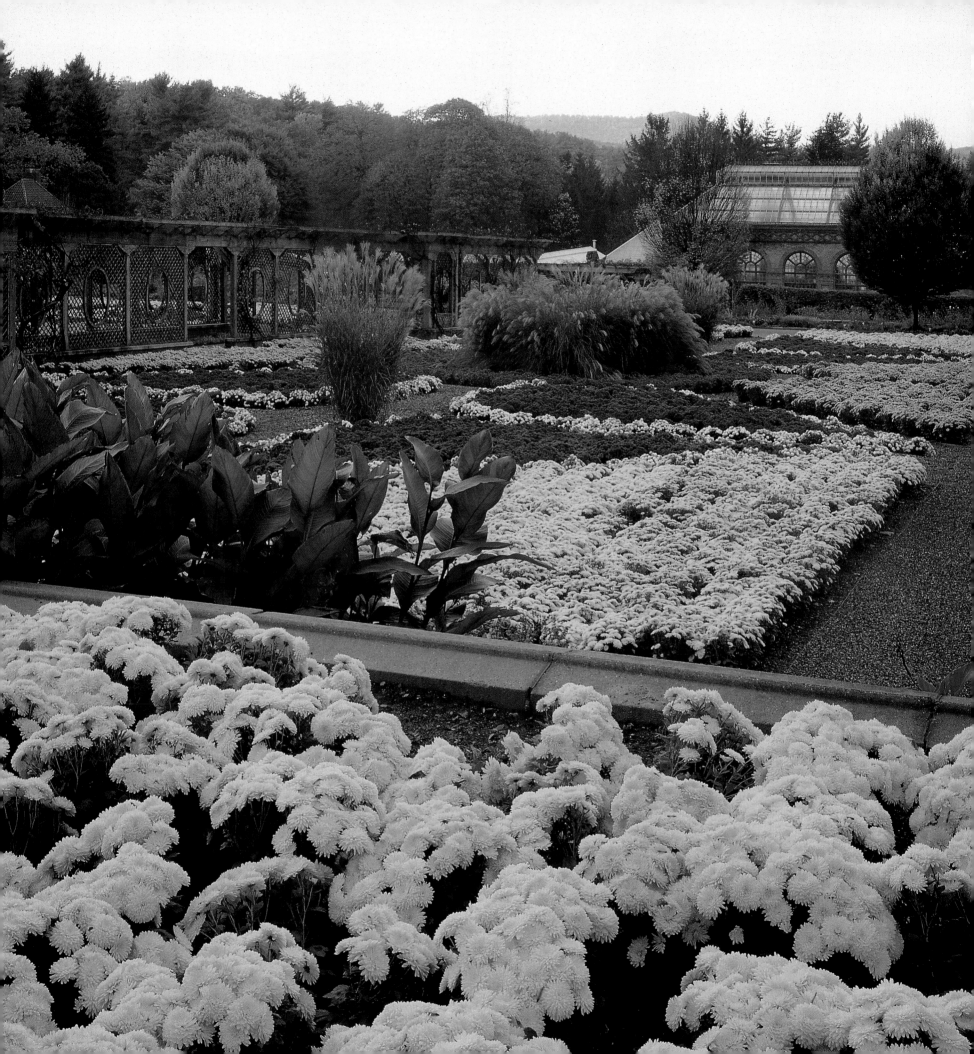

South of the Ramble was the one space that fits Olmsted's definition of a garden: a walled enclosure visually separate from areas with broad landscape effects and devoted to growing plants without any attempt at landscape composition. Olmsted intended to devote this garden to growing choice fruits, vegetables, and flowers for use by the Vanderbilts. He was particularly eager to make it a demonstration ground for espaliered fruit. To this end he enlisted the help of a specialty French nursery, Croux & Sons. The example would, he thought, be a valuable one for American visitors. A heated conservatory building was needed to grow early-ripening and delicate fruits, palms, ferns, and flowering plants. Olmsted sited it at the lower end of the walled garden so that it would not interfere with the view of the lake from the Esplanade.

The fruit and vegetable garden was simply a functional feature, whatever its educative value might be, and not part of the scenic progression leading away from the house and continuing down through the Glen, a sheltered area picturesquely planted with a variety of shrubs. The Glen has a delicate atmosphere created through prolific use of ferns and low-growing, flowering plants. Because the Glen was to be used only by pedestrians, Olmsted could achieve an effect of intricacy and intimacy that was not possible along the approach road. In time this area was transformed by Chauncey Beadle, the head gardener, into the Azalea Garden, which name and character it retains today.

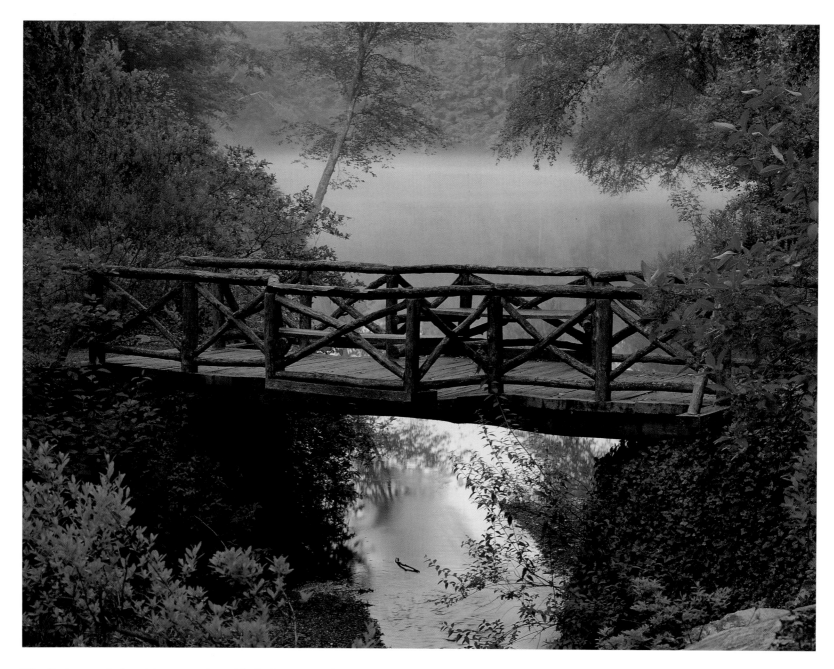

The final space designed in connection with the house was the Lake, today called Bass Pond, which Olmsted created at the bottom of the Glen. He constructed two islands to add variety to views across it, increasing the apparent extent of space beyond them and creating "more effect of intricacy and mystery." The islands also served as secluded nesting places for waterfowl. The islands and shallow shores of the pond were to be planted with locally gathered aquatic plants—flags, rushes, cat-tails, and irises—to create an impression of wildness and profusion.

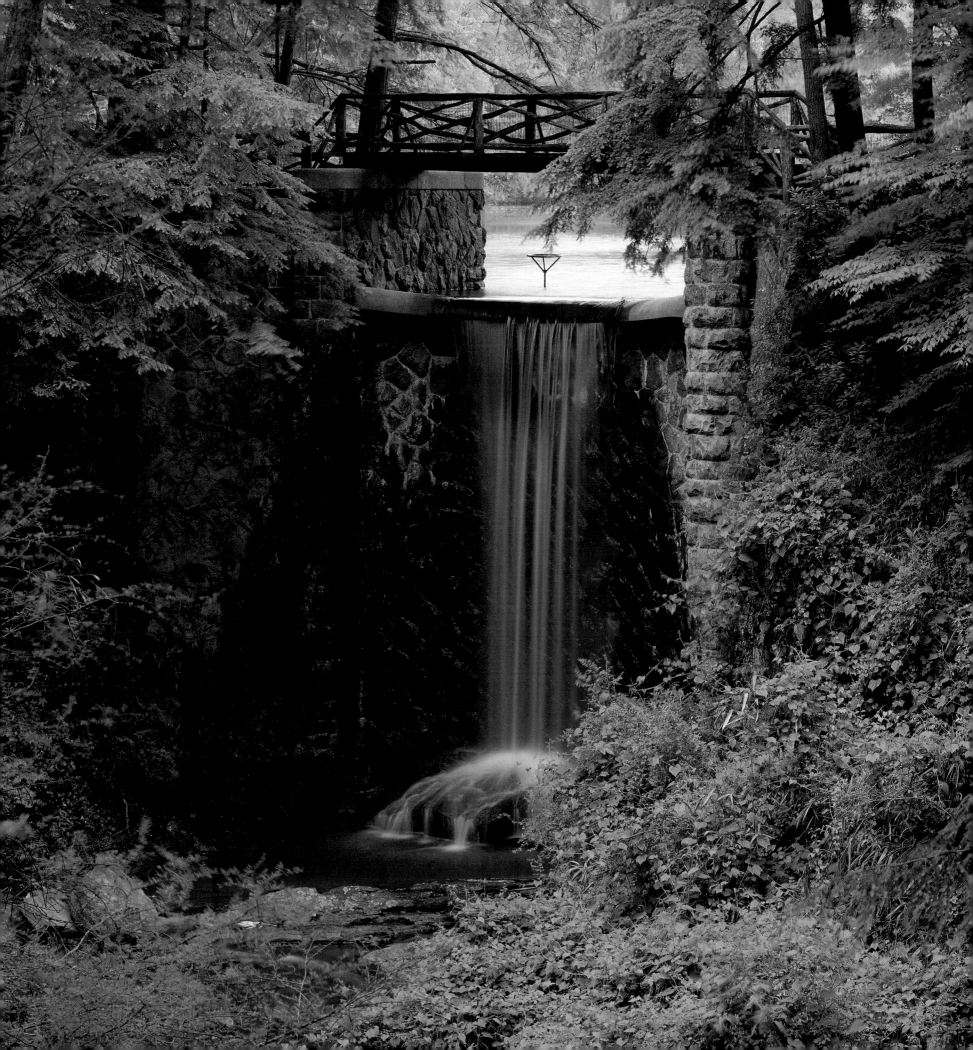

The shelter and stone stairs at the upper end of the pond still retain much of the rustic character and scenic beauty that Olmsted planned for them. One can still experience the dark enclosure of hemlocks, overhanging the dam and the stream below it, as Olmsted described it in his written directions for planting the area.

After leaving the pond, the Glen Road descends to the floodplain of the
French Broad River. It passes agricultural fields and rustic stone bridges.
A major feature is the lagoon, which enhanced the view from Biltmore
House with a larger body of water than the river alone provided.

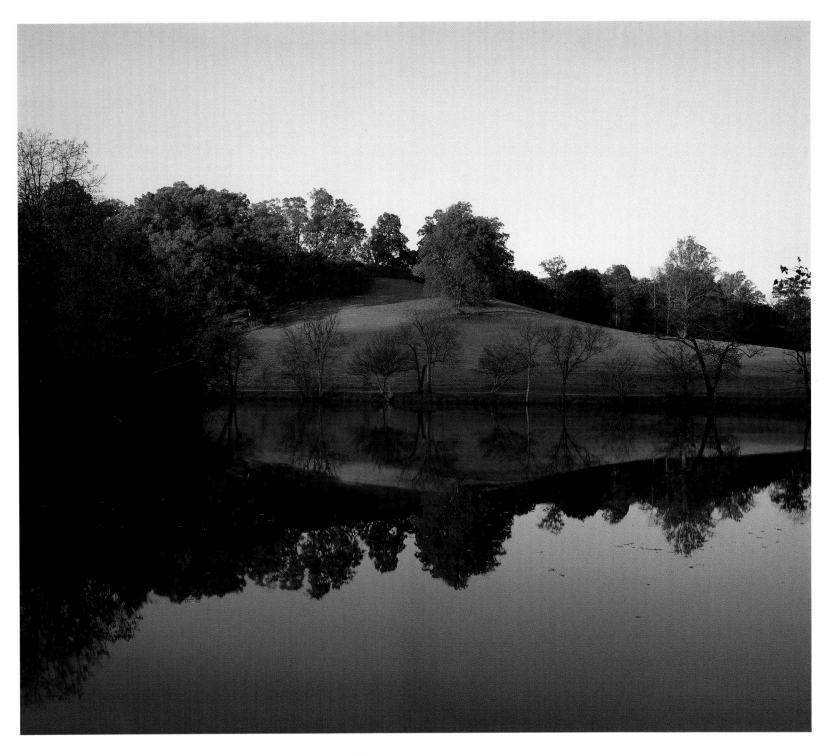

The lagoon also acts as a reflecting pool for the view back toward the chateau. In this area one also encounters the pastoral landscape of Deer Park, which Olmsted created as a foreground for the vista from the house.

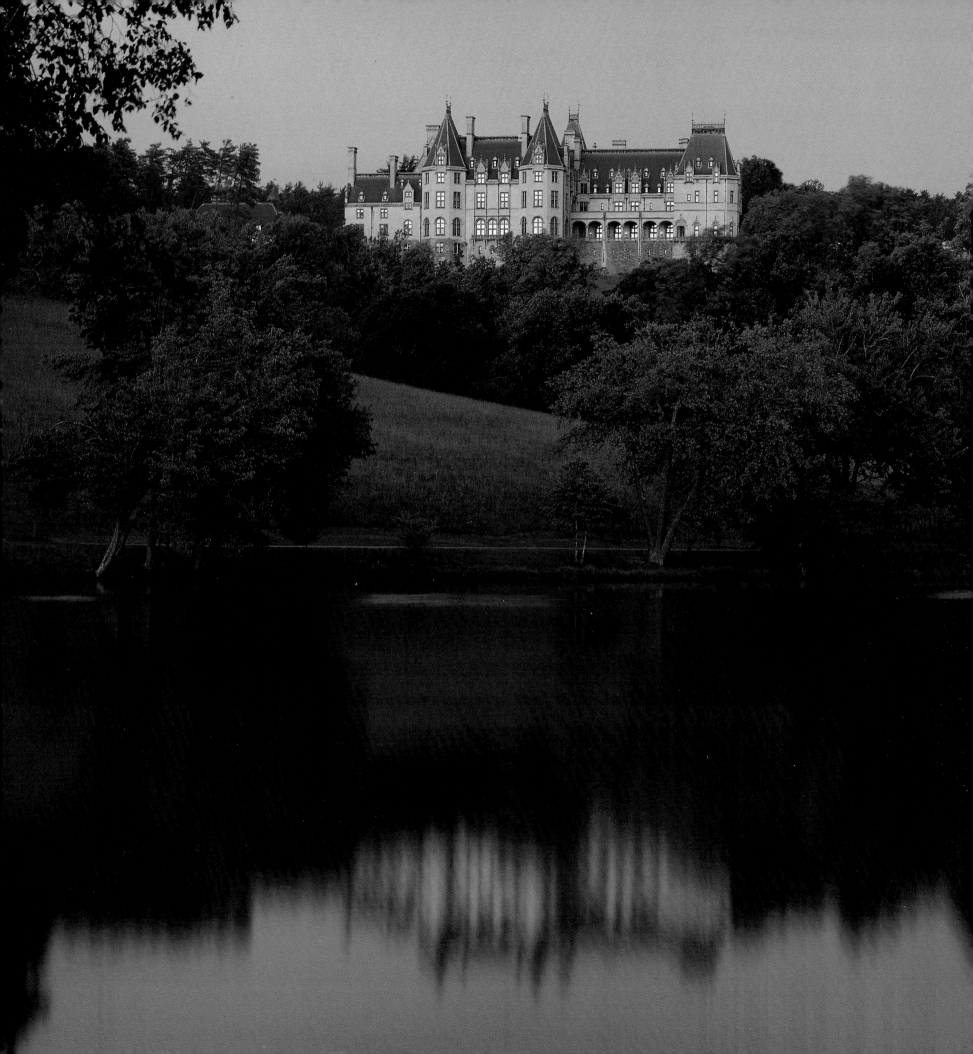

Today the landscape of the Biltmore Estate provides a remarkable
evocation of the scenic variety that Olmsted sought to create.
The rhododendrons of the approach road are still striking, however much
the richness and variety of Olmsted's planting has been simplified and
the delicate ground cover along the edge of the road replaced by mowed
grass. In the grounds near the house one can still experience the
progression through separate spaces planted for different effects that
Olmsted designed so carefully.

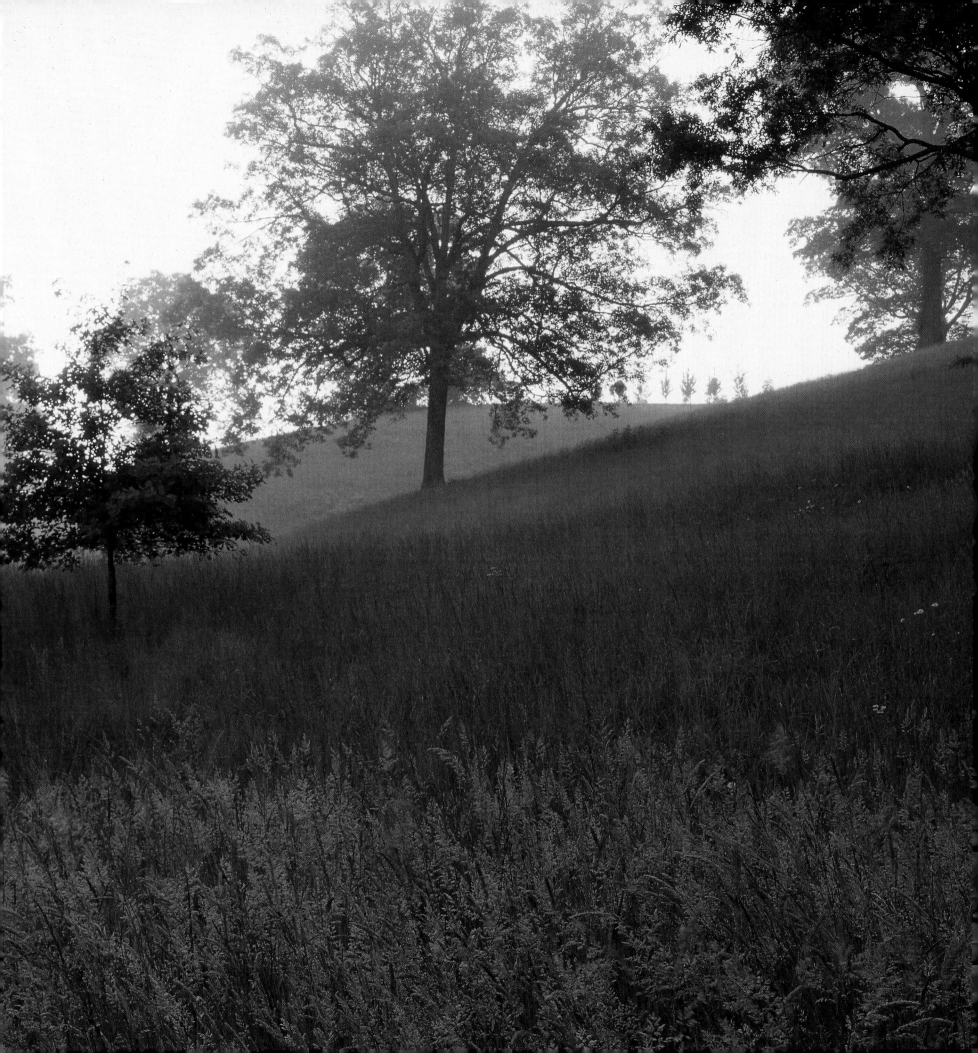

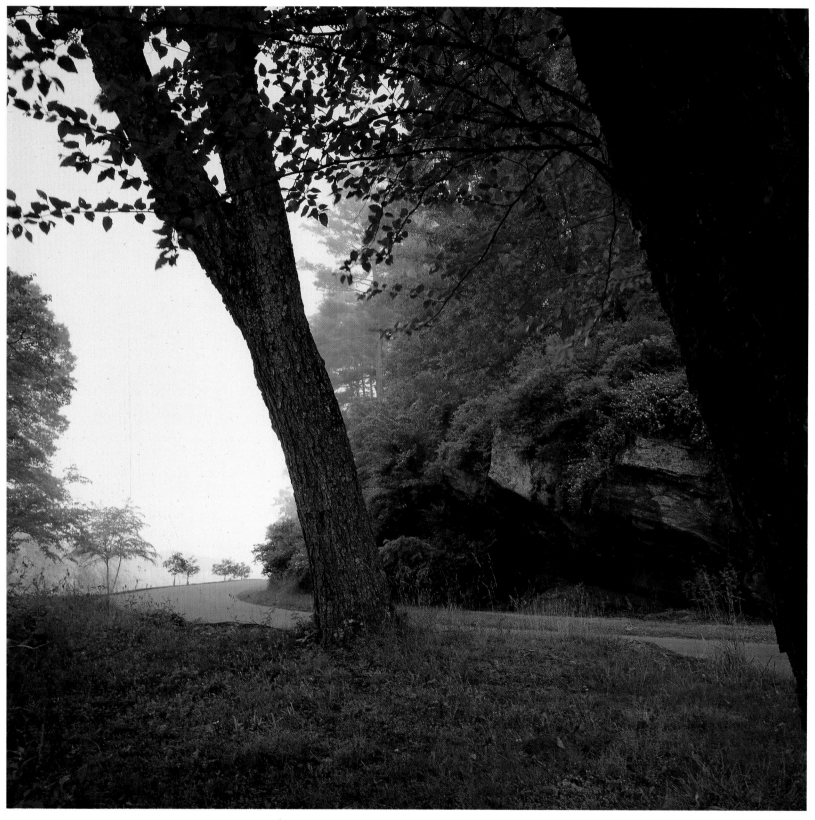

256

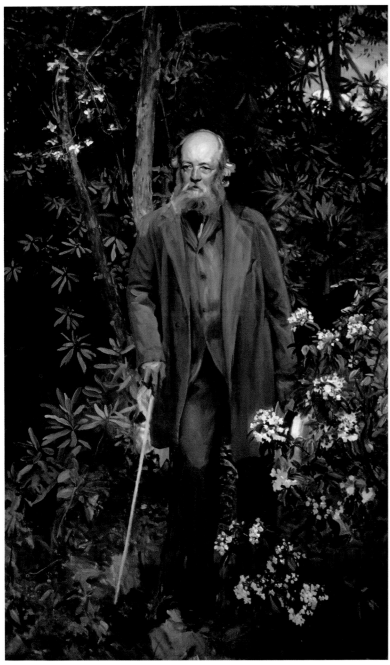

John Singer Sargent, *Portrait of Frederick Law Olmsted*, 1895.

For Olmsted, Biltmore was a vitally important commission. In the spring of 1894 he reiterated that "the public is more and more making a resort of the place and I more & more feel that it is the most permanently important public work and the most critical with reference to the future of our profession of all that we have." At the same time working there took a toll on his health. Whenever he visited the estate, he was nearly prostrated by vertigo and related symptoms. He reported, "I am feeling the elevation in increased heart action and aggravated roaring and deafness but so far have escaped sickness and blind-staggers, and hope not to be laid up as before." On other trips he had to retreat to bed for a week, unable to eat or walk, before becoming acclimatized. Such sickness was a sign of his growing frailty and a reminder that the Biltmore project was a race against time. By the fall of 1894 it was evident that his memory was no longer reliable. He increasingly forgot his earlier plans and contrived new and different solutions to design problems already solved. By November 1895, effectively removed from professional practice but still hoping for a recovery, he wrote his son:

I can only say that as the time for revision of the work draws near, and as I am drawn away from it and realize more and more the finality of this withdrawal, the intenser grows my urgency to be sure that what I have designed is to be realized.

On the walls of Biltmore House there hangs a painting that symbolizes Olmsted's withdrawal. Twenty-five-year-old Frederick Law Olmsted, Jr., served his apprenticeship at Biltmore in 1894 and 1895, learning about plant materials from Chauncey Beadle and keeping track of work between his father's visits. In the spring of 1895 John Singer Sargent began painting portraits for George Vanderbilt of Richard Morris Hunt and Olmsted. That summer Olmsted abruptly withdrew from professional practice before his portrait was finished. Taking advantage of the physical resemblance between father and son, Sargent prevailed on young Rick to model for him. A few months later the son succeeded his father as a member of the Olmsted firm.

The Ongoing Legacy

DURING 1895, as he felt his powers failing, Olmsted struggled to prepare his successors to carry on. His greatest desire was that his son and namesake, Frederick Law Olmsted, Jr., should succeed him as the leading landscape architect in the country. But young Rick had barely begun his professional training when he arrived at Biltmore as an apprentice in the fall of 1894. By that time his half-brother John C. Olmsted had been a valuable assistant to Olmsted for ten years followed by ten years as a partner in the firm.

Olmsted had trained two other designers who promised to play key roles in the perpetuation of his complex and subtle approach to landscape architecture. One was Henry Sargent Codman, a nephew of Charles S. Sargent of the Arnold Arboretum. He apprenticed with Olmsted and became a partner in 1889. By that time he had assumed responsibility for the Stanford University campus. As planning of the World's Columbian Exposition of 1893 got underway in Chicago, he became the firm's on-site representative for that vast project. His personal qualities and professional ability greatly impressed the architect Daniel Burnham, who was chief of construction for the fair. Burnham made Codman a member of the small inner group that decided the design issues for the entire exposition. But Codman was not destined to carry on the Olmsted tradition into the next generation: in January 1893, at the age of twenty-nine, he died suddenly while recuperating from an appendectomy. His death was a great shock to Olmsted; he wrote Gifford Pinchot: "You will have heard of our great calamity. As yet, I am as one standing on a wreck and can hardly see when we shall get afloat again."

The other promising young designer whom Olmsted trained was Charles Eliot, son of the president of Harvard University and nephew of the architect Robert S. Peabody of Peabody and Stearns. Young Eliot served a two-year apprenticeship with Olmsted beginning in spring 1883. Eliot then spent a year studying landscape design in Europe and returned to Boston at the end of 1886 to set up his own practice. Olmsted was

particularly impressed by Eliot's ability as a writer. "I have seen no such justly critical notes as yours on landscape architecture matters from any traveller for a generation past," he told his protégé, adding that he could contribute greatly to the future of the profession in that way. Eliot's greatest professional work was with scenic reservations. He played a leading role in the 1891 founding of the Trustees of Reservations in Massachusetts, which served as a model for the creation of the National Trust in Great Britain in 1895. He was also a moving force in the Metropolitan Park Commission of Boston, for which he began the planning of several scenic reservations and parkways.

After the death of Henry Codman, Olmsted prevailed on Eliot to join his firm as a partner and assist in meeting the mounting pressure of design commissions. Eliot brought the planning of the Boston metropolitan parks with him to the firm. He took on other projects as well, including the park system of Olmsted's birthplace, Hartford, Connecticut. It was after a day of planning Keney Park in that city in March 1897 that Eliot was struck down by meningitis. He died within a week at the age of thirty-seven. It therefore fell to the two Olmsted brothers, John and Frederick, to carry on Olmsted's design legacy. During the fifty-five years between Olmsted's retirement in 1895 and the retirement of his namesake in 1950 the firm of Olmsted Brothers carried out over three thousand commissions.

John C. Olmsted had already played an important role in the planning of the last park systems of his stepfather's career in Boston, Rochester, and Louisville. Until his death in 1920 at the age of sixty-seven John was senior partner of the firm. He did an immense amount of work during his career of forty-five years, involving the whole range of design projects carried out by the Olmsted firm. He did campus planning for numerous colleges, including Smith, Mount Holyoke, the University of Chicago and the University of Washington. He planned residential subdivisions, and designed the grounds of a variety of public institutions. John C. Olmsted also played a major part in planning the extensive park systems of Essex County, New Jersey; Dayton, Ohio; and Seattle. He designed parks in Portland, Oregon; Portland, Maine; Spokane, Washington; Charleston, South Carolina; and New Orleans. He also continued the firm's park designing in the Boston area.

The spectacular natural setting and the extent of the firm's work make the Seattle park system especially significant. In all the firm participated in planning three dozen parks, parkways, and recreation grounds in the city. John C. Olmsted began developing the park system in 1903. His report of that year offered proposals for redesigning ten existing parks, creating twenty new parks and playgrounds, and constructing many miles of boulevards to connect the whole system. The most extensive drive was Lake Washington Boulevard, which ran eight miles along the western shore of the lake.

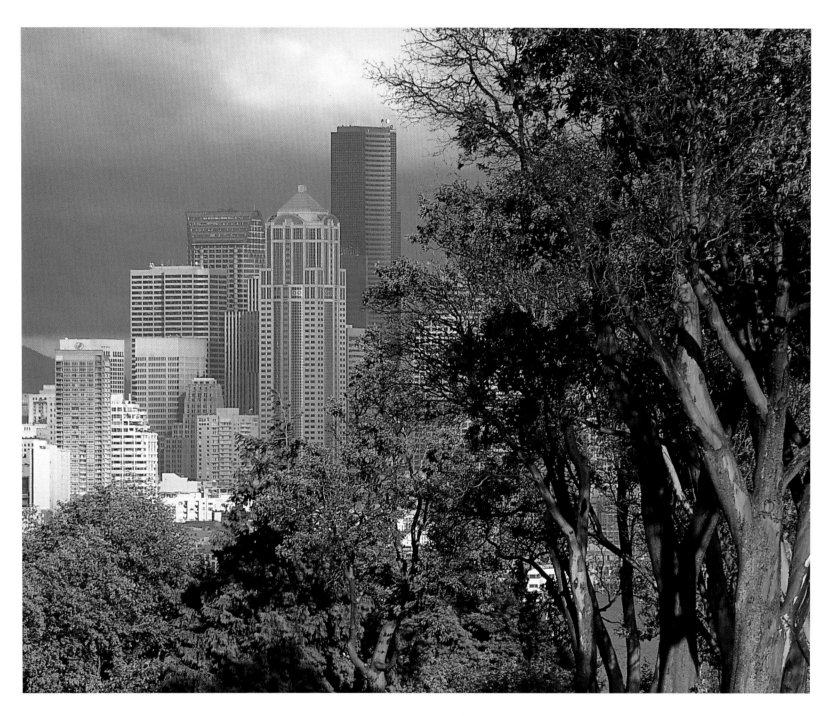

One special quality of the Seattle parks and boulevards is their lush vegetation, a feature that would have delighted Olmsted himself. The dense ground cover, ferns, and climbing vines such as one encounters in Coleman, Ravenna, and Schmitz Parks, Interlaken Boulevard, and the Washington University Arboretum represent the key materials of the Olmstedian picturesque. Few other Olmsted park systems retain anything like the profusion of vegetation to be found in these parks.

The other remarkable aspect of the Seattle parks is their dramatic views. In Magnolia Park striking Madrone trees are outlined against Puget Sound and the Olympic range in one direction and against the tall buildings of the central city in the other. From other parks one looks out at the Cascades and Mount Rainier.

Seattle has a parks department that is noted for its professionalism and its dedication to preserving the Olmsted firm's heritage. The taxpayers traditionally give strong support to the park system, including authorizing funds for expansion, whether by acquiring environmentally sensitive areas throughout the city or by creating innovative new parks. Freeway Park demonstrates one way to bring the amenity of landscape design to a marginal site, as Olmsted so often did during his career. The dense plantings amidst paved surfaces and architectural forms are reminiscent of design solutions that he developed for other regions of the country—notably the semiarid West. Gas Works Park transformed a derelict site;

the "working up" of its characteristic features recalls the imagination Olmsted brought to bear in some less appealing places.

Other areas in Seattle, such as Fort Lawton, offer the potential of innovative public space in a uniquely beautiful setting. John C. Olmsted prepared an extensive report for this site in 1910 when it was still a military reservation, showing how landscape improvements and the construction of public pleasure drives could make the fort a valuable supplement to the city's park system. The opportunity remains for imaginative enrichment of the park system on that site.

264

Opposite: Freeway Park.

Although Frederick Law Olmsted, Jr., had little formal training in landscape design before he entered the firm in 1895, he received intensive preparation in the following few years. By 1898 he had become a partner in the firm of Olmsted Brothers, which was formed after the death of Charles Eliot. Almost immediately he began to take his father's place. His first important appointment, in 1901, was to the Senate Park Commission of Washington, D.C., or MacMillan Commission, which revived the Mall and Pierre L'Enfant's plan for the city. The other members, Daniel Burnham, Charles Follen McKim, and Augustus St. Gaudens, had all played a leading role with his father in planning the World's Columbian Exposition.

Over the years the younger Frederick Law Olmsted made significant contributions to the public space of Washington, drawing up the plan for a park system for the District of Columbia and designing Rock Creek Park. He also oversaw the extensive park-planning work of the Olmsted firm in Baltimore, Maryland. There he continued his father's practice of reserving urban stream valleys as linear greenways to tie together a city's park system. Other park designs included Fort Tryon Park in upper Manhattan, site of the Cloisters. He also developed several major plans for residential communities, including Forest Hills Gardens in Queens and Palos Verdes outside Los Angeles; he prepared city plans for Newport, Rhode Island; Boulder, Colorado; Rochester, New York; New Haven, Connecticut; and Pittsburgh, Pennsylvania. From 1920 to 1950 he was senior partner of the firm of Olmsted Brothers and continued to practice until his death in 1957 at the age of eighty-seven, one hundred years after his father began to design Central Park in New York.

Frederick Law Olmsted, Jr., also continued the work on scenic reservations begun by his father. He served on commissions concerned with Yosemite National Park and the Niagara Reservation, participated in the planning of Acadia National Park, the East Bay regional parks in the San Francisco metropolitan area, and the series of mountain parks west of Denver. His most extensive planning of scenic reservations was preparation of a list of one hundred sites for inclusion in the proposed California state-park system, a project he completed in 1929. The most important site to secure, he concluded, was Point Lobos near Monterey. Over the next decade he prepared many plans for developing Point Lobos as a state park.

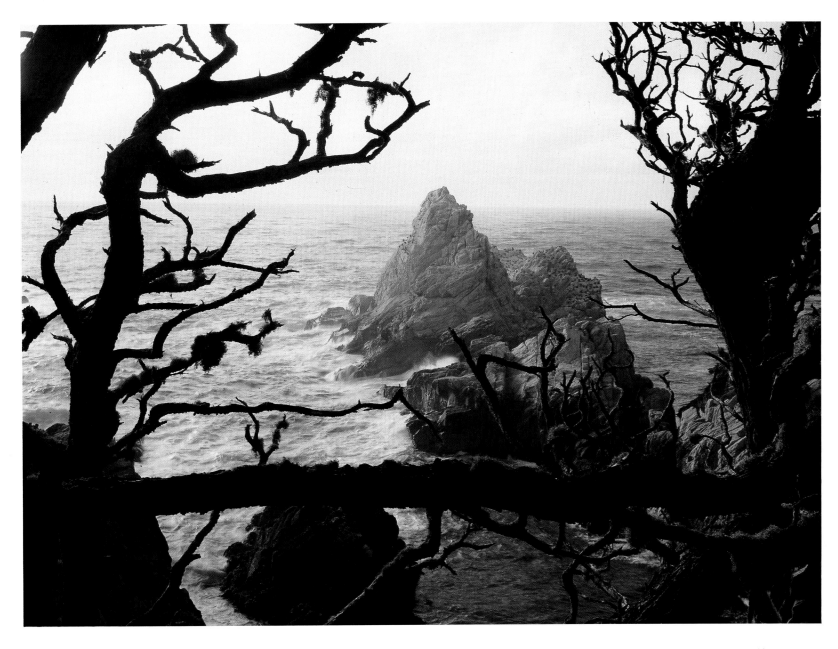

Following the approach of his father, he saw more qualities of value in the scenery of Point Lobos than simply the "vast power and dramatic quality" of the forces at work on the headland. These included:

The functional adaptation of a richly varied vegetation, marine and littoral, to the impact of waves and currents, of ocean winds, and wind-borne spray and spume and fog—from the lithe sea-weed up through the tapestries of rock-plants to the gnarled cypresses and the wind-moulded pines.

The cypresses, telling a poignant story of survival in a battle against great odds, twisting and buttressing themselves against the thrust of wind and pull of gravity, extracting vigor from the driving sea-fogs and adapting themselves to the drenching sprays of salt that sometimes crust the soil with white and rout the advance of other trees.

269

During the thirty years following the Second World War the Olmsted firm's design legacy suffered. Neglect and the intrusion of incompatible uses beset many of the parks and public spaces designed by the firm. During the past twenty years, however, there has been a revival of interest in Olmsted's ideas and landscapes. Observances in 1972 of the sesquicentennial of his birth included exhibitions at the National Gallery of Art in Washington and the Whitney Museum of American Art in New York. The following year a twelve-volume edition of his writings began to receive continuous funding from the National Endowment for the Humanities and National Historical Publications and Records Commission. In 1974 the first full-length study of him, *FLO: A Biography* by Laura Wood Roper, was published.

In 1980 the National Park Service acquired Olmsted's home and office in Brookline, Massachusetts, along with the great archive of documents, plans, and photographs there. The place was designated as the Frederick Law Olmsted National Historic Site. Since then the Park Service has renovated the house and initiated a comprehensive restoration of the grounds. Many of the plans and photographic negatives in the archives have been inventoried and conserved. The collection of reports and correspondence of the firm was transferred to the Manuscript Division of the Library of Congress, which has organized the firm's records and Olmsted's own papers. It has also microfilmed much of the collection, which is used increasingly by researchers involved in restoring landscapes designed by Olmsted and his successors.

In 1981 the National Association for Olmsted Parks was founded to increase public awareness of the firm's legacy of design and to facilitate exchange of information between persons in a variety of fields who are concerned with that legacy—including community activists, historic preservationists, historians, landscape architects, and park administrators. Stemming from conferences that the Association has held in cities with significant projects designed by the Olmsted firm, a number of local and regional Olmsted organizations have been formed. They have supported, in particular, the restoration of Olmsted-designed public parks in their areas.

The creation of restoration master plans and execution of improvements based on them have also increased during the past two decades. The first and most notable undertaking was Central Park in New York City. In 1979 Elizabeth Barlow Rogers was appointed administrator and charged with coordinating the operation and restoration of Olmsted's first and most famous design. The Central Park Conservancy, created the following year, has set the standard for private assistance of public agencies and has brought about the transformation of the park. The administration of Mayor Edward Koch made recovery of the Olmsted parks in New York City an important priority. This program led to the appointment of Tupper Thomas as administrator of Prospect Park. Master plans were developed and construction begun there and in the other principal Olmsted parks in the city—Morningside, Riverside, and Fort Tryon parks in Manhattan and Fort Greene Park in Brooklyn.

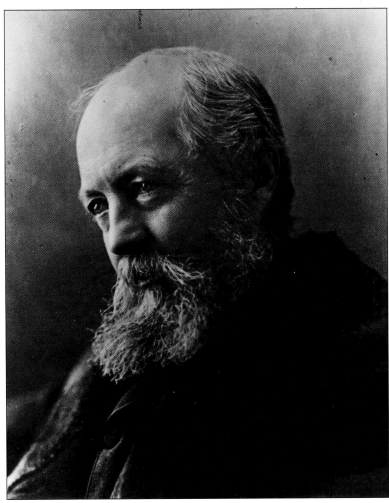

Frederick Law Olmsted, c. 1890.

A similar broad-scale restoration began in 1984 under the auspices of the Massachusetts Department of Environmental Management, leading to historic landscape reports and master plans for a dozen Olmsted-firm parks in the commonwealth and the beginning of construction in several of the parks. Numerous cities have begun the restoration process. Rochester and Buffalo, New York, and Louisville, Kentucky, have established master plans for the parks and parkways designed by Olmsted and his successors. Other cities,including Atlanta, Baltimore, Chicago, Seattle and Montreal are engaged in a similar process.

The year 1995 marks the centennial of Olmsted's retirement. In this book the authors have offered an overview of his thought and a record of the present condition of his works. We have attempted to show his significance as a landscape architect and the remarkable range of his work. Hopefully, this will help to stimulate efforts to secure greater public benefit from the landscapes that he created. In that case the passage from John Ruskin that he quoted in his last great park report for Franklin Park may prove to be prophetic:

Let it not be for present delight, nor for present use alone; let it be such work as our descendants will thank us for, and let us think . . . that a time is to come when . . . men will say "See! this our fathers did for us."

NOTES

Unless otherwise indicated, manuscripts cited are in the Frederick Law Olmsted Papers, Manuscript Division, Library of Congress, Washington, D.C., and the author of published references is Frederick Law Olmsted. Documents published in the Papers of Frederick Law Olmsted series are indicated by *PFLO*, followed by volume and page number, as (*PFLO*, 1: 297)

Chapter 1

p.10: "Passages in the Life of an Unpractical Man" (*PFLO*, 1: 100, 108-9).

p.11: Ibid., (*PFLO*, 1: 99, 117).

p. 13: Frederick J. Kingsbury to John Hull Olmsted, May 8, 1847; FLO to Elizabeth Baldwin Whitney, Dec. 16, 1890.

p. 14: FLO to Charles Loring Brace, July 12, 1847;
Walks & Talks of an American Farmer in England (New York, 1852), vol 1, p. 245;
FLO to Elizabeth Baldwin Whitney, Dec. 16, 1890.

p. 16: Charles Loring Brace to Frederick J. Kingsbury, in *The Life of Charles Loring Brace, Chiefly Told in His Own Letters*, ed. Emma Brace (New York, 1894), p. 61;
John Hull Olmsted to Frederick J. Kingsbury, May 1847;
FLO to Charles Loring Brace, Jan. 12 [1847];
Walks & Talks, vol. 1, p. 133.

p. 17: Ibid., p. 79;
FLO to Charles Loring Brace, Nov. 12, 1850.

p. 18: Timothy Dwight, *Travels in New-England and New-York* (1821-22); reprint. ed., ed. Barbara Miller Solomon, 4 vols. (Cambridge, Mass., 1969); vol. 2, pp. 231, 346-47).

p. 20: A. J. Downing, *A Treatise on the Theory and Practice of Landscape Gardening* (1841; reprint ed., ninth edition, Sakonnet, RI, pp. vi, vii;
A. J. Downing, "Our Country Villages," *Horticulturist*, vol. 4, no. 12 (June 1850), pp. 538, 539.

p. 21: FLO to Charles Loring Brace, Dec. 1, 1853 (*PFLO*, 2: 235-36);
"A Tour in the Southwest, Number Eight," *New-York Daily Times*, April 24, 1854 (*PFLO*, 2: 278).

p. 24: Frederick Law Olmsted, *A Journey Through Texas* (New York, 1857), pp. 193, 188.

p. 25: John Hull Olmsted to FLO, Nov. 13, 1857;
FLO to Calvert Vaux, Nov. 26, 1863 (*PFLO*, 5: 148).

p. 26: Henry W. Bellows to FLO, Aug. 18, 1863;
Katharine Prescott Wormeley, *The Other Side of the War* (Boston, 1889), pp. 63-64;
George Templeton Strong, *Diary of the Civil War, 1860-1865*, ed. Allan Nevins (New York, 1962), vol. 3, p. 291;
Henry W. Bellows to John H. Heywood, March 10, 1863, U.S. Sanitary Commission Papers, New York Public Library, Box 611, no. 1740.

p. 27: FLO to Mary Perkins Olmsted, Aug. 12, 1863 (*PFLO*, 4: 688);
FLO to Mary Perkins Olmsted, Oct. 15 [1863] (*PFLO*, 5: 111-12);
FLO to Henry W. Bellows, April 28, 1864 (*PFLO*, 5: 226-27);
FLO, "The Pioneer Condition and the Drift of Civilization in America" (*PFLO*, 5: 659).

p. 28: Calvert Vaux to FLO, June 3 [1865] (*PFLO*, 5: 387);
FLO, Manuscript fragment.

Chapter 2

p. 32: FLO to Mariana Griswold Van Rensselaer, June 1893.

p. 33: FLO, "Passages in the Life of an Unpractical Man," (*PFLO*, 1: 100);
Walks & Talks, vol. 1, p. 87.

p. 34: FLO to Mariana Griswold Van Rensselaer, June 1893;
FLO, Manuscript fragment;
FLO to Elizabeth Baldwin Whitney, Dec. 16, 1890;
Boston, Mass., Park Department, *Notes on the Plan of Franklin Park and Related Matters* (Boston, 1886), p. 42;
FLO, Manuscript fragment;
Olmsted, Vaux & Co., "Report of the Landscape Architects," Jan. 24, 1866, in Brooklyn, N. Y., Park Commissioners, *Annual Reports. . . 1861-1873* [hereafter cited as BPC, *Annual Reports, 1861-1873*], (Brooklyn, 1873), p. 95.

p. 35: *Mount Royal, Montreal* (New York, 1881), p. 23;
Walks & Talks, vol. 2, p. 155;
"Trees in Streets and in Parks", *The Sanitarian*, vol. 10, no. 114 (September 1882), pp. 517-18;
FLO to Sir William Hooker, c. Nov. 29, 1859 (*PFLO*, 3: 232);
FLO to Henry Sargent Codman, July 30, 1892.

p. 36: FLO, Manuscript fragment;
Charles Eliot Diary, p. 71, Charles Eliot Papers, Frances Loeb Library, Graduate School of Design, Harvard University;
FLO to Calvert Vaux, Sept. 3, 1887, Vaux Papers, New York Public Library;
Humphry Repton, *Sketches and Hints on Landscape Gardening*, ed. John Nolen (Boston and New York, 1907), p. 7;
FLO, Manuscript fragment.

p. 37: Olmsted, Vaux & Co., "Report of the Landscape Architects," Jan. 24, 1866, in BPC, *Annual Reports, 1861-1873*, p. 100.

p. 38: Olmsted, Vaux & Co., "Report of the Landscape Architects & Superintendents," Jan. 1, 1868, in BPC, *Annual Reports, 1861-1873*, p. 190;
FLO, "Address to Prospect Park Scientific Association," 1868;
Walks & Talks, vol. 2, p. 156;
FLO to Mary Perkins Olmsted, Sept. 25, 1863 (*PFLO*, 5: 80, 83).

p. 39: FLO, Manuscript fragment.

p. 42: FLO to Mariana Griswold Van Rensselaer, May 22, 1893;

FLO to Edward M. Moore, Aug. 5, 1888, Olmsted Associates Records, Manuscript Division, Library of Congress [hereafter cited as OAR/LC], vol. A2, p. 695;
FLO, Manuscript fragment.

p. 43: FLO to Dr. Thomas Hill, Nov. 3, 1875;
Mount Royal, Montreal, p. 43;
FLO to Rudolph Ulrich, March 24, 1892;
FLO to Charles Eliot Norton, Oct. 19, 1881, Norton Papers, Houghton Library, Harvard University.

p. 44: FLO, draft report to Hartford Park Commissioners [1895];
FLO to Frederick J. Kingsbury, Nov. 17, 1848 (*PFLO*, 1: 322);
Charles Eliot to W. P. Garrison, Nov. 2, 1896, Letterbook vol. 2, Charles Eliot Papers, Frances Loeb Library, Graduate School of Design, Harvard University.

Chapter 3

p. 46: *Public Parks and the Enlargement of Towns* (Cambridge, MA, 1870), pp. 6-7;
Olmsted, Vaux & Co., "Report of the Landscape Architects and Superintendents," Jan. 1, 1868, in BPC, *Annual Reports, 1861-1873*, pp. 178, 179, 188;
For a fuller discussion of Olmsted's concept of the metropolis of the future, see David Schuyler, *The New Urban Landscape: The Redefinition of City Form in Nineteenth-Century America* (Baltimore, 1986).

p. 47: "The Future of New-York," *New-York Daily Tribune*, Dec. 28, 1879.

p. 48: Olmsted, Vaux & Co., "Report of the Landscape Architects and Superintendents," Jan. 1, 1868, in BPC, *Annual Reports, 1861-1873*, p. 191;
A Consideration of the Justifying Value of a Public Park (Boston, 1881), p. 19.

p. 49: Boston, Mass., Park Department, *Franklin Park and Related Matters*, pp. 100-03;
Walks & Talks, vol. 2, p. 64;
F. L. & J. C. Olmsted, *Plan of Public Recreation Grounds for the City of Pawtucket* (Boston, 1888), p. 7;
FLO, Manuscript fragment;
Mount Royal, Montreal, p. 63;
Public Parks and the Enlargement of Towns, p. 19.

p. 50: Ibid., p. 18;
Olmsted, Vaux & Co., "Report of the Landscape Architects," Jan. 24, 1866, in BPC, *Annual Reports, 1861-1873*, p. 96;
Justifying Value of a Public Park, p. 19;
FLO, "Address to Prospect Park Scientific Association."

p. 51: Frederick Law Olmsted and Calvert Vaux, "A Review of Recent Changes ... in the Plans of the Central Park," New York, Department of Public Parks, *Second Annual Report* (New York, 1872), pp. 75-78;
Olmsted, Vaux & Co., "Report of the Landscape Architects," Jan. 24, 1866, in BPC, *Annual Reports, 1861-1873*, p. 97;

p. 54: FLO to Parke Godwin, Aug. 1, 1858 (*PFLO*, 3: 201);

Public Parks and the Enlargement of Towns, p. 27;
A. J. Downing, "The New-York Park," *Rural Essays* (New York, 1853), p. 150.

p.. 56: New York, N.Y., Department of Public Parks, "Statistical Report of the Landscape Architect, 31st December, 1873, Forming part of Appendix L of the Third General Report of the Department" (New York, 1875), p.46 (*PFLO*, 3: 43).

p. 68: Frederick Law Olmsted and Calvert Vaux, "Review of Recent Changes in the Plans of the Central Park," p. 71.

p. 69: Ibid., pp. 73-74;

p. 70: FLO to Commissioners of Central Park, Jan. 22, 1861 (*PFLO*, 3: 304);

p. 74: FLO, "Address to Prospect Park Scientific Association."

p. 75: Ibid.

p. 85: *Chicago Times*, Feb. 20, 1867, cited in Daniel M. Bluestone, *Constructing Chicago* (New Haven, 1991), p. 26;
FLO to Joseph W. Donnersberger, April 20, 1894, OAR/LC, vol. A33, p. 889;
FLO to Rudolph Ulrich, March 24, 1891, OAR/LC, vol. A13, p. 886.

p. 86: Chicago South Park Commission, *Report Accompanying Plan for Laying Out the South Park, Olmsted, Vaux & Co., Landscape Architects* (Chicago, 1871), p. 13.

p. 87: Ibid., p. 13;
FLO to Rudolph Ulrich, March 24, 1891;
H. W. S. Cleveland to FLO, July 25, 1888.

p. 88: *Mount Royal, Montreal*, pp. 44, 48.

p. 89: FLO to Horatio A. Nelson, July 26, 1876, Archives Municipales de Montr_al;
FLO to Horatio A. Nelson, April 4, 1876, Archives Municipales de Montr_al;
Mount Royal, Montreal, pp. 51, 57-59, 77-78.

p. 90: *The Park for Detroit* (Boston, 1882), p. 32.

p. 91: *Belle Isle: After One Year*, (privately printed, 1884), p. 22.

p. 94: "A Healthy Change in the Tone of the Human Heart," *The Century Illustrated Monthly Magazine*, vol. 32 (October 1886), p. 963;
"Mr. Olmsted's Report," Oct. 1, 1868, in "Preliminary Report Respecting a Public Park in Buffalo," (Buffalo, 1869), in Buffalo, N.Y., Park Commission, *Annual Reports* [1871-1882];
FLO to George E. Waring, Jr., April 13, 1876;
Buffalo, N.Y., Park Commission, *The Projected Park and Parkways on the South Side of Buffalo. Two Reports by the Landscape Architects* (Buffalo, 1888), pp. 7, 12.

p. 98: "Report on Back Bay," Boston, Mass., Board of Commissioners of the Department of Parks, *Tenth Annual Report* (Boston, 1885), p. 14.

p. 99: FLO to Charles S. Sargent, July 8, 1874, OAR/LC, Box B68.

p. 101: See Cynthia Zaitzevsky, *Frederick Law Olmsted and the Boston Park System* (Cambridge, MA, 1982), pp. 195-97.

p. 104: FLO to John C. Olmsted, May 15, 1892.

p. 106: Sylvester Baxter, *Boston Park Guide* (Boston, 1896), p. 21.

p. 112: "Report of F. L. Olmsted & Co. Landscape Architects," in Louisville, Kentucky, Board of Park Commissioners, *First Annual Report* (Louisville, 1891), pp. 51-57.
p. 115: Ibid., p.56;
Olmsted Brothers, Report, c. Nov. 1, 1899, OAR/LC, Box B83;
Olmsted Brothers to Andrew Cowan, March 12, 1908, OAR/LC, Box B83.

Chapter 4

p. 116: FLO, Manuscript fragment;
Olmsted, Vaux & Co., *Preliminary Report upon the Proposed Suburban Village at Riverside, Near Chicago* (New York, 1868), p. 7 (*PFLO*, 6: 275);
FLO to Edward Everett Hale, Oct. 21, 1869 (*PFLO*, 6: 346);
Staten Island Improvement Commission, *Report of a Preliminary Scheme of Improvements* (New York, 1871), pp. 12, 15.
p. 117: *Public Parks and the Enlargement of Towns*, p. 8;
Report Upon a Projected Improvement of the Estate of the College of California, at Berkeley, Near Oakland (New York, 1866), p. 11 (*PFLO* 5, 554).
p. 118: Olmsted, Vaux & Co., *Report upon the Proposed Suburban Village at Riverside*, pp. 12, 19, 20 (*PFLO* 5: 278, 284).
p. 121: Ibid., pp. 17, 22, 24, 27-28 (*PFLO*, pp. 280, 285-88);
FLO to Edward Everett Hale, Oct. 21, 1869 (*PFLO*, 5: 347).

p. 124: FLO to Frederick Law Olmsted, Jr., July 23, 1895.

Chapter 5

p. 126: FLO to Frederick Knapp, Oct. 8, 1866 (*PFLO*, 6: 126-28);
FLO to Charles Loring Brace, Aug. 25, 1862 (*PFLO*, 4: 414).
p. 127: FLO to James Colgate, Oct. 19, 1883.
p. 129: FLO to Charles W. Eliot, June 8, 1886.
p. 132: FLO to Leland Stanford, Nov. 27, 1886.
p. 134: John S. Butler to FLO, Dec. 3, 1872;
FLO to Charles Dalton, June 27, 1875;
FLO, draft reports on McLean Asylum, Dec. 13, 1872 and Aug. 17, 1873.

Chapter 6

p. 136: FLO to Henry W. Bellows, April 28, 1864 (*PFLO*, 5: 227);
Report Upon the College of California, pp. 4, 7 (*PFLO*, 5: 548, 551);
Staten Island Improvement Commission, *Preliminary Scheme of Improvements*, p. 24.
p. 137: FLO, Manuscript fragments;
"Plan for a Small Homestead," *Garden and Forest*, May 2, 1888, p. 111;
FLO to R. J. Goddard, (n.d.).
p. 138: Frederick Law Olmsted, Jr., to William Schack, Aug. 10, 1936, OAR/LC;
Walks & Talks, vol. 1, p. 84;
FLO, "A Homestead," (draft manuscript) p. 3;

FLO to Mariana Griswold Van Rensselaer, May 17, 1887;
FLO to Charles T. Hubbard, Feb. 2, 1884.
p. 141: FLO to John C. Olmsted, Sept. 12, 1884;
FLO, Manuscript fragments.
p. 149: "A Modern Massachusetts Farm," *Garden and Forest*, March 30, 1892, p. 146.
p. 157: FLO to John C. Phillips, Sept. 27, 1881.
p. 158: FLO to John C. Phillips, May 11, 1880.
p. 162: FLO to John C. Phillips, March 6, 1882.
p. 164: Ibid.;
FLO to John C. Phillips, May 11, 1880.
p. 167: FLO to John C. Phillips, Sept. 27, 1881.
p. 170: FLO to John C. Phillips, May 11, 1880.

Chapter 7

p. 175: Mariana Griswold Van Rensselaer, *Henry Hobson Richardson and His Works* (1888; reprint ed., New York, 1969) p 40;
Mariana Griswold Van Rensselaer, "Landscape Gardening—III", *American Architect and Building News*, vol. 23, no. 628 (Jan. 7, 1888), p. 4;
FLO, Draft manuscript, March 1877.
p. 180: FLO to Oakes Ames, April 10, 1882;
FLO, "A Few Annotations, for Private Use Only, upon 'Architectural Fitness'...," in Cynthia Zaitzevsky, "The Olmsted Firm and the Structures of the Boston Park System," *Journal of the Society of Architectural Historians*, vol. 32, no. 2 (May 1973), pp. 170-71.
p. 182: Ibid.
p. 187: Ibid.;
Cynthia Zaitzevsky, *Frederick Law Olmsted and the Boston Park System*, pp. 165-66.

Chapter 8

p. 188: FLO to Whitelaw Reid, Nov. 26, 1874, Whitelaw Reid Papers, Manuscript Division, Library of Congress;
"Index to Trees About the Capitol, with Advice to Visitors Interested in Them," in *Annual Report of the Architect of the United States Capitol* (Washington, 1882), p. 16.
p. 193: "The National Capitol," *New-York Daily Tribune*, Dec. 5, 1874;
FLO to Justin S. Morrill, Aug. 4, 1874.
p. 194: FLO to Edward Clark, Oct. 1, 1881, in *Annual Report of the Architect of the United States Capitol* (Washington, 1881), pp. 14-15.
p. 195: FLO to E. H. Rollins, c. February 1882.
p. 196: FLO to F. H. Cobb, May 30, 1881.
p. 198: FLO to F. H. Cobb, Oct. 21, 1879, OAR/LC, vol. D2;
FLO to F. H. Cobb, May 30, 1881.

Chapter 9

p. 201: FLO to Mary Perkins Olmsted, Nov. 20, 1863 (*PFLO*, 5: 136-37);
FLO to Henry W. Bellows, Aug. 8, 1864, Henry Whitney Bellows Papers, Massachusetts Historical Society, Boston, Mass.;
FLO, "Preliminary Report upon the Yosemite and Big Tree Grove" [August 1865] (*PFLO*, 5:

490, 500).
p. 202: Ibid. (*PFLO*, 5: p. 500).
p. 205: Ibid. (*PFLO*, 5: p. 493).
p. 210: Frederick Law Olmsted and Calvert Vaux, *General Plan for the Improvement of the Niagara Reservation* (New York, 1887), p. 21;
"Notes by Mr. Olmsted," in New York (State), State Survey, *Special Report ... on the Preservation of the Scenery of Niagara Falls ...* (Albany, 1880), pp. 28, 30.
p. 212: Ibid., p. 29;
James Terry Gardner, "Report of the Director," in Ibid., pp. 20-21.
p. 213: Olmsted and Vaux, *Plan for Niagara Reservation*, pp. 15, 16.

Chapter 10

p. 216: FLO to Henry S. Codman, July 30, 1892;
FLO, Manuscript fragment;
Preliminary Report in Regard to a Plan of Public Pleasure Grounds for the City of San Francisco, p. 28 (*PFLO*, 5: 541).
p. 217: Ibid., p. 24 (*PFLO*, 5: 534);
FLO to William Hammond Hall, Oct. 5, 1871.
p. 218: FLO to Major R.W. Kirkham, in *The Organization of Mountain View Cemetery Association, Oakland, California* (San Francisco, 1865), pp. 45, 50, 52, 60 (*PFLO*, 5: 474, 476, 478, 482);
FLO to William Robinson, March 1875.
p. 220: *Report Upon the College of California*, p. 18 (*PFLO*, 5: 561).
p. 221: FLO to Charles W. Eliot, July 20, 1886;
p. 222: FLO to C. A. Roberts, Dec. 9, 1890, OAR/LC, vol. A11, pp. 277-78;
F. L. Olmsted & Co., "Design Map of the Village of Lake Wauconda in Perry Park, Douglas County, Colorado," March 28, 1890, Job #1091, Frederick Law Olmsted National Historic Site, Brookline, Mass.;
FLO to Frederick Law Olmsted, Jr., Aug. 1, 1895.

Chapter 11

p. 225: For the story of the creation of Biltmore Estate, see John M. Bryan, *Biltmore Estate: The Most Distinguished Private Place* (New York, 1994);
FLO to William A. Thompson, Nov. 6, 1889, OAR/LC, vol. A5, p. 470;
FLO to Frederick J. Kingsbury, Jan. 20, 1891;
Frederick Law Olmsted, Jr., to John C. Olmsted, Aug. 19, 1895, OAR/LC, Box H2, vol. 6.
p. 226: FLO to George W. Vanderbilt, Dec. 30, 1893, OAR/LC, vol. A31, p. 814;
FLO to Messrs. Gall, Manning, Beadle, Boynton and Bottomley, June 10, 1894;
FLO to George W. Vanderbilt, July 12, 1889.
p. 228: Frederick Law Olmsted, Jr., to Phillip Codman, Jan. 4, 1895, OAR/LC, Box H2, vol. 2;
FLO to Chauncey Beadle, July 27, 1895, OAR/LC, vol. A41, p. 711;
FLO to George W. Vanderbilt, July 12, 1889;

FLO to John C. Olmsted, Oct. 31, 1890;
FLO, Manuscript fragment;
FLO to James Gall, Aug. 28, 1891, OAR/LC, vol. A16, p. 627.
p. 230: FLO to George W. Vanderbilt, July 12, 1889.
p. 235: FLO to John C. Olmsted, April 5, 1895, OAR/LC, Box H2, Private letterbook.
p. 238: FLO to Richard Morris Hunt, March 2, 1889.
p. 244: FLO to George W. Vanderbilt, Jan. 29, 1891, OAR/LC, vol. A12, p. 669.
p. 257: FLO to partners, May 3, 1894;
FLO to Frederick Law Olmsted, Jr., Nov. 7, 1895.

Chapter 12

p. 258: FLO to Gifford Pinchot, Jan. 19, 1893, OAR/LC, vol. A24, p. 394;
Charles W. Eliot, *Charles Eliot, Landscape Architect* (Boston and New York, 1902), p. 207.
Keith N. Morgan, "Charles Eliot, 1859—1897. Held in Trust: Charles Eliot's Vision for the New England Landscape (National Association for Olmsted Parks, 1991)
Arleyn A. Levee, "John Charles Olmsted," in *American Landscape Architecture: Designers and Places*, ed. William H. Tishler (Washington, D.C., 1989), pp. 48-51
p. 266: Shary Page Berg, "Frederick Law Olmsted, Jr.," in ibid., pp. 60-65.
p. 269: Frederick Law Olmsted [Jr.] and George B. Vaughan, "A Landscape of Beauty and Meaning," in "Point Lobos Reserve: Interpretation of a Primitive Landscape," (1939), Olmsted Western Office Records, Job #8083, National Park Service, Frederick Law Olmsted National Historic Site,

PHOTOGRAPHY CREDITS

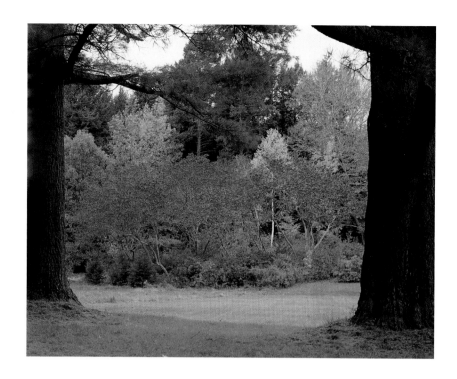

We wish to acknowledge the contributions made by the following people to the preparation of this book; Rolf Diamant, superintendent of Fairsted, the Frederick Law Olmsted National Historic Site in Brookline, Massachusetts, who suggested the collaboration between the authors, and the staff at Fairsted, who helped so much to gather the historical plans and photographs in the book; Maya Moran, on the porch of whose Frank Lloyd Wright house in Riverside, Illinois, the idea for the book first germinated; George and Mimi Batchelder, whose kindness was as great as the beauty of their estate, Moraine Farm; William Cecil, who kindly permitted the extensive photograph of Biltmore Estate that was so important for this book, and Bill Alexander, landscape curator of Biltmore Estate, who pointed out many subtle aspects of the Biltmore landscape; Mr. and Mrs. Oliver F. Ames, who graciously provided access to their estate, Langwater; John W. and Mary Lou Murray, who kindly made the Ephraim Gurney property available to us; Elizabeth Barlow Rogers, administrator of Central Park, and Sarah Cedar Miller, photographer and archivist of the Central Park Conservancy, for providing historical images; Tupper Thomas, administrator of Prospect Park, and her staff, who gave generously of their time; the staff of the Seattle Parks & Recreation Department; A. Blake Gardner for his fine photographic coverage of the rhododendron in bloom at Moraine Farm; and, not least, Charles Miers, who originally saw the worth of the project and saw it successfully launched.

We wish to thank the staff of the Manuscript Division of the Library of Congress, and the staff of the Frances Loeb Library of the Harvard University Graduate School of Design; Julia Sniderman, preservation planning supervisor of the Chicago Park District, for assistance in securing historical photographs; and Herbert Mitchell, for generously sharing his collection of Central Park and Prospect Park images with us.

Special acknowledgement is due to the editors of the Frederick Law Olmsted Papers—Charles Capen McLaughlin, founder of the project, and fellow editors Jane Turner Censer, Carolyn F. Hoffman, Victoria Post Ranney, and David Schuyler for the fruitful exchange of ideas and information that has taken place over the years; and to Francis R. Kowsky, Arleyn A. Levee, and Lauren Meier for assistance and encouragement.

Finally, appreciation is due to the College of Arts and Sciences and the History Department of The American University in Washington, D. C., for sponsorship of the Olmsted Papers editorial project.